Nudes

Eli Levin's long career as a painter is marked by how little it was influenced by the styles of his time. He asks 'how would Giorgione (or Bruegel or Sloan) have done this?' In the second half of the twentieth century American modernists were rarely engaged in figuration, particularly with the nude, but the subject proliferates in Levin's art. There we find him quoting earlier masters' versions of what may be art history's most expressive subject. This book is rare in being a searching discussion, written by an artist, of the meaning of the nude figure in his own life's work.

—Eric Thomson, Argos Gallery, Santa Fe, New Mexico

Nudes

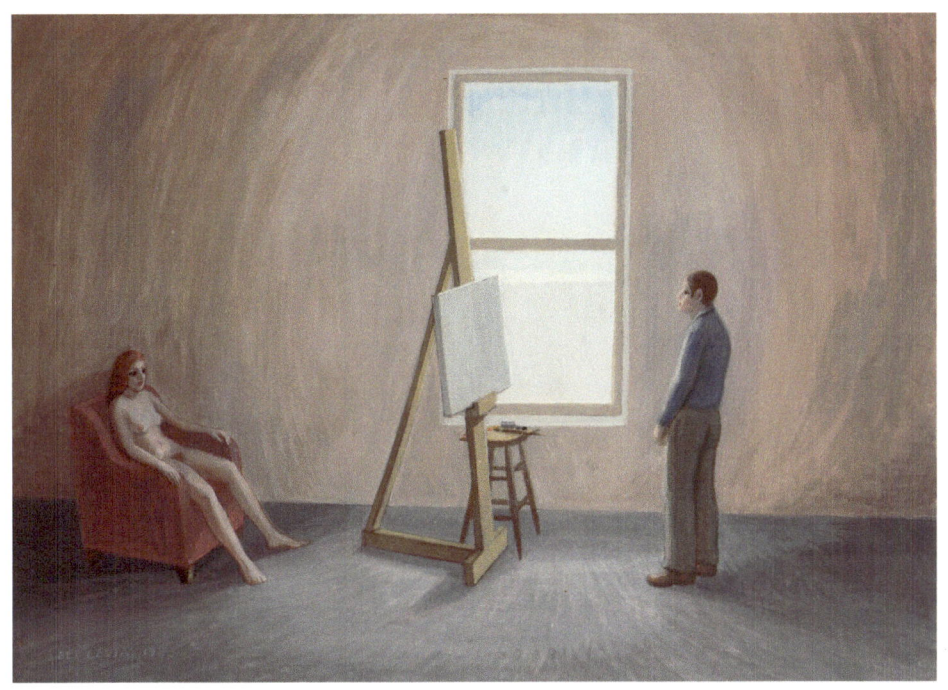

An Artist's Inquiry
1962–2012

Eli Levin

Santa Fe

Other books by Eli Levin from Sunstone Press

Disturbing Art Lessons
A Memoir of Questionable Ideas and Equivocal Experiences

Santa Fe Bohemia
The Art Colony, 1964–1980

Why I Hate Modern Art

© 2018 by Eli Leven
All Rights Reserved

No part of this book may be reproduced in any form or by any electronic or mechanical means including information storage and retrieval systems without permission in writing from the publisher, except by a reviewer who may quote brief passages in a review.

Sunstone books may be purchased for educational, business, or sales promotional use. For information please write: Special Markets Department, Sunstone Press, P.O. Box 2321, Santa Fe, New Mexico 87504-2321.

Printed on acid-free paper

Library of Congress Cataloging-in-Publication Data

Names: Levin, Eli, 1938- author.
Title: Nudes : an artist's inquiry, 1962-2012 / by Eli Levin.
Description: Santa Fe : Sunstone Press, 2018.
Identifiers: LCCN 2018002665| ISBN 9781632931825 (softcover : alk. paper) | ISBN 9781632931832 (hardcover : alk. paper)
Subjects: LCSH: Levin, Eli, 1938- | Nude in art.
Classification: LCC ND237.L614 A4 2018 | DDC 759.13--dc23
LC record available at https://lccn.loc.gov/2018002665

WWW.SUNSTONEPRESS.COM
SUNSTONE PRESS / POST OFFICE BOX 2321 / SANTA FE, NM 87504-2321 /USA
(505) 988-4418 / ORDERS ONLY (800) 243-5644 / FAX (505) 988-1025

To the models, without whom none of this would have been possible.

Acknowledgments

I want to thank Sunstone Press for suggesting the theme of this book. The book has been eight years in the making. But then, I've been painting nudes for sixty years.

The preparations for this book would not have been possible without the following friends who ran computers and other digital equipment for me in various ways:

I had a lifetime of slides and printed photos of my paintings that needed digitizing; thanks to the diligent work, keen eye, and color-adjusting know-how of my painting companion Whitman Johnson, the images look as good or better than the originals.

Thanks also to my sweetie Abby Mattison who typed the manuscript and worked closely with the perfectionist grammatical editor (who wishes to remain anonymous). She also facilitated loads of emails for me.

And thanks to Argos Gallery owner, Eric Thomson, who took many digital photos of my paintings, helped clarify my thoughts, and designed the pages.

Contents

Introduction / 9

I. Disturbing Nudes / 19

II. Mostly Couples / 43

III. Nudes from Life / 87

IV. Myths / 111

V. Contemplative Nudes / 147

Sources / 179

Introduction

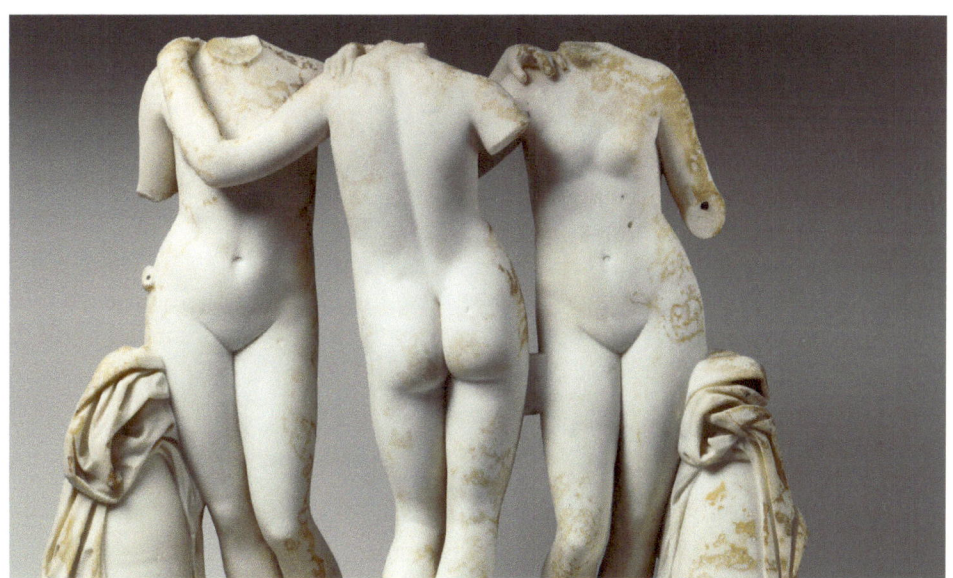

Three Graces, second century CE Roman copy of a Greek work from the second century BCE

In Praise of Nude Paintings

> It is necessary to labor the obvious and say that no nude, however abstract, should fail to arouse in the spectator some vestige of erotic feeling, even though it be only the faintest shadow—and if it does not do so, it is bad art and false morals.
>
> —Sir Kenneth Clark,
> *The Nude: A Study in Ideal Form*

As a little boy I was with my mother and father in a nudist colony, and ever since I've been curious about bodies. It was because of nudes that I fell in love with art. In my childhood, books of paintings showed me what naked people looked like. As a teenager, I drew models and frequented the museums of New York to admire the human form and its subtle beauties in great paintings and sculptures. As a young artist, I aspired to painting nudes that expressed my sexual and aesthetic awe of the human form.

It is said that if you can draw the figure, you can draw anything. Perhaps that's not altogether true. What about landscapes? But surely figures are the hardest subject to master. And even though some artists are masters at figure drawing and even figure painting, this skill might just be used to make girlie pictures or homoerotic images. Then again, these too can be art, as is seen in works by Titian or Michelangelo.

There are many significant qualities of the naked, exposed human form. Our bodies are perhaps more meaningful than any other subject in art.

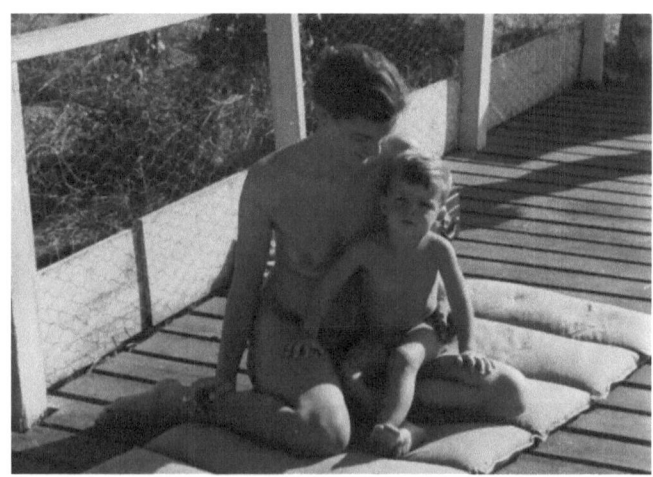

Photograph of Mable Schamp Levin with her son, Eli Jonathan Levin, by Meyer Levin, c. 1940.

In this introduction, I consider some of the intricacies and complications involved in depicting the figure. There are numerous motivations, conscious and otherwise, behind the painting of nudes. Furthermore, there are questions of style and of content. Artists from different times and circumstances reveal a broad range of perceptions. Besides the direct evidence of paintings, there is the hindsight of critical evaluations and theories. In the context of this book, one sees the development evident in my own work. These paintings were done over a fifty year period, so there are changing perceptions and interpretations, which I will discuss in captions to the reproductions.

I am hardly alone in my lifetime obsession with drawing and painting nudes. In art history, the nude is almost ubiquitous, despite many societies' severely restrictive agendas. Who would have expected a pope to fill his private chapel with the overpowering nudes by Michelangelo? Who would have suspected that the landscape artist Turner would leave hundreds of nudes, which were destroyed by the executor of his estate, Ruskin? Who would have thought that Cézanne, who couldn't abide a nude model, would culminate his career painting a series of bathers, however curiously disjointed? Who would have guessed that in Titian's *Sacred and Profane Love*, the sacred woman would be the nude, while the profane woman would be elegantly dressed?

Allegories of truth, justice, liberty, and other abstract ideas are often depicted as nudes. As in the parable of the emperor's new clothes, the fundamental form is waiting for those who have eyes to see. When superfluity seems oppressive, the nude is the fundamental reality underneath the trappings of art.

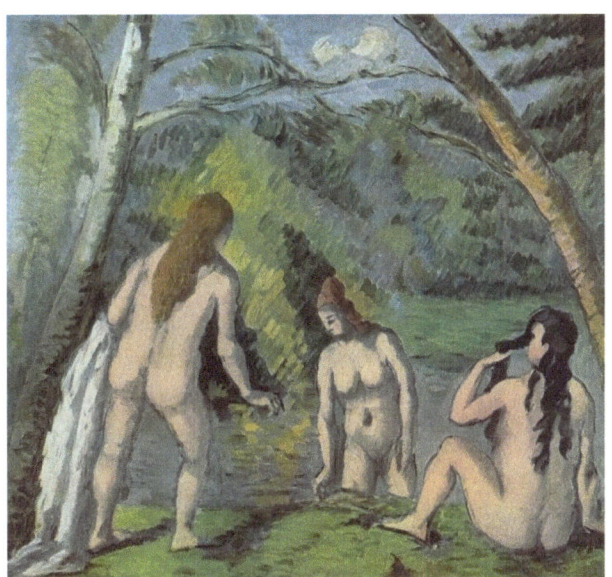

Three Bathers, Paul Cézanne, c. 1882, oil

Use of the Nude

It seemed then [in the Renaissance] that there was no concept, however sublime, that could not be expressed by the naked body . . . In the greatest age of painting, the nude inspired the greatest works; and even when it ceased to be a compulsive subject, it held its position as an academic exercise and a demonstration of mastery. . . . And in our own century, when we have shaken off one by one those inheritances of Greece which were revived at the Renaissance, discarded the antique armor, forgotten the subject of mythology, and disputed the doctrine of imitation, the nude alone has survived.

—Sir Kenneth Clark,
The Nude: A Study in Ideal Form

The basic term "realism" describes all of my paintings—from simply observed still lifes, landscapes and figures, to works of social realism. "Social realism" refers to those paintings of invented scenes that I make up to express my thoughts and feelings about people. Most of my paintings have been in this vein. They include barroom scenes, workers, street scenes, interactions, prisoners, lost souls, and various aspects of society.

Nudes sometimes show up in my social commentary, as in the paintings of strip joints or scenes of torture. But most of my nudes belong to a subtler kind of social statement. In one sense the nudes are humans in the prelapsarian state, without all the manipulations. Many of my nudes are about what it means to be a person alone.

To be a social realist painting nudes is to be involved in long traditions. From the thirteenth through the nineteenth centuries, Western paintings had messages. Many paintings had less than salutary contexts, such as glorifying Catholicism and tyranny.

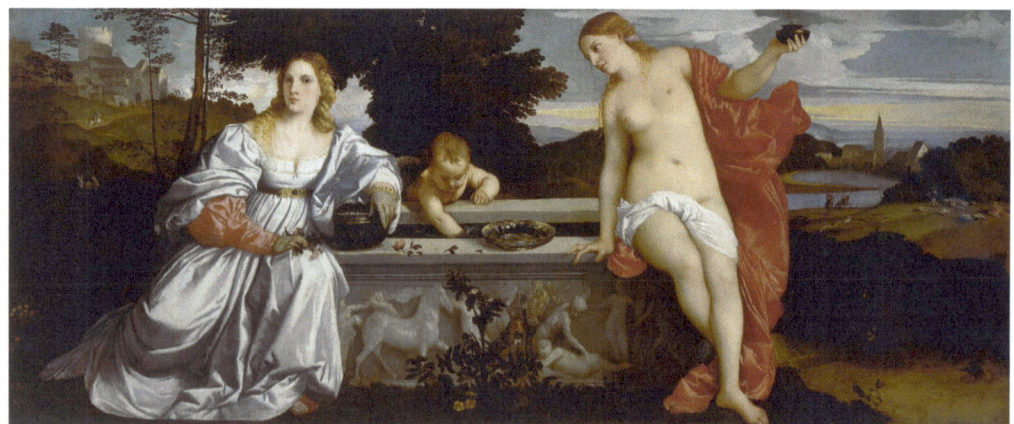

Sacred and Profane Love, Titian, c. 1514, oil

Social realists look for motifs that are more humanitarian: condemning war and brutality, sympathizing with "common" people, celebrating good deeds and simple pleasures. Many artists, despite their patrons, had humane moments. Standing out from their political backgrounds are Piero di Cosimo, Pieter Bruegel the Elder, Vermeer, Chardin, Hogarth, Goya, Millet, Daumier, George Grosz, and John Sloan.

While paintings of nudes are apt to be by their nature less tendentious than the pantheon of saints and heroes, there are also nude Mary Magdalenes and Saint Sebastians. Hercules stands in for many self-aggrandizing rulers. But the nudity often mitigates the message. There are artists whose interest in nudes is pervasive: Botticelli, Michelangelo, Titian, Rubens, Boucher, Tiepolo, Renoir, Modigliani.

Then there are wonderful instances when artists painted rare but special nudes: Giorgione, Tintoretto, Velázquez, Goya, Rembrandt, Ingres, Manet. These nudes express something personal. The figures depicted are often suspended in the moment before their futures envelop them. Susanna or Bathsheba or even Eve is at a pause before fate intervenes.

In our era, nudes have come upon hard times. Is it because of the ubiquitous empire of porn that the public seems to have a distaste for nudes? Yes. Do people feel uneasy because of societal repression? Yes. Is the ability to draw a nude no longer valued in the art world? Yes. Are museums and galleries hesitant to hang nudes? Yes. To avoid these problems, many artists have stopped depicting nudes or, conversely, have painted confrontational nudes—for example, Lucian Freud, Balthus, and Philip Pearlstein.

Confrontation has a valid place, as any good social realist knows. But isn't there something degrading in repeatedly commandeering poor defenseless nudes to make aggressive statements? Given the state of contemporary figurative art and the soft-core porn of advertising, I would venture to say there is something wrong with our collective psyche. This is an issue that I address, both in my own disturbing nudes and in what I hope is the antidote, which is the range of feelings expressed in my later nudes.

The Probity of Painting Nudes

> Representing the female body is a way of killing her. . . . The live creature, a woman . . . cannot be imagined in a culture of misogyny. Her existence must be turned into a case, encased, flattened—in any of the ways visual culture has at its disposal—so that she can remain invisible. The hypervisibility of women . . . is only another way of killing them.
>
> The nude is a case of objectification, of the killing gaze. . . .
>
> —Mieke Bal, "Women as the Topic," *Women Who Ruled: Queens, Goddesses, Amazons in Renaissance and Baroque Art*

> I like . . . nudes, but I do not like people showing them to me.
> —Denis Diderot, salon review of François Boucher

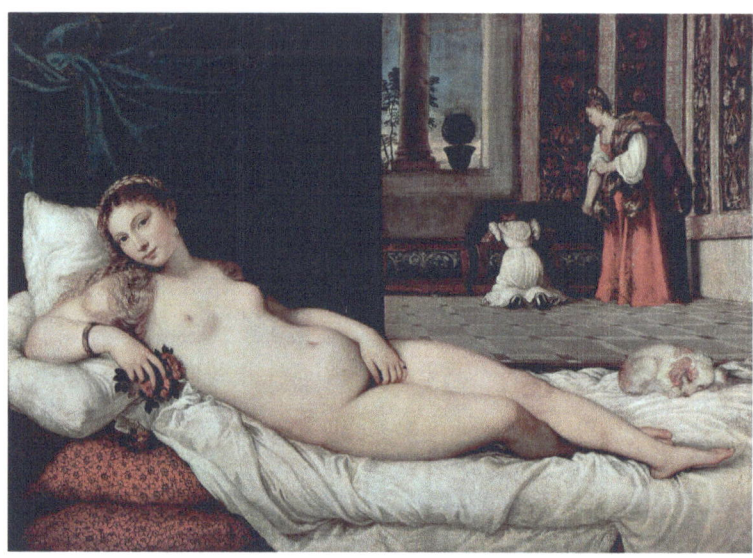

Venus of Urbino, Titian, c. 1538, oil

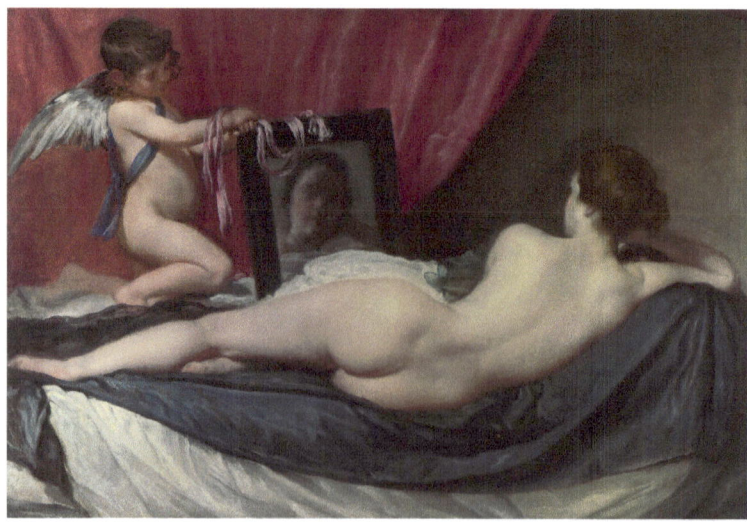

The Rokeby Venus, Diego Velázquez, c. 1650, oil

Is the female nude a suitable subject for art? Many women do not think so. Judy Chicago argues that when men paint naked women for a male audience, the women are reduced to objects of desire. For Chicago, the Venuses by Titian, Rubens, and Renoir seem to be a kind of high-class pornography. It is understandable that a woman might feel distaste for these depictions of passive naked women, as did the nineteenth-century suffragette who slashed *The Rokeby Venus* by Velázquez (previous page) in London's National Gallery.

Another objection to the female nude is that a woman is perceived by a man as "the other"—that is, whatever the male thinks he is not; passive, decorative, exotic, mysterious, negative, and (illogically) either too materialistic or too spiritual. With so many possible negative interpretations, perhaps we might try to view nude paintings with some empathy for the mindsets of the artists. Maybe their motives were more natural than misogynist. Since men are sexually aroused by women, why shouldn't art express this in beautiful and otherwise intriguing ways?

Instead of trying to inhibit the male artists, why haven't feminists unleashed a countermovement of women painting nude men? I can only think of one female artist, Silvia Sleigh, who in the 1970s did paint nude men (several of whom were art critics).

Diderot's statement was written as a criticism of Boucher's nudes. Diderot didn't like paintings of nudes. He thought looking at nudes should be a private experience. We could extrapolate that Diderot liked whores but not pimps (the artists). Or we could write him off as priggish. But then why did he write a novel about a nun being sexually initiated by her prioress?

Mieke Bal and Denis Diderot show us that in trying to appreciate paintings of female nudes, one negotiates a minefield of negativity and anxiety from both women and men. Ironically, despite the complaints about objectifying and denigrating the female body, the most popular nude in Western art is male—Christ on the cross.

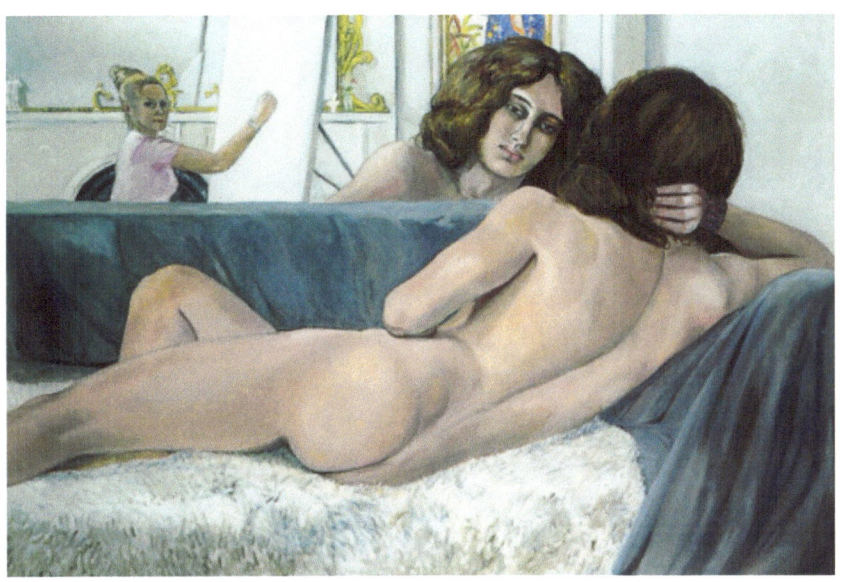

Philip Golub Reclining, Silvia Sleigh, c. 1971, oil

I sometimes paint male nudes in the hope of inverting the stereotypical female imagery. I painted a clothed man approaching a naked woman in bed; then, using the same format, I painted a clothed woman approaching a naked man in bed. However, because of societal preconceptions, the two paintings read very differently.

In my mythological paintings, I have depicted men in the role of passive sex objects, such as Endymion sleepily waiting to be ravaged by Diana, the moon goddess, or Anchises fearful of Venus' overwhelming love. I have even painted *The Judgment of Paris* in reverse—a shepherdess choosing among three naked male gods: Mars, Apollo, and Bacchus.

The several hundred female nudes in my oeuvre amount to an obsession. I was an only child, brought up by an exceptional mother until, when I was twelve, she committed suicide. My close relationship with her, together with the tragic ending, is surely a factor in my repeatedly painting women.

As a young man, I studied in many art schools. My most focused training was with Raphael Soyer from 1958 to 1960. We painted every morning for three hours, a different female nude each week. As monitor, I attended to the models. Similarly, since 1969, I have run weekly life-drawing groups in my studio.

Throughout Soyer's long career, he obsessively made studio paintings of young women. The posthumous exhibit of his last paintings, done in his eighties, were all nudes. Ironically, his numerous nudes are less known than the few Social Realist subjects that he did in the 1930s.

I should have thought twice before emulating Soyer and other nude-obsessed painters. When Renoir was asked how he achieved such sensual flesh tones, he said, "I paint with my penis." Toulouse-Lautrec and Pascin lived in whorehouses. Like Modigliani, they were alcoholics, and all three died young. While these artists have strongly influenced me, I am uncomfortable with their excesses.

Most of my teachers came from the Social Realist movement, primarily in the 1930s, and much of my work is in the same vein. They were often communists (as I am) and worked in Roosevelt's government art programs.

Cynthia, Raphael Soyer, c. 1971, oil

Besides Social Realism, another type of realism I practice relates to my personal experiences and emotions. In these works, the images of women are from my imagination. Sometimes, they allude to art of the past. This happened especially from 1993 to 2001, when I concentrated on interpreting Greek and Roman myths, subjects that often featured the nude.

A third category of my realism is painting directly from life. I have done hundreds of still lifes, interiors, landscapes, and cityscapes. In the late 1980s and early 1990s, I made around thirty paintings directly from female models. Each took about thirty hours. I depicted these young women as honestly and sympathetically as I could. Many people thought these paintings were my best work. However, they also said they would hesitate to hang them in their homes. Finally, a collector bought twenty of them. A family man, he hung them in the stairwell to his basement, illuminated only by a bare bulb.

Nude paintings are often projections of the artist's psyche and evolve out of a conscious fantasy or, conversely, from some deeply unconscious source. As Flaubert said, "Madame Bovary—c'est moi." Several of my paintings depict an introspective nude sitting on the edge of her bed, a mood that I often feel when I hesitate to get up and face the world.

Looking back over my work, I find that the nudes parallel my development as a person and an artist. Over more than half a century, there have been changes in my understanding of women and a concomitant development in my artistic style. I see a trajectory from bold to subtle, expressive to contemplative. The early nudes are disturbing, those from the middle period express awe, and the later paintings are more accepting.

It is often said that artists are not the best judges of their own work. I've had to believe that I understand my work; otherwise, I don't think I could have continued to paint. I'm aware of what I'm painting and that the pictures express my thoughts and feelings. They help me to know myself. I paint even if nobody else is interested, but I do hope people will see the paintings and relate to my ideas and feelings.

Feminists and other skeptics might regard as delusional my efforts to depict the opposite sex with understanding. If these people are right, I hope at least that my delusions are illuminating. I am glad that these paintings, many never seen, are now accessible in this book for the public to contemplate.

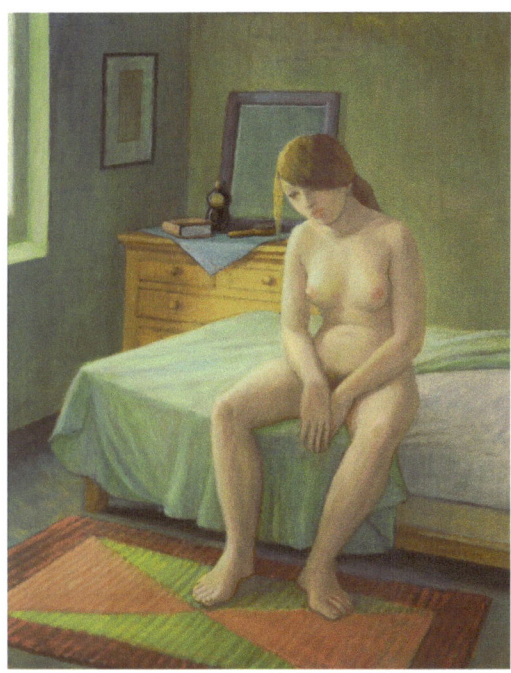

Morning, Eli Levin, 2004, egg tempera, 20 x 16 in.

I. Disturbing Nudes

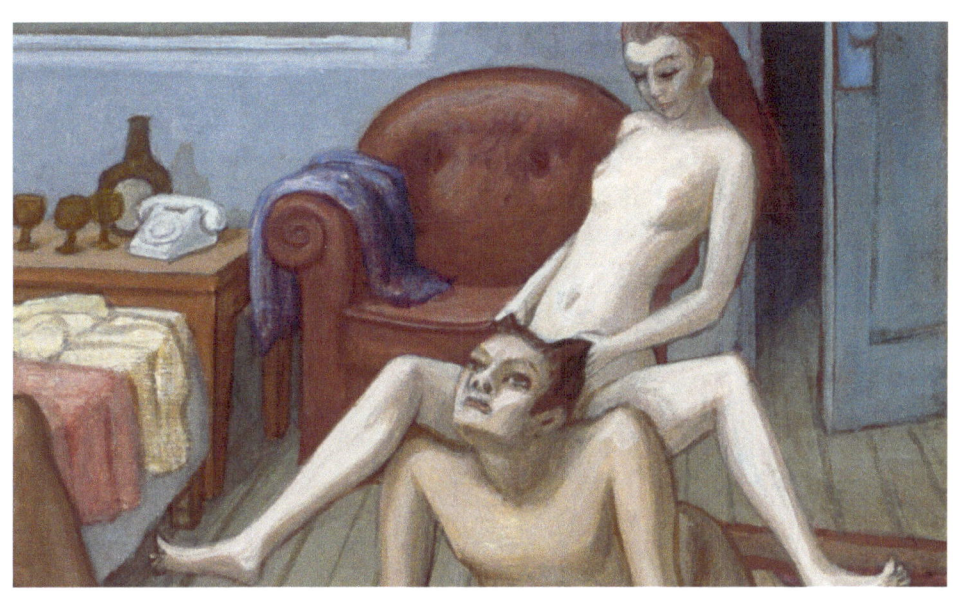

My early nude paintings were expressions of my hormonal imagination, and many are confrontational. They came from dreams and attempts to fathom my subconscious. The obsessive imagery in these paintings from the 1960s and 1970s sometimes recurs in my later work in subtler form. In a few instances, I painted subjects that were extremely difficult to confront—for example, the large rape scenes done in the 1980s. They are strongly painted but almost impossible to look at. Around 2000, I read *There Once Was a World* by Yaffa Eliach; in this book, she chronicled life in the shtetl Eishyshok, which was wiped out by a Nazi death squad. I forced myself to depict the pit full of bodies. Another time, after a dream about watching a television program in which tortured people were being presented, I painted *Triumph of the Tortured*. These particular images violate all ideas of propriety but address hidden realities. I painted these images in the hope of some kind of catharsis.

Artists who influenced this work were Goya, Pieter Bruegel the Elder, Gustave Moreau, Heinrich Kley, George Grosz, and Otto Dix. I also searched fin-de-siècle Symbolist imagery about women: sex, death, madness, the demonic, and the pathetic.

In the early 1970s, I underwent extensive Jungian analysis, concentrating on dream work, three times a week for two years. Because of that, I developed a more self-conscious approach. The nudes became integrated into painted concepts that were not so obviously obsessive but expressed a subtler and wider range of meanings.

In the 1980s, I took extended trips to New York to further my abilities with anatomy and the nude at the Art Students League. The stark boldness of my early style receded as I gained subtlety in drawing, composition, and painterly qualities. My nudes became integrated with realistic perception, social subject matter, and lessons from art history. Ironically, my style moved closer to that of my early teachers Raphael Soyer, Philip Reisman, and George Grosz. Incidentally, all three were communists in their early careers. Other influences on my work were from WPA era art, in particular Thomas Hart Benton, Diego Rivera, Reginald Marsh, Paul Cadmus, and George Tooker. Most of those artists used egg tempera, as I do.

My usual practice is to start with drawings, filling numerous sketchbooks. Sometimes, these pencil drawings are developed with watercolor or colored pencils. For the paintings, I do loose copies of one of these drawings as underpainting. Also, many of my etchings have been inspired by my drawings.

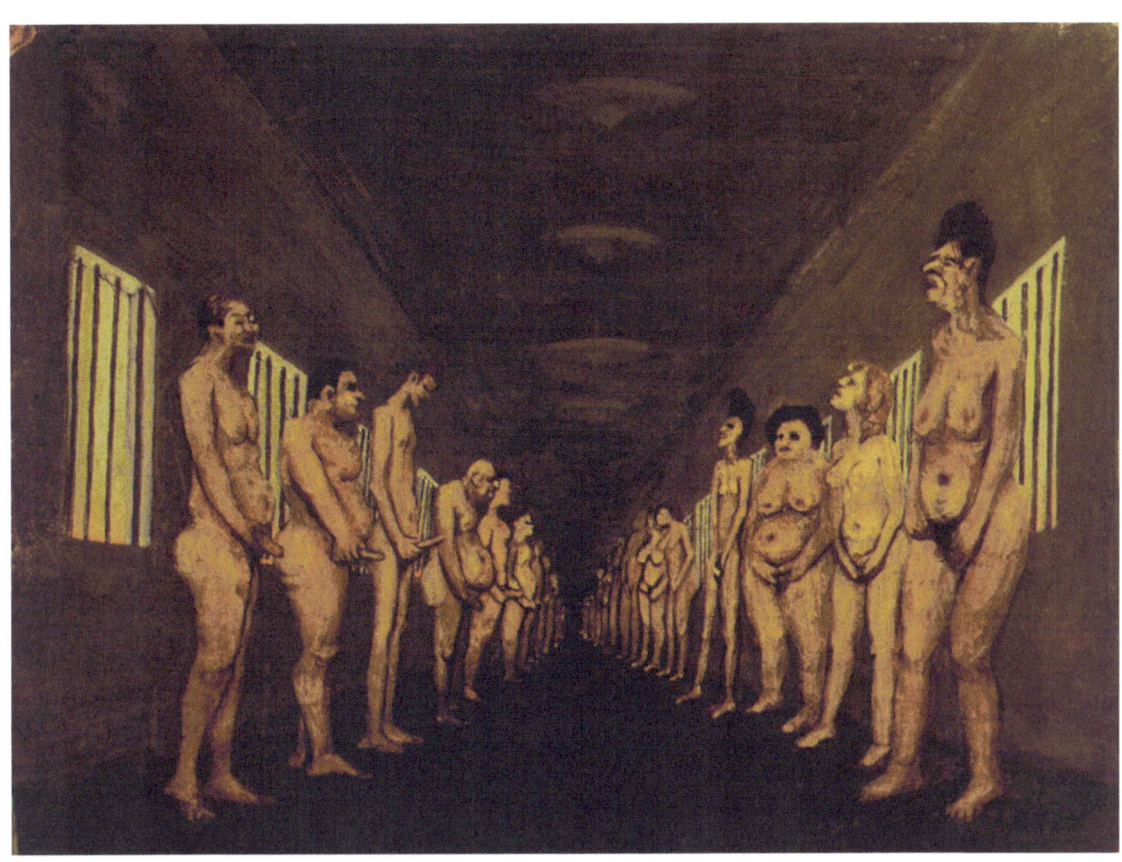

The Sun Also Sets, 1962 and 1970, oil over egg tempera, 24 x 30 in.

The title is a play on the name of a novel by Hemingway. There is irony in his very sane hero's being impotent due to a war injury while the people in the asylum are all sexed up. I was living in a slum tenement in Boston's North End. My Polish landlady told me of her life: scrubbing floors, then spending ten years in an asylum, then scrubbing floors again, until she bought the old building.

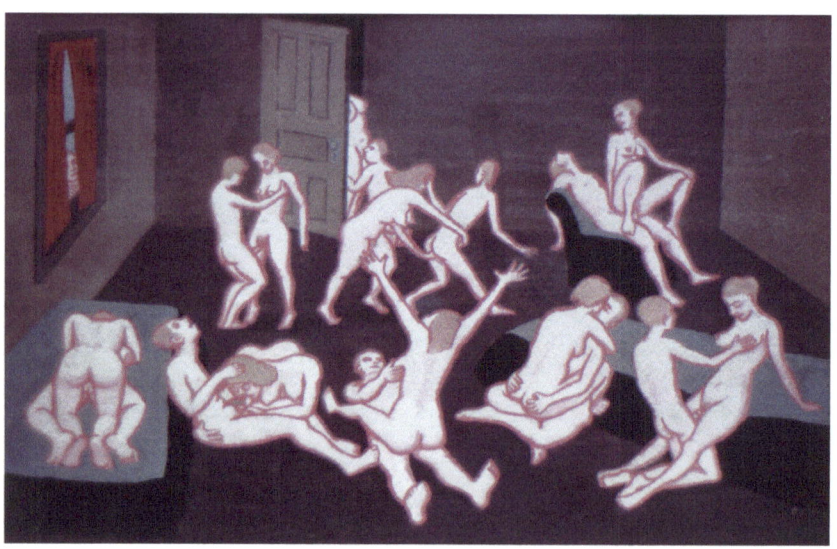

Couplings, 1969, watercolor, 9 x 14 in.

I was remembering my student days at the Boston Museum School, when some of my friends participated in orgies. I'm peeping through the window.

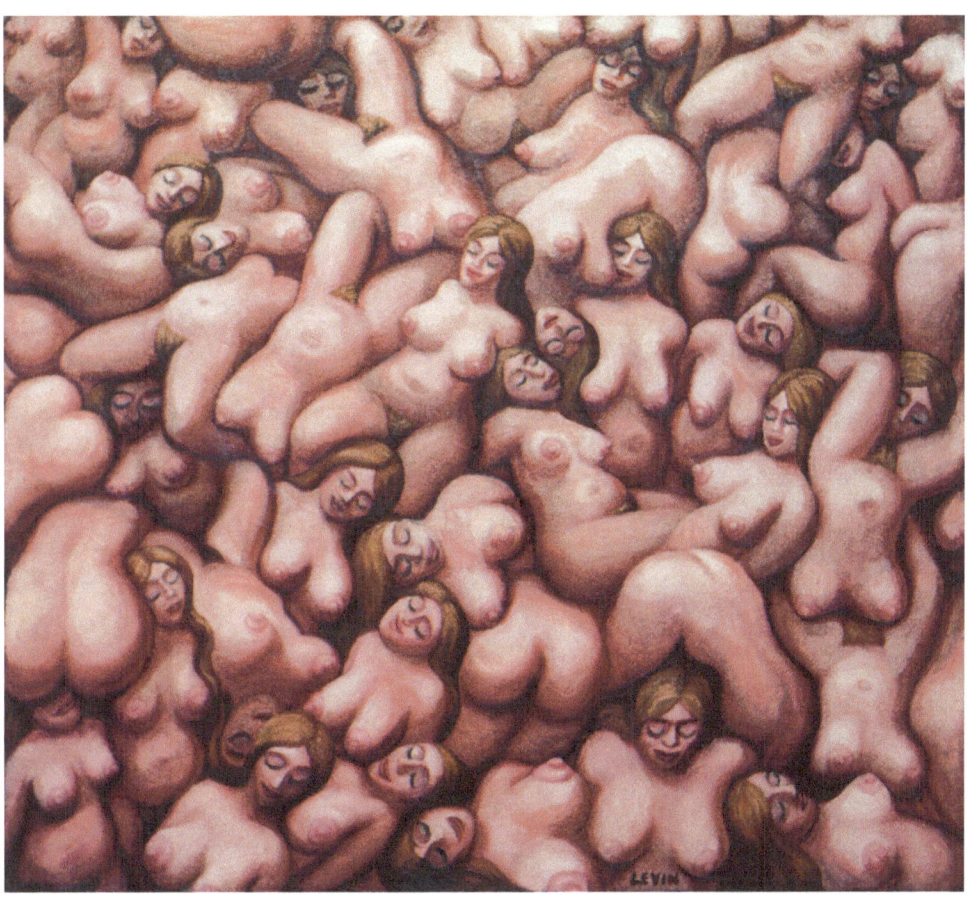

Pink Women, 1978, oil, 42 x 46 in.

This orgy of flesh is another of my overstimulated reactions to memories of student licentiousness. The painting was also influenced by my reading Paul Goodman's writings on the polymorphic perverse.

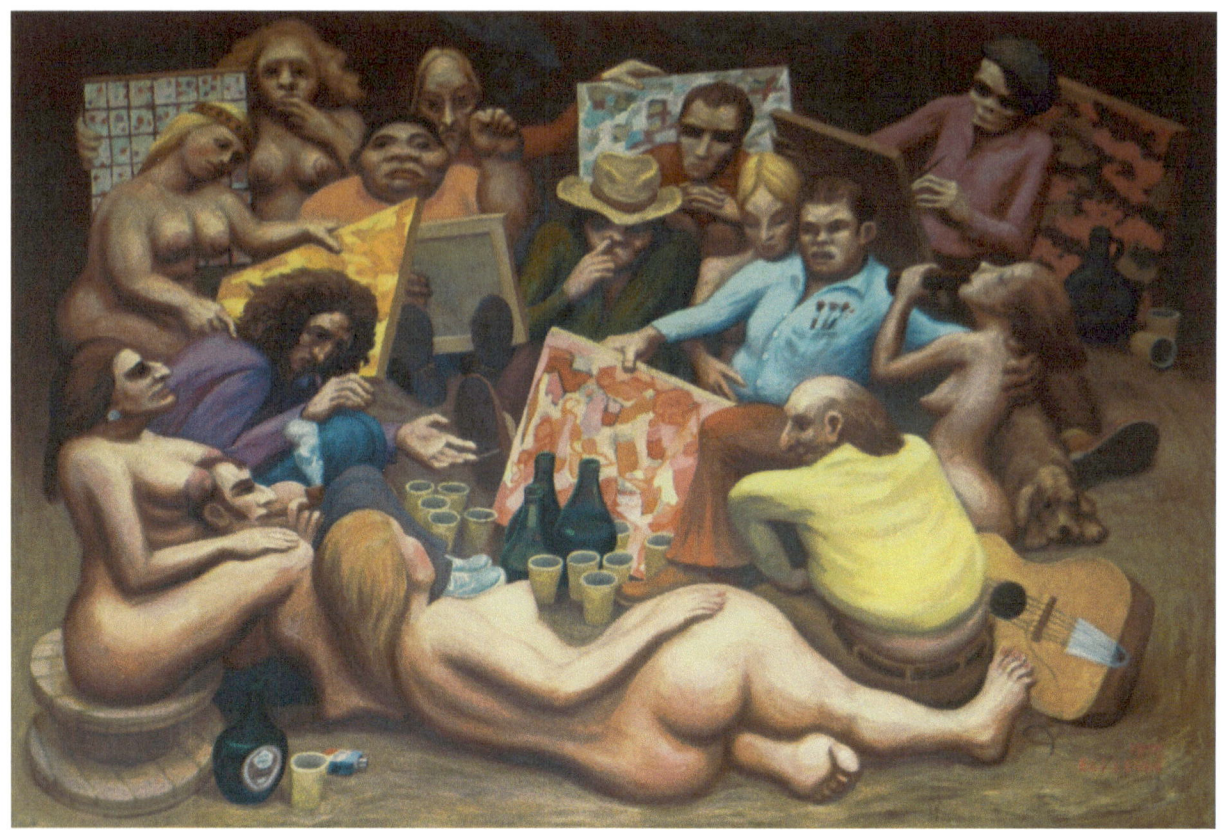

Santa Fe Artist Group, 1976, oil, 30 x 40 in.

We got together an activist art group in the mid 1970s. Our agenda included show-and-tell meetings. We also lobbied the museum and finally organized a big group exhibit in Santa Fe's unused Armory in 1977. As a result, the building became the Armory for the Arts.

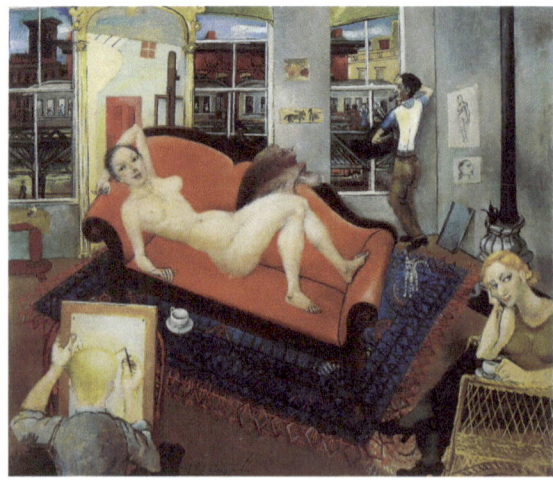

Nude by the El, Philip Evergood, c. 1934, oil

This is a depiction of a Depression-era group of artists and their model by one of my favorite Social Realist painters.

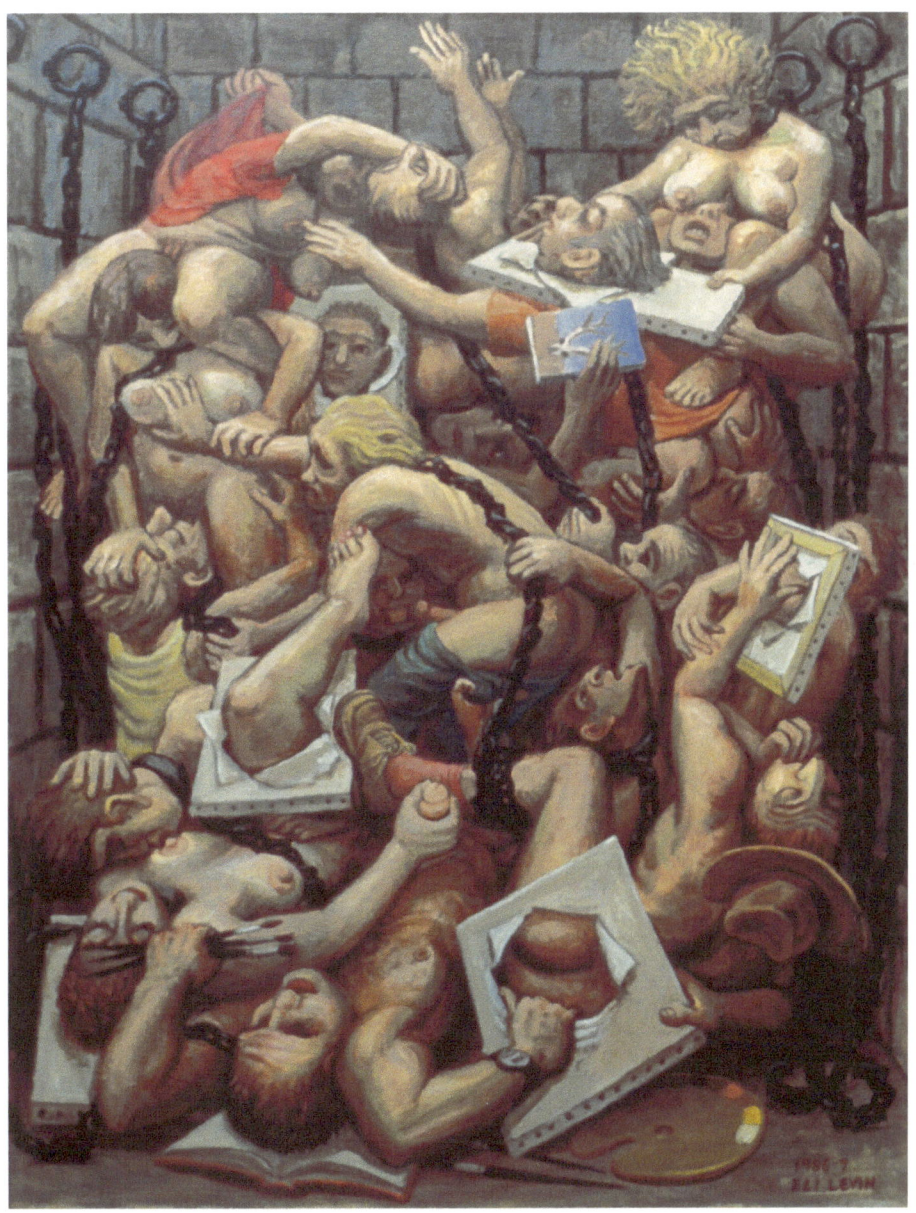

Battle of the Naked Artists, 1989, oil, 40 x 30 in.

I use the pile of bodies in a more social realist context and combine this image with the theme of *Santa Fe Artist Group*. The art group has disintegrated into mad competitiveness.

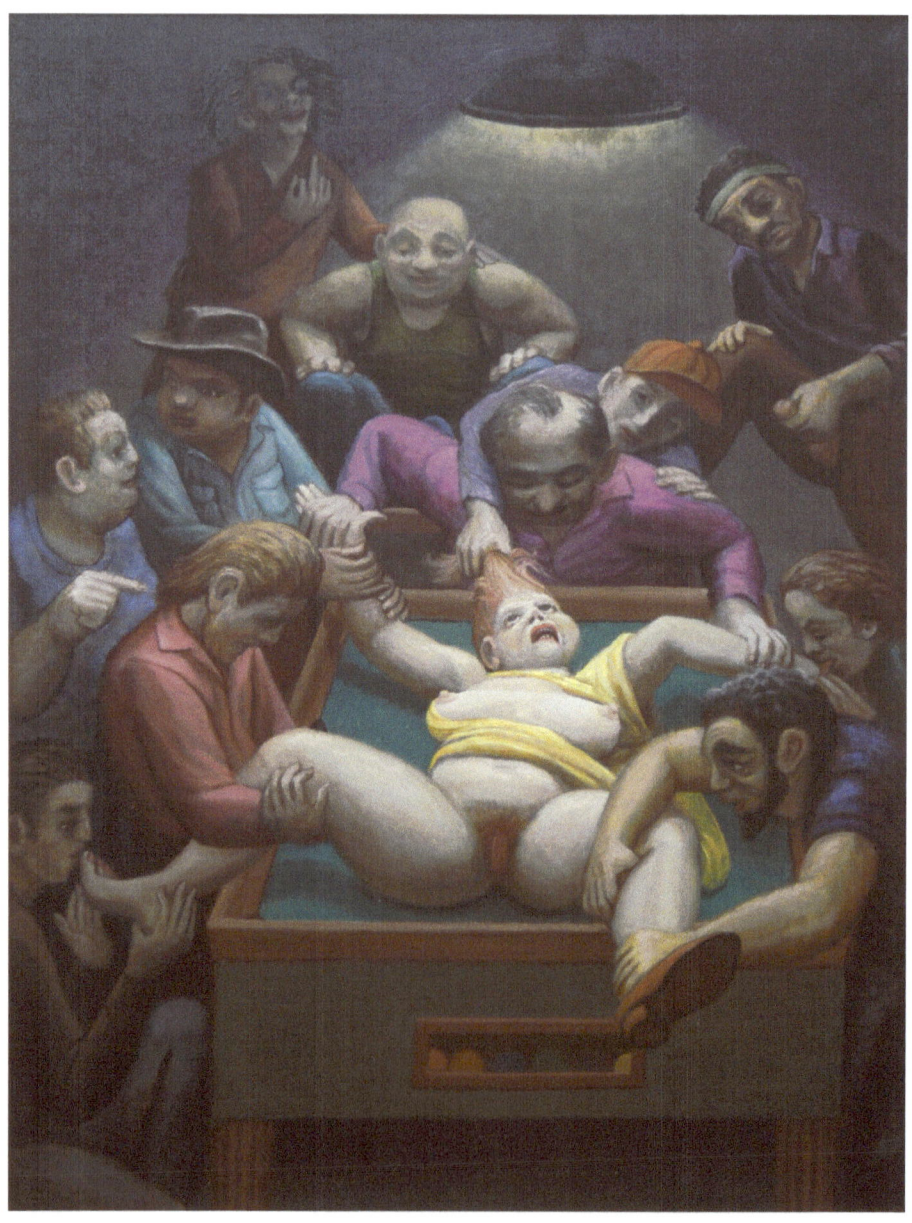

Woman Raped, 1989, oil, 40 x 30 in.

This is a reaction to an actual event that was dramatized in *The Accused*, a movie with Jodie Foster. My friend Maritza Arrastía wrote a play about the same event. Though I had my doubts about painting the rape, I tried.

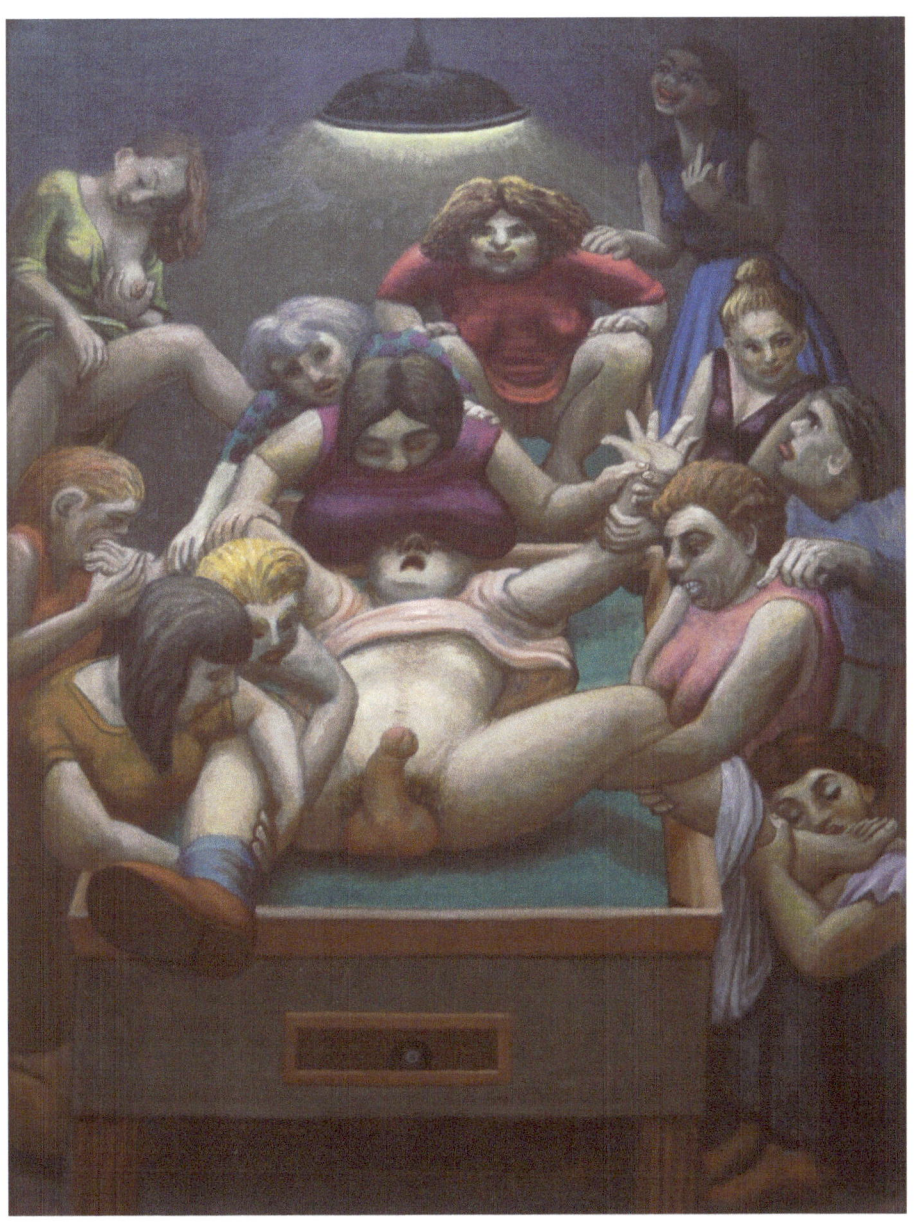

Man Raped, 1989, oil, 40 x 30 in.

The first rape painting left me with a feeling of complicity, so I tried the second version. This version, reversing the sexes, is problematic. I was going to include a close-up hand with large scissors, but that seemed too extreme.

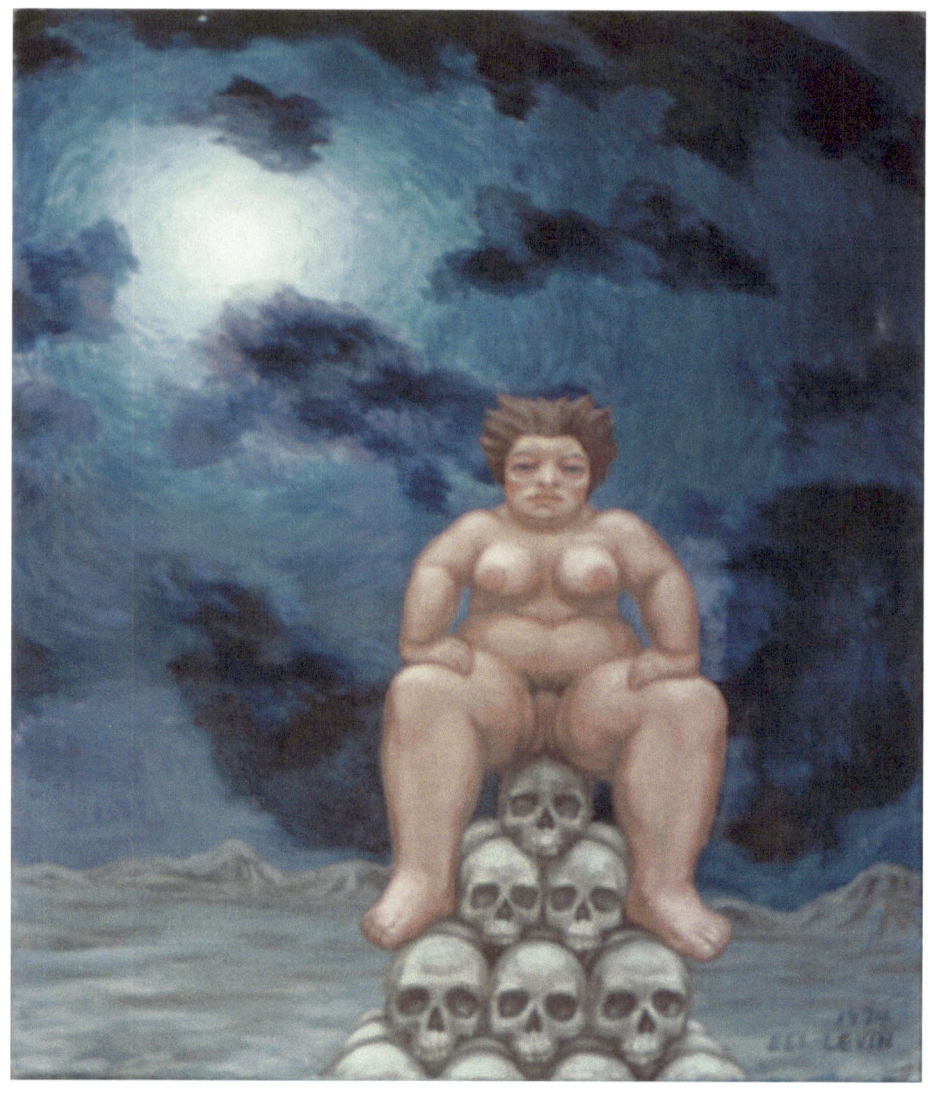

Night Goddess, 1975, oil, 40 x 36 in.

This female archetype appears in many of my paintings. See p. 35; note the thirty-three year interval. The pile of skulls was inspired by the Russian war artist Vasily Vereshchagin.

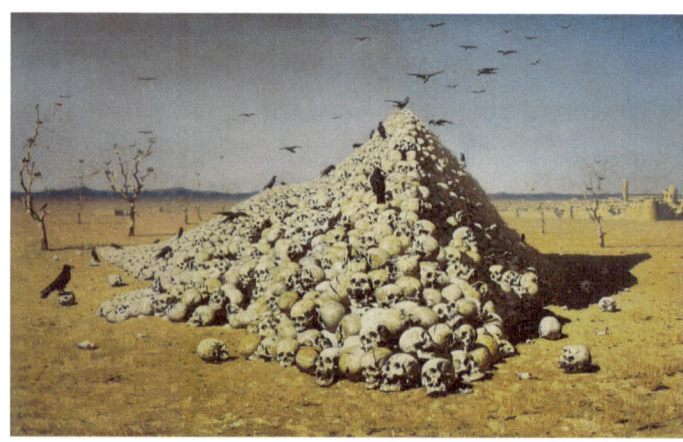

The Apotheosis of War, Vasily Vereshchagin, c. 1871, oil

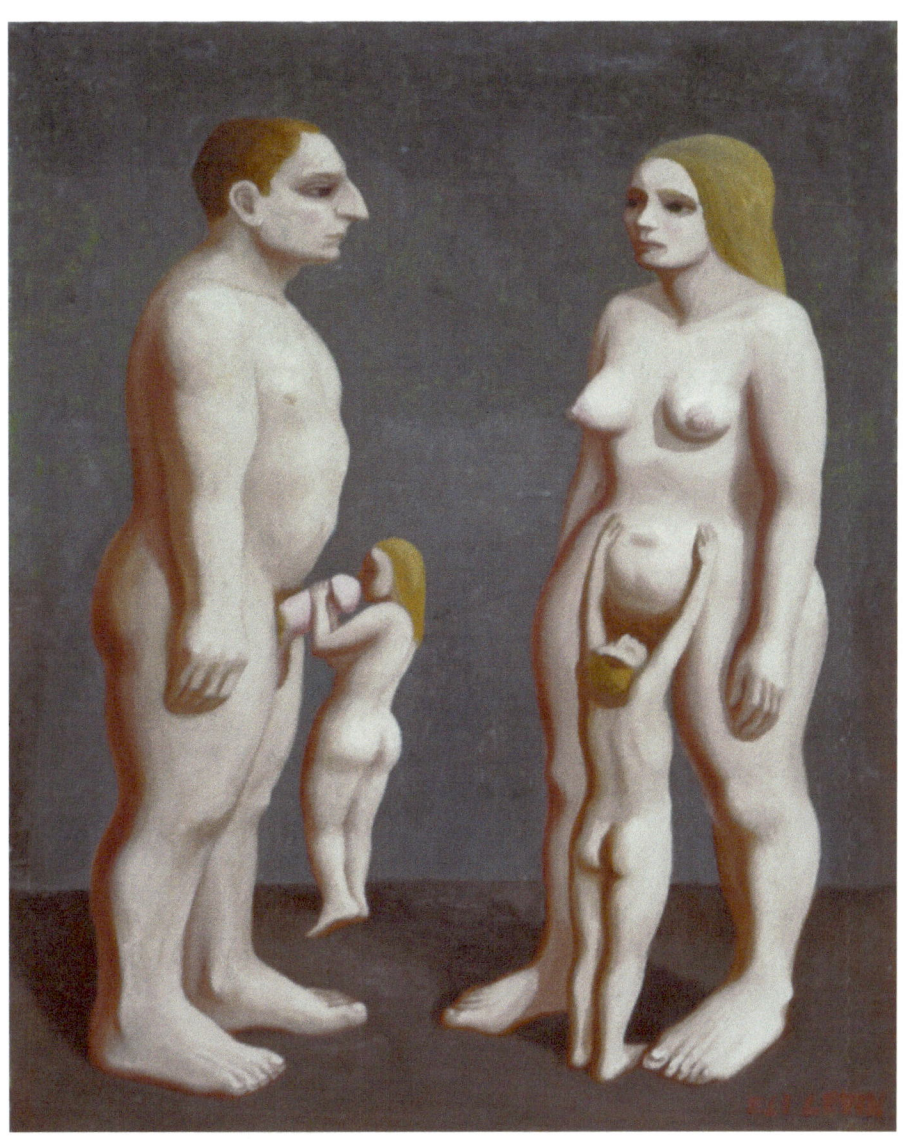

Couple with Homunculi, 1974, oil, 30 x 24 in.

The man and woman imagine being serviced by each other. This painting disturbed people, including my father, who usually liked my sexual imagery and even owned a large wood penis that I carved.

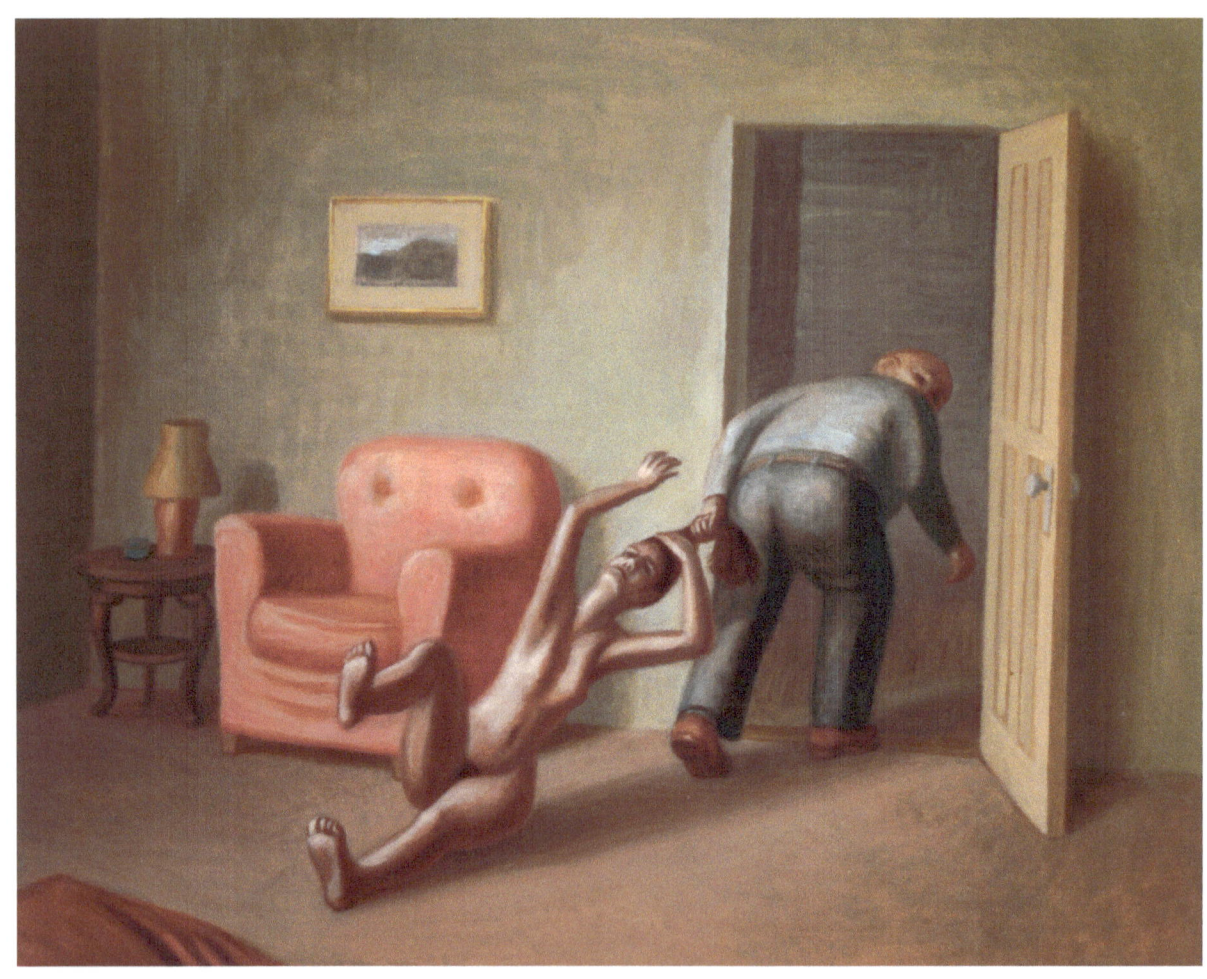

Bedtime, 1979–81, oil, 24 x 30 in.

In this oil painting, another male-chauvinistic fantasy, there is a nice use of brown underpainting and glazing.

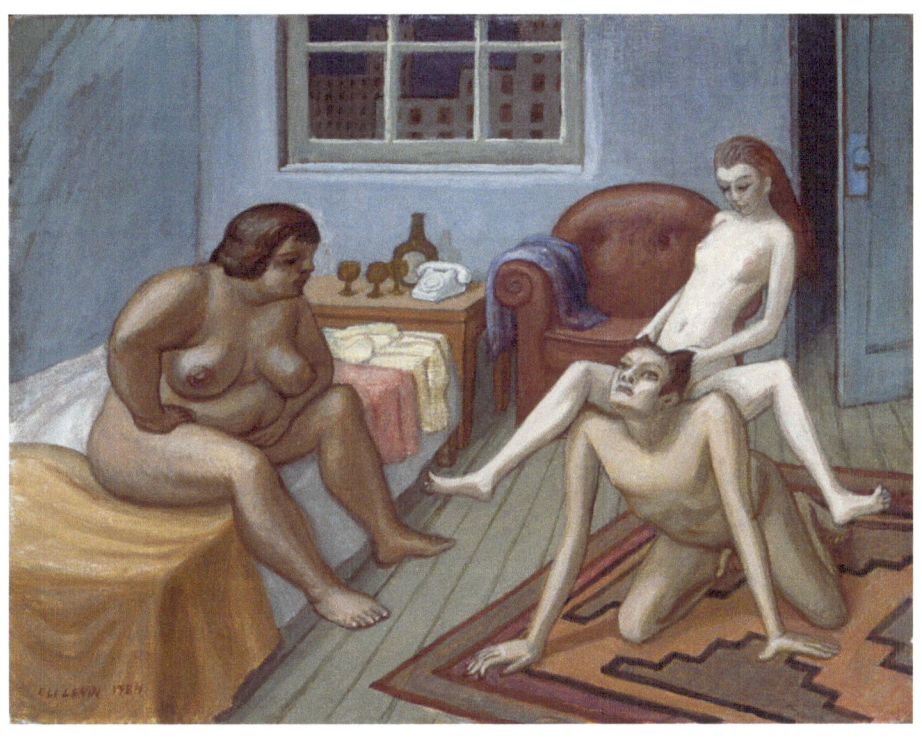

Ménage à Trois, 1983, egg tempera, 11 x 14 in.

How did I think up this little egg tempera? The couple is derived from Aristotle and Phyllis, a subject engraved by Lucas van Leyden and others (see p. 114). Though I was in Santa Fe, the dour scene depicts New York.

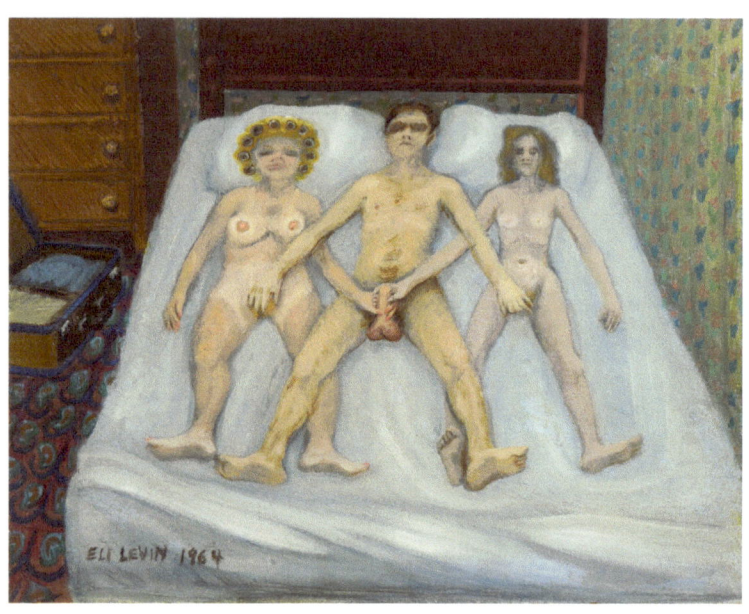

Three in Bed, 1964, oil, 8 x 10 in.

This is a transposed memory of an event that took place, albeit in three sleeping bags.

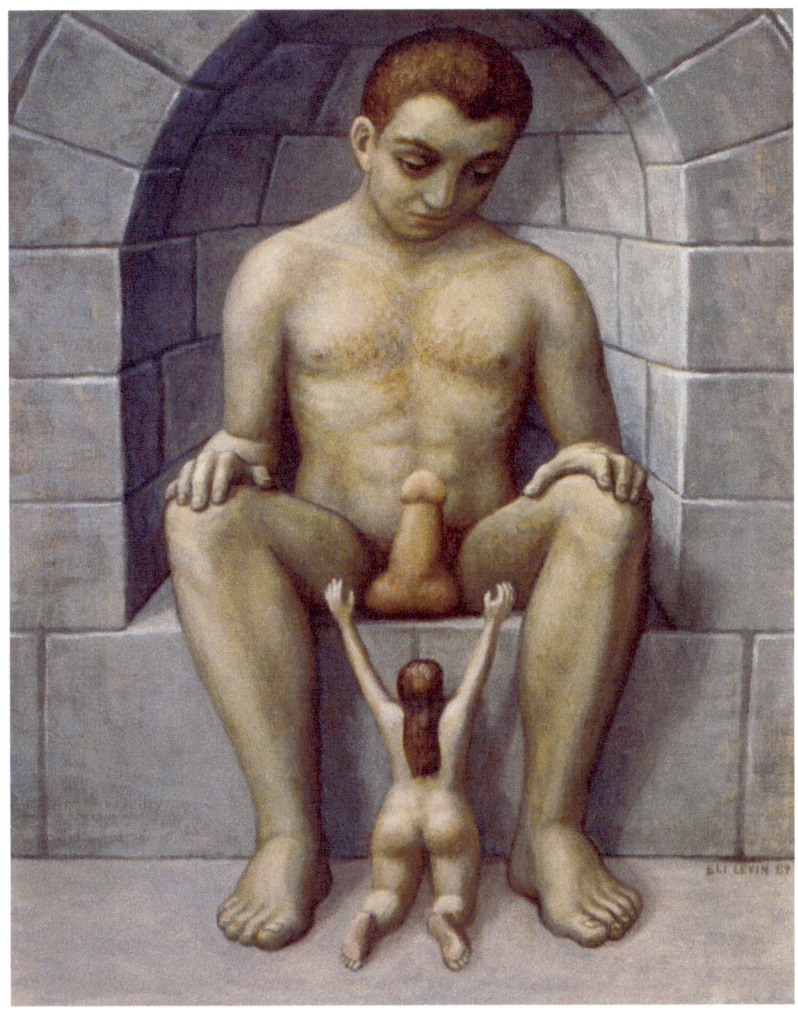

Jupiter and Thetis, 1989, oil, 30 x 24 in.

Thinking about male chauvinism, I decided to take it to the extreme. The image is inspired by an early painting by Ingres, in which Jupiter is even more vainglorious.

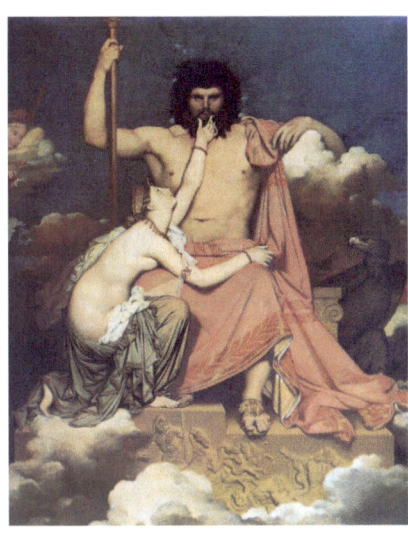

Jupiter and Thetis, Dominique Ingres, c. 1811, oil

She is begging the alpha god to spare her son, Achilles, from death in the Trojan War.

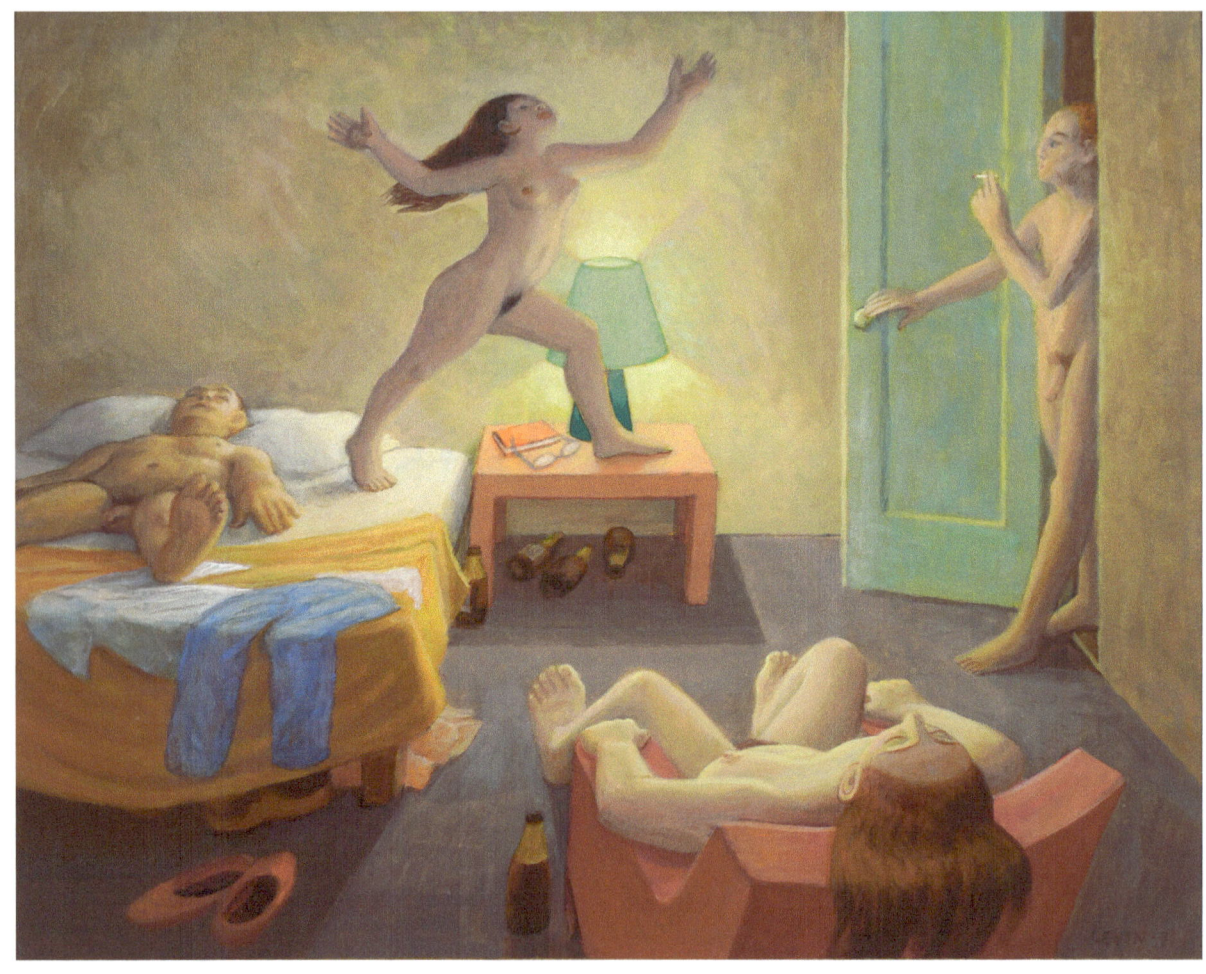

Orgy, 2000, egg tempera, 24 x 30 in.

The depiction of four wasted people perhaps evolved from the unpleasant memory of my one and only LSD experience, though I did the painting twenty-five years later.

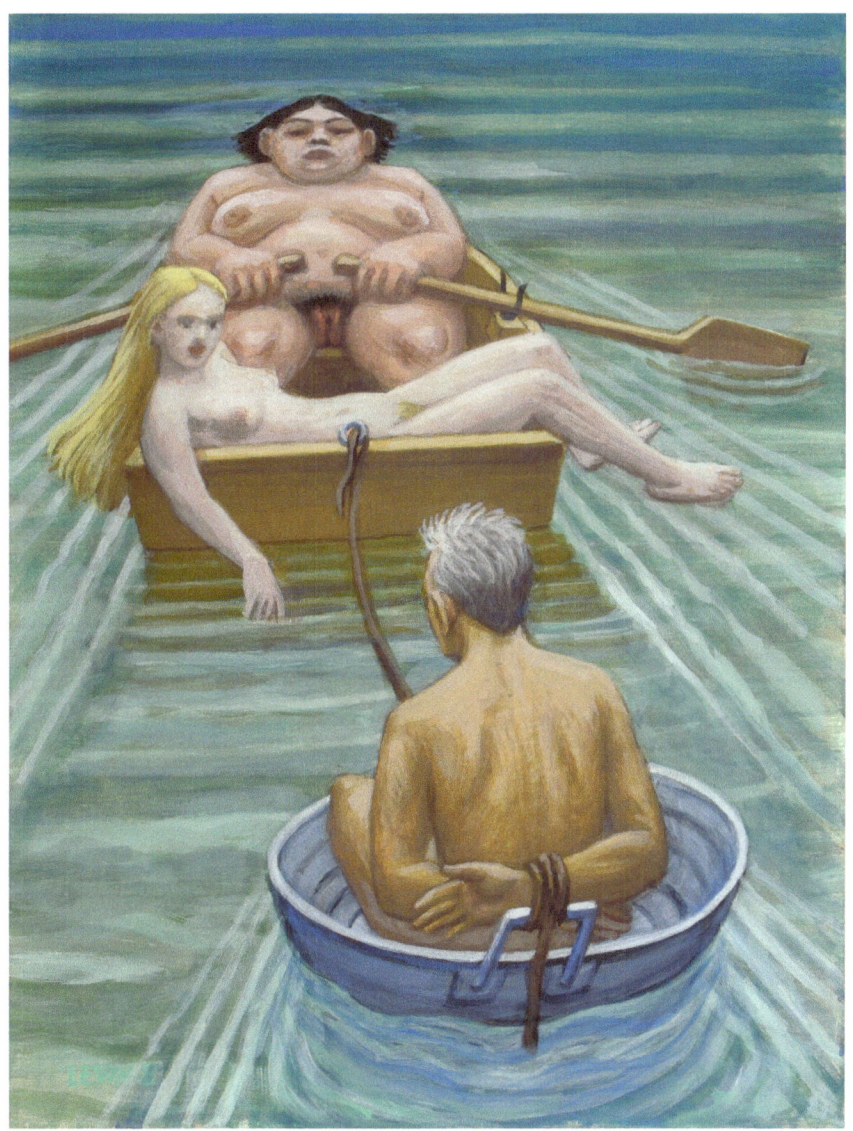

Out to Sea, 2008, egg tempera, 24 x 18 in.

Two dissimilar goddesses take me for a ride. This is from a waking dream, which inspired five paintings—mostly premonitions of death, among other questionable things.

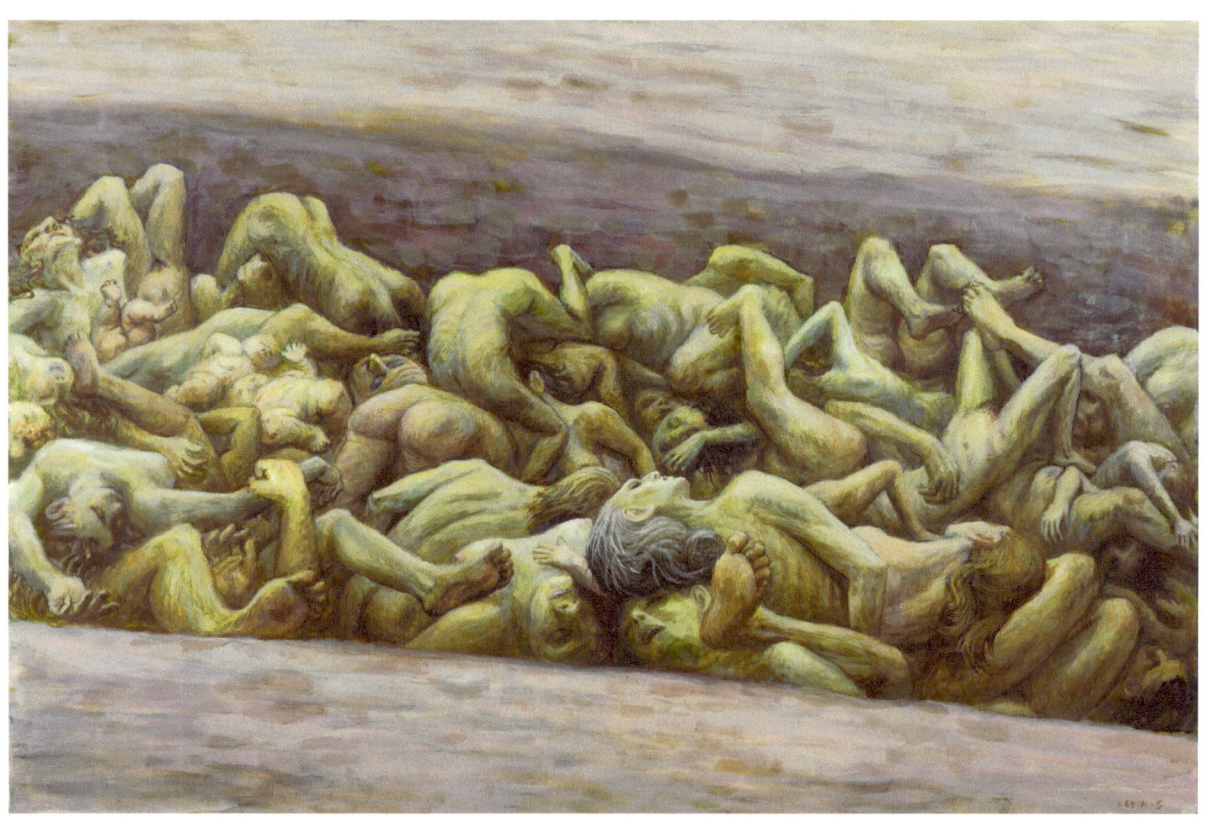

Genocide, 1999, egg tempera, 22 x 30 in.

I painted this after I read *There Once Was a World*, a book by Yaffa Eliach. With the Lithuanian militia, German death squads massacred Jews in the Pale of Settlement.

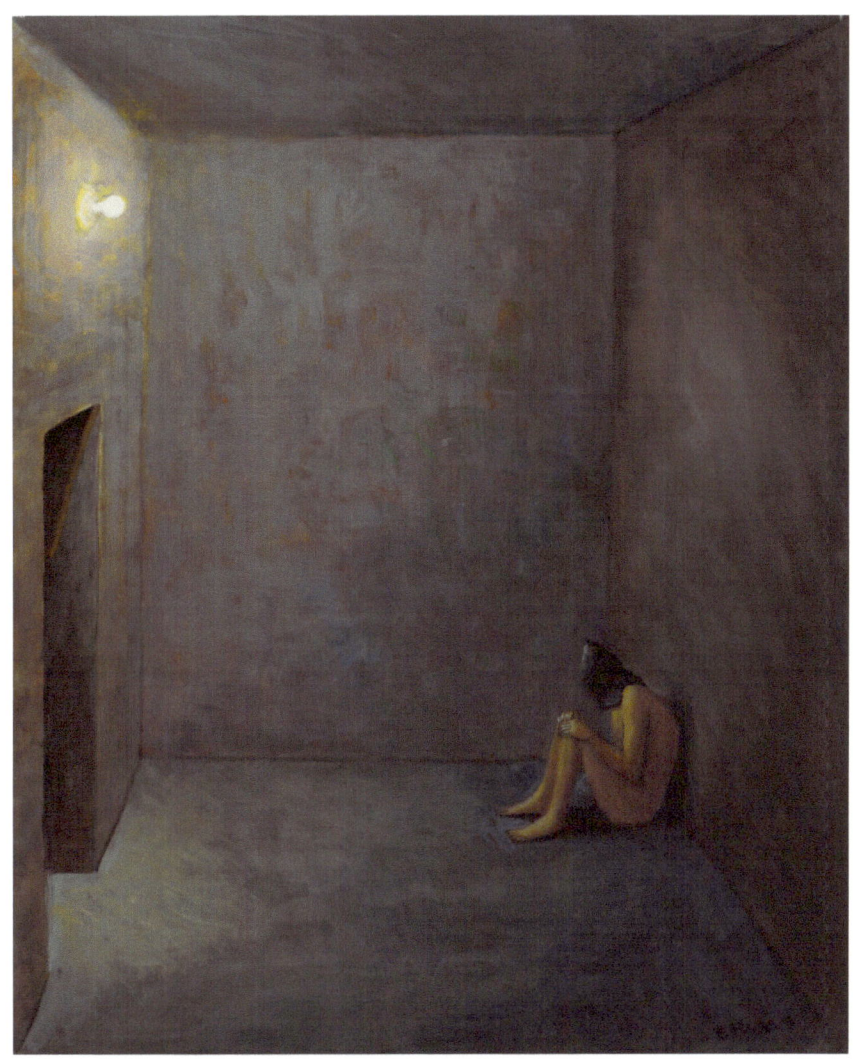

Waiting, 2009, egg tempera, 20 x 16 in.
My reaction to the Abu Ghraib and Guantánamo prisons.

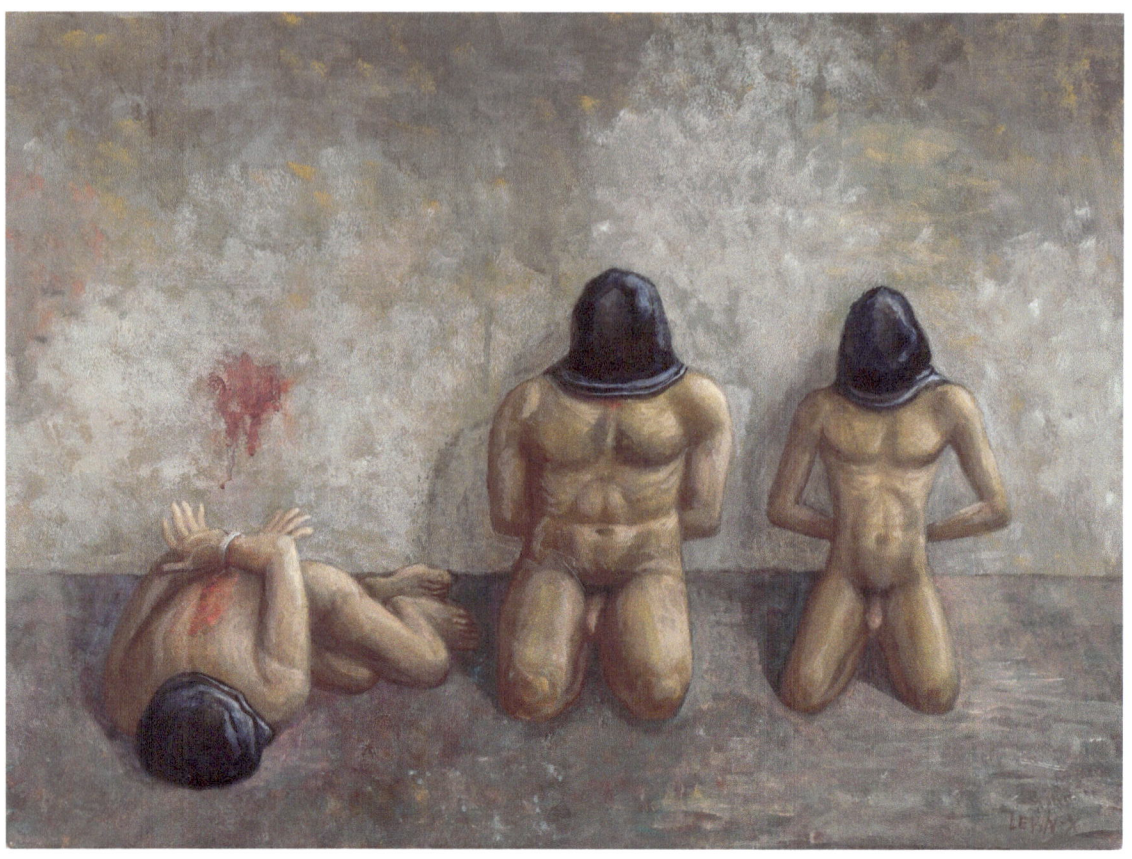

Execution, 2009, egg tempera, 18 x 24 in.

Argos, our studio gallery, exhibited a collection of Goya's etchings, including many from the *Disasters of War* series. I grew up with one of the worst images from that series, a castration, which hung in our living room.

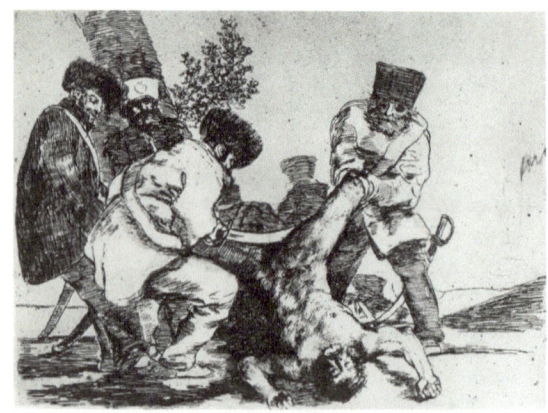

Qué hay que hacer mas?, Francisco de Goya, c. 1810, etching

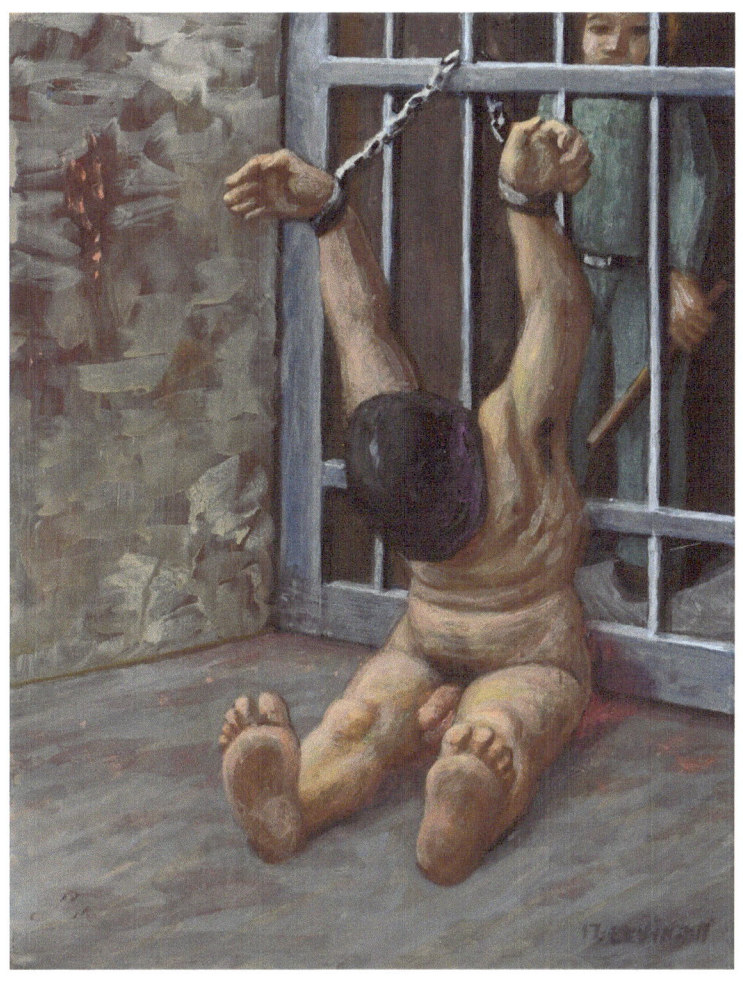

Chained Prisoner, 2007–11, egg tempera, 12 x 9 in.

My work on the Prisoner series coincided with Fernando Botero's powerful Abu Ghraib paintings.

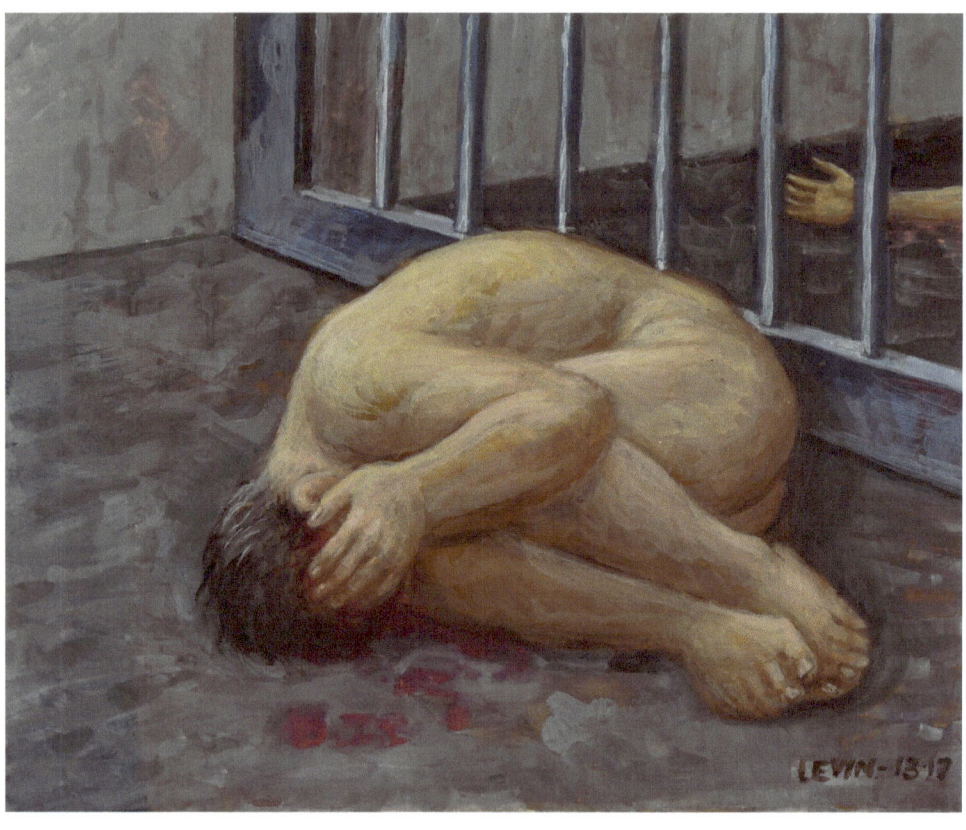

Prisoners in Adjacent Cells, 2007–13–17, egg tempera, 10 x 12 in.

While still a student I saw a painting by George Grosz, *After the Interrogation*, showing guards leaving a filthy cell in which remained a bucket of blood and offal. Or so I remember.

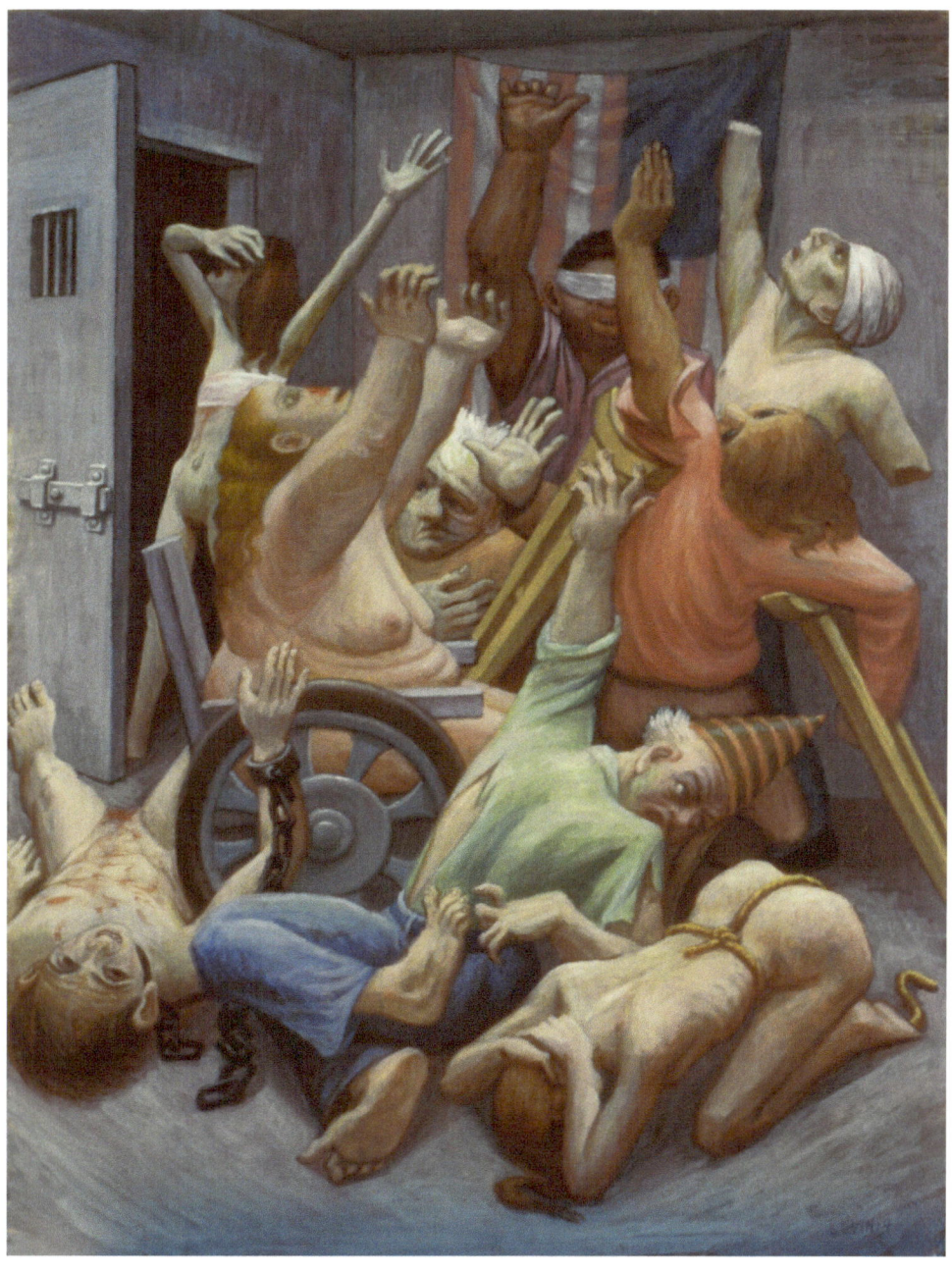

Triumph of the Tortured, 2004–10, egg tempera, 40 x 30 in.

This image came in a dream, probably induced by our government's escalated use of torture. The composition recapitulates some of my earlier obsessions. The idea was that TV news would feature recently released torture victims.

II. Mostly Couples

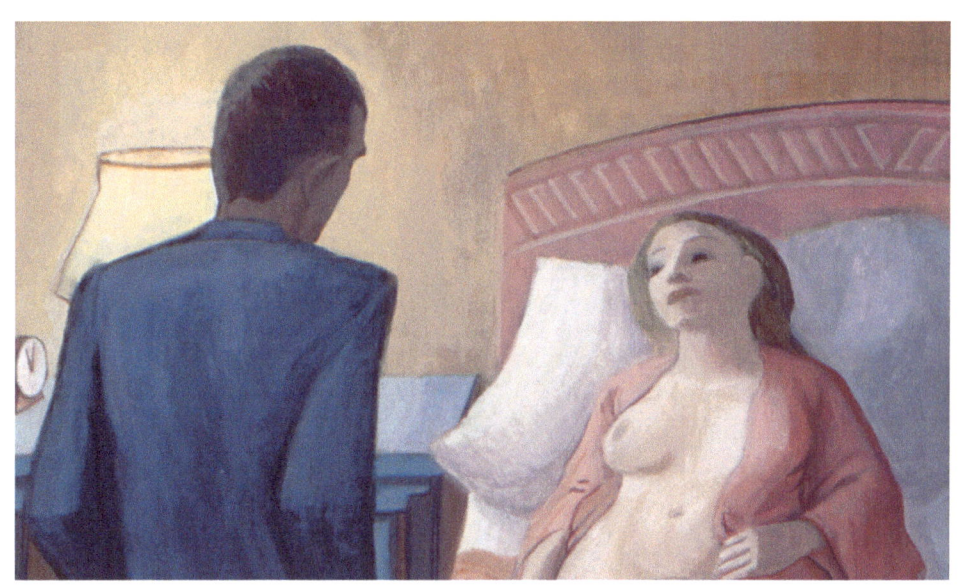

My early nudes came from my anxieties, fantasies, and projections. Eventually, I maintained more distance between myself (and, by extension, the viewer) and my nudes. Rather than portraying single nudes, which are open to voyeuristic interpretations, I began depicting relationships between couples. The nudes of both sexes began to have their own lives within the pictures and acted out relationship scenarios. These paintings are like scenes in plays. Think of Ibsen's *Hedda Gabler*; beyond being a projection of the playwright's, Hedda seems to have her own existence.

I often make a second version, reversing the sexes. These diptychs bring an ironic twist to narrative painting. A similar concept can be found in the works of eighteenth-century artist William Hogarth, who played with variations, such as his two engravings of a bedroom scene, *Before* and *After*. He also contrasted whole series of engravings, such as *Harlot's Progress* and *Rake's Progress*.

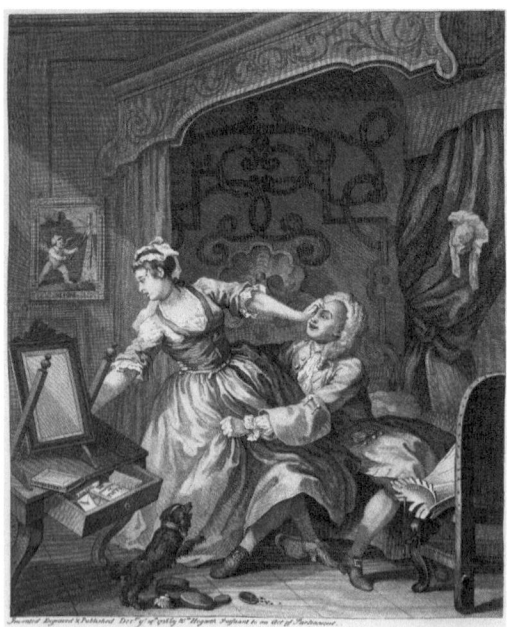

Before, William Hogarth, 1736, engraving

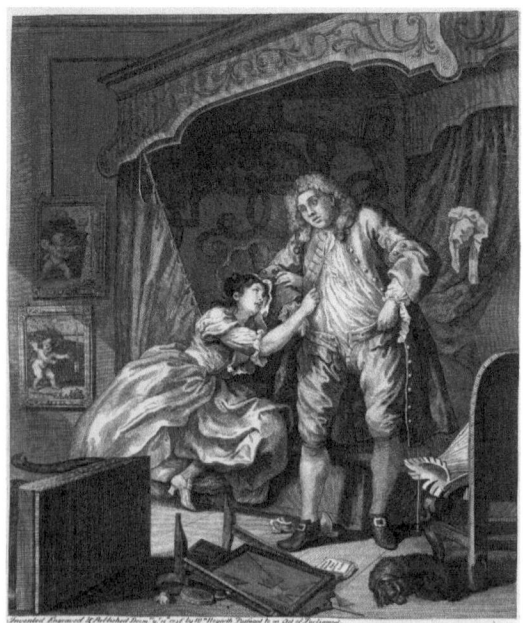

After, William Hogarth, 1736, engraving

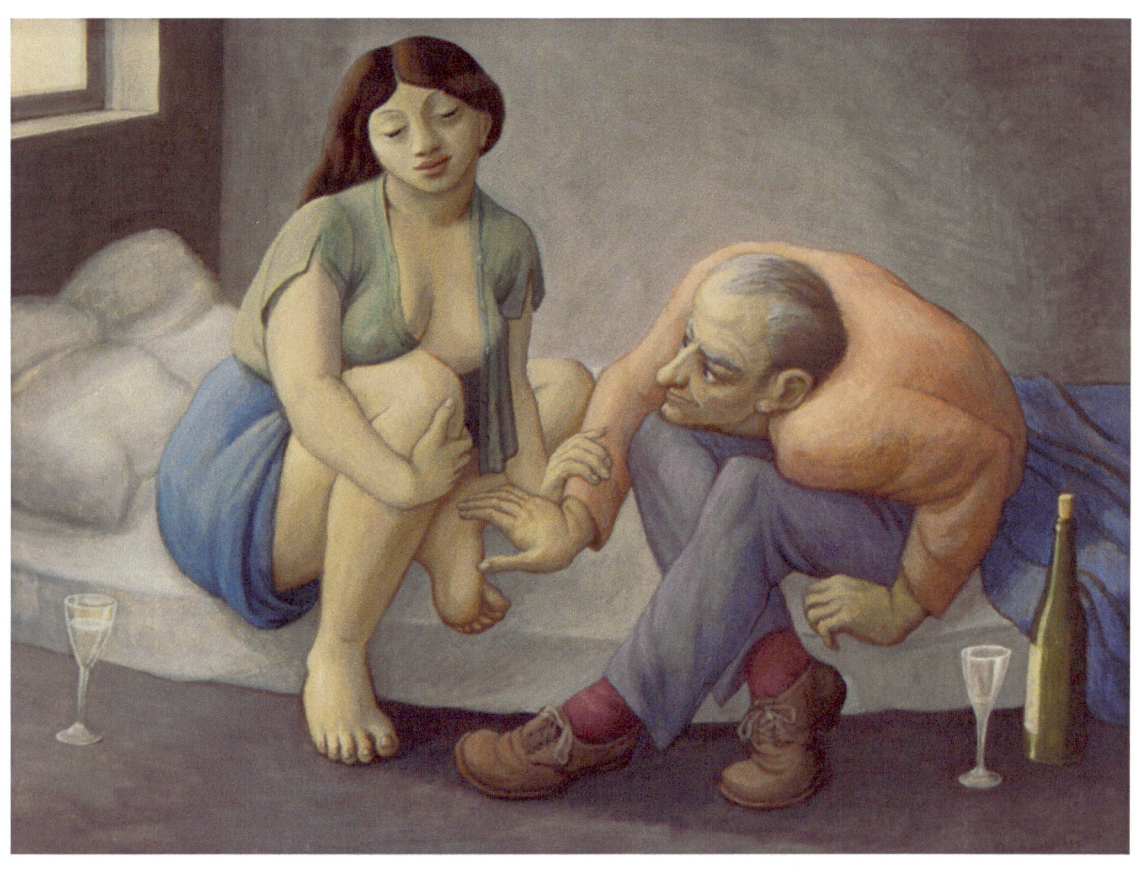

Just a Peek, 1991, egg tempera, 18 x 24 in.

Another variation of the awkward bedroom scene, this composition was based on an obscure Baroque painting I saw and sketched at the World's Fair in Knoxville, Tennessee.

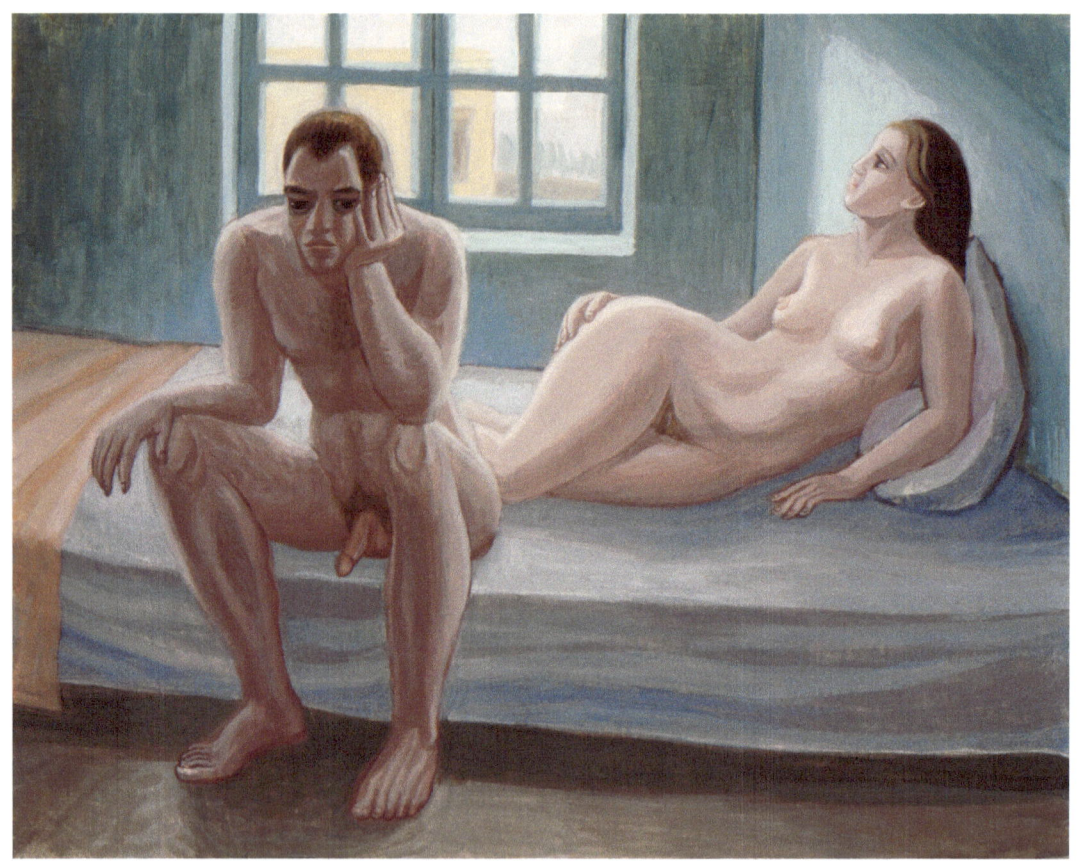

Impotence, 1981, egg tempera, 16 x 20 in.
This self-portrait of an awkward moment deals with an understandably uncommon subject.

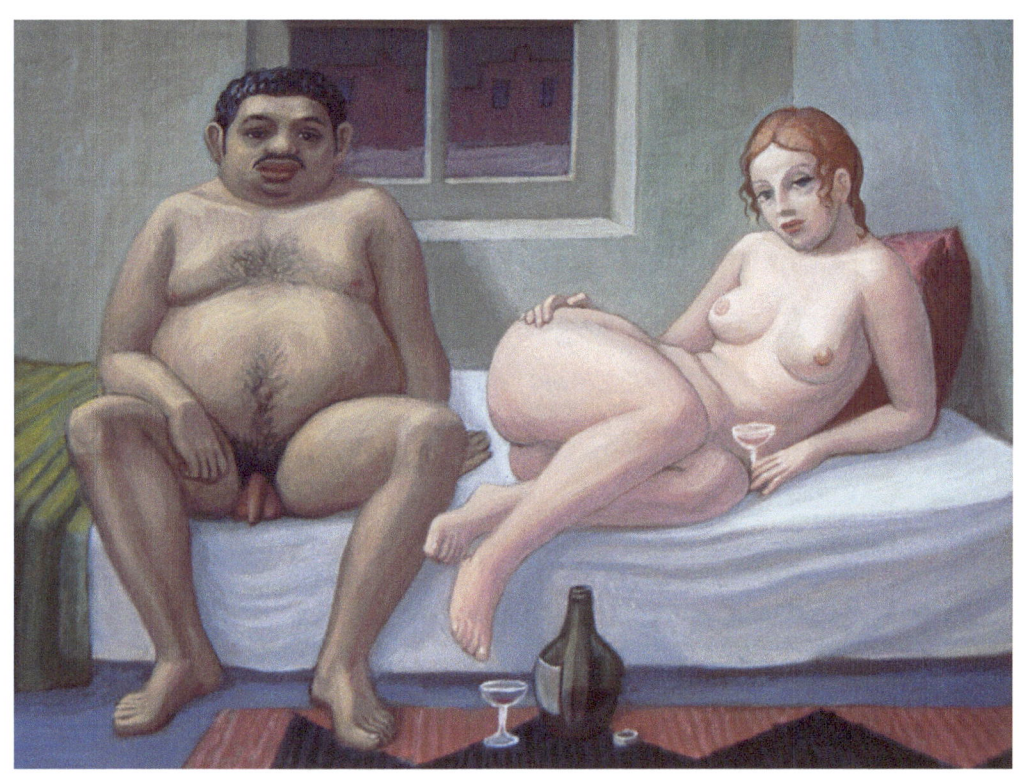

Unequal Partners II, 1985–90, egg tempera, 12 x 16 in.

A theme common in northern European Renaissance art is transposed to New Mexico.

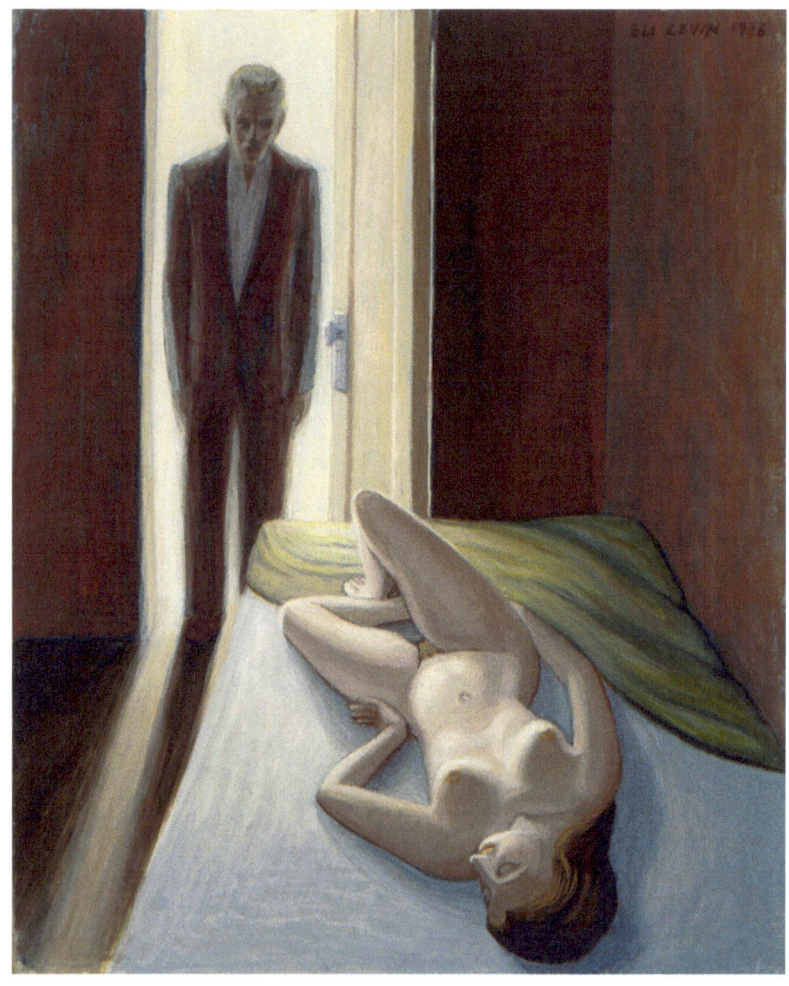

Bedroom, 1986, egg tempera, 15 x 12 in.

This little painting is from a series of six depicting tense bedroom confrontations.

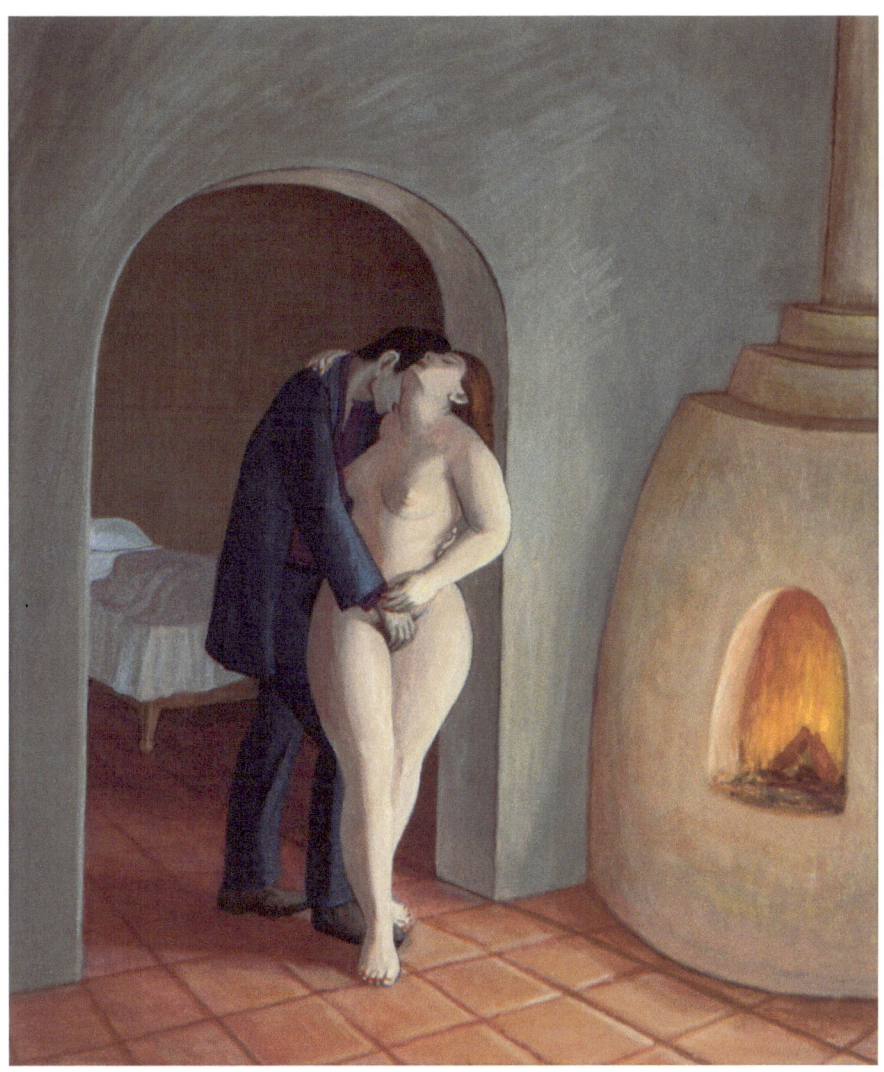

Light My Fire, 1992, egg tempera, 20 x 16 in.

The kiva fireplace is a nice regional touch. I've built these fireplaces in my gallery, home, and studio, and I've painted several as sexual metaphors (see pp. 63–65).

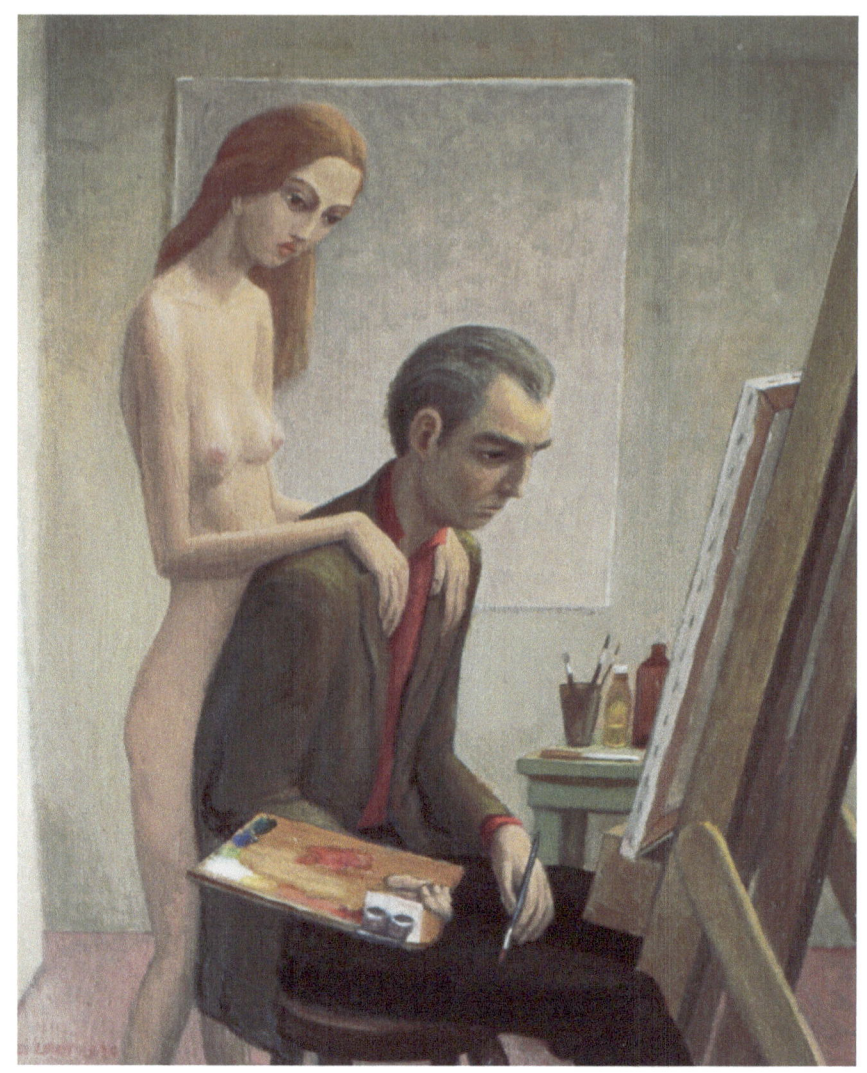

Artist and Muse, 1988–92, egg tempera, 20 x 16 in.

The earliest version was an engraving done in 1965. The empty canvas is an oblique reference to a novel by Alberto Moravia, in which the hero was too obsessed with sex to paint.

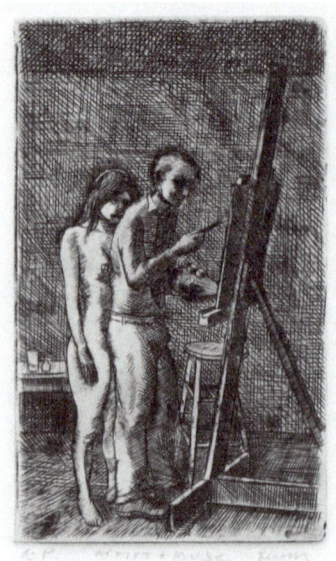

Artist and Muse, c. 1965, engraving, 7 x 4 in.

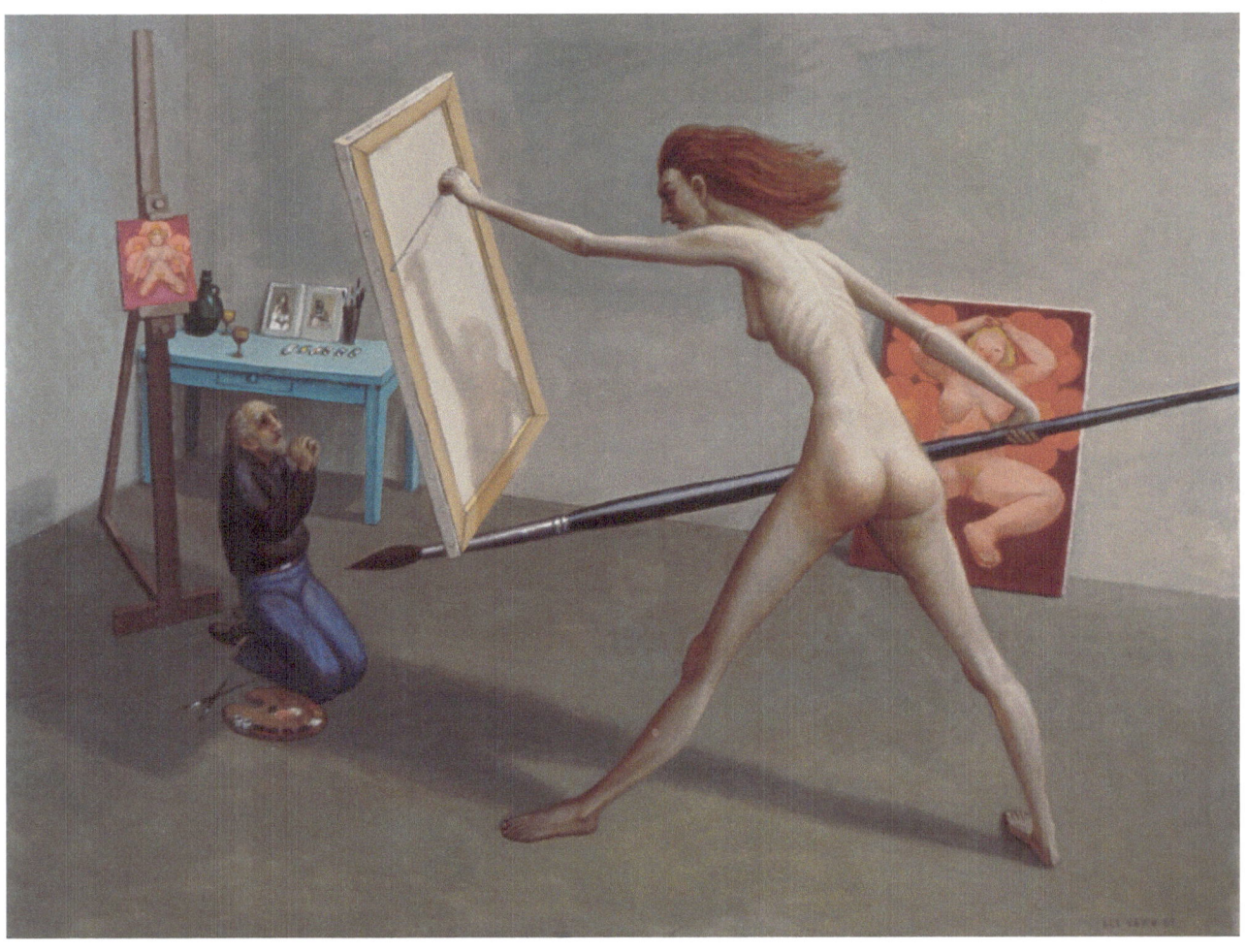

Angry Muse, 1989, egg tempera, 36 x 48 in.

In a reversal of Artist and Muse, the muse here is inhibiting, rather than inspiring. The painter of nudes is overwhelmed by his subject in more ways than one.

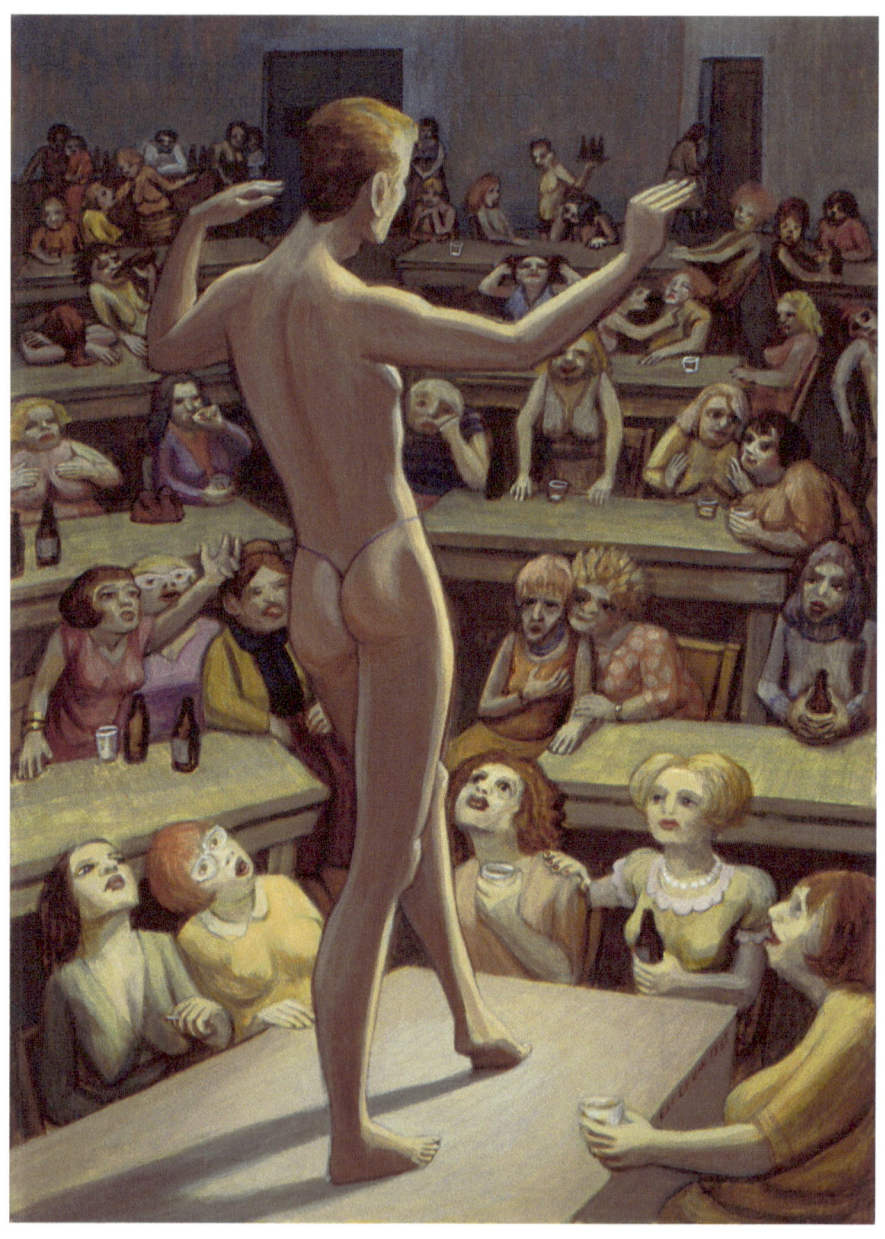

Man, 1986, egg tempera, 28 x 20 in.

Chippendales came to Santa Fe, and several women described their evenings out to me. In addition, one of the personal trainers at the gym, who was also a male stripper, described the scene from his perspective.

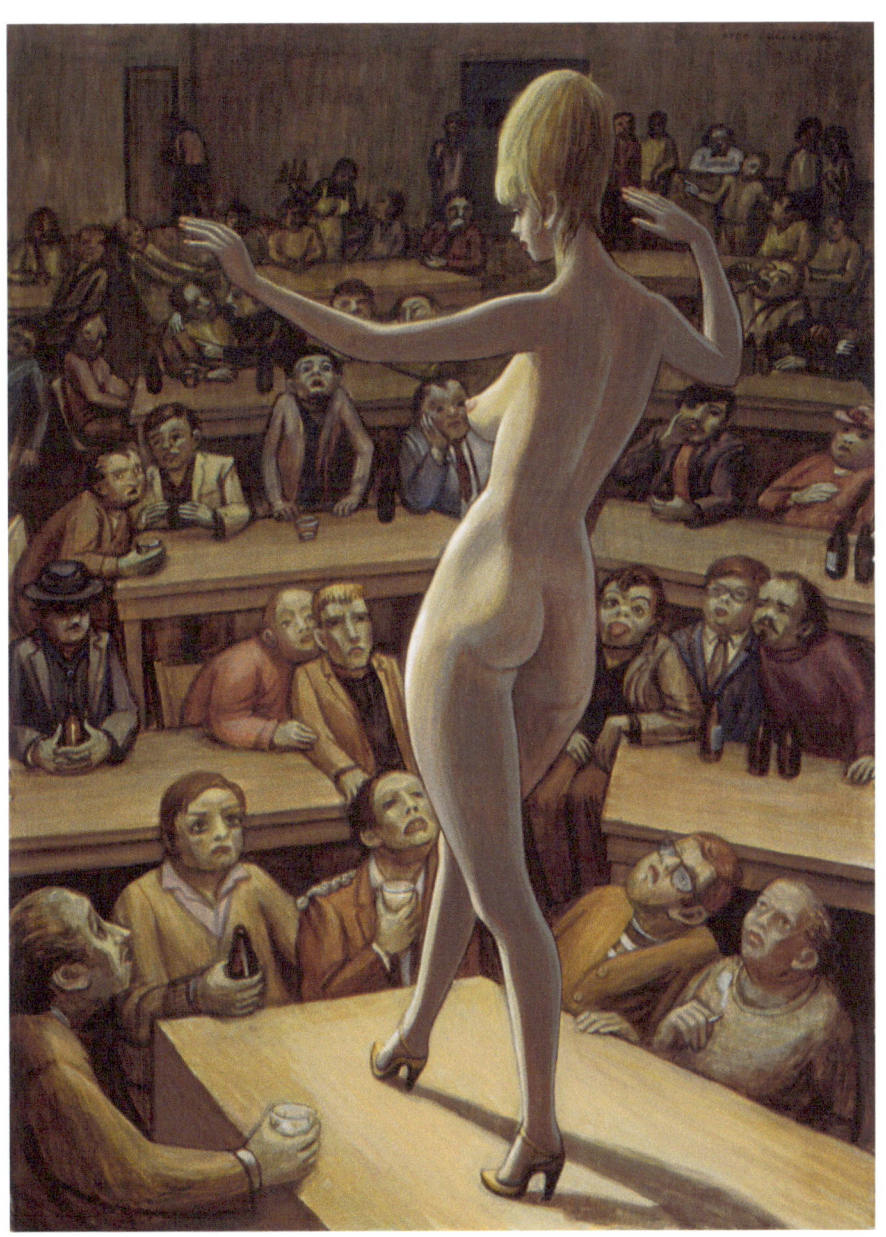

Woman, 1986, egg tempera, 28 x 20 in.

In my student days in Boston, I used to go down to the Combat Zone, where there were wild bars and strip joints. I used my memories for a companion piece to *Man*.

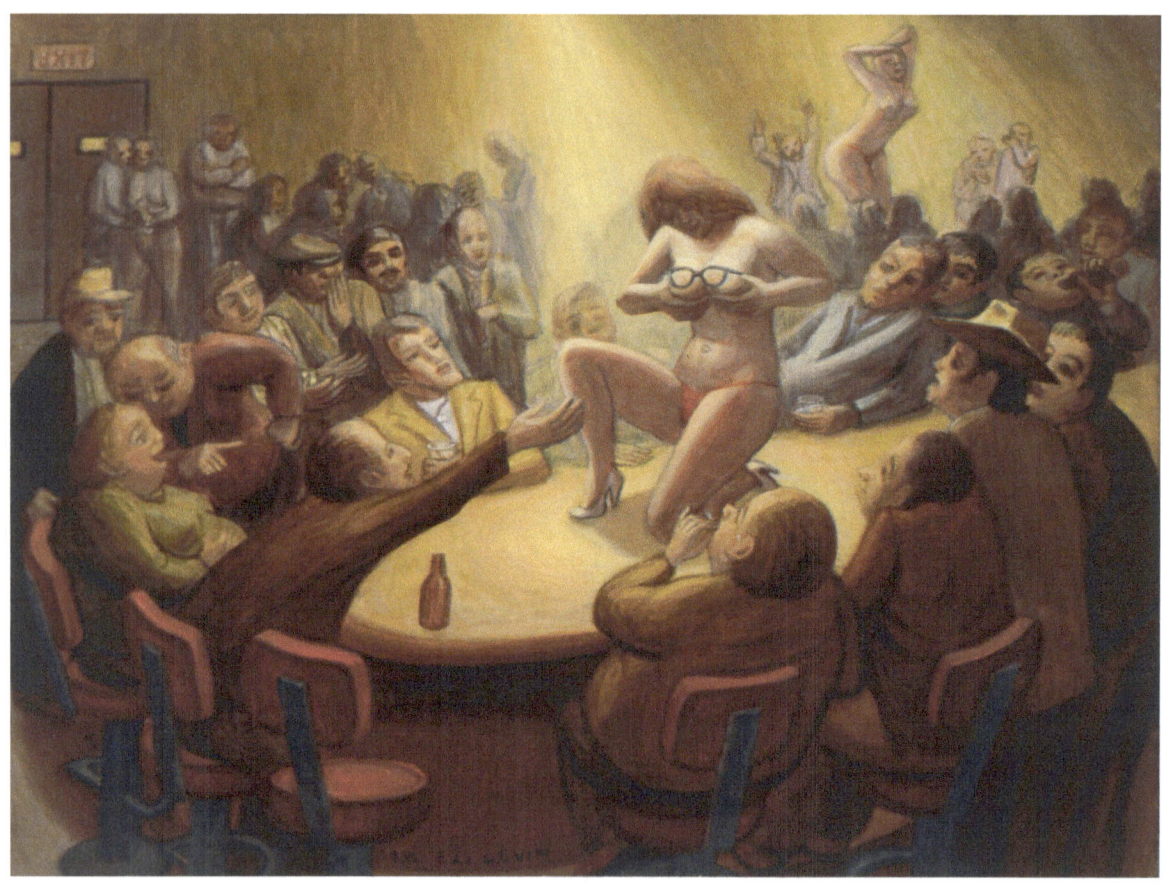

Eyeglasses, 1978, egg tempera, 18 x 24 in.

Where did I get this odd idea? I've never been comfortable with audience participation.

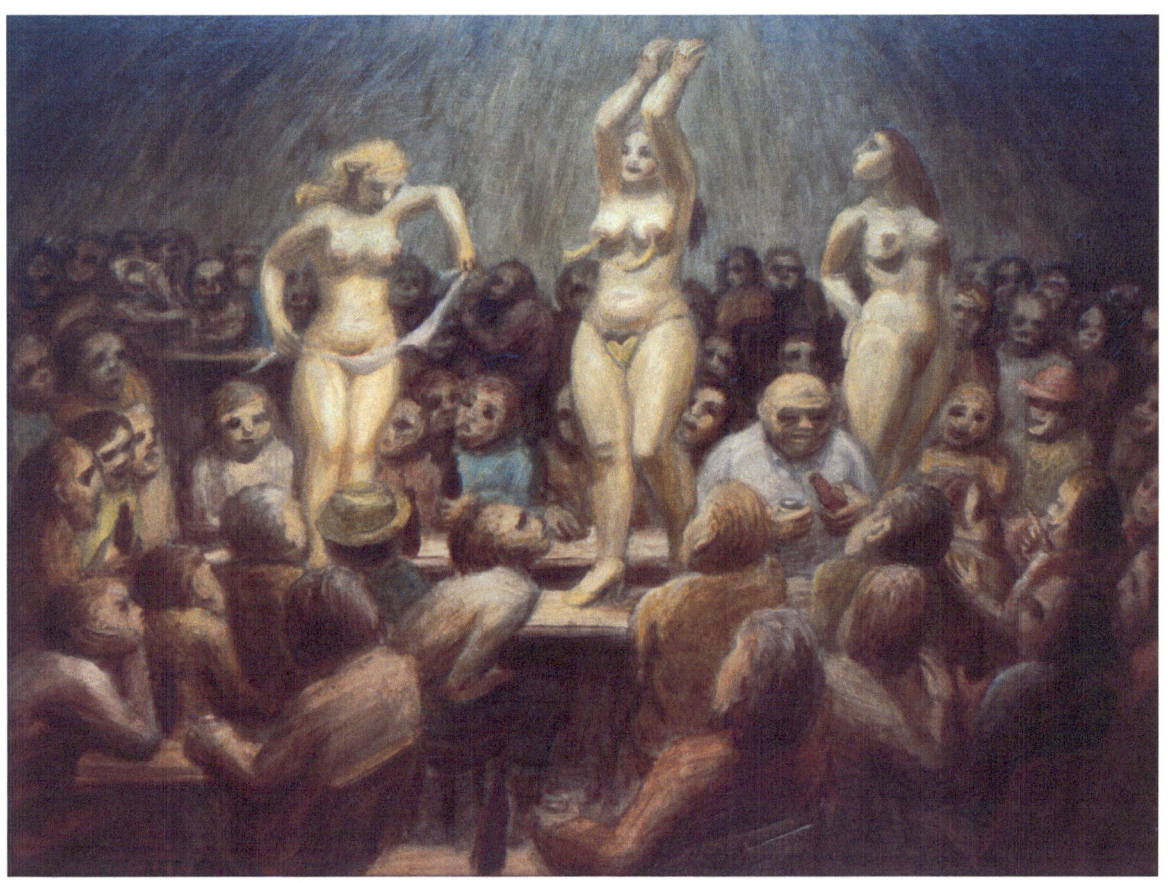

Strip Joint, 1977, egg tempera, 18 x 24 in.

A children's dentist commissioned me to paint a strip joint in Denver, which his father ran. The dentist sent photographs of big-busted women and his old man behind the bar with a microphone. Putting that painting together was hard work. Later, I painted this more general version for myself.

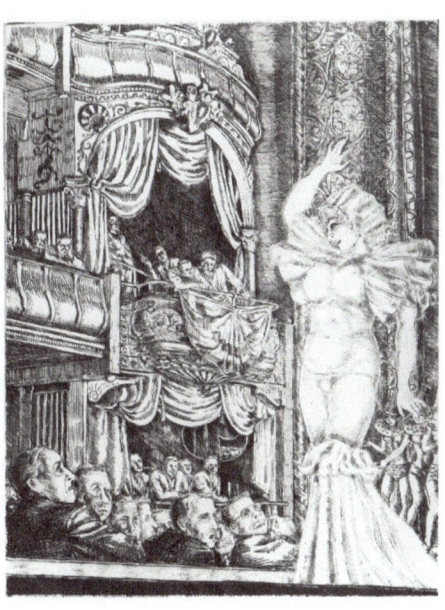

Star Burlesque, Reginald Marsh, c1933, etching

Marsh, a Social Realist, inspired me with his subject matter and techniques, both in etching and egg tempera.

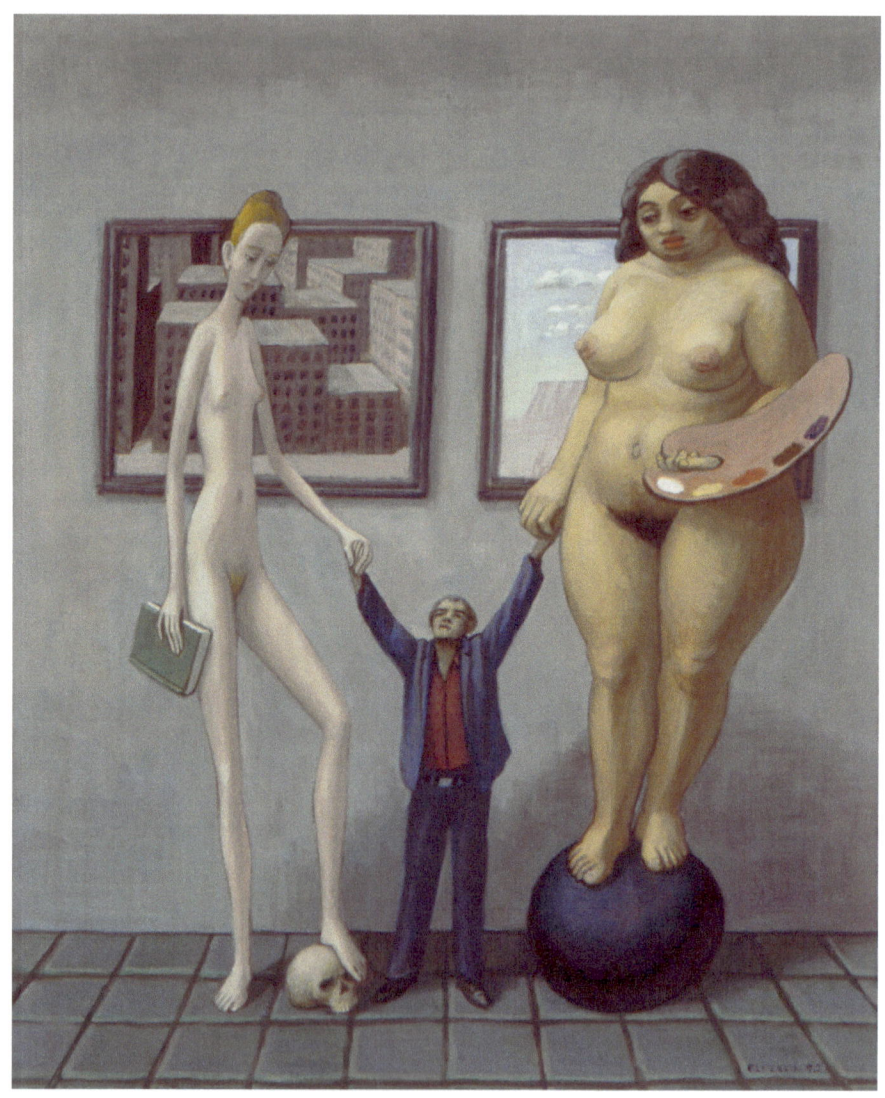

New York, New Mexico, 1992, egg tempera, 20 x 16 in.

I stole the title from an exhibition by Frank Ettenberg, an abstract painter. Here, Little Eli is between his two muses, the anemic literary New Yorker and the earthy Santa Fe artist's muse.

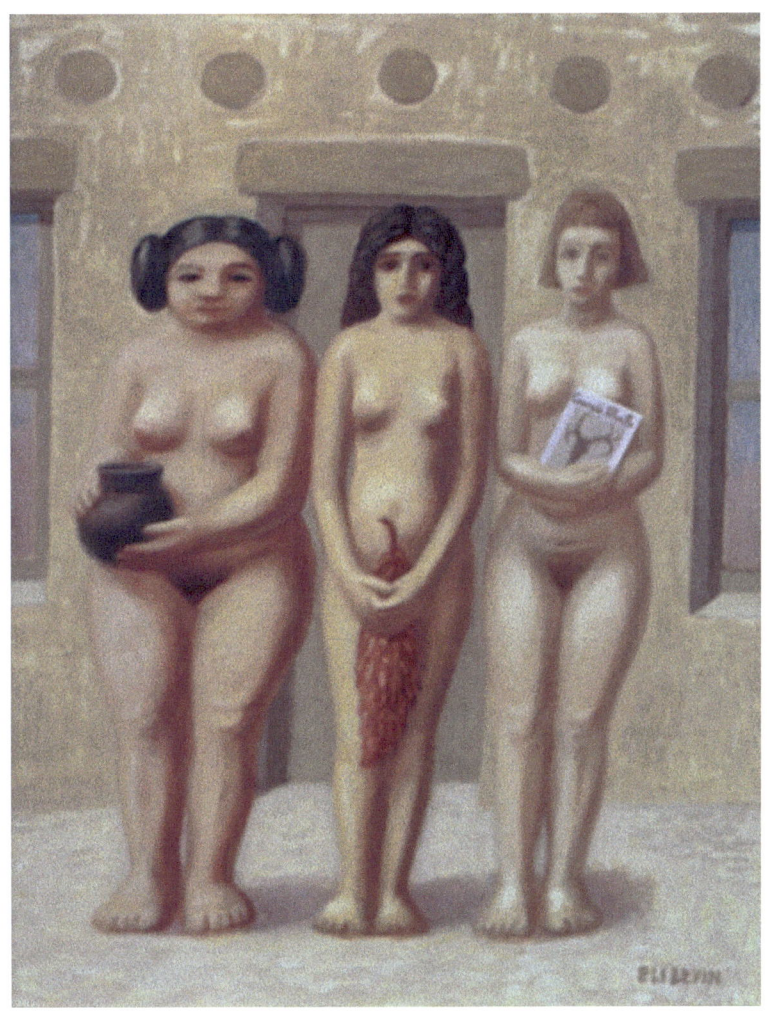

Southwest Muses, 1978, egg tempera, 30 x 24 in.

These nudes are allegorical, standing for the three southwestern cultures: a Native American with a Santa Clara pot, a Hispanic with a *ristra*, and an Anglo with an art book about Georgia O'Keeffe.

Nude and Cat, 1981–91, egg tempera, 9 x 12 in.

An early version in a series of thin women, this small tempera has a delicate art-deco feeling that I like.

Sunlight on Bed, 1992, egg tempera, 20 x 16 in.

At first, there was a stolid man standing near the door, but I took him out. These attenuated figures done in tempera were a stylistic extreme for me and reflected my fascination with 16th century Mannerism.

Come to Bed, 1990, egg tempera, 20 x 16 in.
In the series of thin women, this painting captures a pleasing moment.

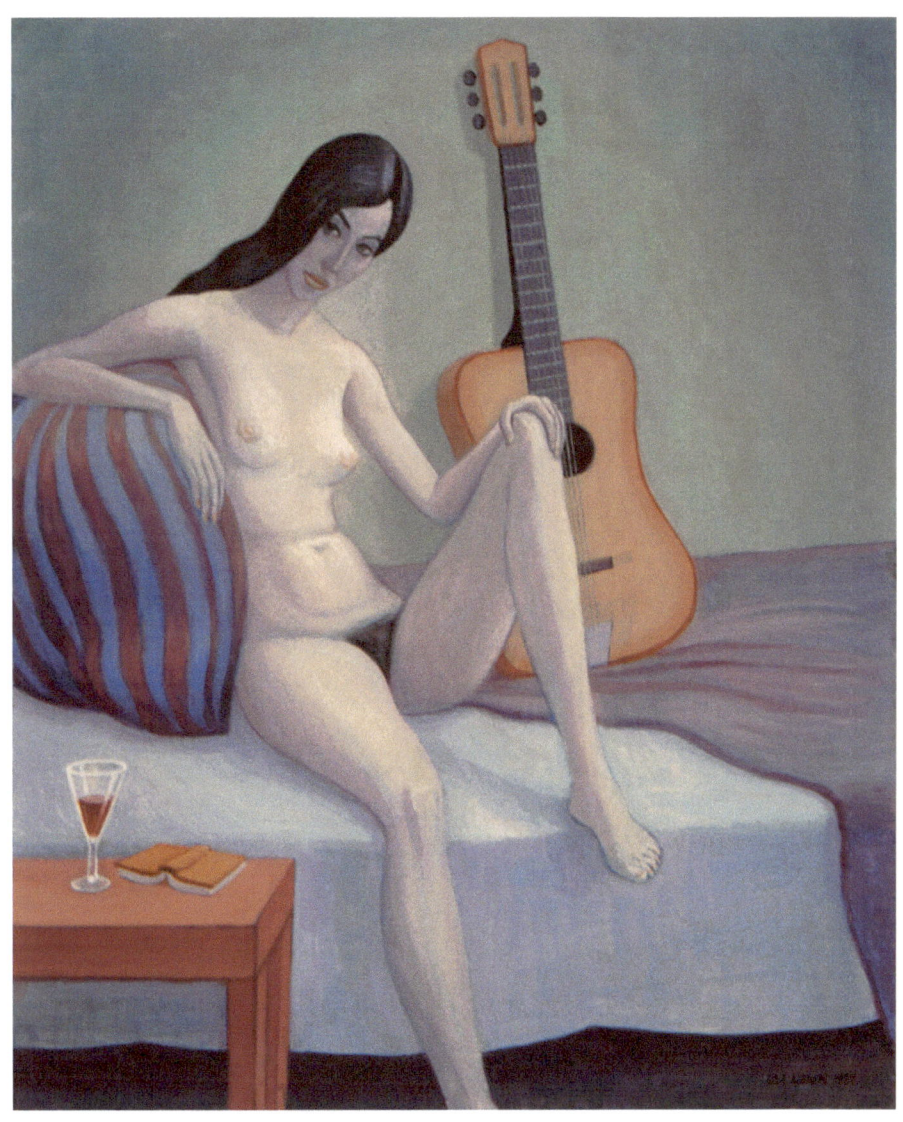

Nude with Wine and Guitar, 1991, egg tempera, 20 x 16 in.

This is a scary memory portrait of the New York Jewish woman who inspired many of the thin nudes.

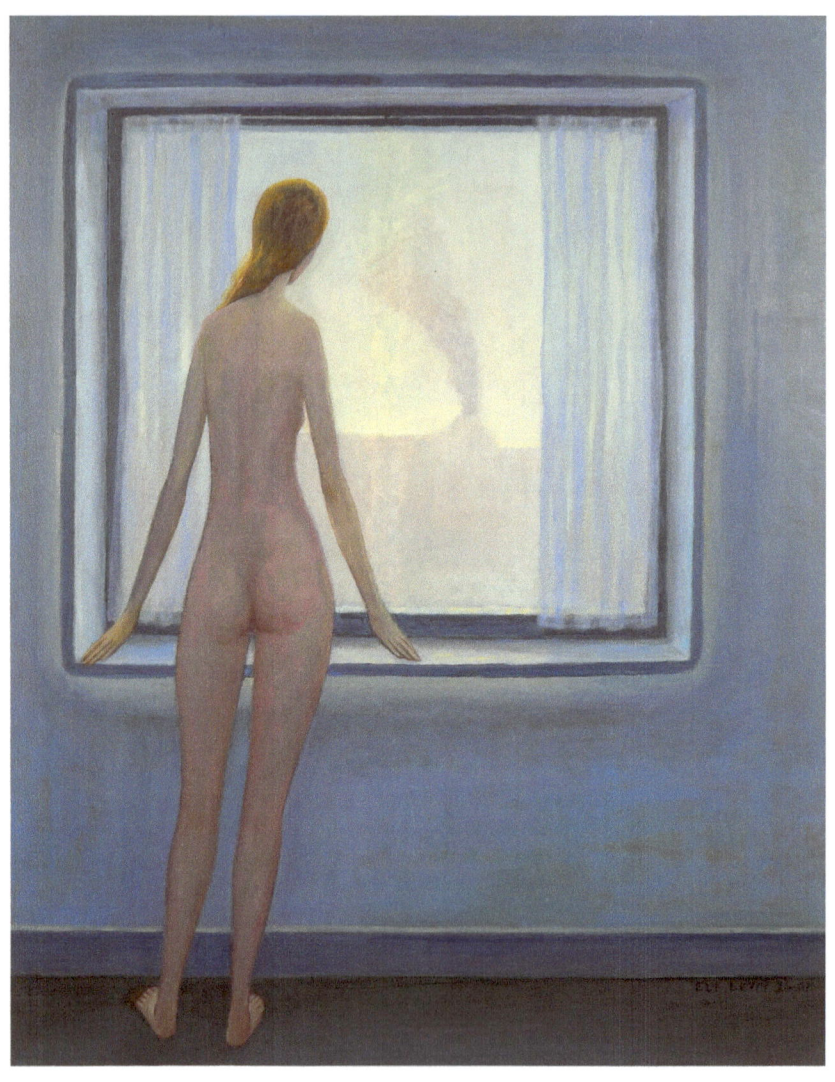

Blue Day, 1992, egg tempera, 20 x 16 in.

I was trying to suggest a quiet loneliness. What looks like a volcano outside is supposed to be an adobe chimney. The ashy smoke is a metaphor for wasted love.

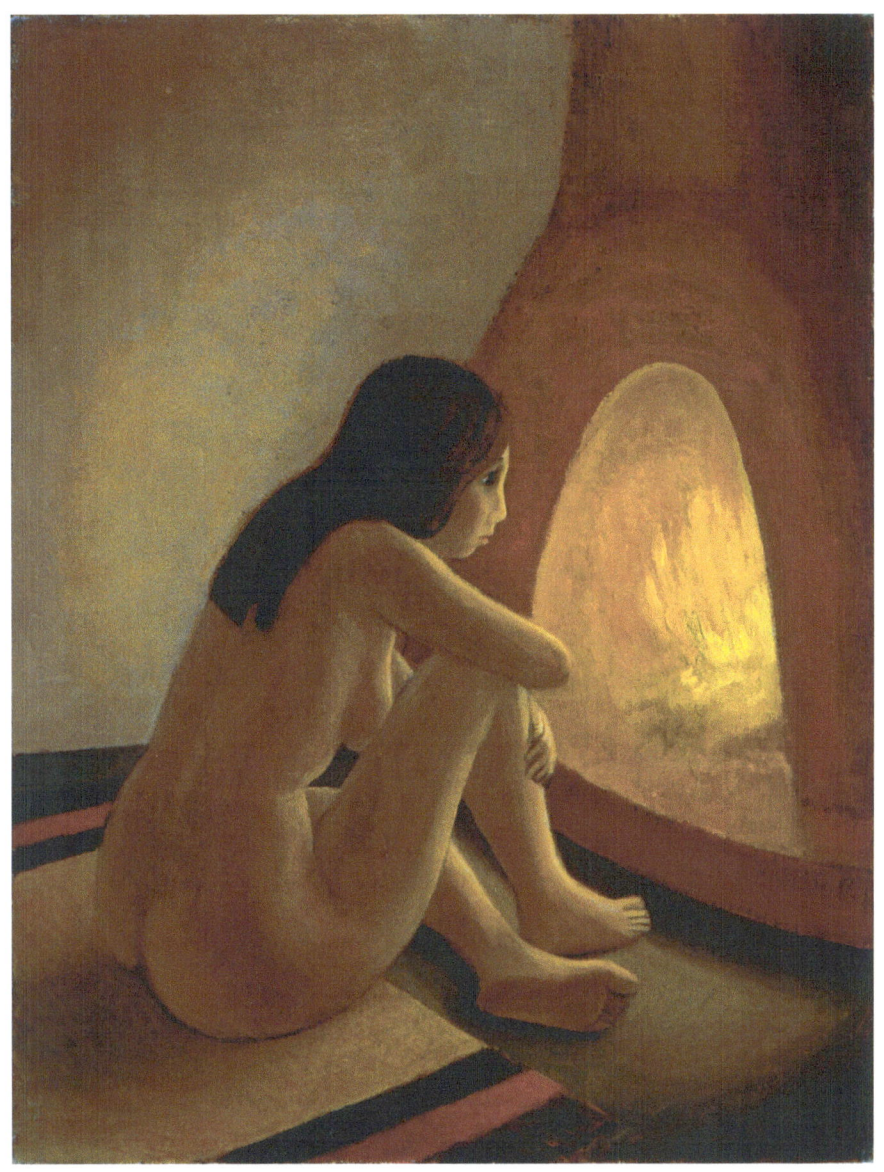

Girl and Fireplace, 1989, egg tempera, 24 x 18 in.

The thin women morph into a nude-and-fireplace series, which is more regional than the other series. This version has a Hispanic girl, a kiva fireplace, and a Native American rug.

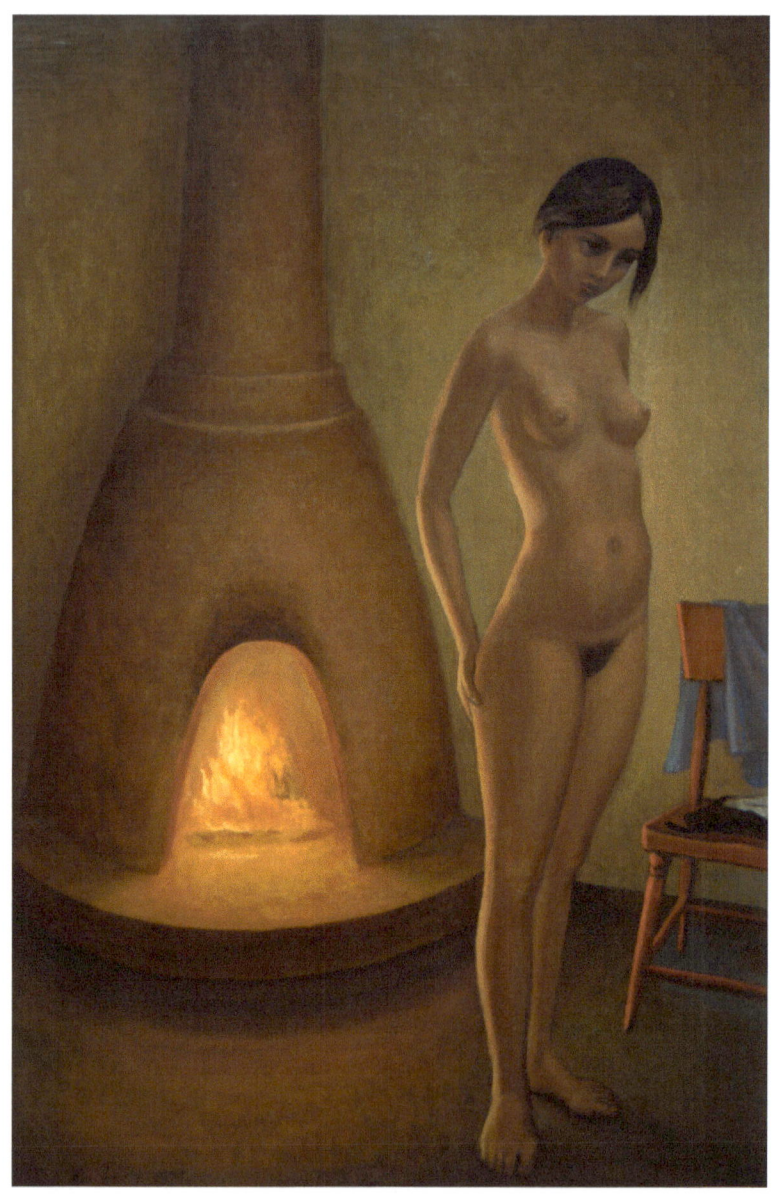

Standing Nude and Kiva, 1984, egg tempera, 25 x 18 in.

This is the same subject, turned around. There is still more elongated elegance than in my usual style.

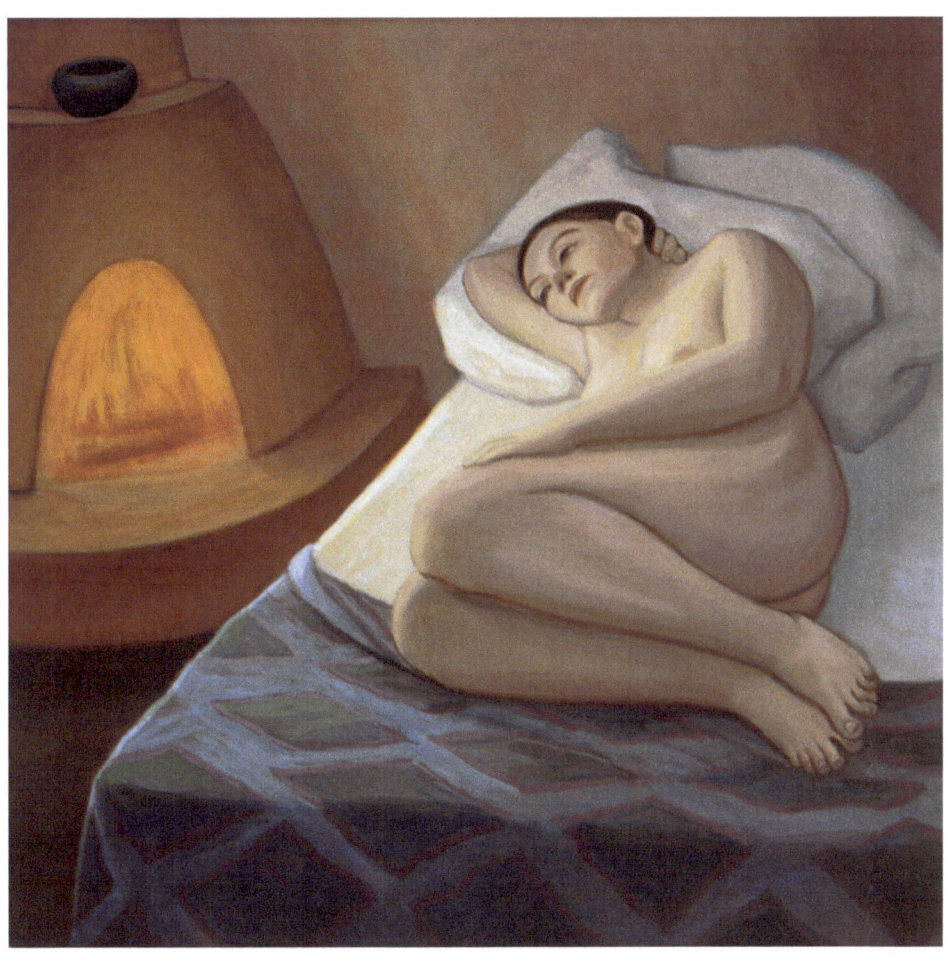

Fireside Reverie, 1993, egg tempera, 16 x 16 in.
I am partial to this one: the calm light, the clarity of the tempera, the meditative mood.

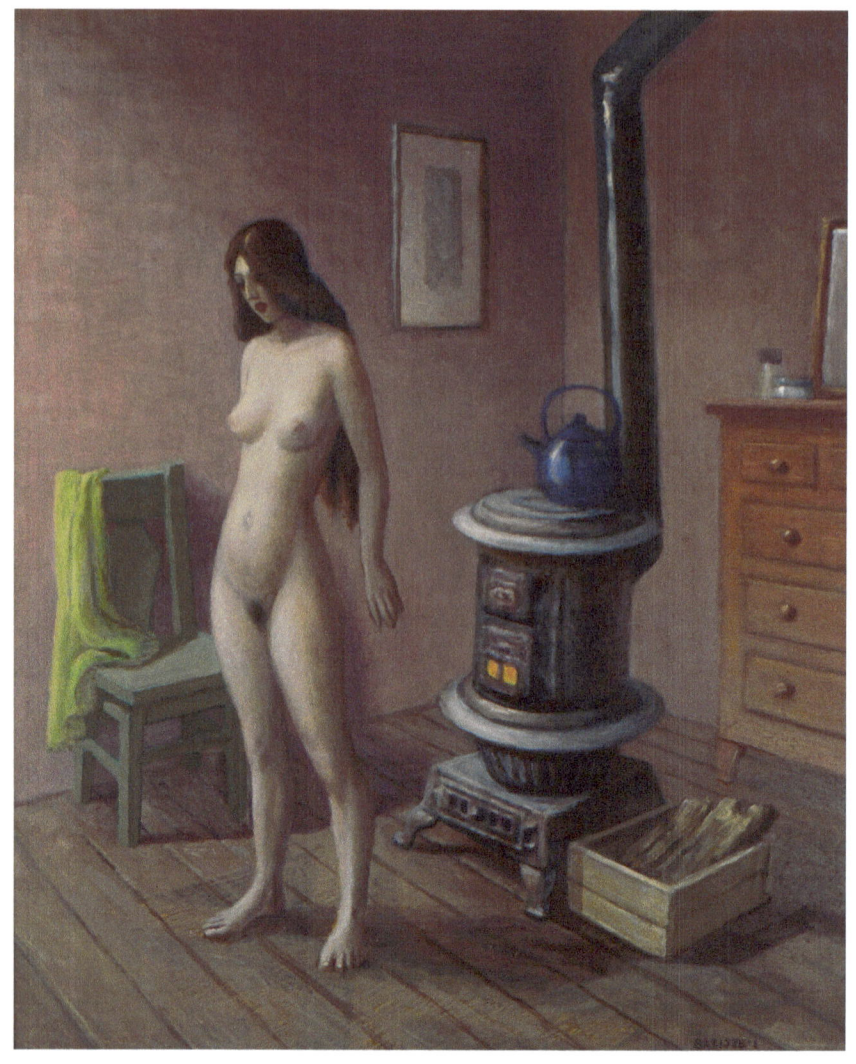

After the Shower (second version), 2001, oil, 20 x 16 in.

While the room is imaginary, the wood stove is like the one in my studio. An earlier etching showed a glimpse of the shower behind the partially open bathroom door. This painting is surprisingly similar to *Sami and Stove*, p. 99.

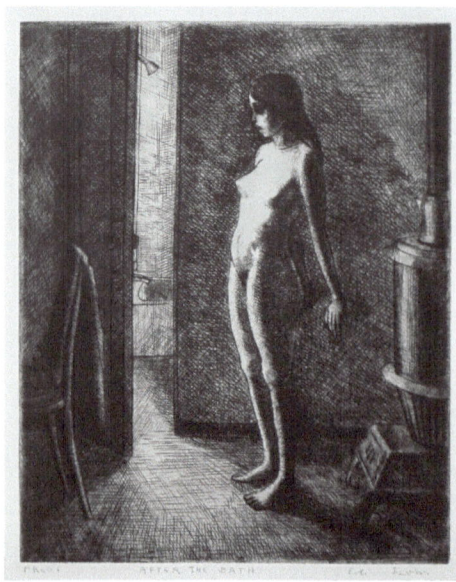

After the Bath, c. 1990, etching, 10 x 8 in.

This is one of my best-selling etchings.

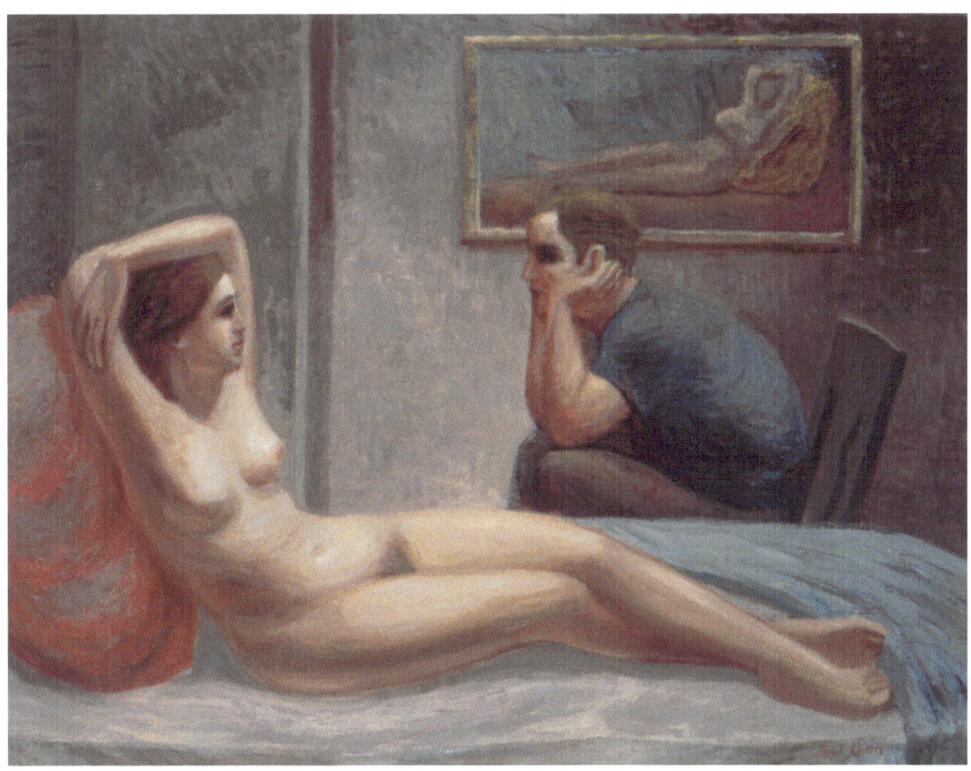

Nude and Admirer, 1979, oil, 24 x 30 in.

This depicts some kind of tense moment, similar to the mood of a painting by Edward Hopper in which a clothed man sits on a bed with a partially nude woman reclining behind him. My painting is also like Titian's variations of *Venus with the Organist* (p. 74).

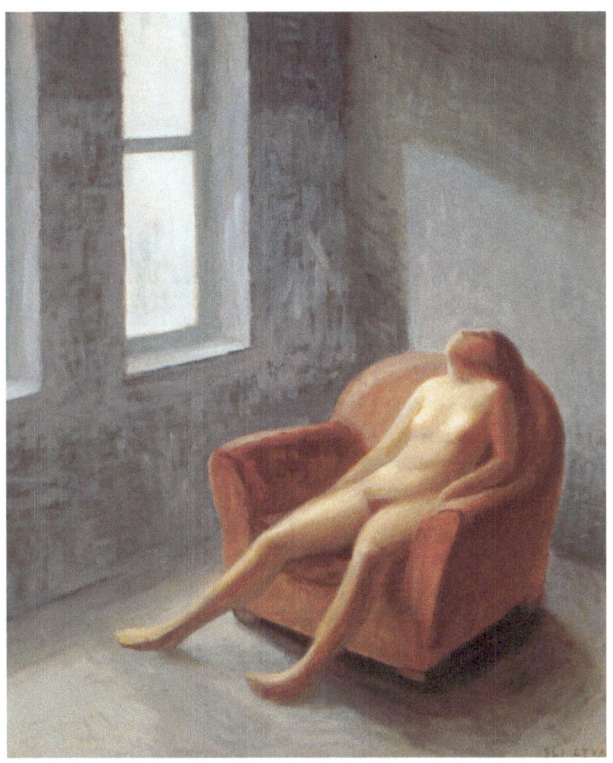

Exhausted, 1979, oil, 30 x 24 in.

In an early version of the introspective nudes, this enervated lady in a barren city room appears expressionistically Hopperesque.

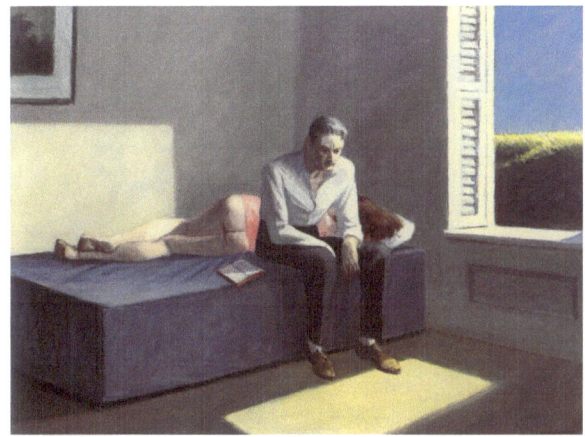

Excursion into Philosophy, Edward Hopper, c. 1959, oil

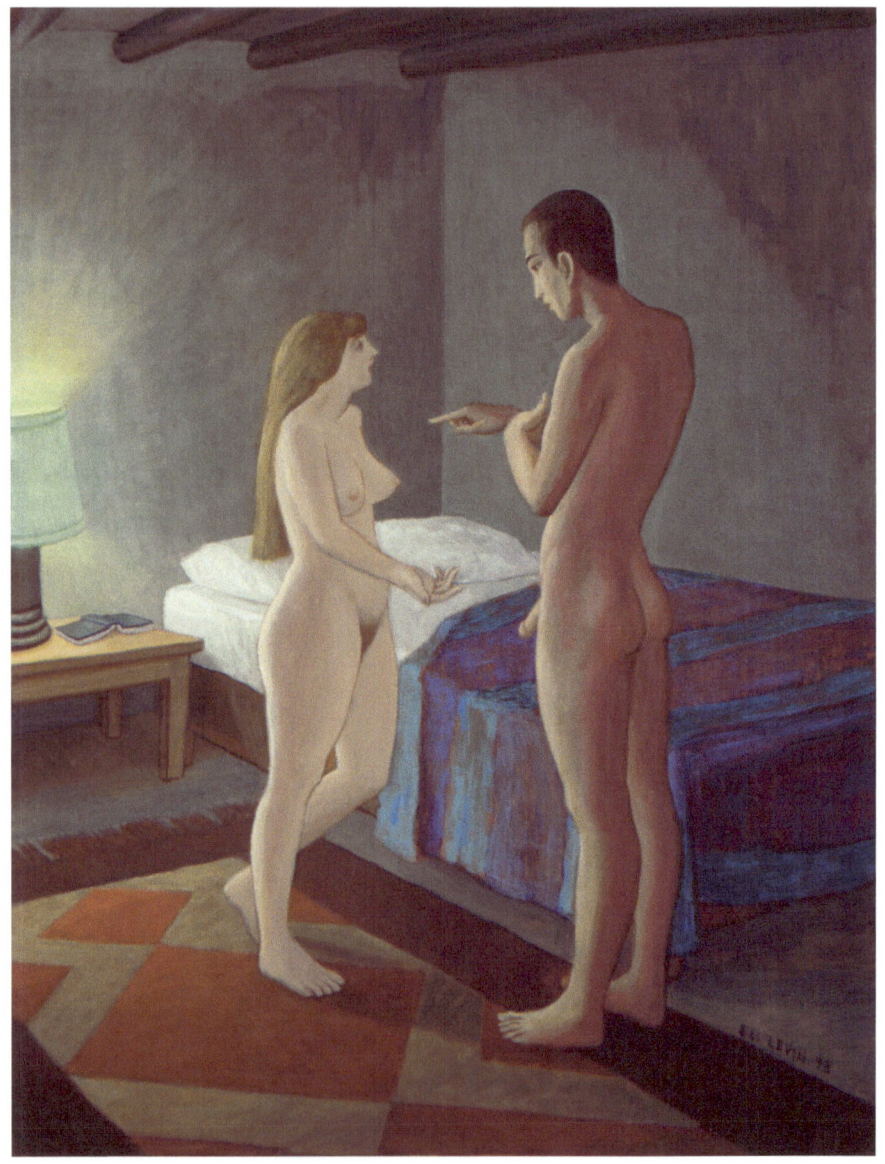

Bedroom Bargaining, 1993, egg tempera, 24 x 18 in.

This is one of my favorites. There is such equality between the couple, yet the image is full of ambiguity. The furnishings and spatial relationships also seem just right.

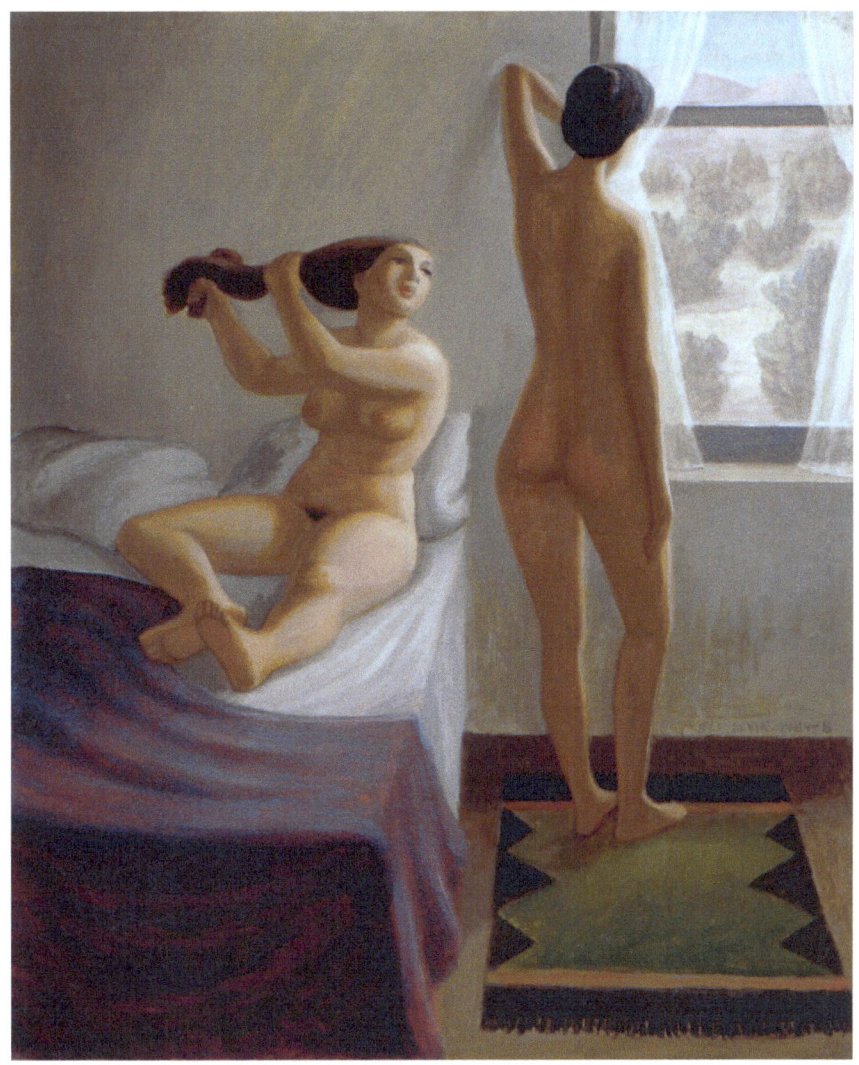

Winter Morning, 1986, oil, 20 x 16 in.

This painting of two local women on a high-desert winter morning was derived from my failed attempt to paint a convincing depiction of two nudes by a bed in 1959, while I was studying art at Brandeis. The realization that I couldn't make realistic figures influenced my decision to go back to New York in 1960 and paint from models in Raphael Soyer's class.

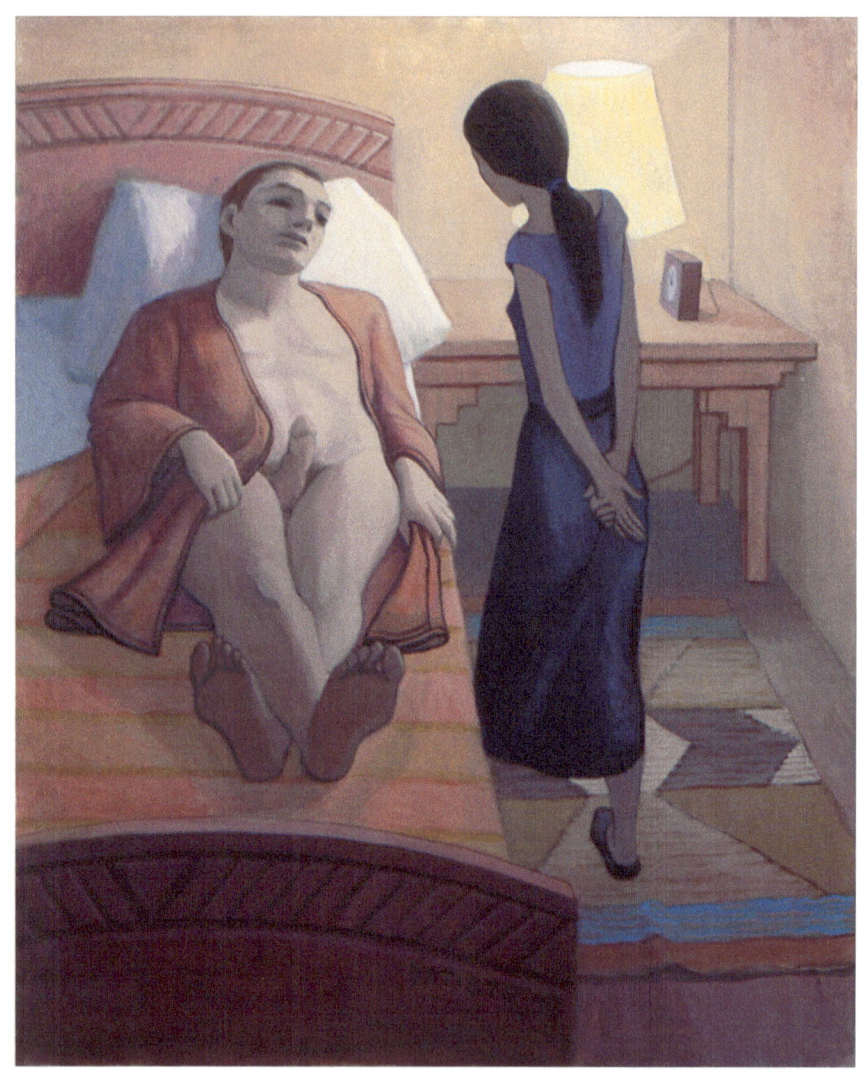

Bedside Conversation Diptych (left), 1993, egg tempera, 20 x 16 in.

Here, we have sexual confrontation and the awkwardness of one figure being clothed. Viewers are often uneasy when an erection is depicted.

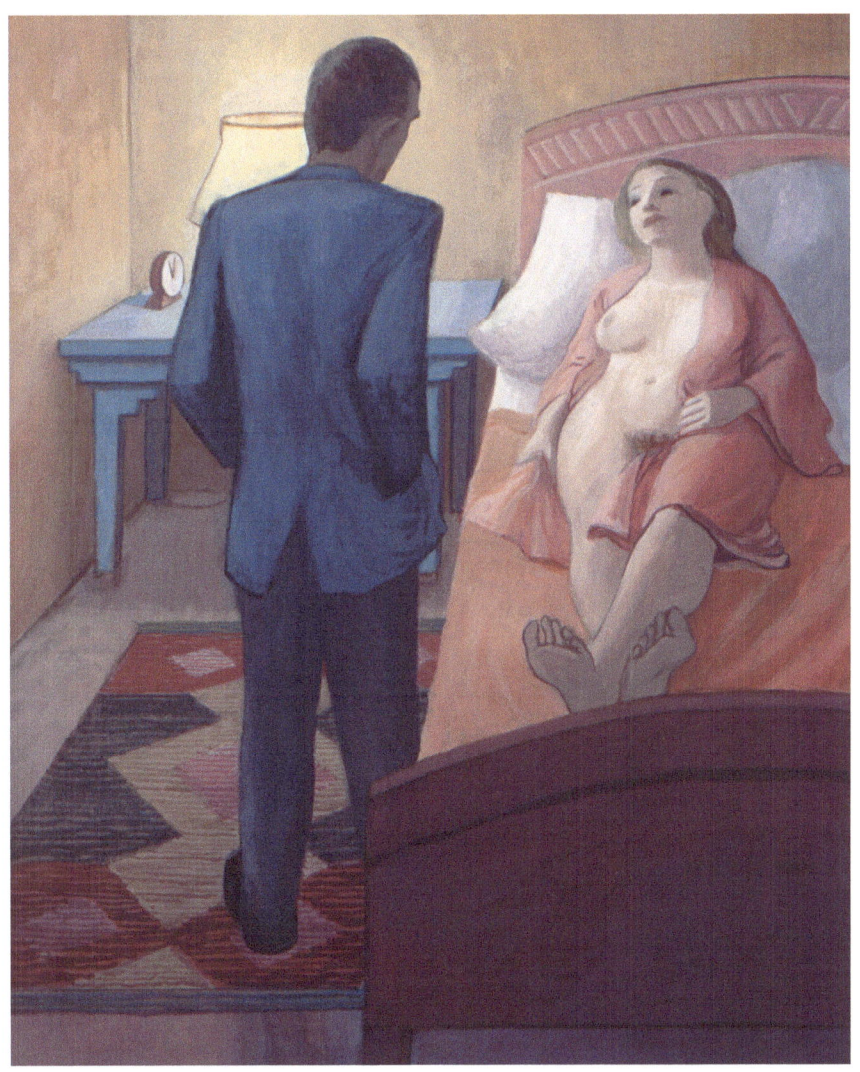

Bedside Conversation Diptych (right), 1993, egg tempera, 20 x 16 in.

This variation causes another kind of unease because the man feels threatening. Even the rug is threatening.

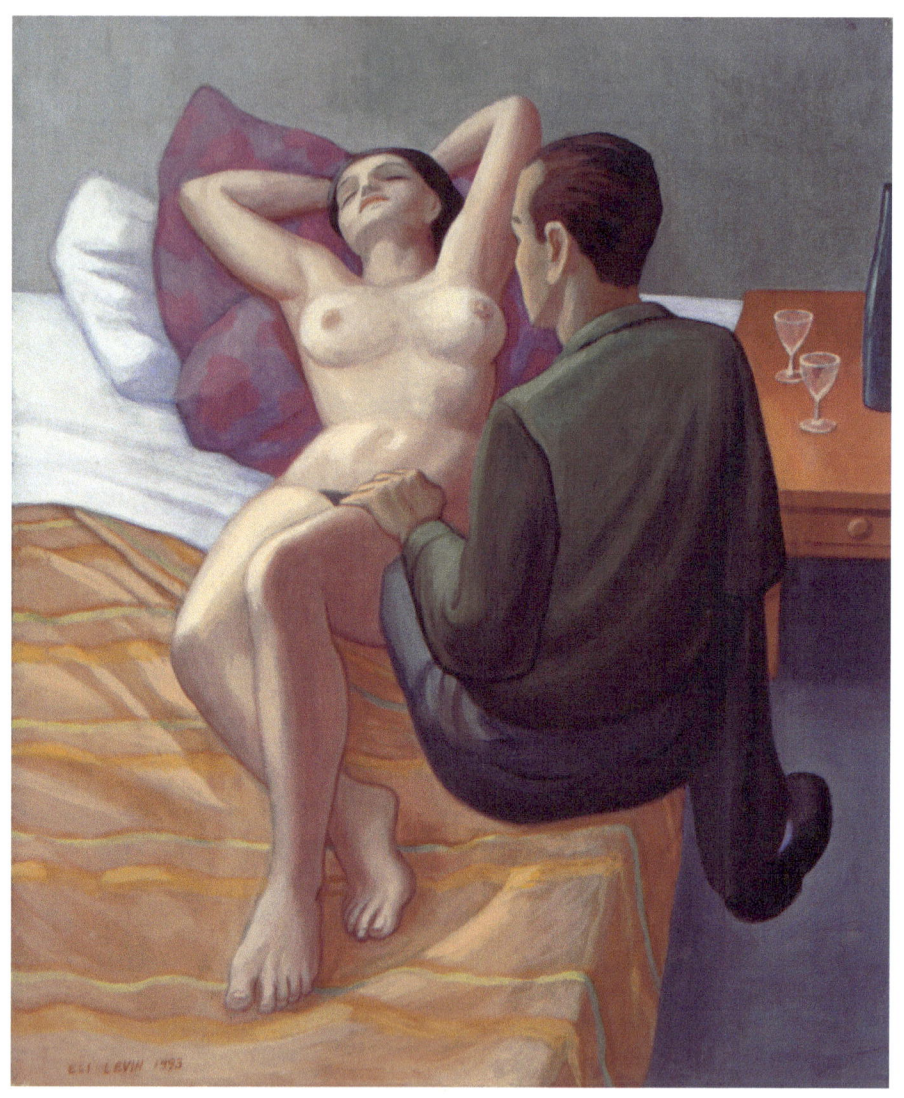

Admiration of the Female, 1993, egg-oil emulsion, 22 x 18 in.

This depicts my hesitant worship of the nude. I used a little-known tempera formula from Pietro Annigoni, an Italian twentieth-century academic realist.

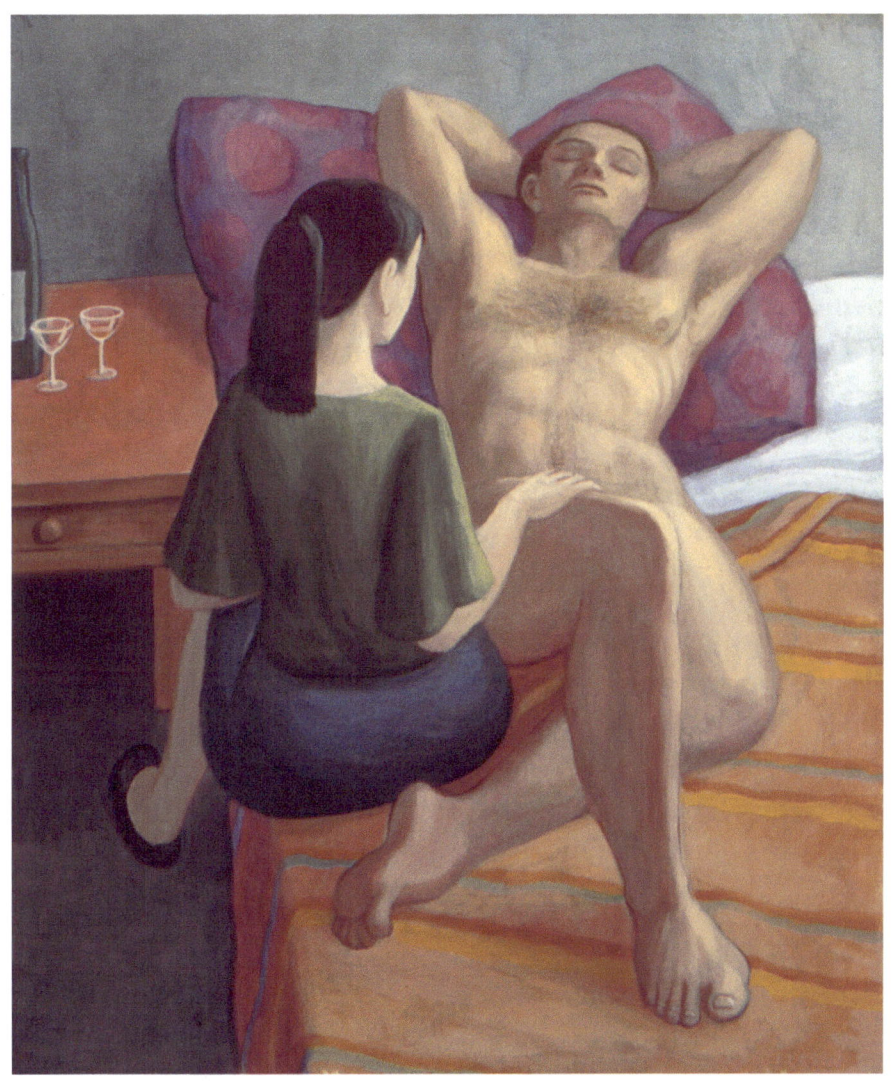

Admiration of the Male, 1993, egg-oil emulsion, 22 x 18 in.
The reversal is even more awkward: a shy girl and a vain man.

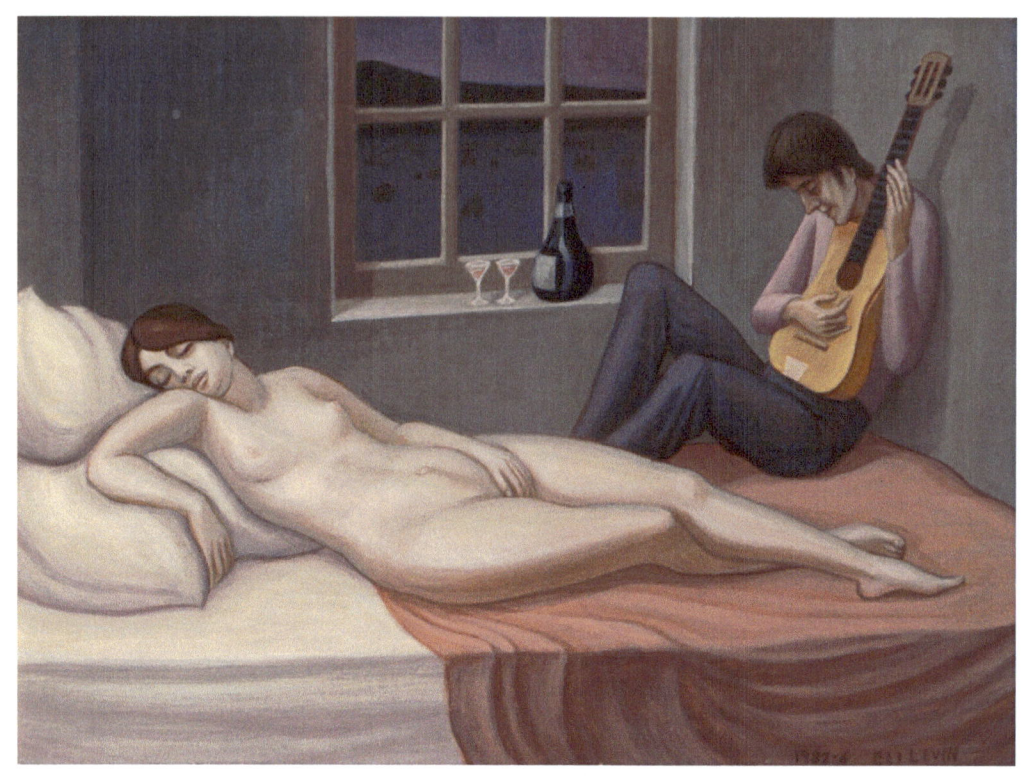

Serenading the Woman, 1982–86, egg tempera, 12 x 16 in.

This scene is closely derived from Titian's series of reclining Venuses.

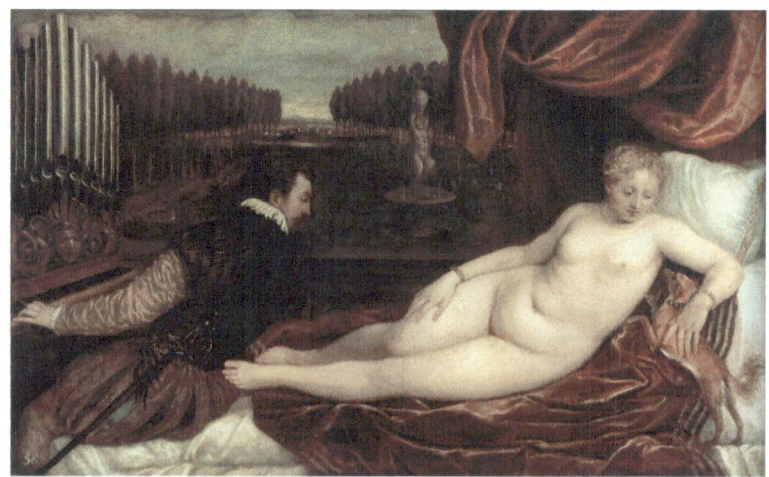

Venus with the Organist, Titian c. 1550, oil

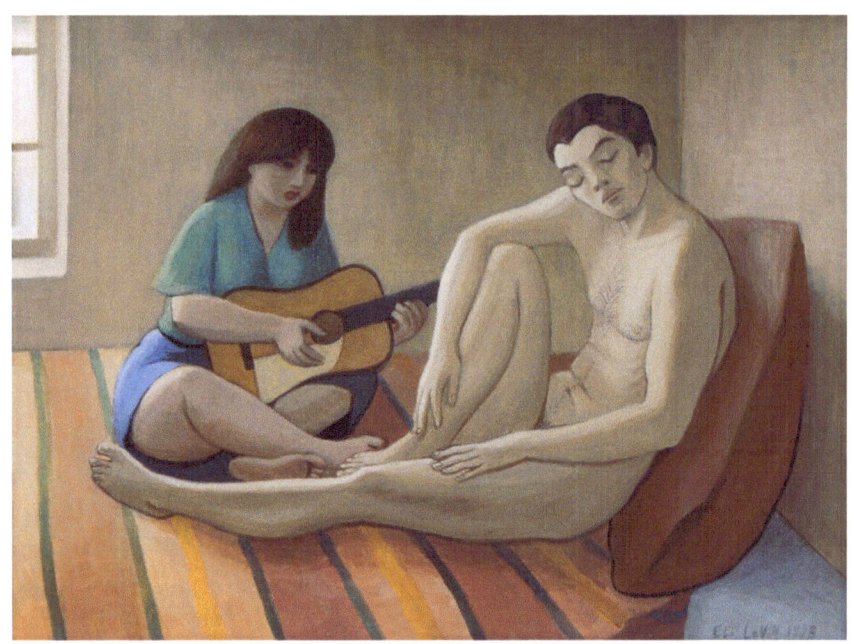

Serenading the Man, 1993, egg tempera, 12 x 16 in.

This variation of the theme is a sexual reversal. The subject is male egotism.

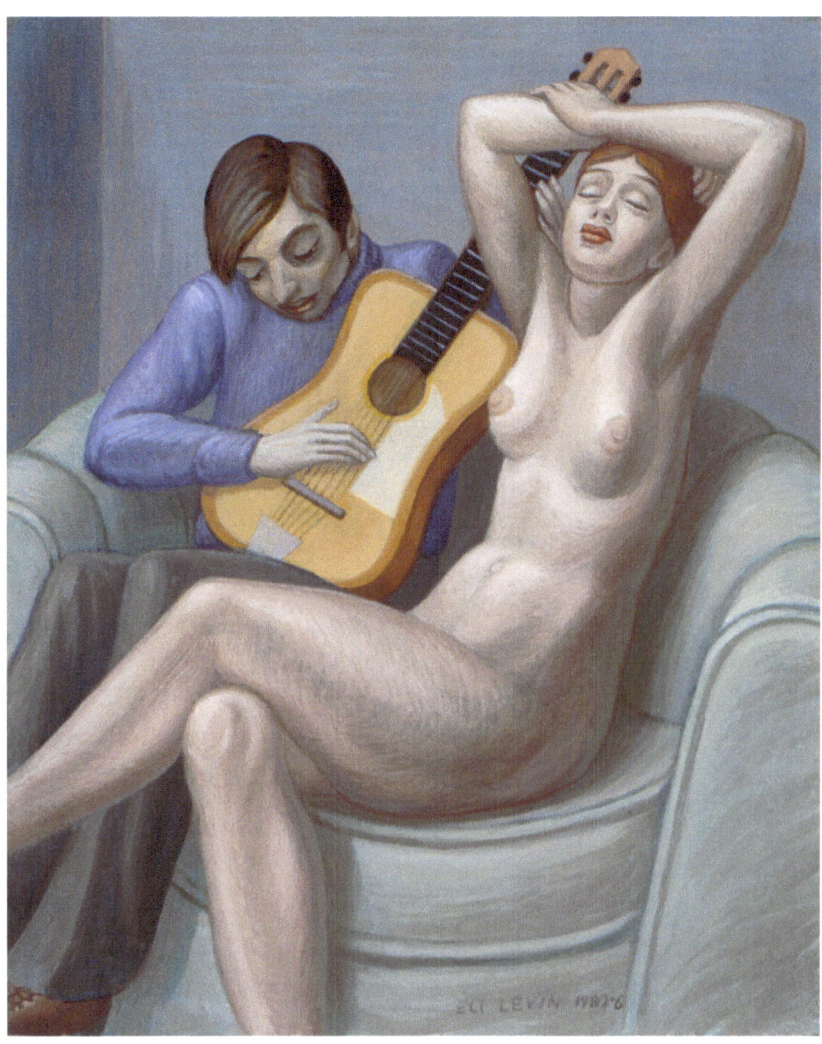

Serenade, 1982–86, egg tempera, 20 x 16 in.

In high school, I was intrigued by, and envied, the sexual allure of guitar players.

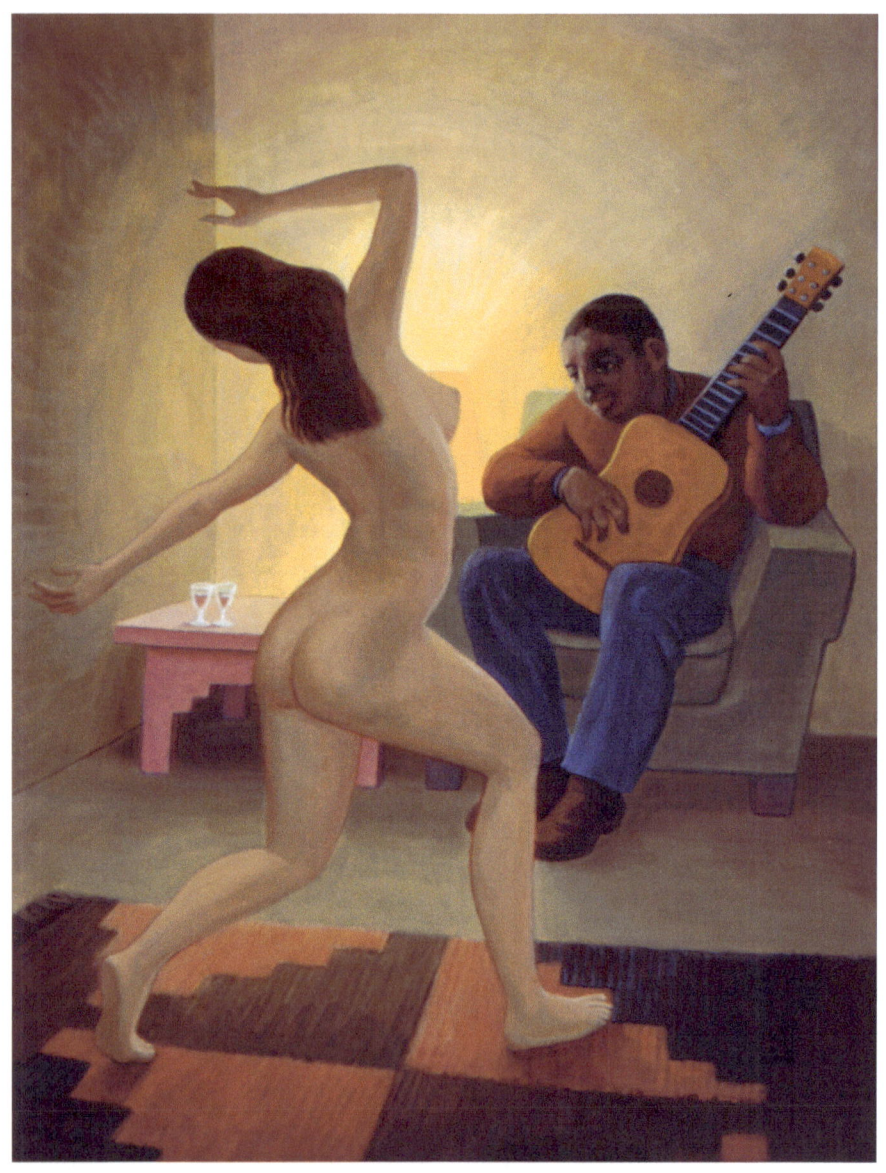

Black and White, 1992, egg tempera, 24 x 18 in.

Here's the theme of the sexy guitar player again, with an added racial aspect.

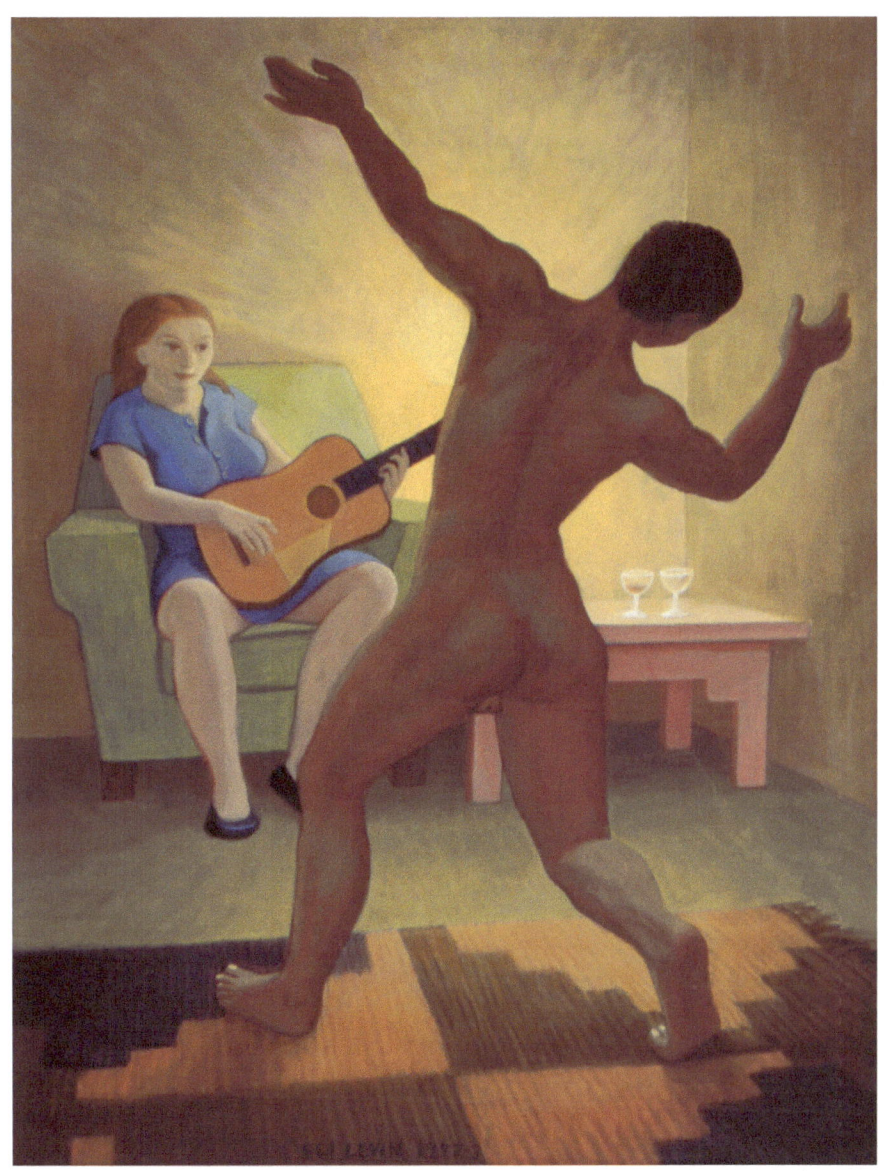

White and Black, 1992–93, egg tempera, 24 x 18 in.

In the name of political correctness, I've painted the reversal. Which, if either, is more disconcerting? Or is the supposed tension a thing of the past?

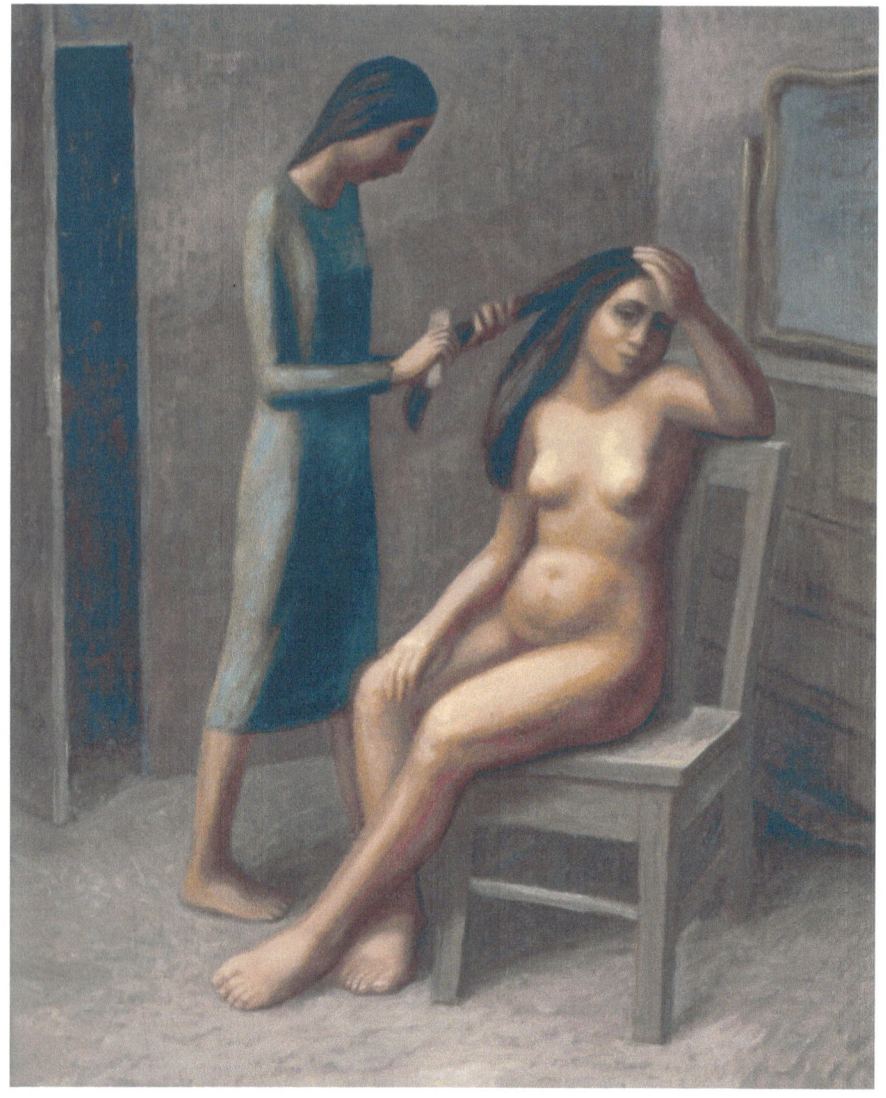

Sisters II, 1978, oil, 30 x 24 in.

This memory painting is of the Hispanic girl who lived with me for several years. She's with her youngest sister, who stayed with us for a while. The composition is derived from a Picasso done in his classic period. My brother Gabriel Levin, a poet who lives in Jerusalem, has a smaller version done in egg tempera. Here is his tribute to the painting.

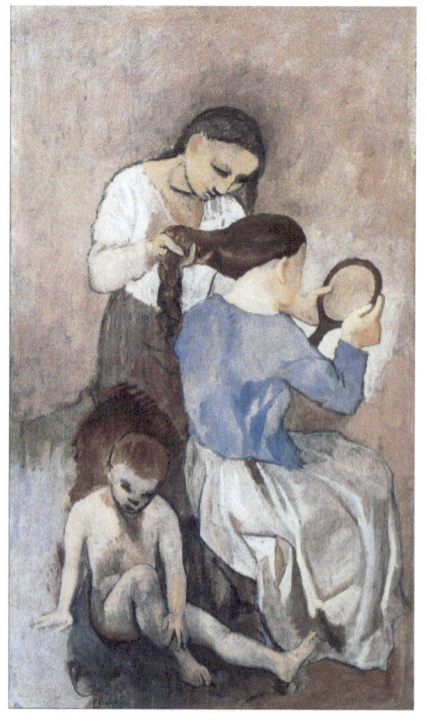

Hairdressing, Pablo Picasso, c. 1906, oil

BOXED IN
 for E. L.

How readily they assume
their double lives, seated
or standing, inhaling
the finely ground, toxic
medium of their being,
sequestered in the poorhouse
of the stare, unburnished,
stripped bare, or frocked

in midnight blue; how keenly
they smolder, for the time
being, in the spartan
room, with its chiffonier
and opaque mirror,
the one, lean and dark,
brushing the crinkles
out of the other's hair,

in full view and all flesh-
tints, prolonging
the bristles' caress, coyly
immodest; how she leans
her cheek on the perch
of her shoulder, thighs
pressed, the raised palm
on which her brow

rests firming her breast
up, so that our wonder
and admiration are affirmed
unabashedly (nude!)
without redress, at arm's
length from their maker,
egged on by the boxed-in
compass of his gaze.

 —Gabriel Levin

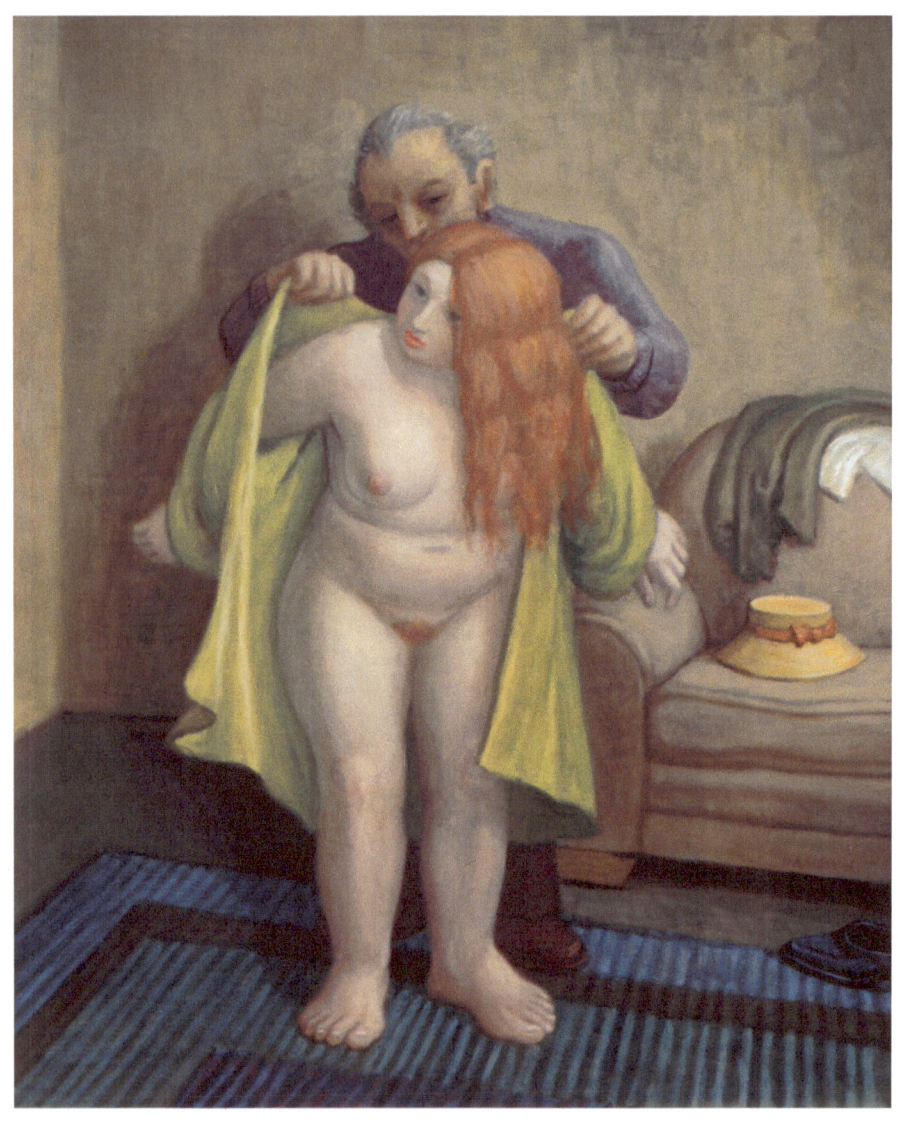

Dirty Old Man, 2005, egg tempera, 20 x 16 in.

An artist and his model; the moment is ambiguous. Is it professional, polite, personal?

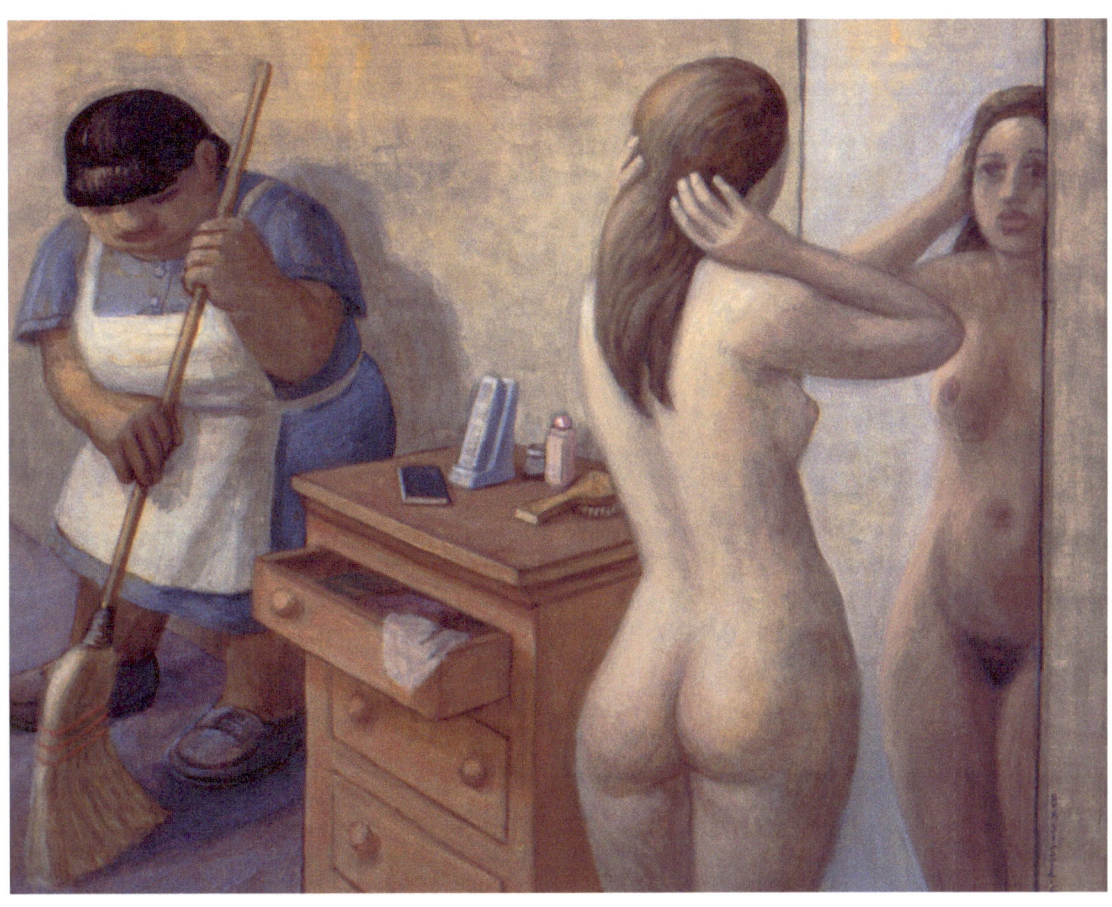

Maid and Nude, 2006, egg tempera, 16 x 20 in.
I've combined the social realism of my maid series and janitor series with my nude series.

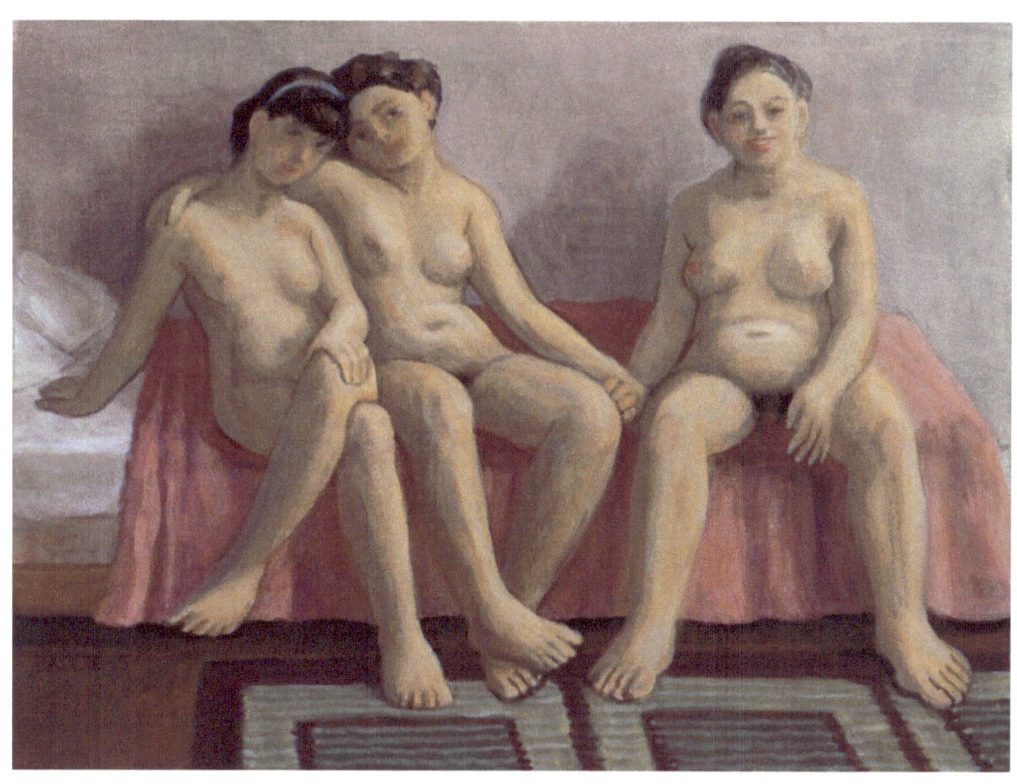

Three Women on a Bed, 2005, egg tempera, 9 x 12 in.

Nineteen years later, I tried to develop the theme of *Winter Morning*, p. 69, into a more convivial image.

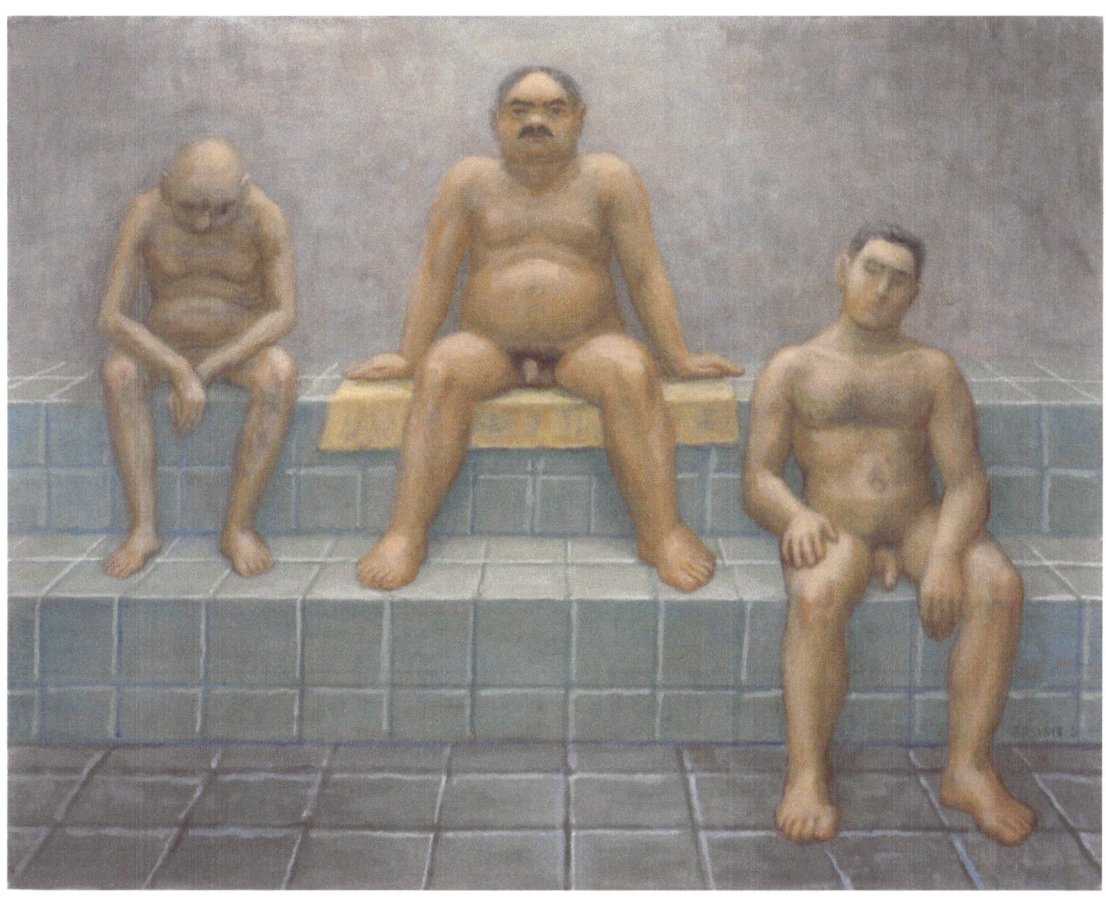

Steam Room, 2000, egg tempera, 16 x 20 in.

Inspired by the local spas, I've painted several scenes with a hot tub, a sauna, or a steam room. It's difficult to indicate steam or fog with egg tempera, a crisp linear medium, but I tried. This picture also presents a topos: the three ages of man.

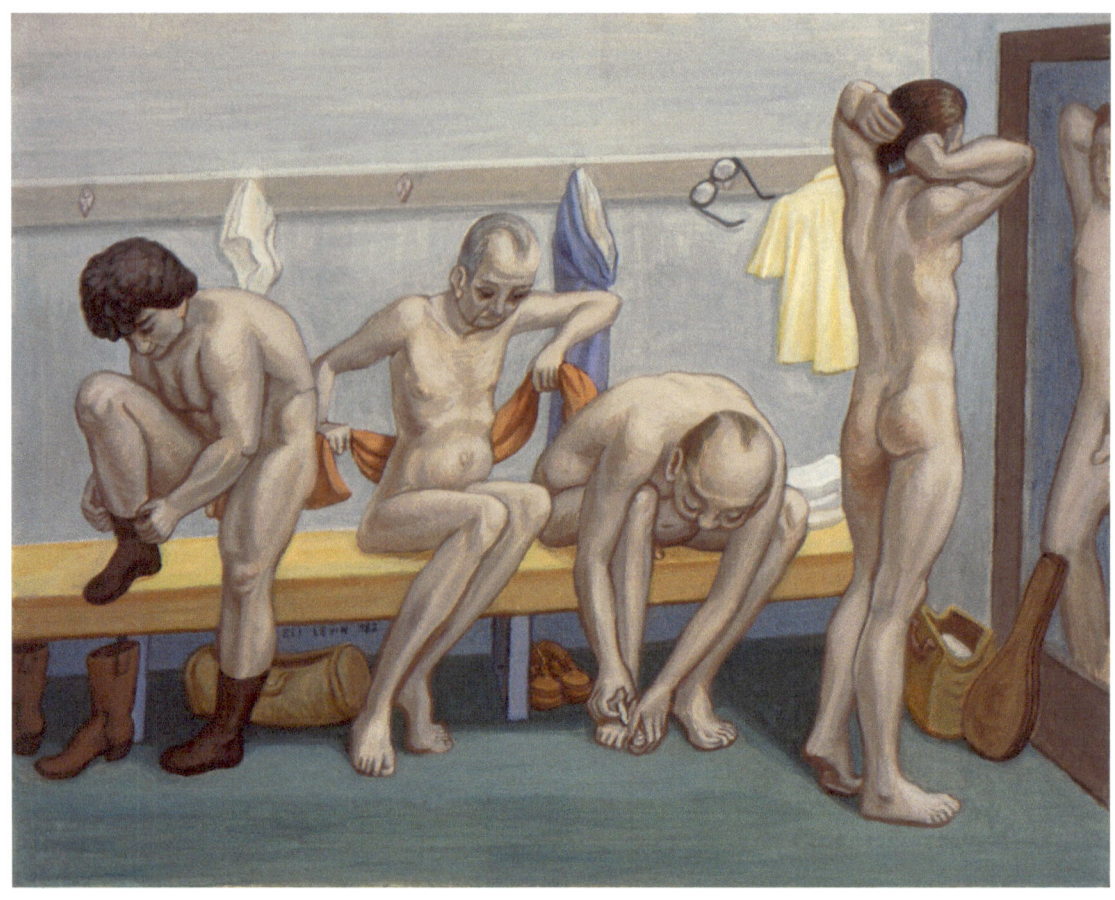

Men's Dressing Room, 1982, egg tempera, 16 x 20 in.

This was done before *Women's Dressing Room* (facing page) and was inspired by the changing room at the gym where I worked out. A 1930s oil by Paul Cadmus of a men's locker room was a reference, though there's a lot more going on in his version.

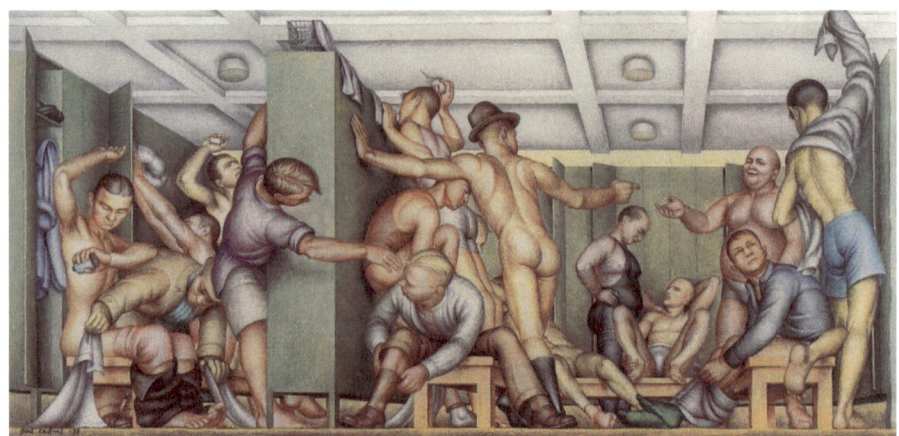

YMCA Locker Room, Paul Cadmus, c. 1933, oil

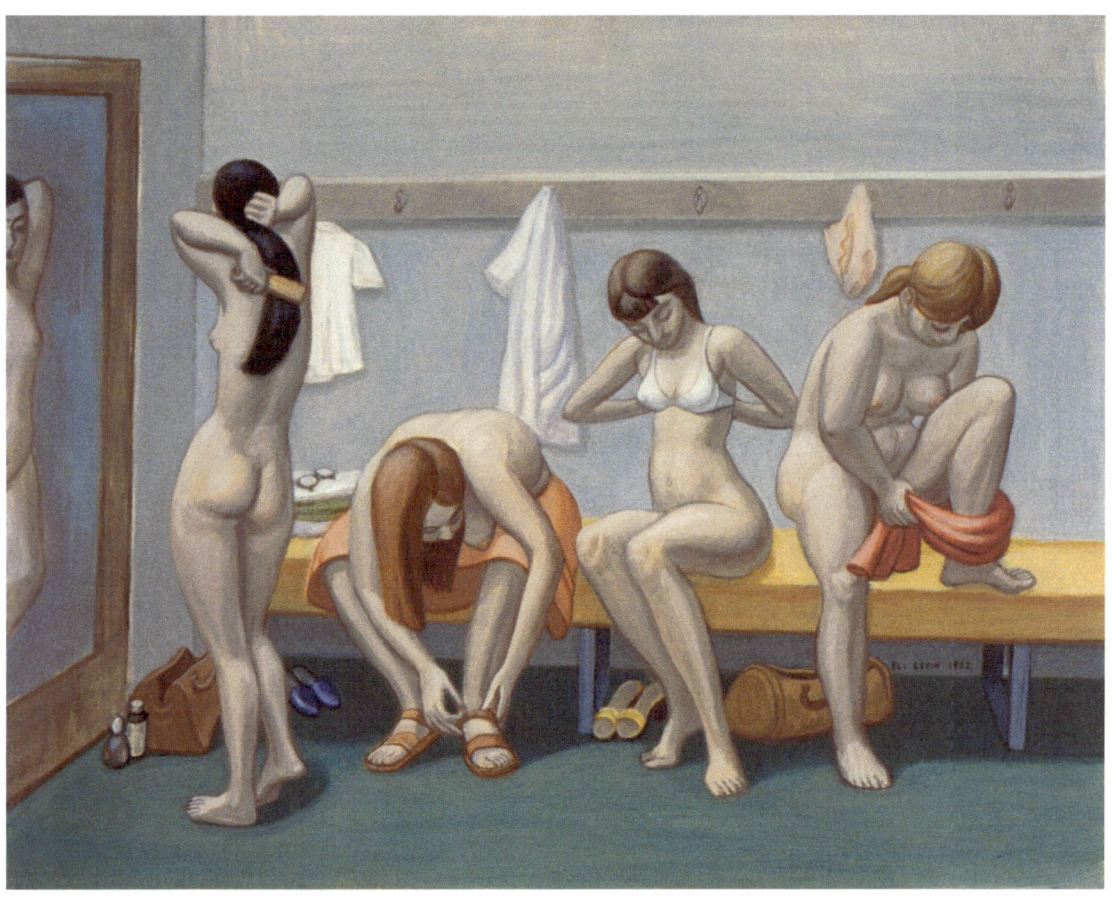

Women's Dressing Room, 1982, egg tempera, 16 x 20 in.

At the same gym, which is no longer open, there was a peephole in the locked door between the changing rooms. The peephole was plugged up, so I used my imagination. Some years later, the two pictures were hung in the appropriate locker rooms of another gym. At some point, a staff member reversed the paintings.

III. Nudes from Life

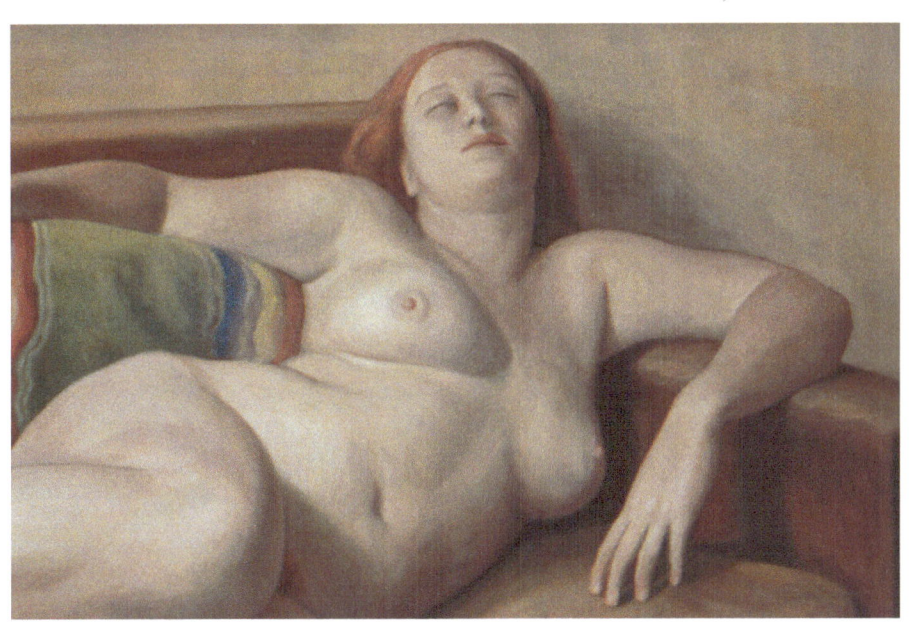

Throughout my career, I've enjoyed painting still lifes. I first thought that posing a live model would be somewhat like setting up objects on a table and depicting them. Believe me, the models are a lot more complicated. There is the intricacy of the human form, the subtle shifting of the pose and perhaps even its untenability, the complicated posing schedules, and—most daunting—the personalities of the models.

The sexual aspect of painting private models is also an issue. During the years that I portrayed single nudes, I chose to paint attractive young women. We were confronting each other in the intimacy of my studio. A painting took about thirty hours. Most, but not all, of the models returned to pose for three or four paintings. Along with developing friendships, there was the sensuality of the situation. This was inherent in translating the models' bodies into paintings. Some of the models even said they too felt a sensuality in being gazed upon. This potential awkwardness was augmented because I was paying for their compliance; fifteen dollars an hour, at an average of four hundred and fifty dollars per painting. Suppressing emotional and sensual reactions to the models, I maintained at least a modicum of reserve. If tension built up, I found it difficult to concentrate on painting. It was hard enough struggling with the technical difficulties of painting: the light falling on the skin, the anatomy, the foreshortening, the accessories, and the overall composition. What might have seemed to be a romantic situation to an outsider was fraught with anxiety.

I worried about the viewers' reactions to these carefully observed full-length portraits of nude women. Some responses were prurient. Still, many viewers were impressed, both with my elaborate egg-tempera technique and the close observation and naturalism of the nudes. Nevertheless, hoping to develop a more personally integrated ability to use my imagination, I eventually gave up painting nudes from life.

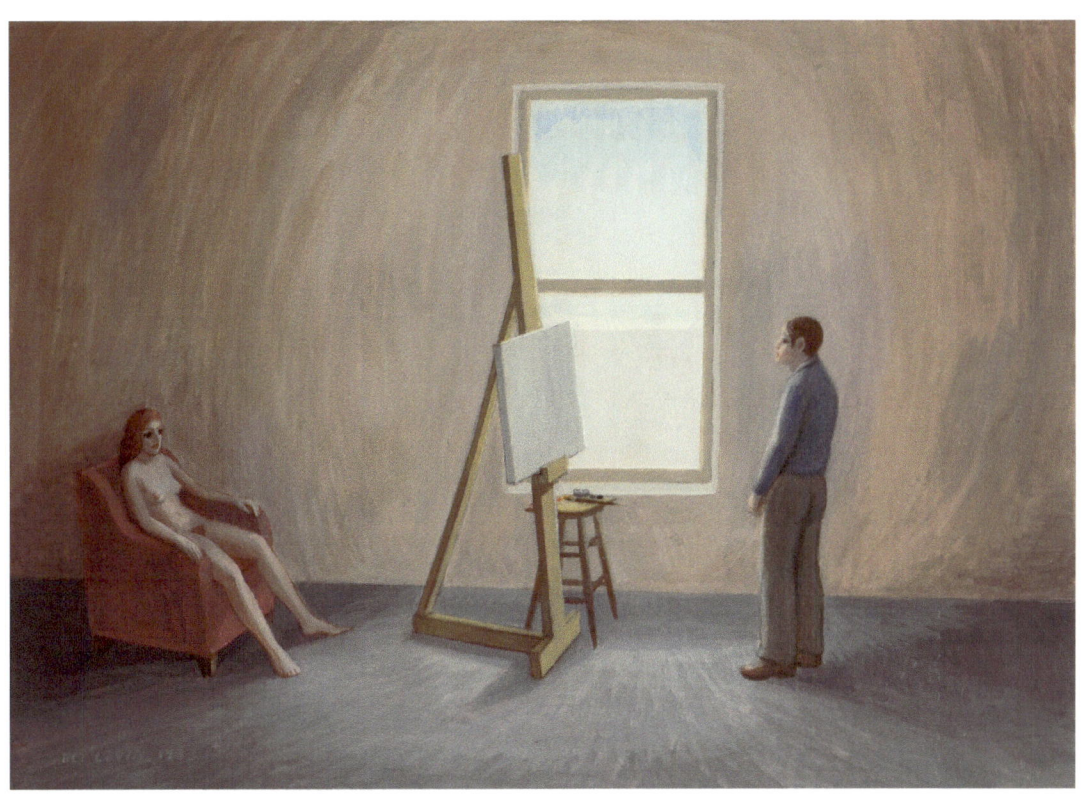

Artist and Model, 1982, egg tempera, 12 x 16 in.

This painting is related to an early Rembrandt of a similar subject, featuring the artist in the background facing a large canvas on a triangular easel. Rembrandt's painting is dramatic while mine is calm.

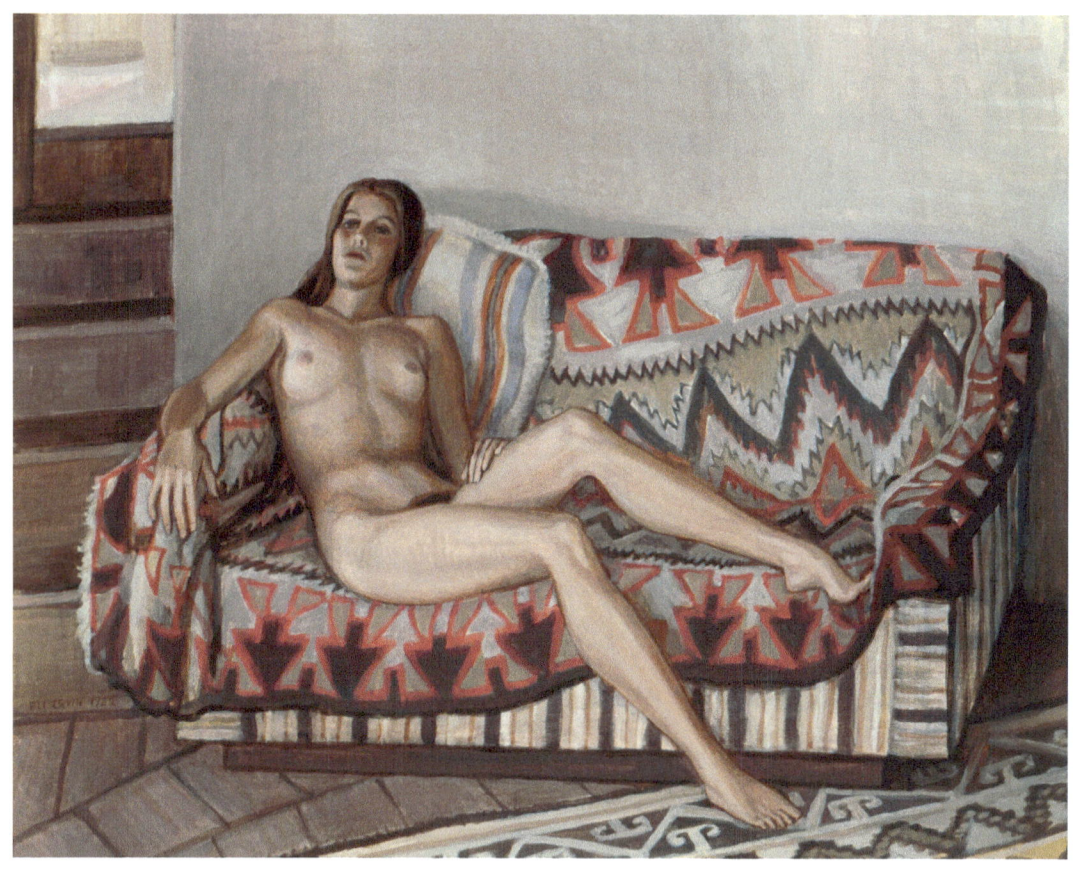

Elisabeth, 1982, egg tempera, 16 x 20 in.

This early nude of an elegant, tall model was painted in my studio loft. The steps in the painting lead to the upstairs apartment, the last room I built onto my house. A very ugly couch is hidden under a Mexican blanket.

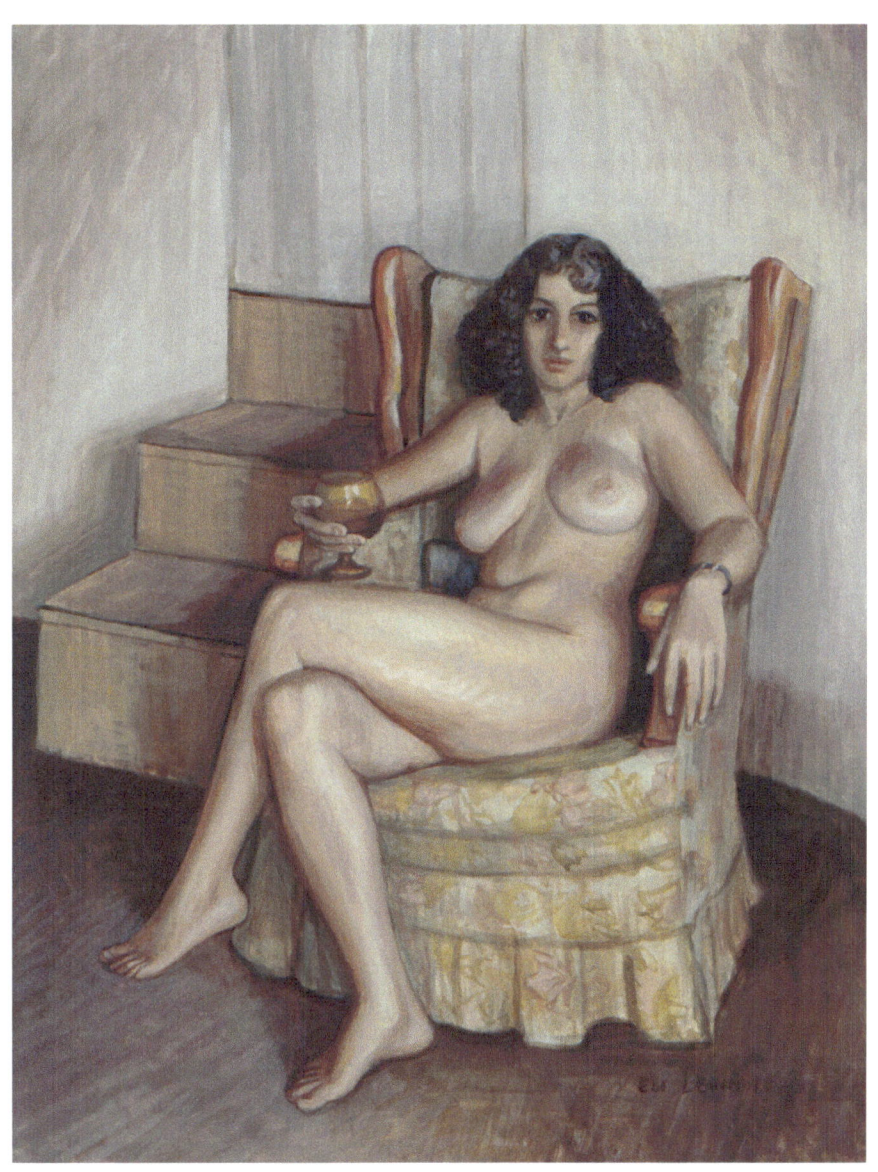

Michelle, 1984, egg tempera, 24 x 18 in.

This model was a flamboyant young Jewish woman, who I met in Santa Fe and later encountered in Israel, then in Santa Fe again. She finally married an Orthodox klezmer musician, migrated to Israel, and had many children.

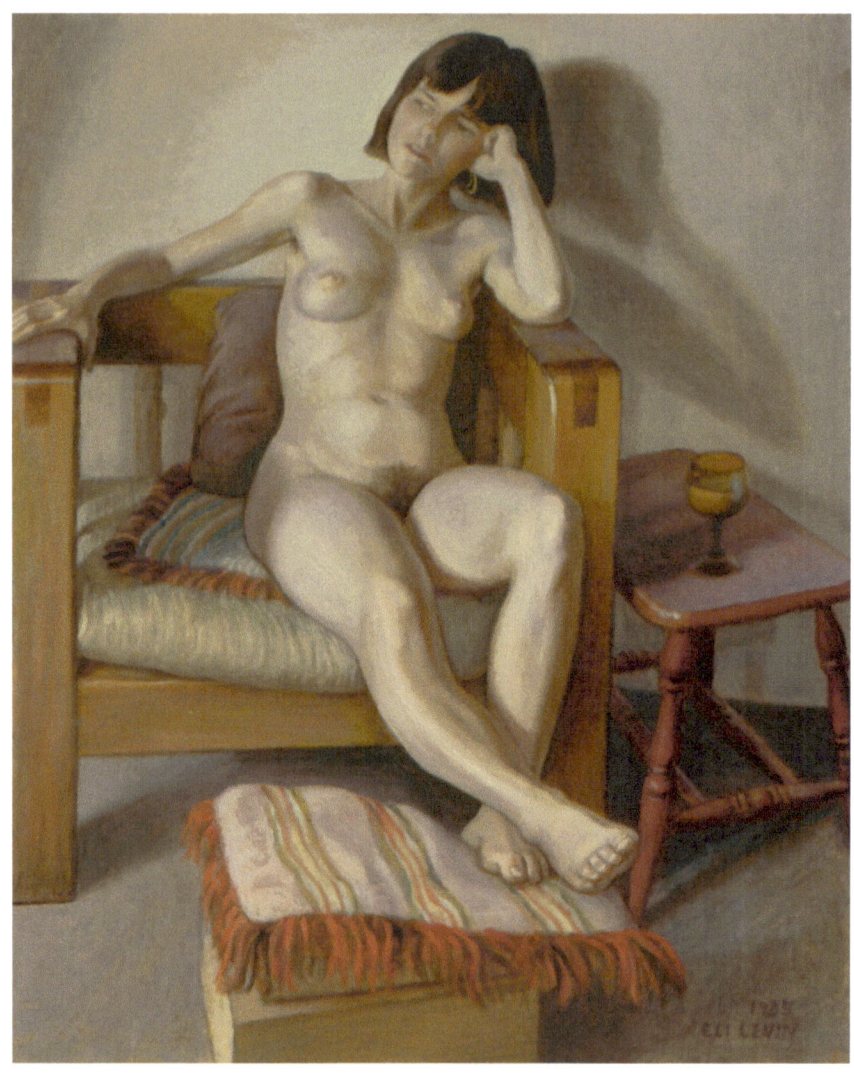

Pam (large version), 1985, oil, 20 x 16 in.

Gary Faigin and I painted his wife, Pam, in my studio. Sometime after she finished posing for us, I invited Gary to join me in painting Jessica, the fourteen-year-old daughter of two artists I knew. I had already done my first painting of her, and I was about to start another (pp. 106-107). Gary did join me, but Pam came and dragged him away. She later set off an acrimonious controversy by writing and publishing an article attacking Gary and me for painting a fourteen-year-old model. The article appeared in the journal published by the art school that Gary and Pam had established.

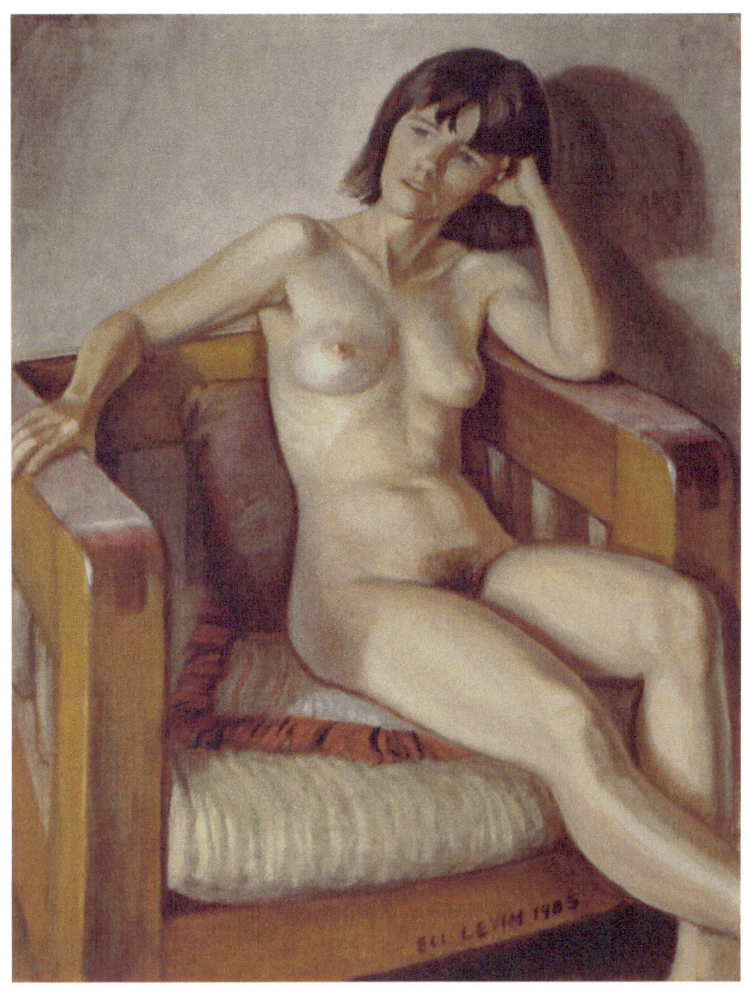

Pam (small version), 1985, oil, 16 x 12 in.

Gary took longer to paint than I did, so I shifted my position slightly and did a second version, which was smaller than the first. Unlike most of my nudes from life, these portraits of Pam are oils.

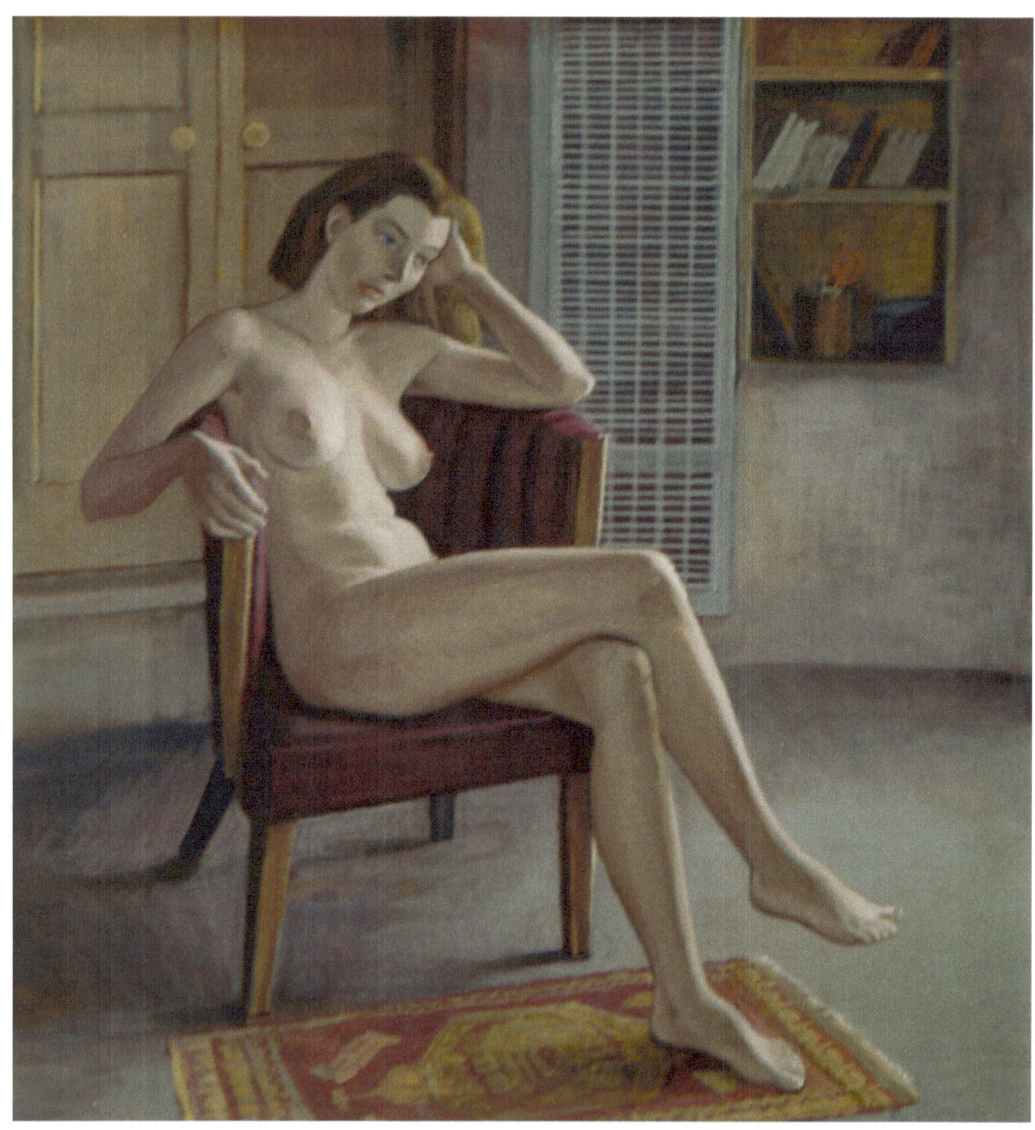

Carmen Lopez, 1992, egg tempera, 26 x 24 in.

Carmen was one of the first models in this series. She seemed bored or maybe uncomfortable, and she stopped posing. I usually work the whole painting at once, but I had to finish the background without her.

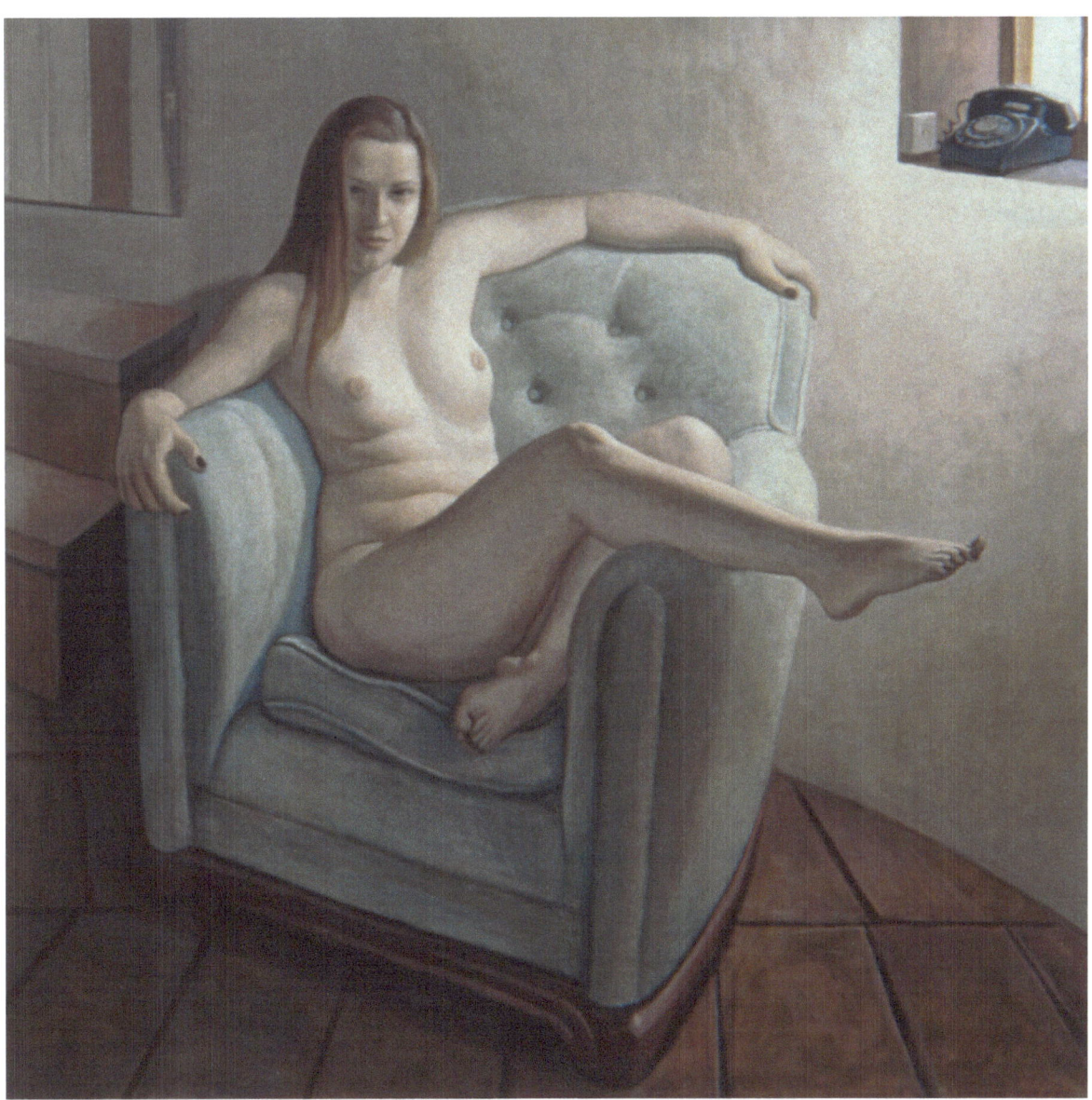

Adele, 1995, egg tempera, 30 x 30 in.

Adele modeled for my drawing group, often together with her mother, Glenda. They had no car; sometimes, when they had no ride, I picked them up at their assisted-living apartment. Glenda's closet was piled high with her journals, and the rest of the rundown apartment was full of Adele's autobiographical comic books. I bought several of these from Adele, and I'm even in one.

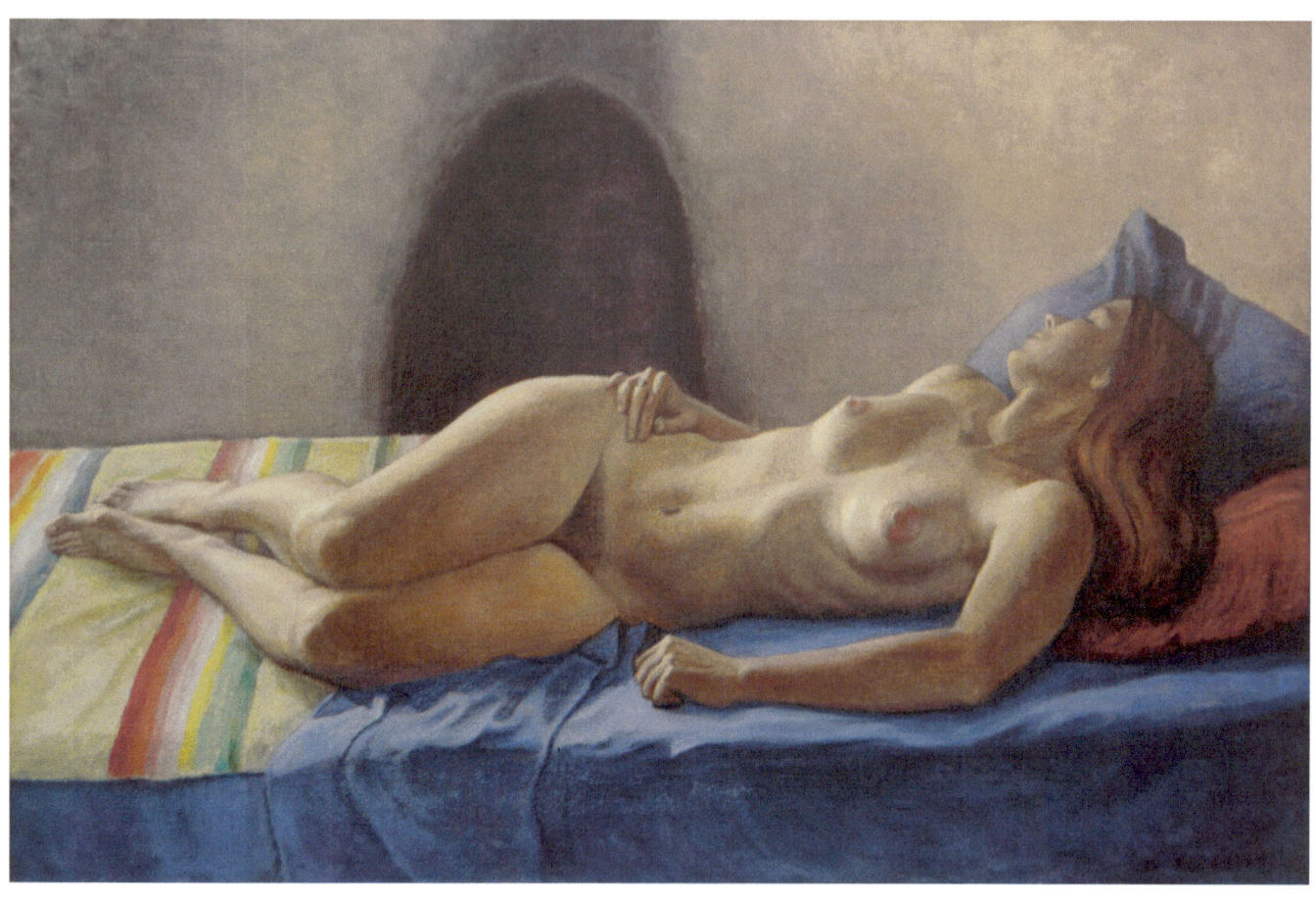

Sami Reclining, 1990, oil, 24 x 36 in.

This time, I managed to paint an oil of a real nude and a real kiva fireplace, which I built myself (witness the smoke stains). I wish I'd included a fire going, like in the imaginary versions, but it was summertime.

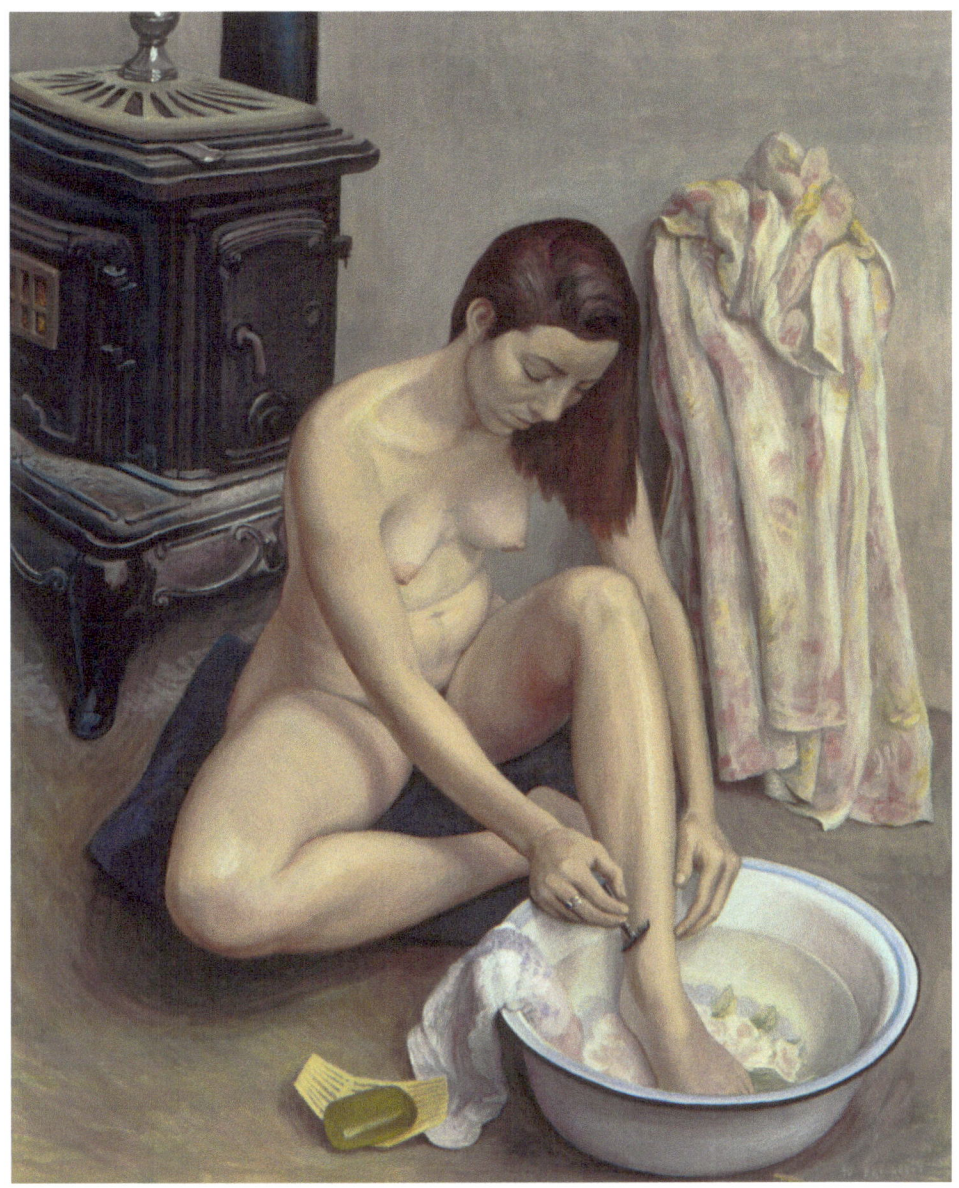

Sami Shaving Her Leg, 1990, egg tempera, 30 x 24 in.

Sami, who was my girlfriend at the time, insisted on this pose. She even went out and bought the basin. It was an awkward but endearing arrangement, and the pose turned out to be difficult for her to hold. I still have that basin, but Sami is married and living in Massachusetts.

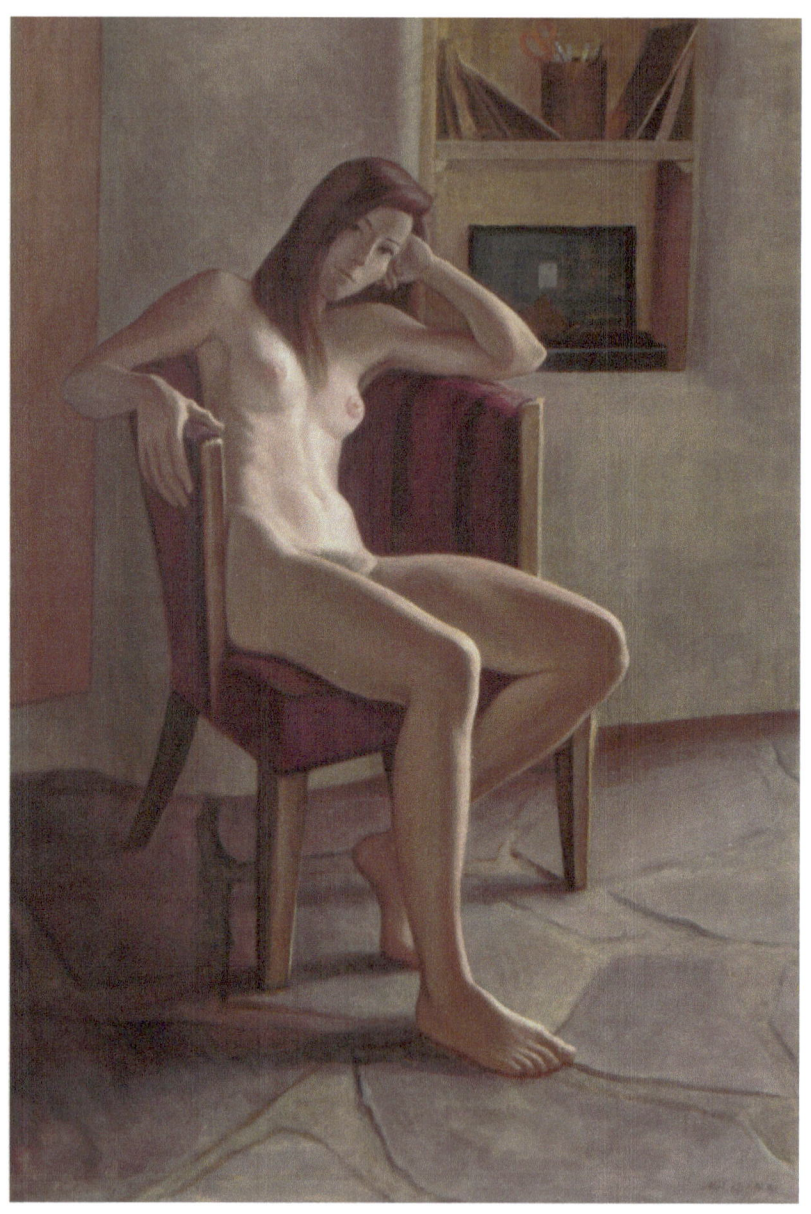

Sami in Chair, 1991, egg tempera, 30 x 20 in.

This took place in the same corner of the studio, with the same chair, in almost the same position as Carmen's (p. 94). Sami fit the chair better.

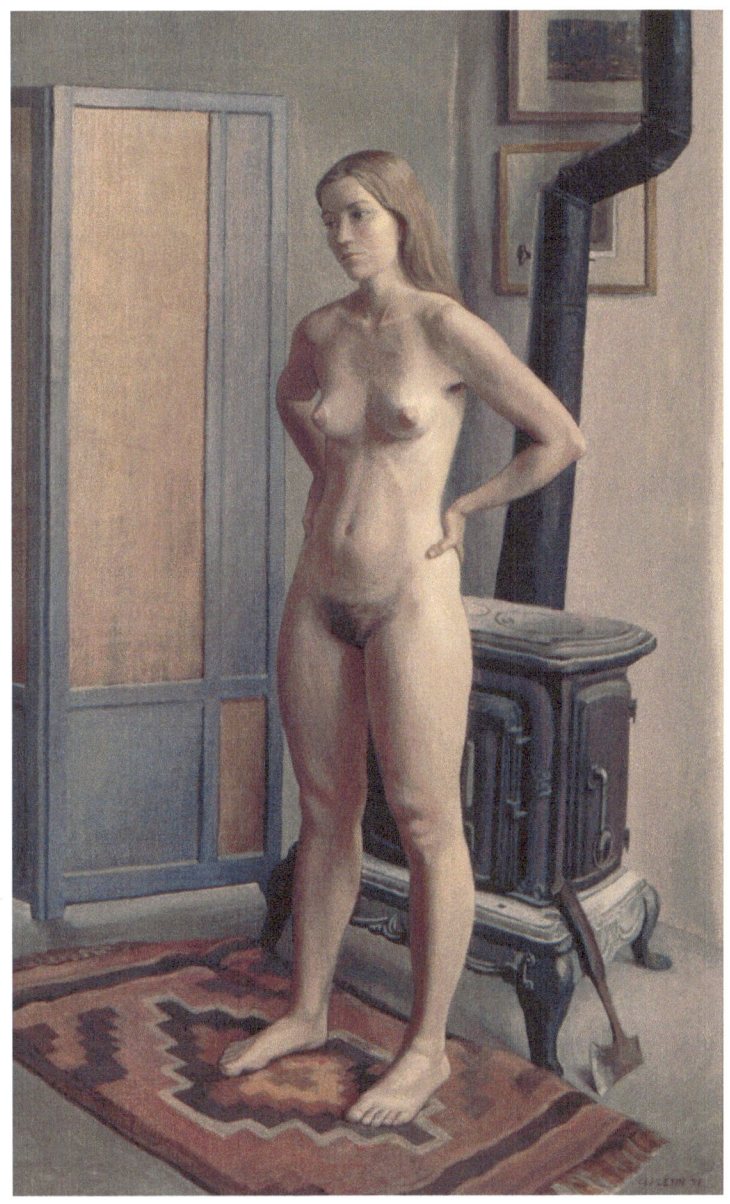

Sami and Stove, 1991, egg tempera, 30 x 18 in.

Here's a real-life version of a subject I often made up. The hatchet is a disconcerting touch. The screen came from the estate of the artist Gustave Baumann and was constructed and painted by him. Unfortunately, Sami repainted it. Adding injury to insult, Gary's and Pam's art school borrowed the screen and it fell off the roof of their car.

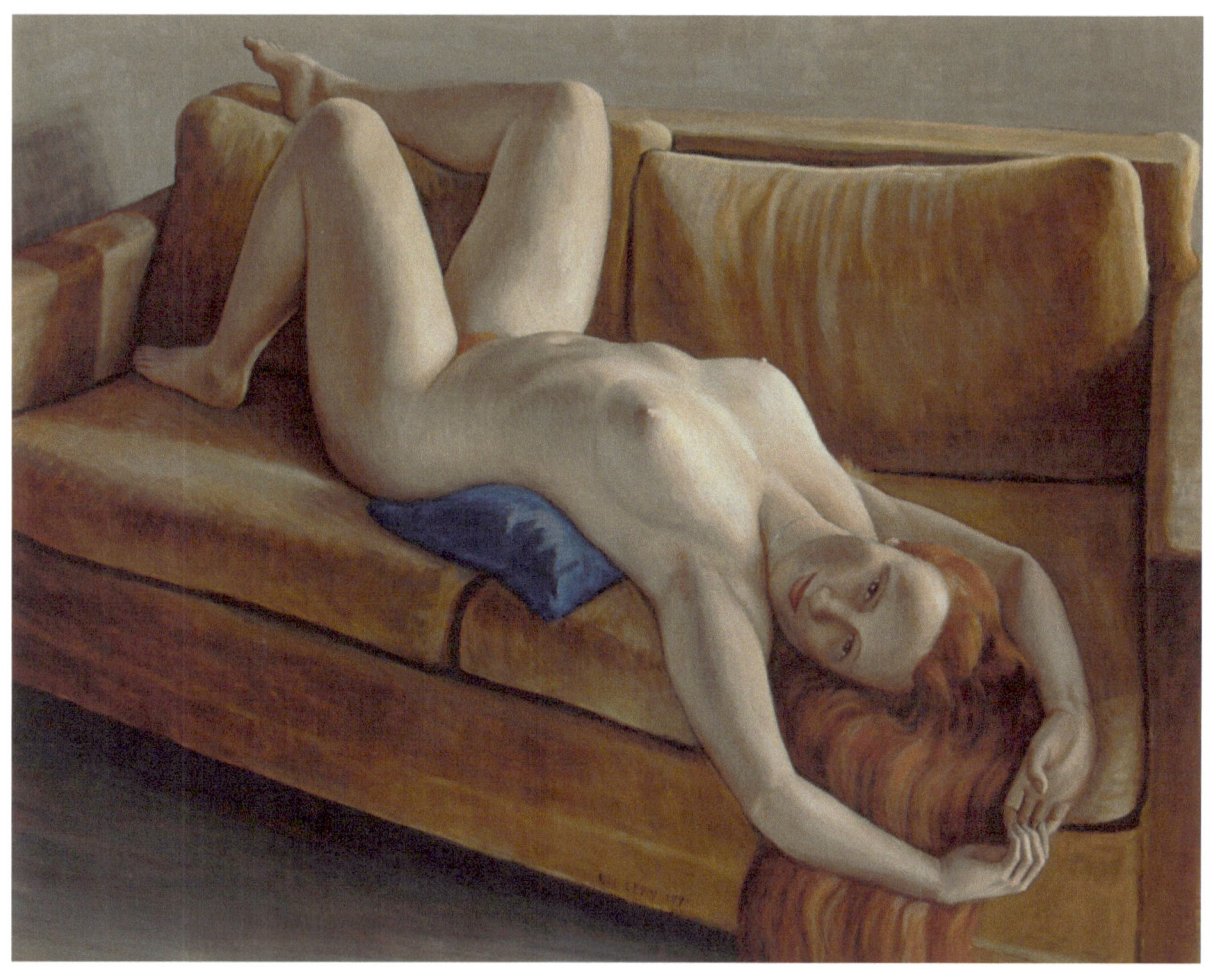

Mia Reclining, 1991, egg tempera, 24 x 30 in.

This pose was chosen by Mia, the little minx. Though the pose was painful to hold, especially the hands, she persevered and loved the result.

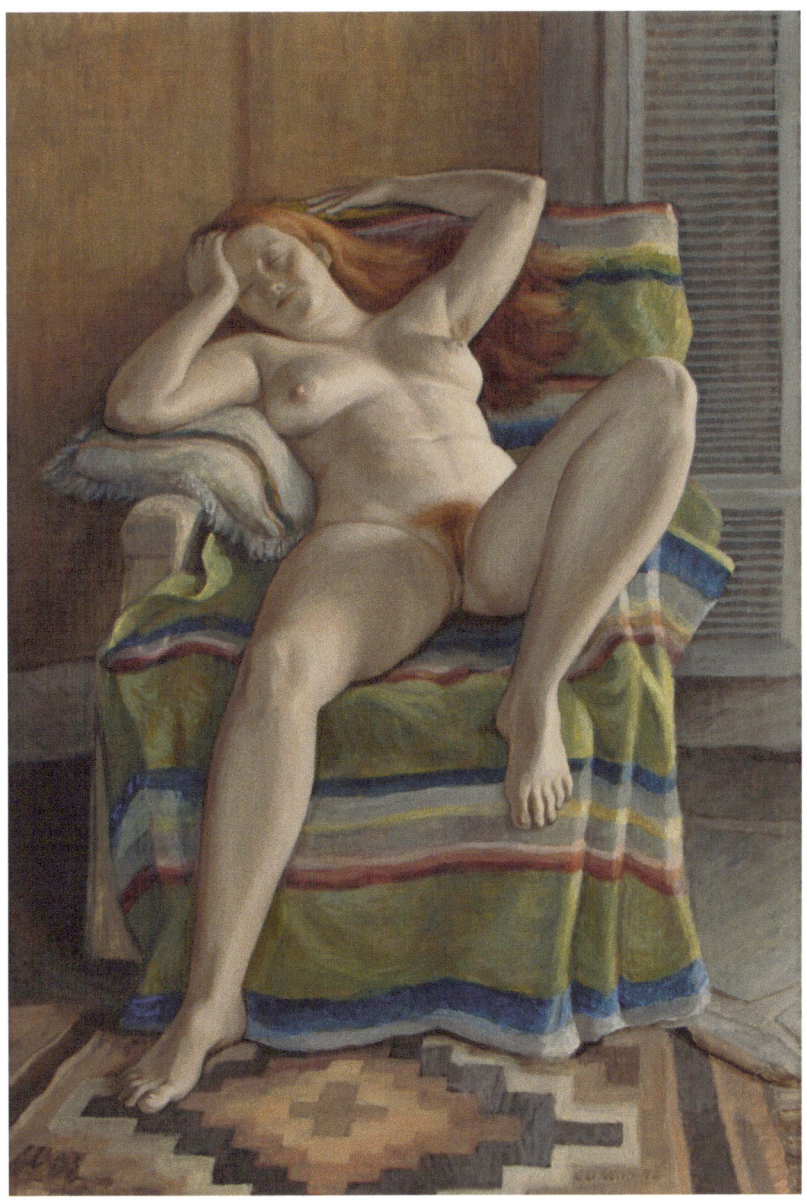

Mia in Chair, 1992, egg tempera, 30 x 20 in.

One of my favorites, this painting has had a difficult history, having been rejected four times. First, Martha Mayer Erlebacher, a well-known painter of nudes, was going to buy it but changed her mind. Then, the Las Vegas Art Museum censored this portrait from my retrospective, the only reject out of more than one hundred paintings. My patron, Dr. Robert Bell, bought more than twenty of my nudes but later asked to trade this one back, as it bothered his wife. Finally, a wealthy amateur artist in my drawing group put a deposit on the painting, but his check bounced. He claimed his wife had emptied his account. He bounced another check, then wanted his deposit back. I kicked him out of the group.

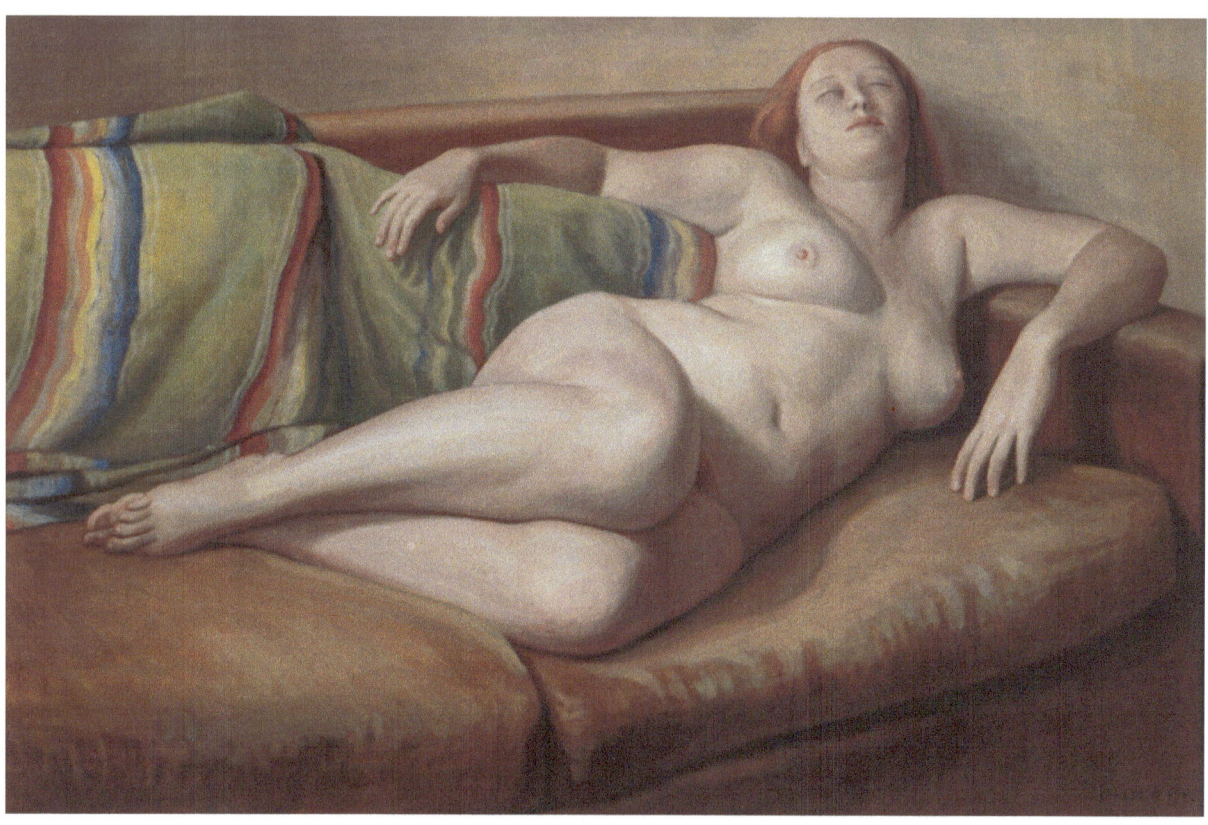

Plump Mia, 1992, egg tempera, 20 x 30 in.

In this last version of Mia, rather Titianesque, the egg-tempera medium works well in depicting skin and fabric.

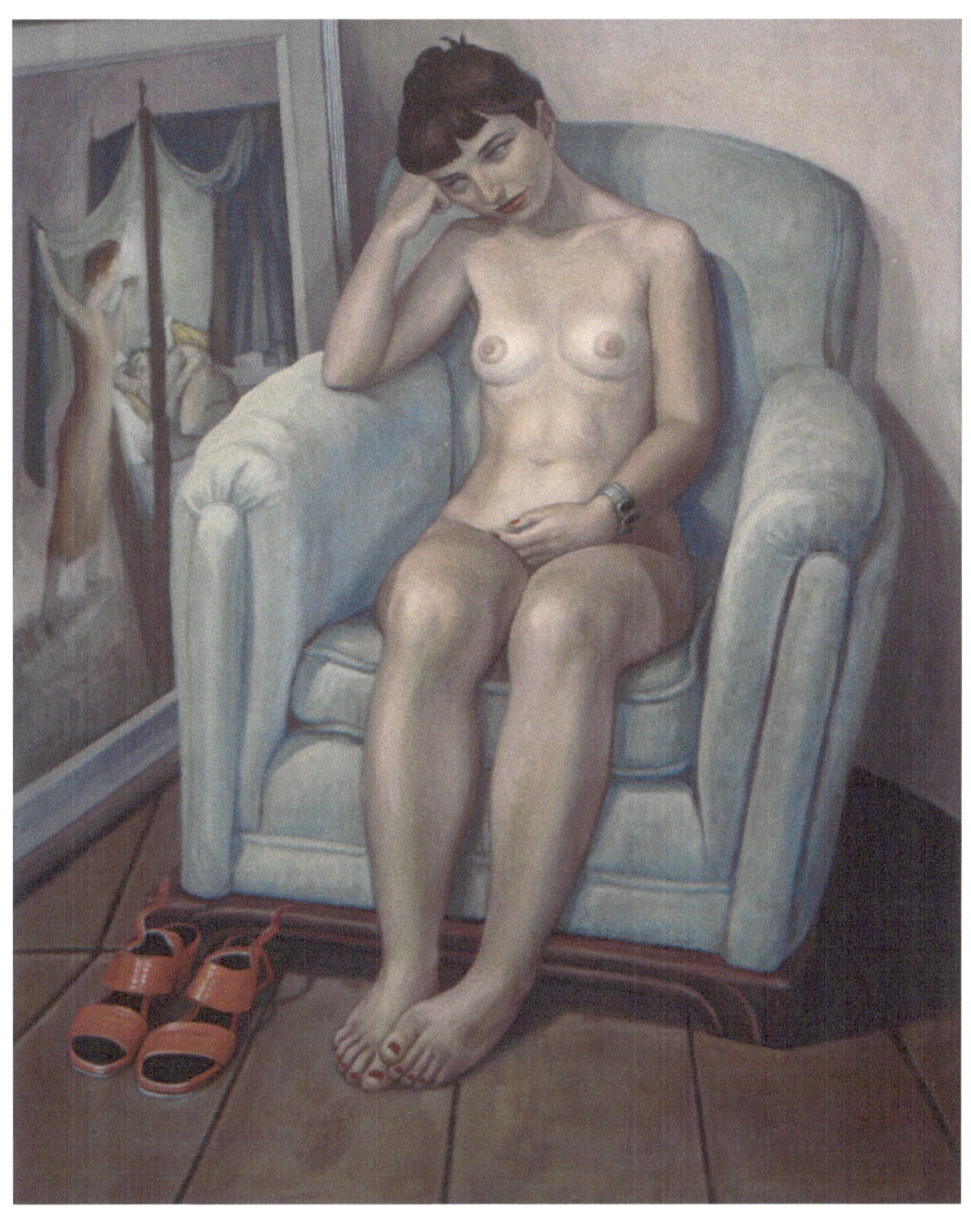

Lake in Green Chair, 1995, egg tempera, 30 x 24 in.

This is the same chair that Adele used (p. 95), but Lake took a more decorous pose. Behind her is one of my paintings titled *Psyche Discovers Cupid*, a second version of the subject on p. 120.

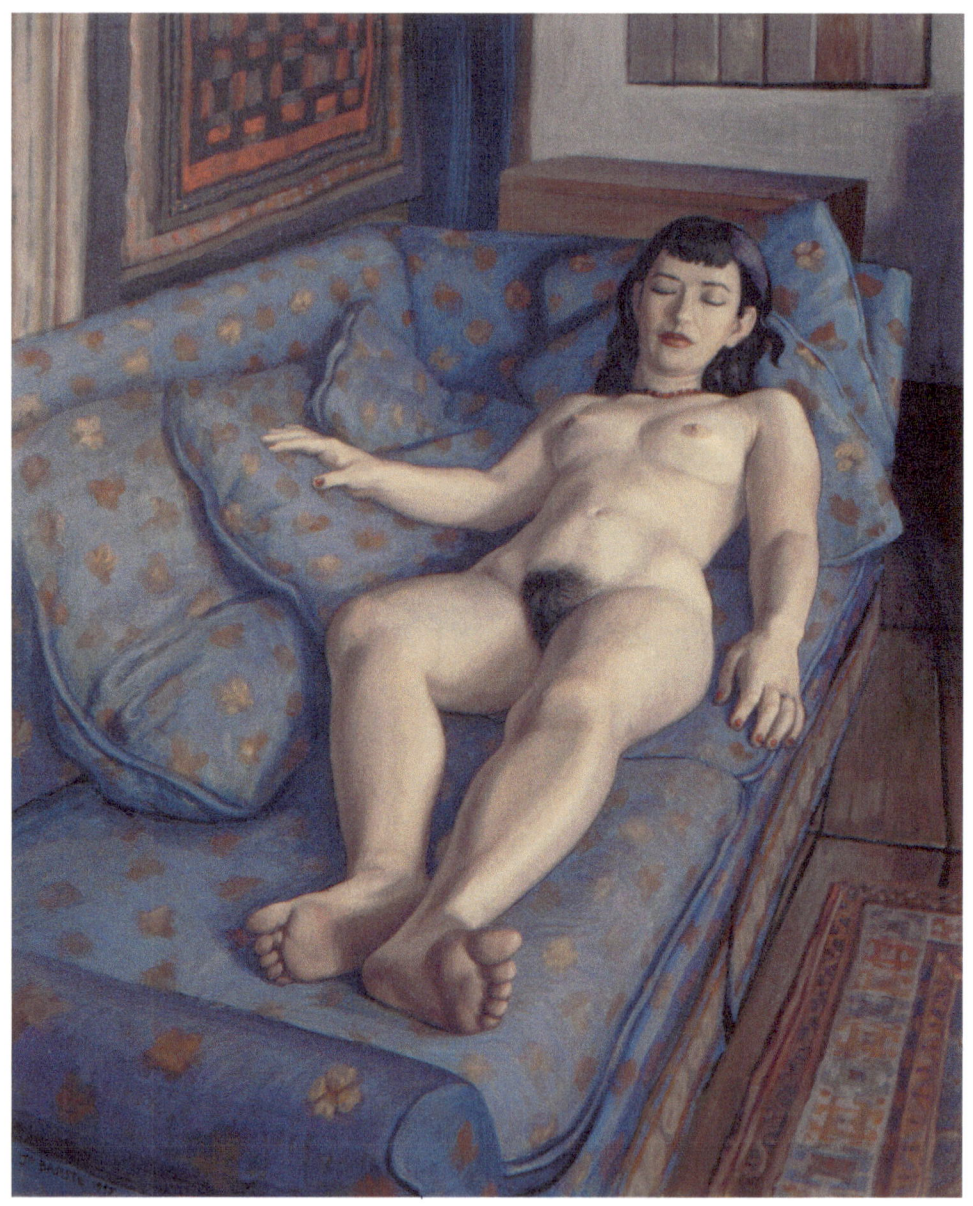

Lake, Eyes Closed, 1995, egg tempera, 30 x 24 in.

Lake modeled five times. Here, she is wearing a band around her neck, like Manet's Olympia. Lake seems rather peacefully resting, as I'd intended—hardly confrontational as with Manet's model.

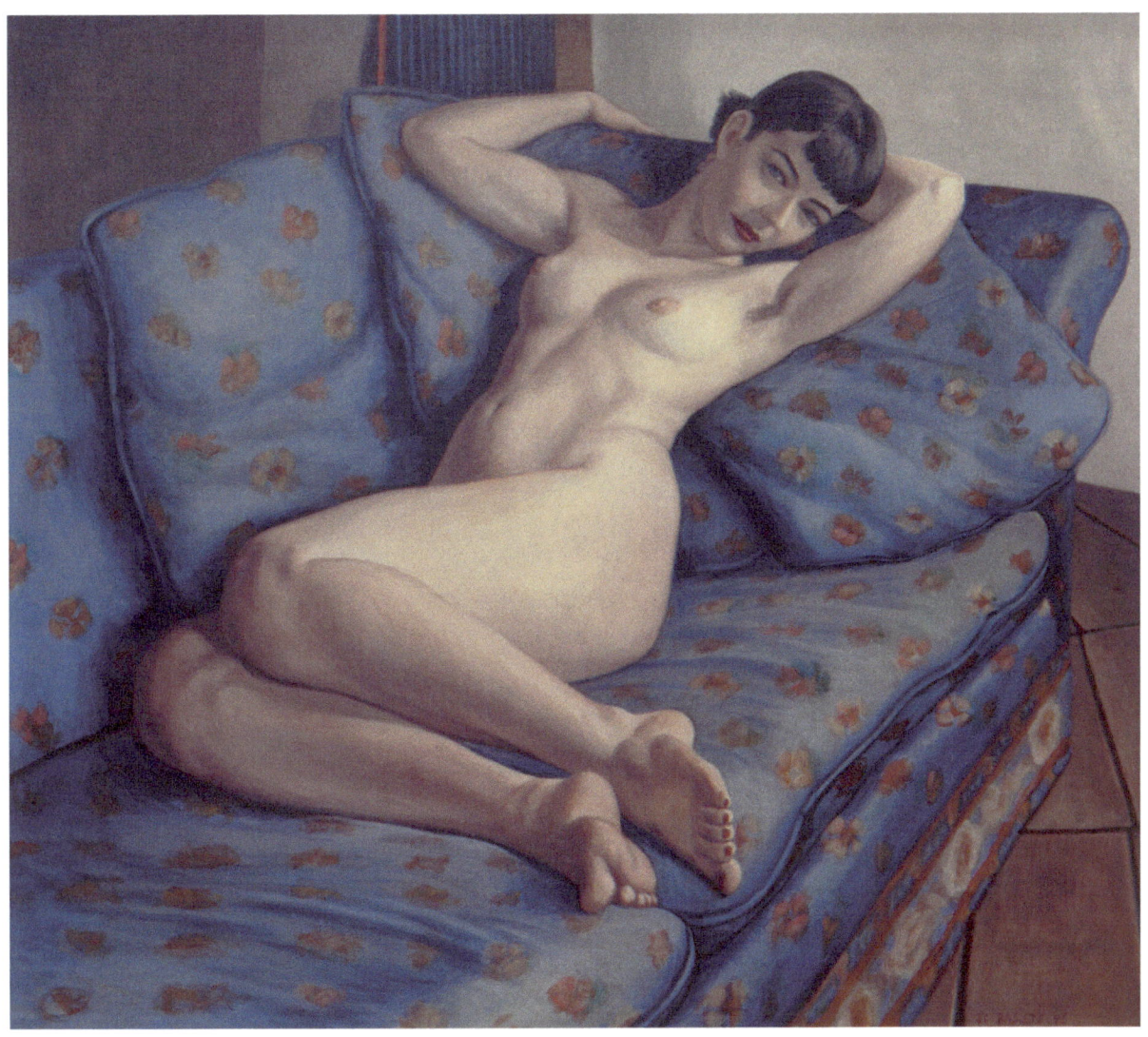

Lake, Eyes Open, 1995, egg tempera, 27 x 30 in.
This painting has a different feeling from that in the eyes-closed version; Lake is aware and in control.

105

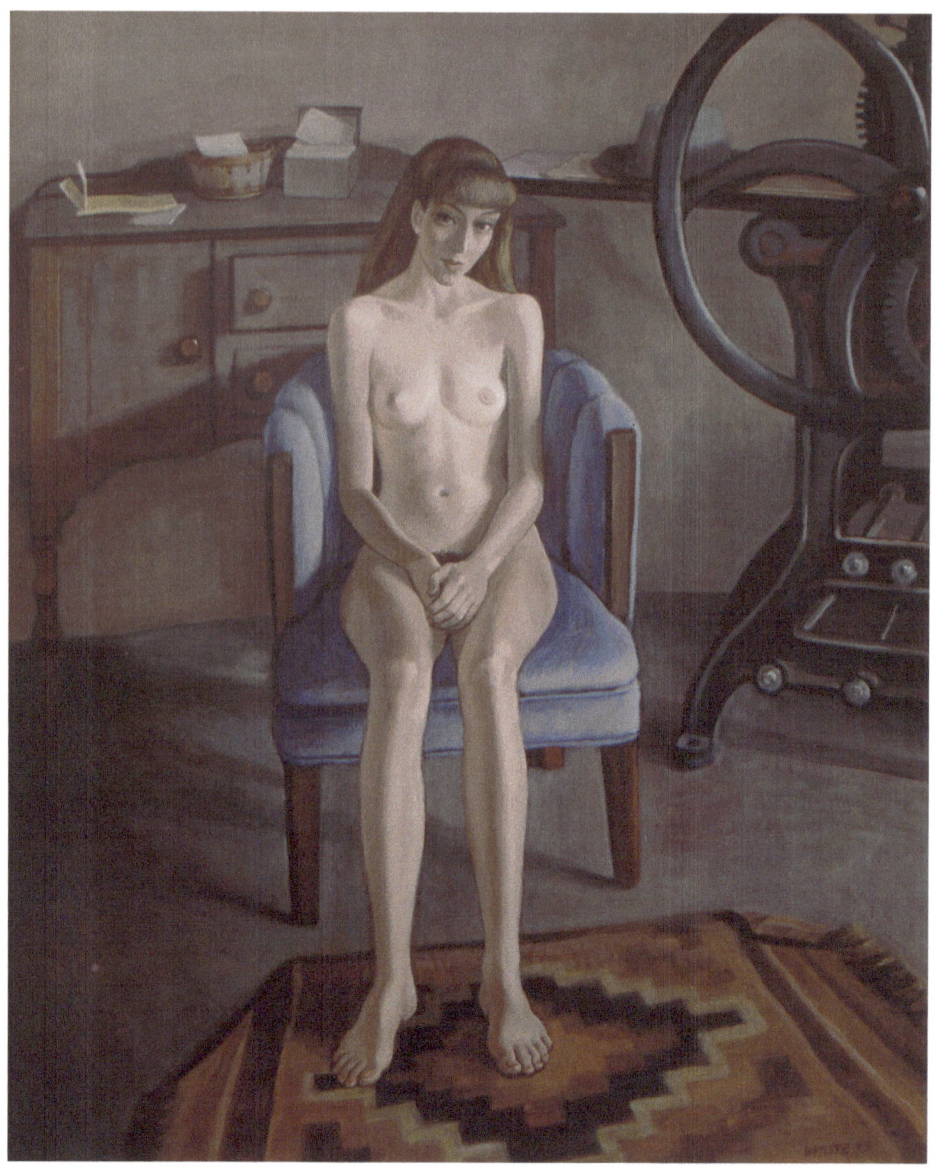

Fourteen Years Old, 1993, egg tempera, 30 x 24 in.

Jessica wanted to buy designer clothes for high school. Her parents, both artists, suggested that Jessica model. As she was so young, I got the idea of painting a variation of Edvard Munch's *Puberty*.

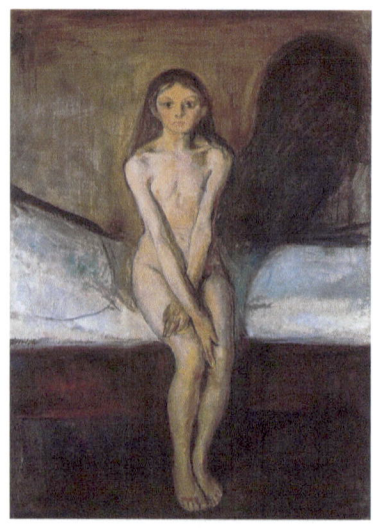

Puberty, Edvard Munch, c. 1894–95, oil

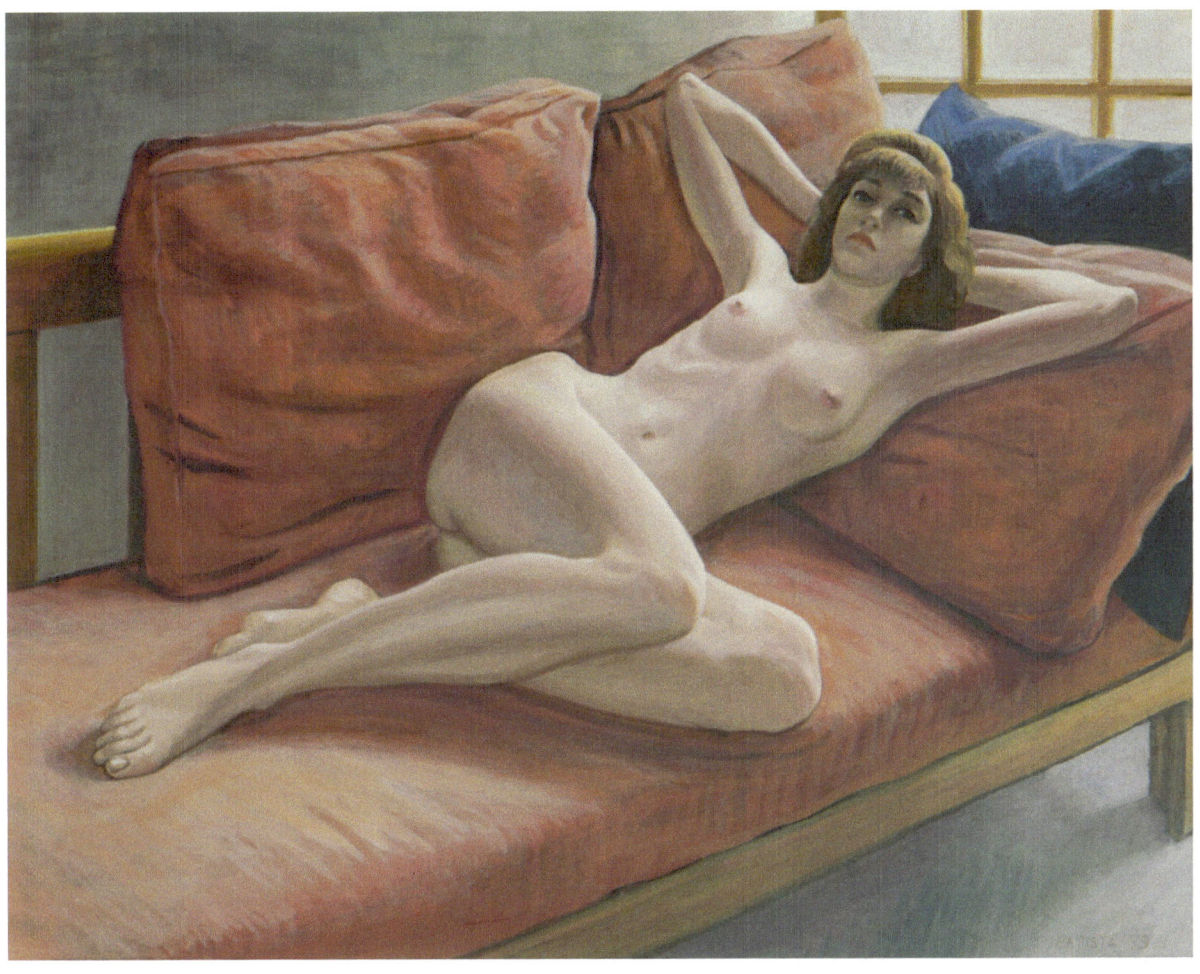

Jessica (second version), 1993, egg tempera, 24 x 30 in.

Jessica picked this pose; it is less awkward than the first one. She seems older, though I did this painting right after the other one. It is interesting how similar this pose is to the one Lake chose (p. 90).

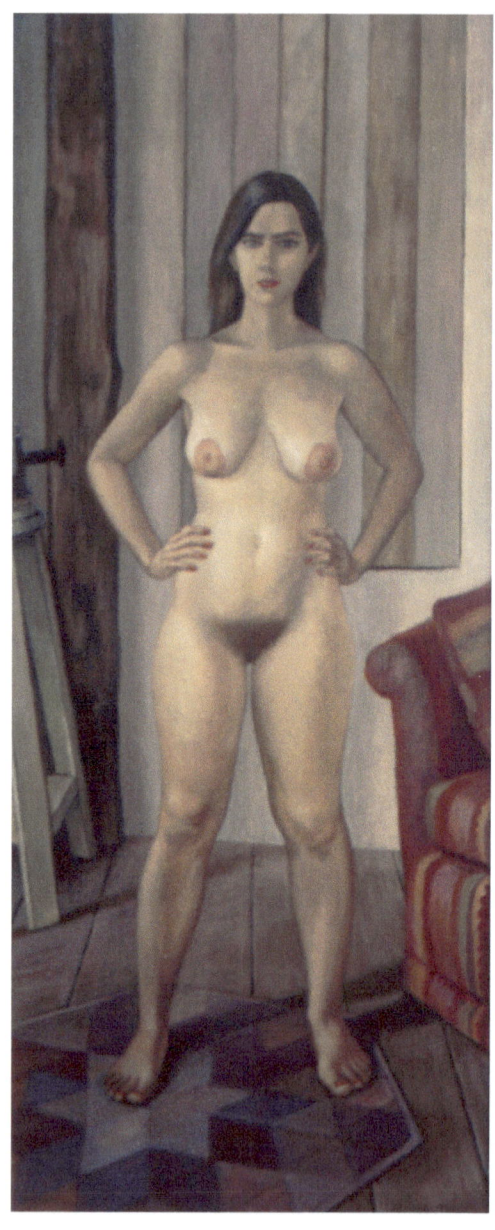

Christy, 1995, egg tempera, 30 x 12 in.

Christy and her husband, both artistic craftspeople, commissioned this nude portrait. She insisted on the confrontational pose.

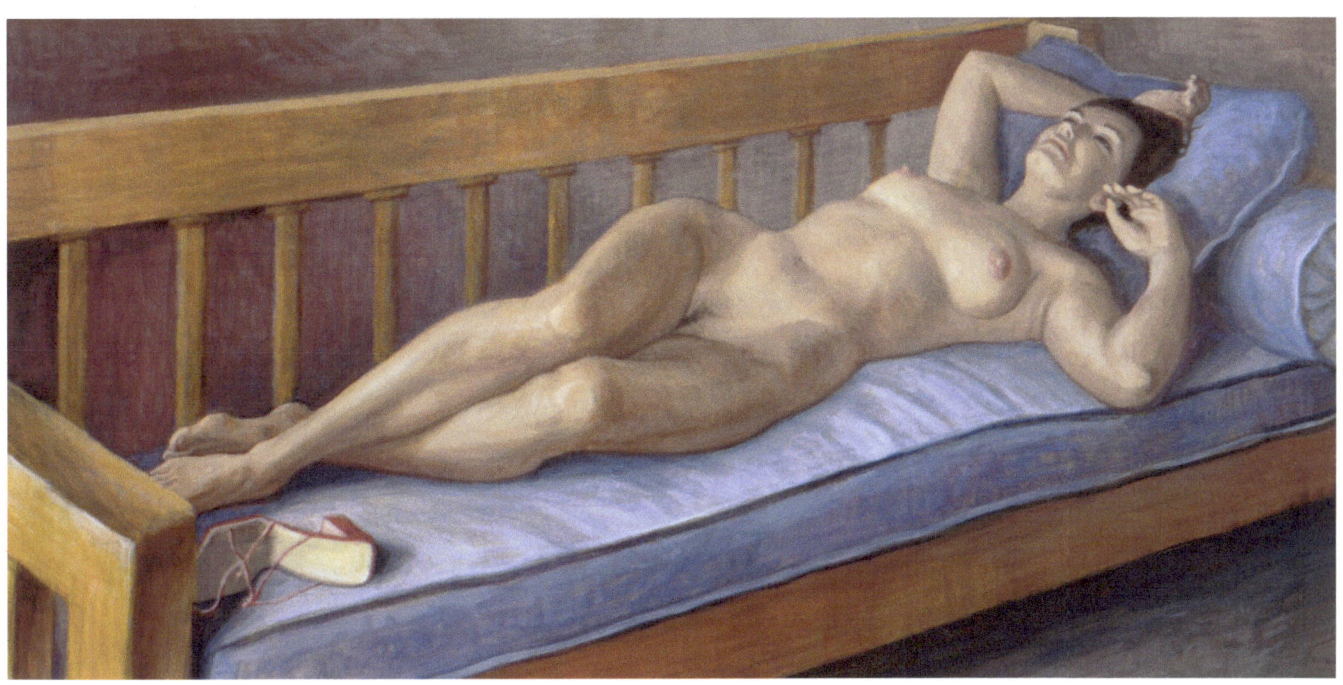

Elena, 2001, oil, 18 x 36 in.

I sold my house and studio in Santa Fe and moved to my place on the Embudo River, where I built a smaller adobe house and studio. I painted this portrait in oil, the others in oil being the paintings *Pam* (pp. 92-93) and *Sami Reclining* (p. 96). *Elena* is the painting I traded with the collector who wanted to return *Mia in Chair* (p. 101).

IV. Myths

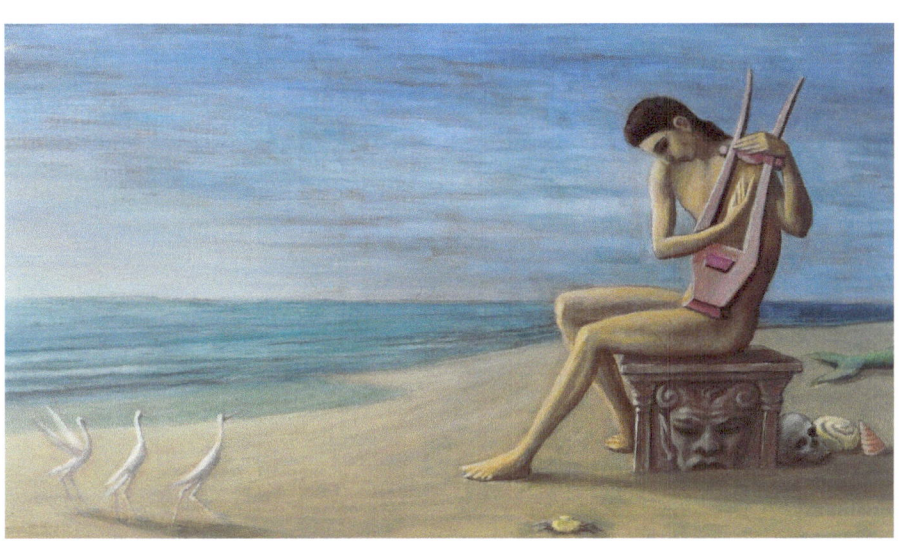

From 1993 to 2001, I painted Greek and Roman myths. Taking the name of my paternal grandfather, from the old country, I signed the mythological paintings Jo Basiste. Before this change of name and style, I had taken a graduate program at St. John's College, which consisted of seminars discussing great books of the Western tradition. We started with Homer and Plato, who incorporated some mythology in their writings. Unfortunately, the myths in themselves were not considered as part of the core curriculum. Even Ovid's *Metamorphoses*, the greatest poetic compilation of myths, did not make the great books list.

Great books got me thinking about great painters—masters who painted nudes with intriguing narratives. Mythological subjects were common in these artists' paintings and were even more prevalent in early engravings done for private perusal, away from the inquisitorial eyes of Catholicism. The artists almost always found their subjects in Ovid's Metamorphoses, and so did I.

Though I had been painting in the social realist style, I also loved the early and middle Renaissance artists, as well as a variety of other painters who lived before the twentieth century. My mythological paintings were influenced by art from the following periods and movements: Renaissance, Mannerism, Baroque, Neoclassicism, Victorian, and Symbolism.

Why did I try to reinvent myself? The short answer is it was an identity crisis. Artistically, I hoped to remove myself even further from the mindset of modern art. For the old masters, historical painting was the highest category of art. Mythological and Christian imagery were the principal subjects. As I am an atheist, I chose myths.

I didn't have the ability or desire to depict fancy Greek and Roman clothing; heroes in dresses were off-putting. Nor did I want to paint myths in the guise of modernity, though this might have had greater appeal to contemporary taste.

I have tried to explain the subjects of my mythological paintings, only to observe the listener's eyes glazing over. The most appreciative viewers are often children and young people who have been reading myths and are full of curiosity.

As the twenty-first century came around, my rear-guard stance began to waver. During those eight years, my paintings were not exhibited, despite my attempts to find a dealer. When a gallery owner said she would take me on if I went back to painting bar scenes and signing my old name, I did. Eventually, the goodhearted owner began including some of my new paintings of nudes in bathrooms and bedrooms.

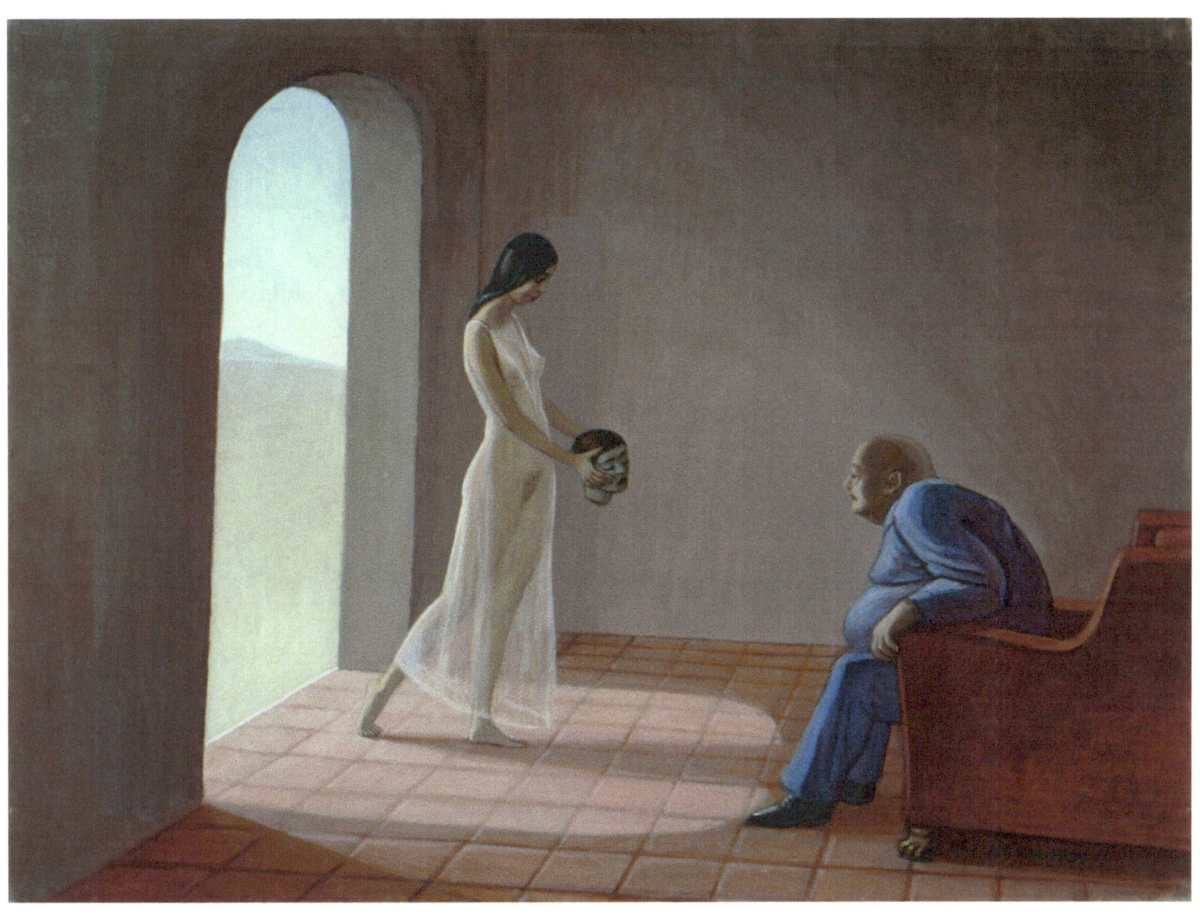

Salome, 1984–85, egg tempera, 18 x 24 in.

Done before I started the myth series, this is the only biblical subject I've painted. I have otherwise avoided the Old Testament and the New Testament. There's something of Sigmund Freud's (and perhaps my own) "family romance" in this painting.

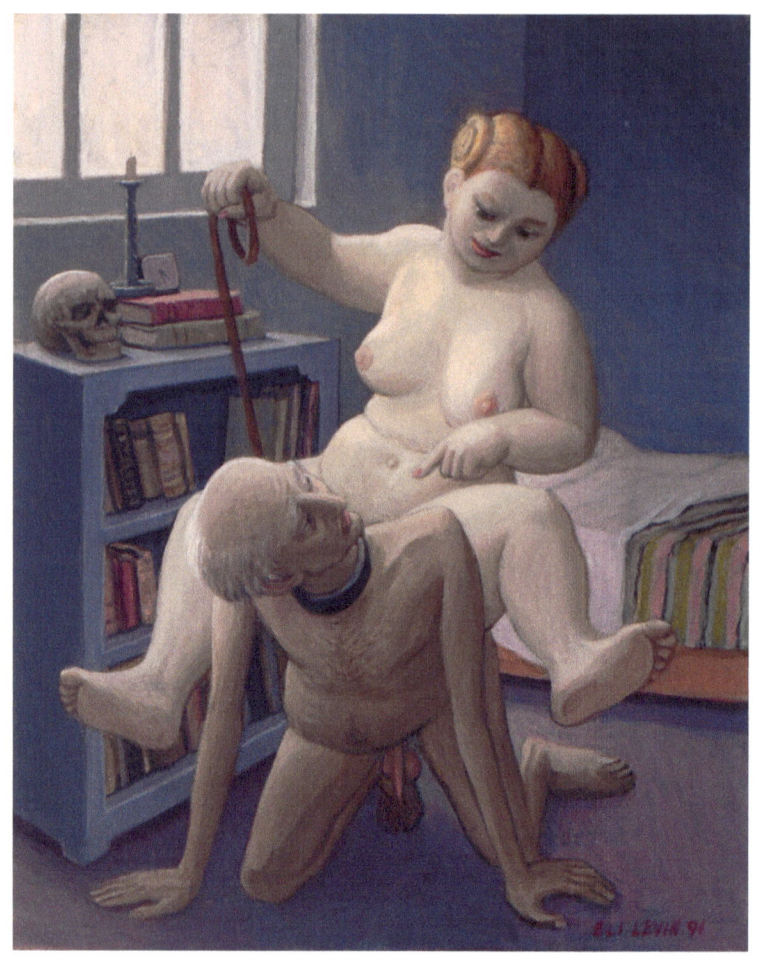

Aristotle and Phyllis, 1991, egg tempera, 14 x 11 in.

This is a contemporary take on the medieval myth illustrating body over mind, to which I've added a *memento mori* theme in the background.

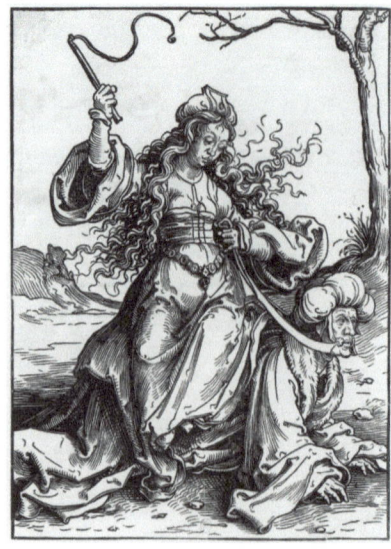

Aristotle Ridden by Phyllis, Lucas van Leyden, c. 1515, woodcut

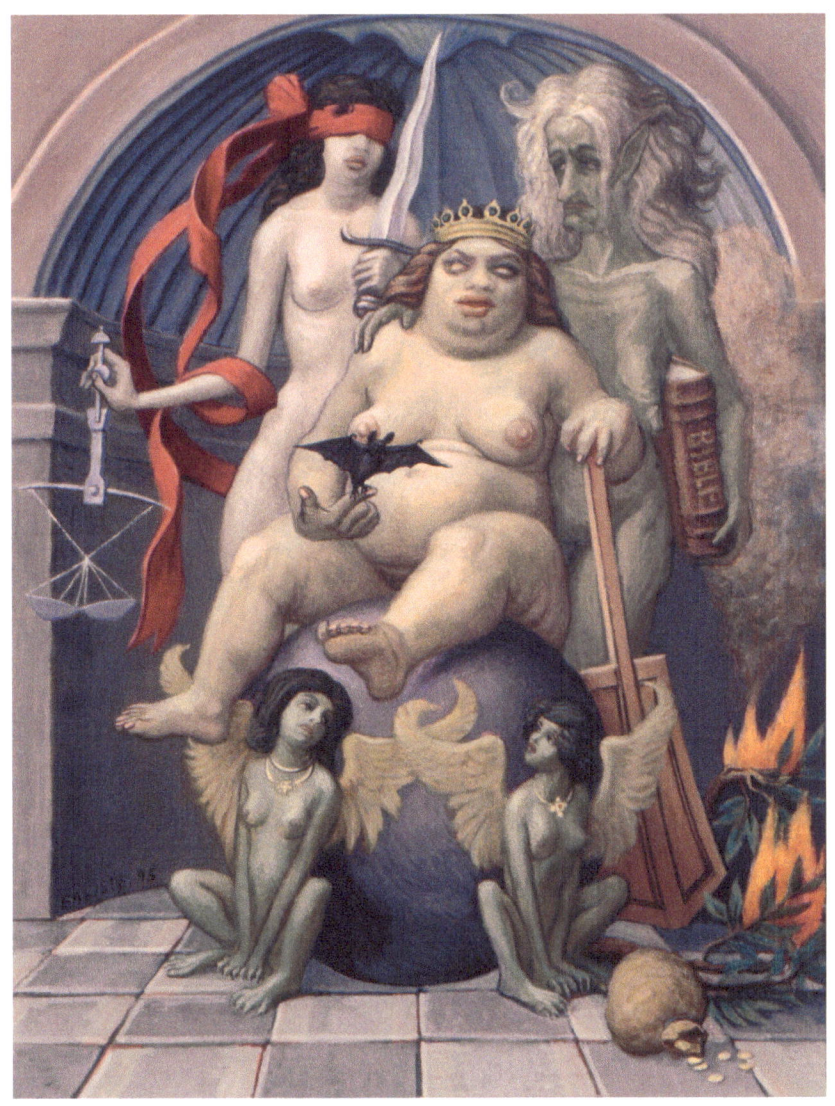

Allegory of Ignorance, 1996–97, egg tempera, 20 x 16 in.

This image is from an even more complicated engraving after a drawing by Andrea Mantegna (1431–1506). The three women in my version represent the Ruler flanked by Justice and Religion, all in their negative aspects.

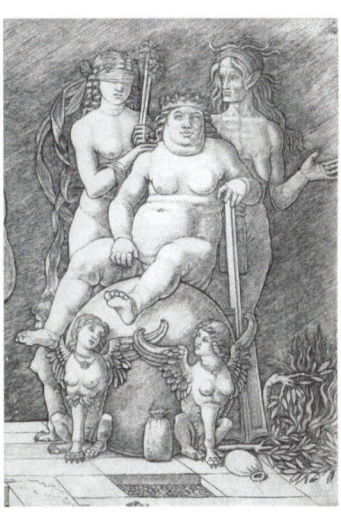

Virtus Combusta (detail), Andrea Mantegna, c. 1490–1500, engraving

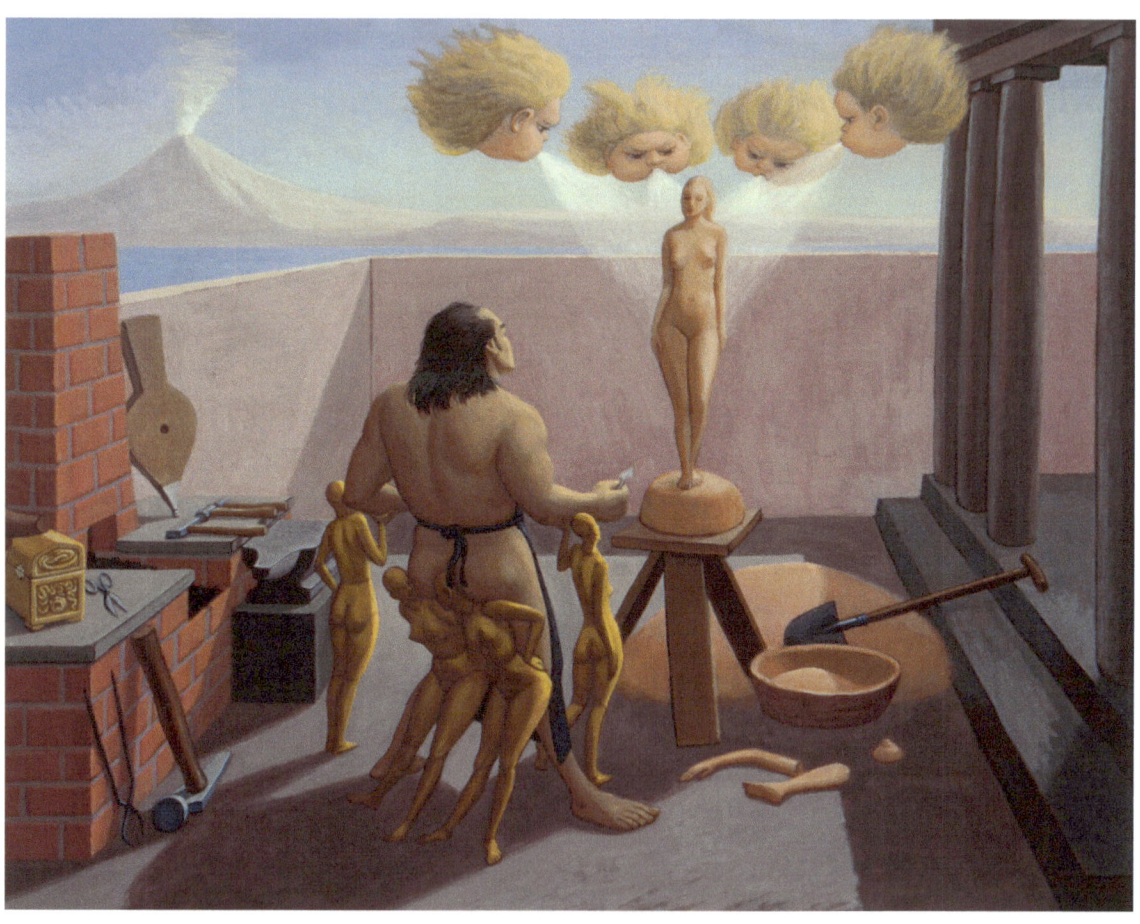

Hephaestus and Pandora, 1994–95, egg tempera, 22 x 30 in.

I'm proud of this complicated and original visual concept. The text is from Hesiod's creation myth, in which the god of the forge creates the first woman out of clay. The four winds breathe life into her. The little female assistants are automatons.

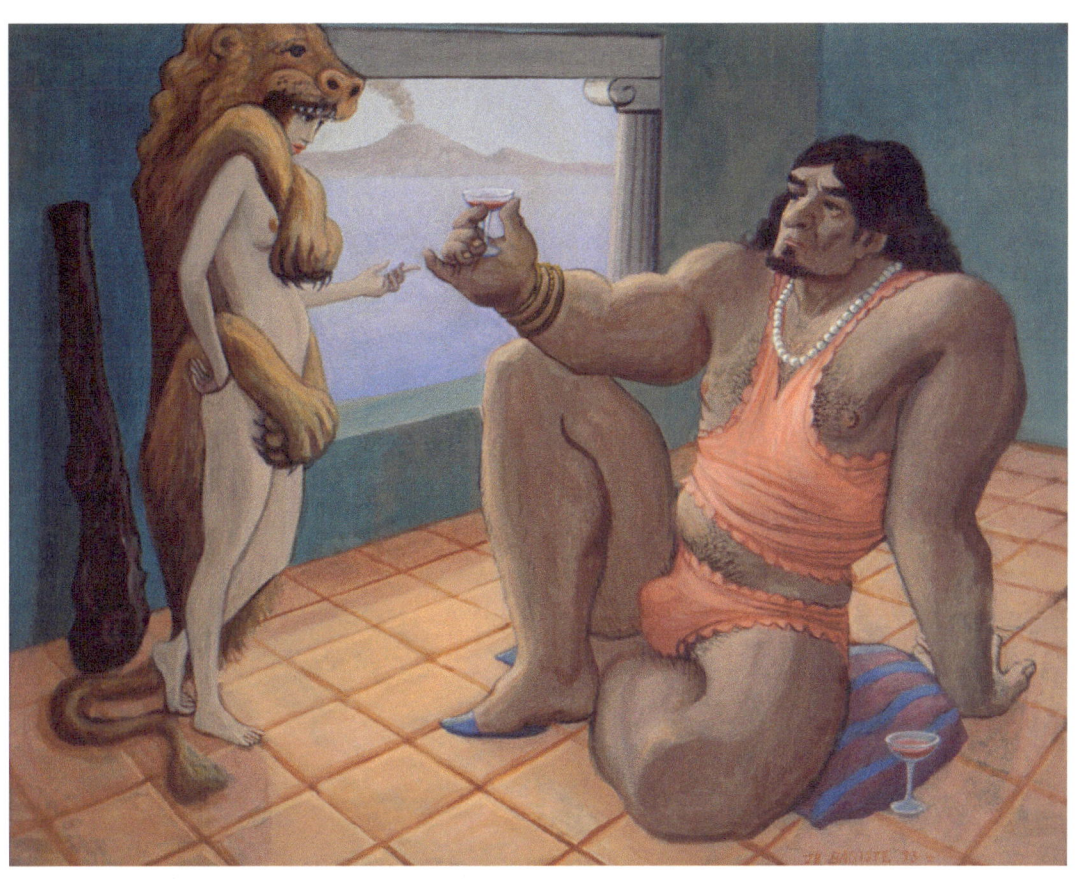

Hercules and Omphale, 1993–94, egg tempera, 16 x 20 in.

Because of a murder Hercules committed, Zeus enslaved him to Omphale, which led to cross-dressing and other odd behavior, often depicted by northern European artists.

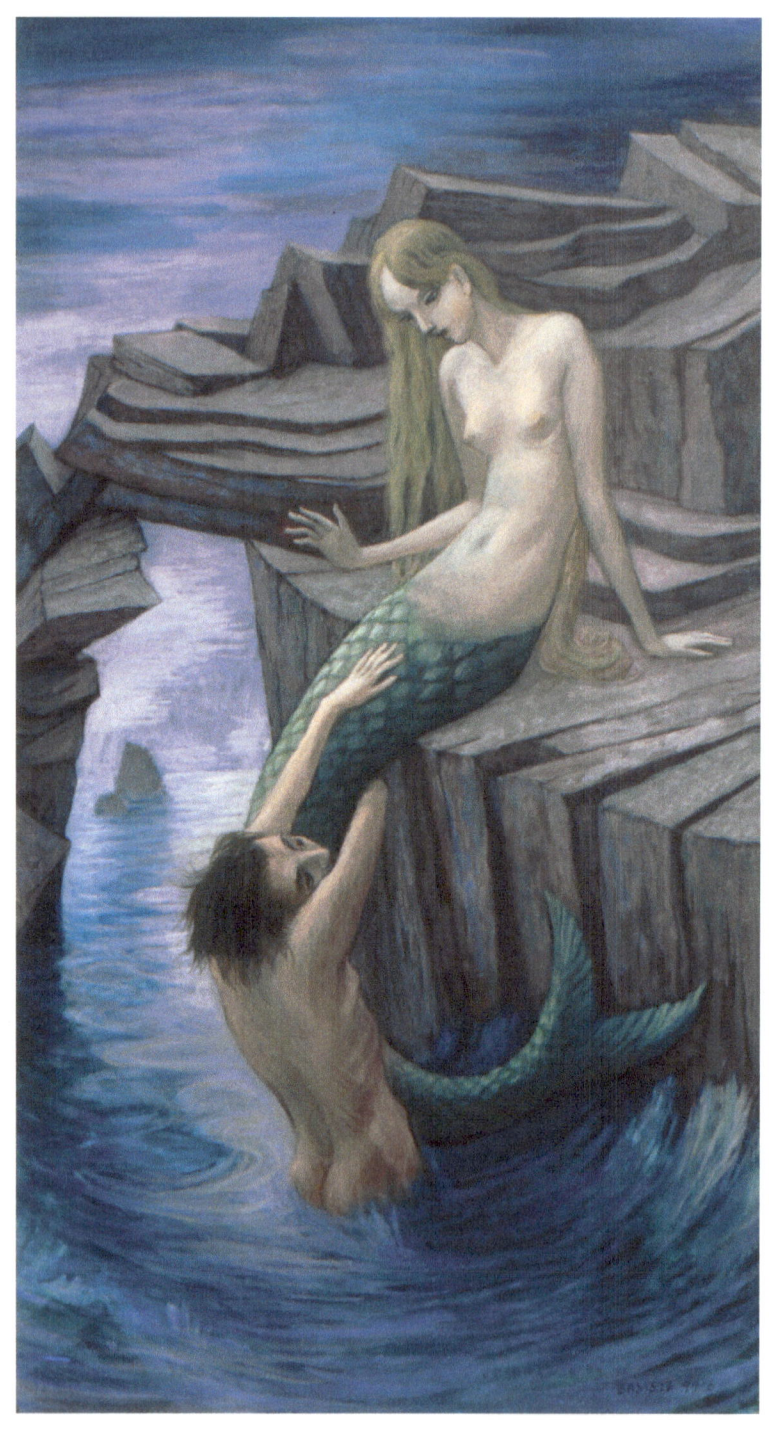

Mermaid, 1994–97, egg tempera, 30 x 16 in.

This image comes from the *Odyssey*, where the Siren's songs bewitched sailors. Sometimes, I'm overly influenced by fin-de-siècle Symbolist art.

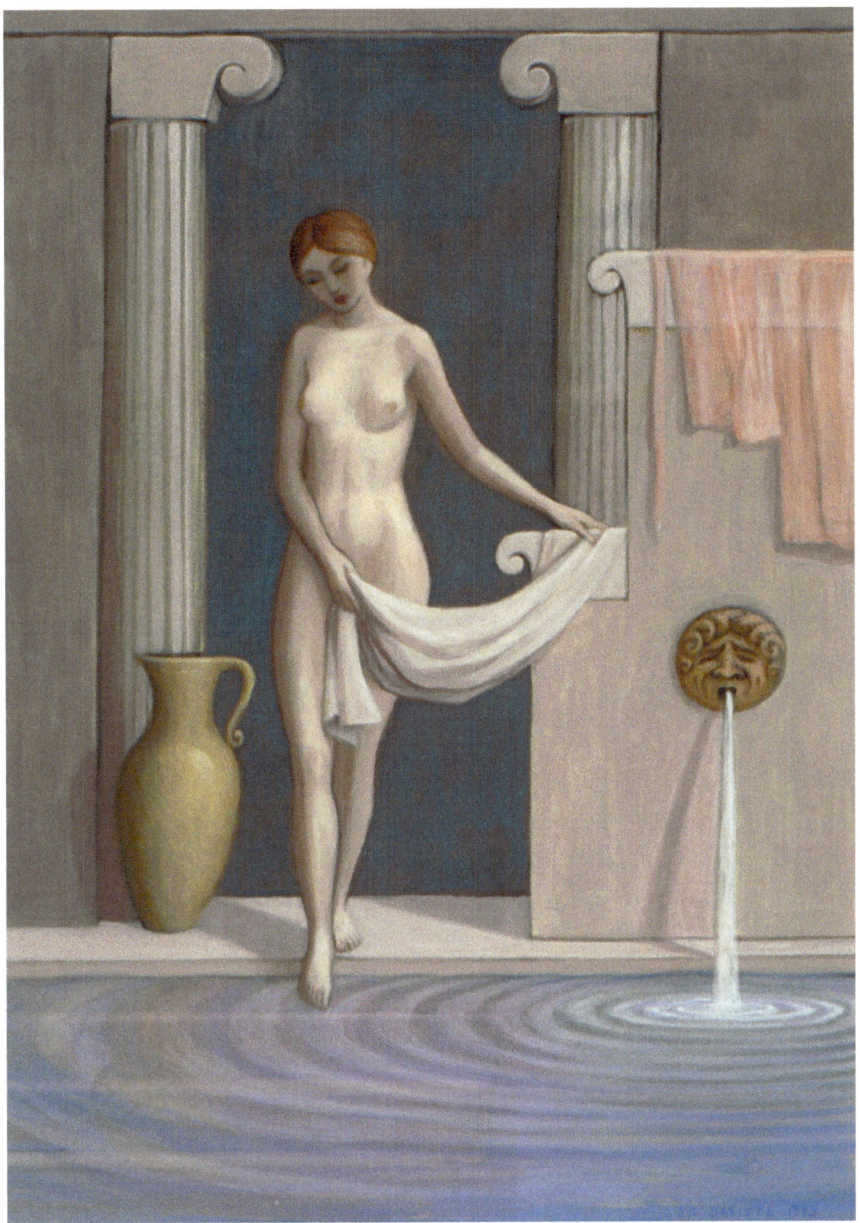

Psyche's Bath, 1993, egg tempera, 20 x 14 in.

This was done in the first year of my myth series. I was influenced by a lovely painting of a similar name by Frederic Leighton, and I tried to be conscientiously classical.

The Bath of Psyche, Frederic Leighton, c. 1889–90, oil

Frederic Leighton was president of the Royal Academy and leader of a late Victorian classicist movement called the Olympians.

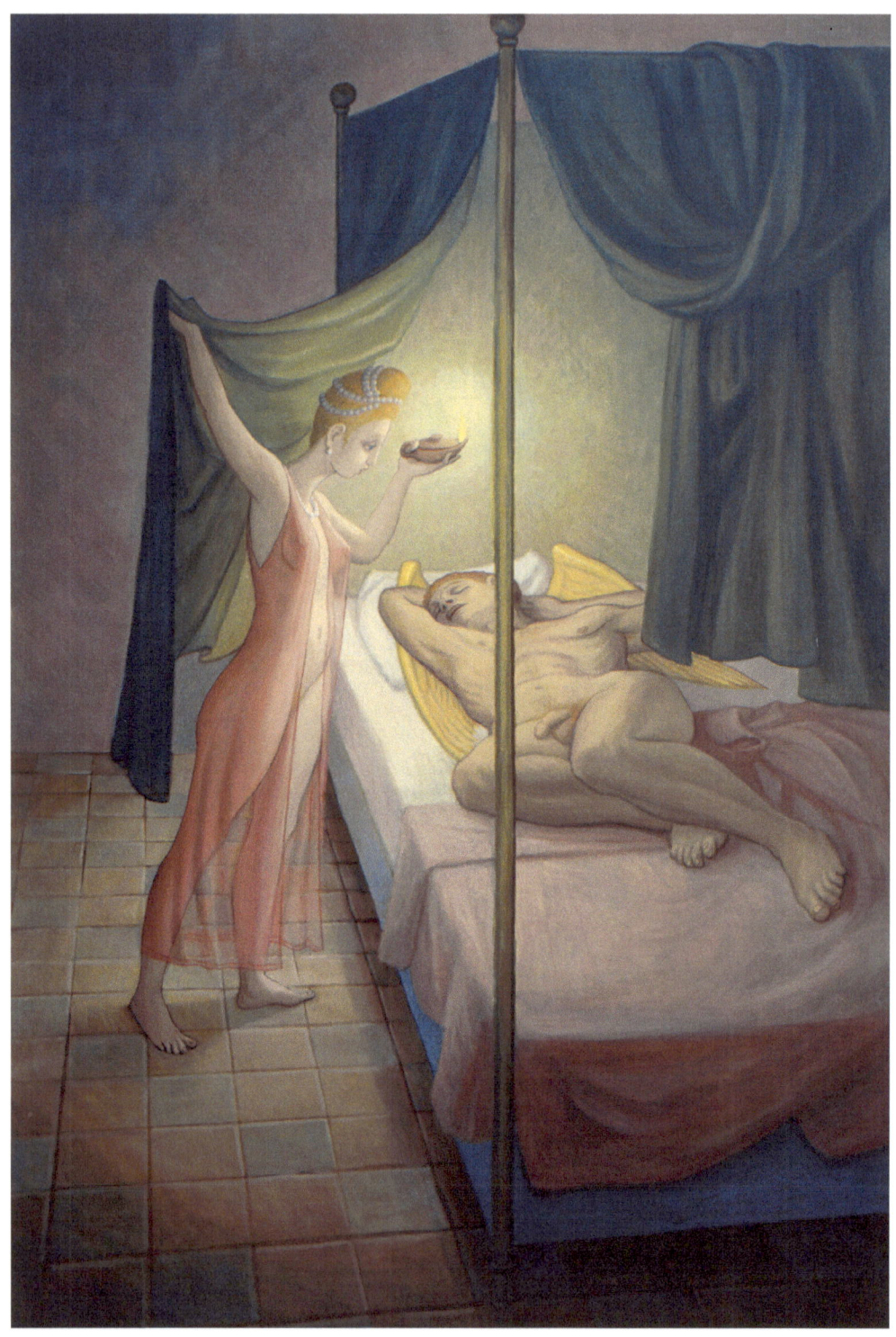

Psyche Discovers Cupid, 1993, egg tempera, 36 x 24 in.

I'd painted a woman approaching a man in bed before, but this scene is in a symbolic tale, where she represents the soul and he represents love.

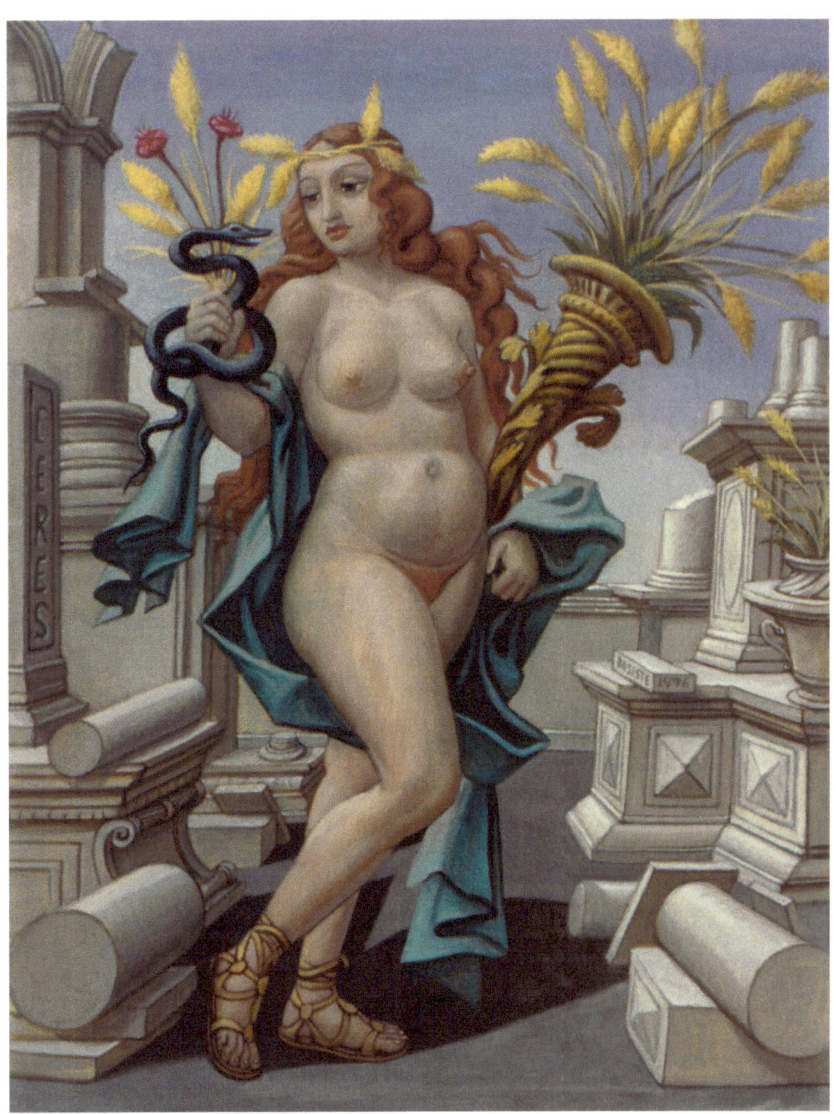

Ceres, 1996, egg tempera, 24 x 18 in.

As an engraver, I have studied Early Renaissance engravings. Since prints were distributed privately, their subject matter was much less restricted than that of paintings done for a church or a ruler. Many engravings derive from myths. Ceres, the harvest goddess, is such an image. I've hardly changed it, except for the large size, the volumetric shading, and the addition of color.

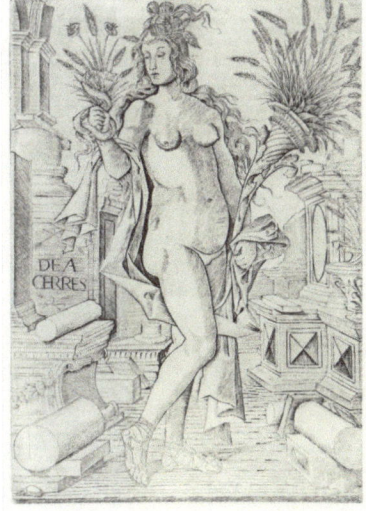

Ceres, Nicoletto da Modena, c1500–06, engraving

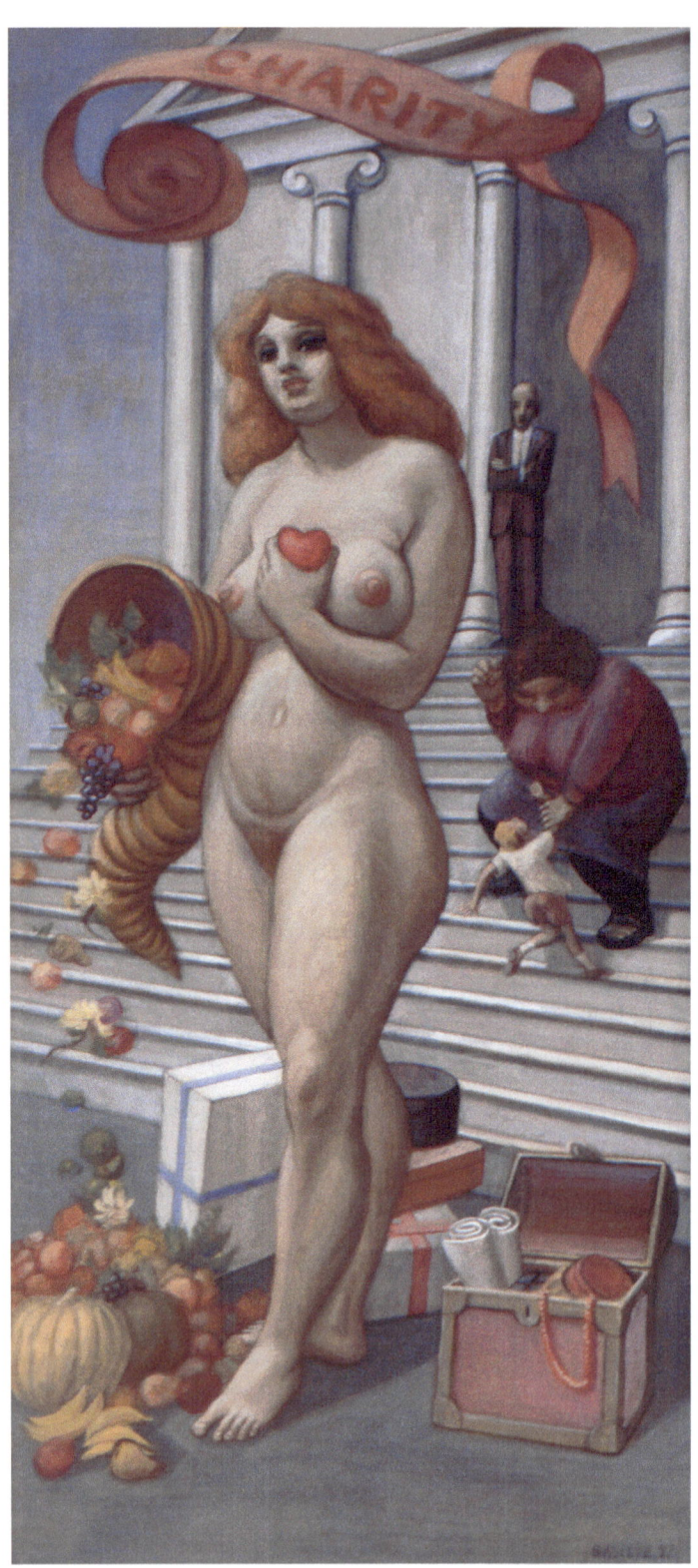

Charity, 1997, egg tempera, 36 x 16 in.

I did a series of the Seven Virtues as allegorical women, with related Vices depicted in the background. Pieter Bruegel the Elder also did the Virtues in a series of complex drawings that were engraved. This figure is reminiscent of Ceres, even to the cornucopia. The accessories come from Cesare Ripa's 1593 book, *Iconologia*, a compendium of attributes and symbols, which was used by many Baroque artists.

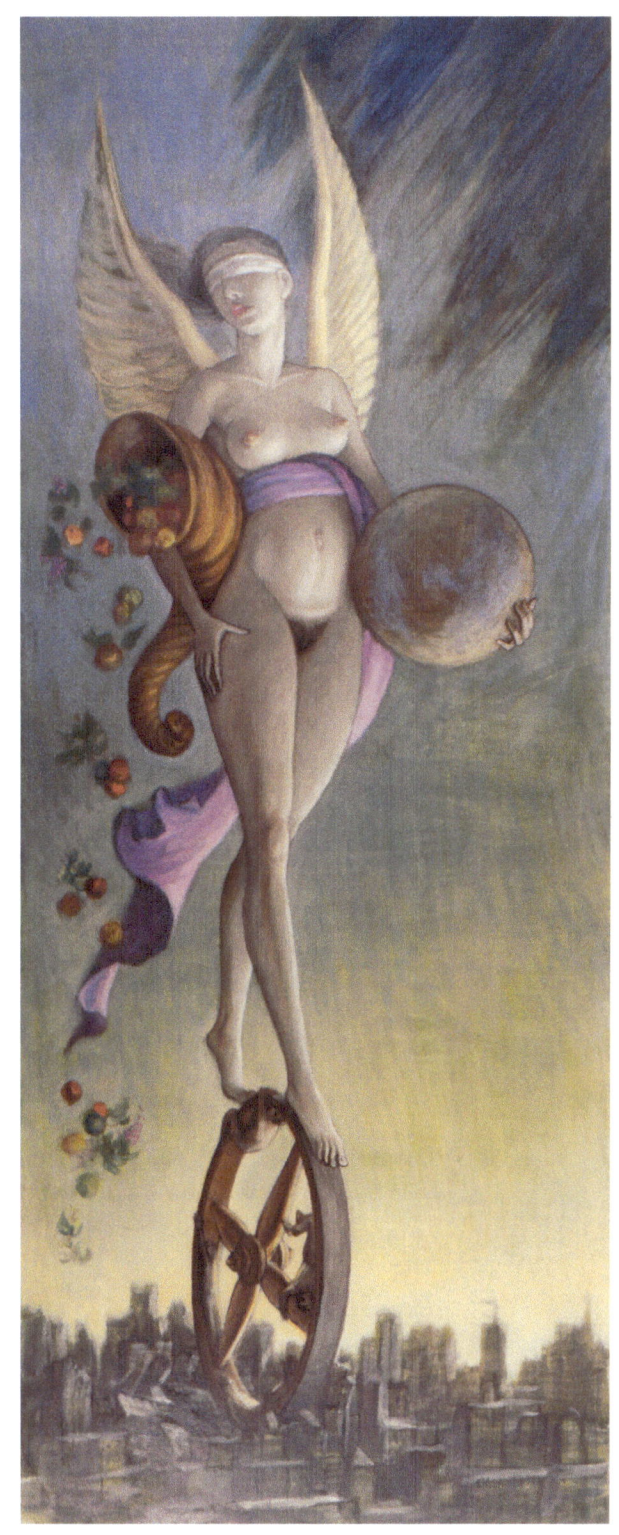

Fortune, 1997, egg tempera, 28 x 11 in.

This eclectic painting came from all over the place, from nineteenth century Symbolism to 1930s Social Realism. The latter evident in the image of the wheel smashing the city.

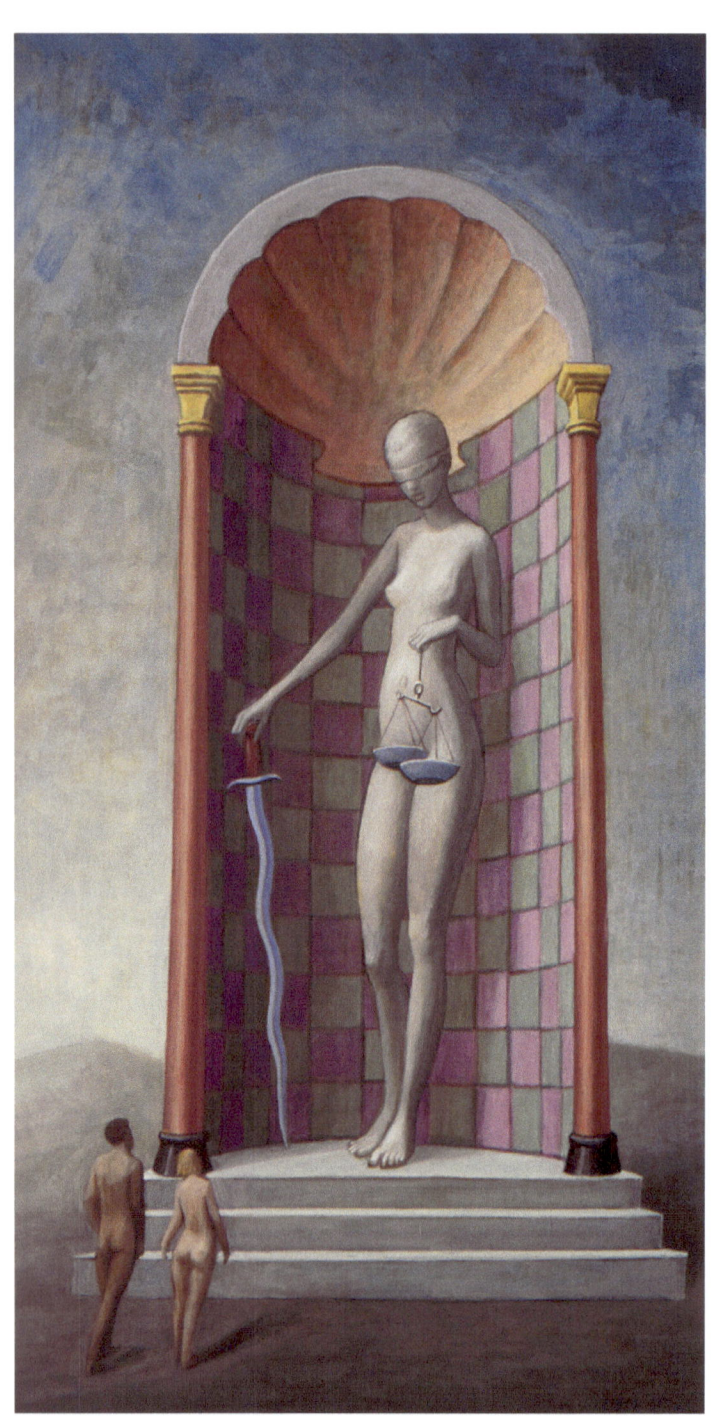

Justice I, 1994, egg tempera, 24 x 12 in.

In this small first version, an innocent nude couple stands in awe of the imposing vision of a fanciful outdoor monument.

Justice II, 2000, egg tempera, 40 x 20 in.

This is one of my last mythological paintings. I used a Mannerist style and traditional iconography, except for a tiny businessman in a suit and a bum. The final version eliminated the businessman.

I got the concept in 1957 from a fellow student in Skowhegan. In a style reminiscent of the Italian Renaissance period, he did a life-size fresco of a nude standing in a niche. The whole sad story is in my book *Disturbing Art Lessons*.

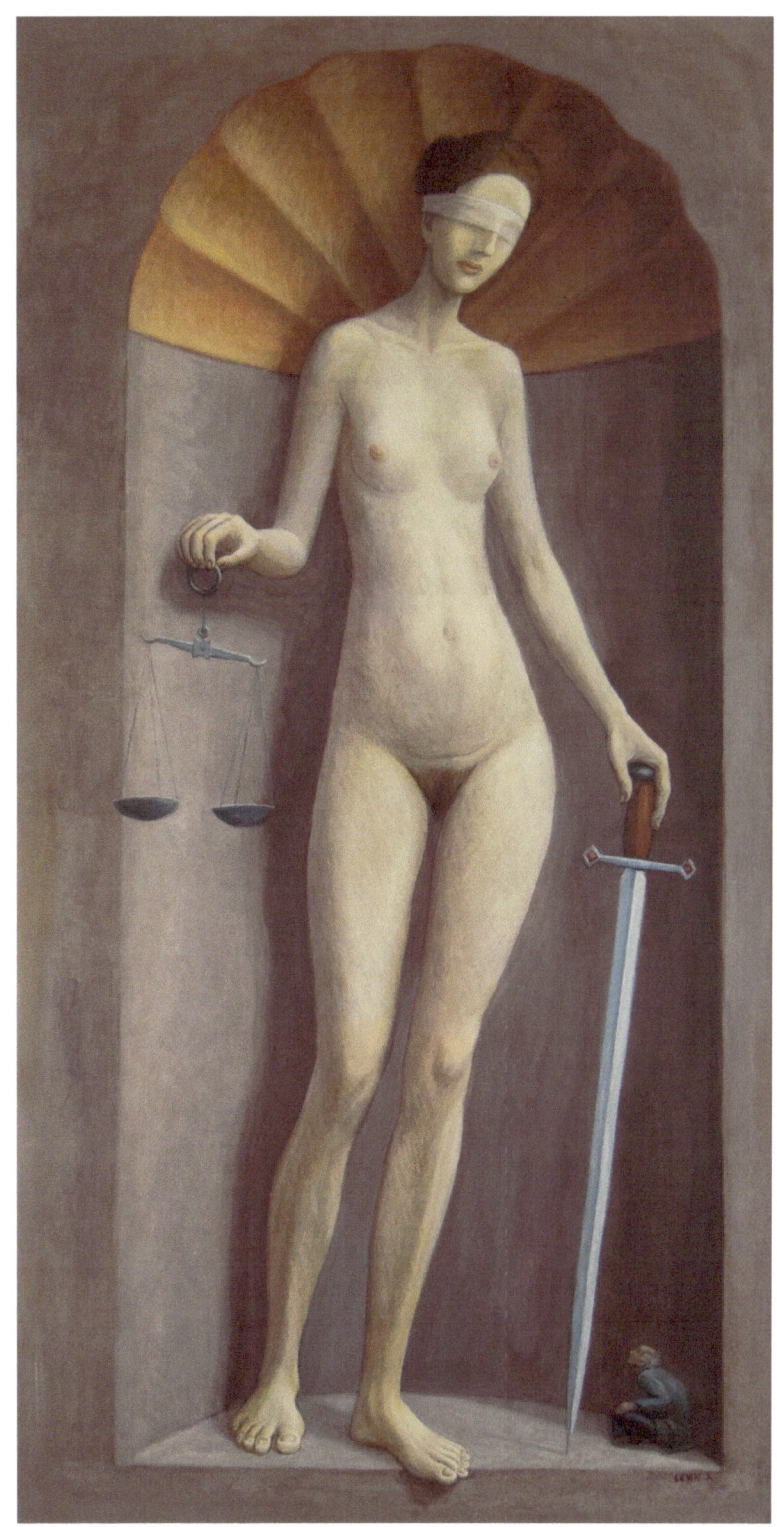

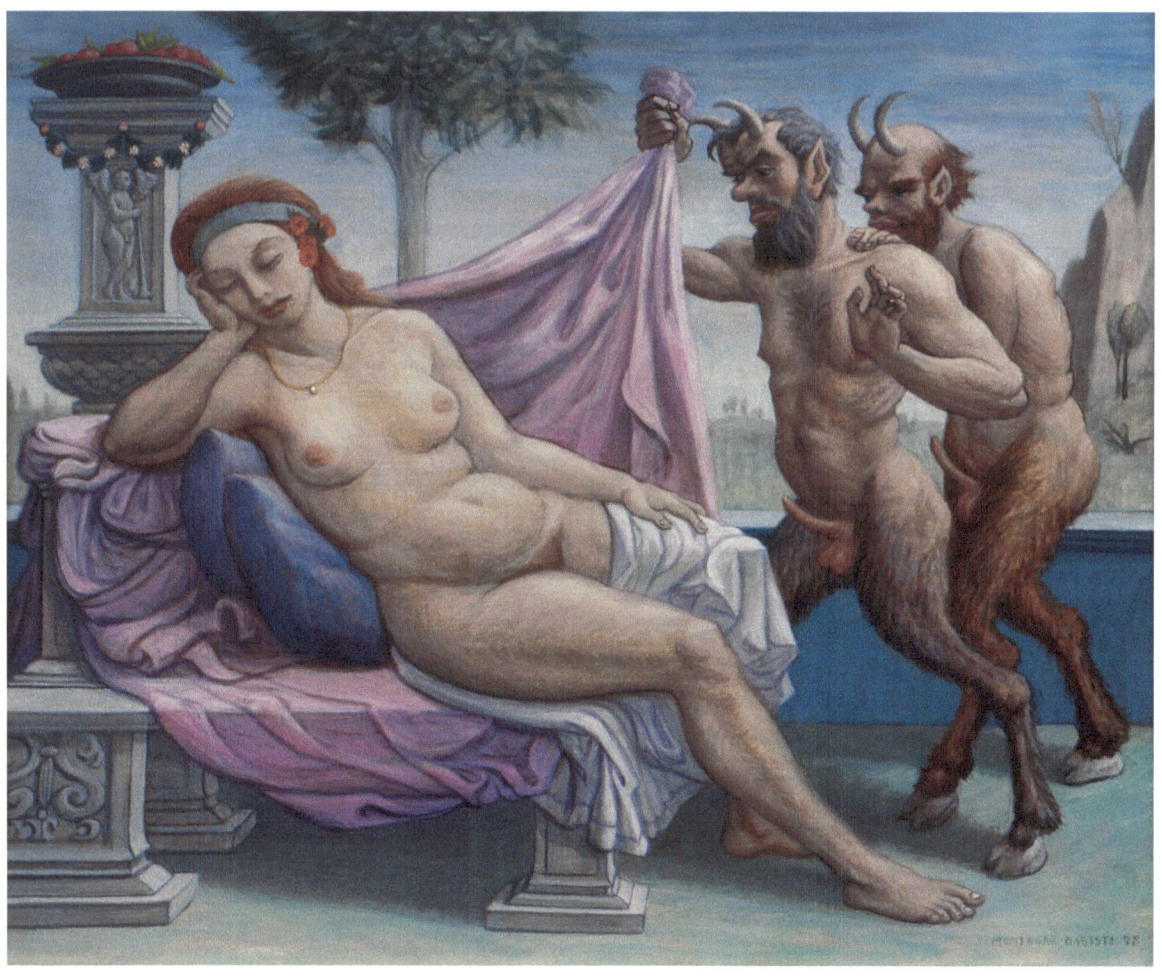

Nymph and Satyrs, 1998, egg tempera, 20 x 24 in.

My version is close to the Italian engraving, but the two babies had to go. I've done another variation with a sleeping satyr and peeping nymphs.

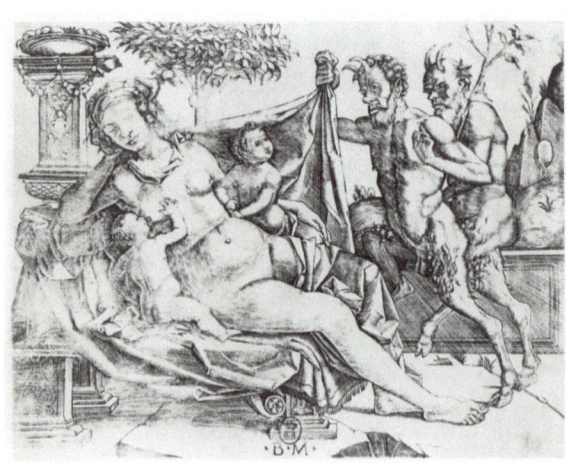

Sleeping Nymph and Two Satyrs, Benedetto Montagna, c. 1505–06, engraving

Satyrs, being part goat, have often been depicted with carrot-like penises.

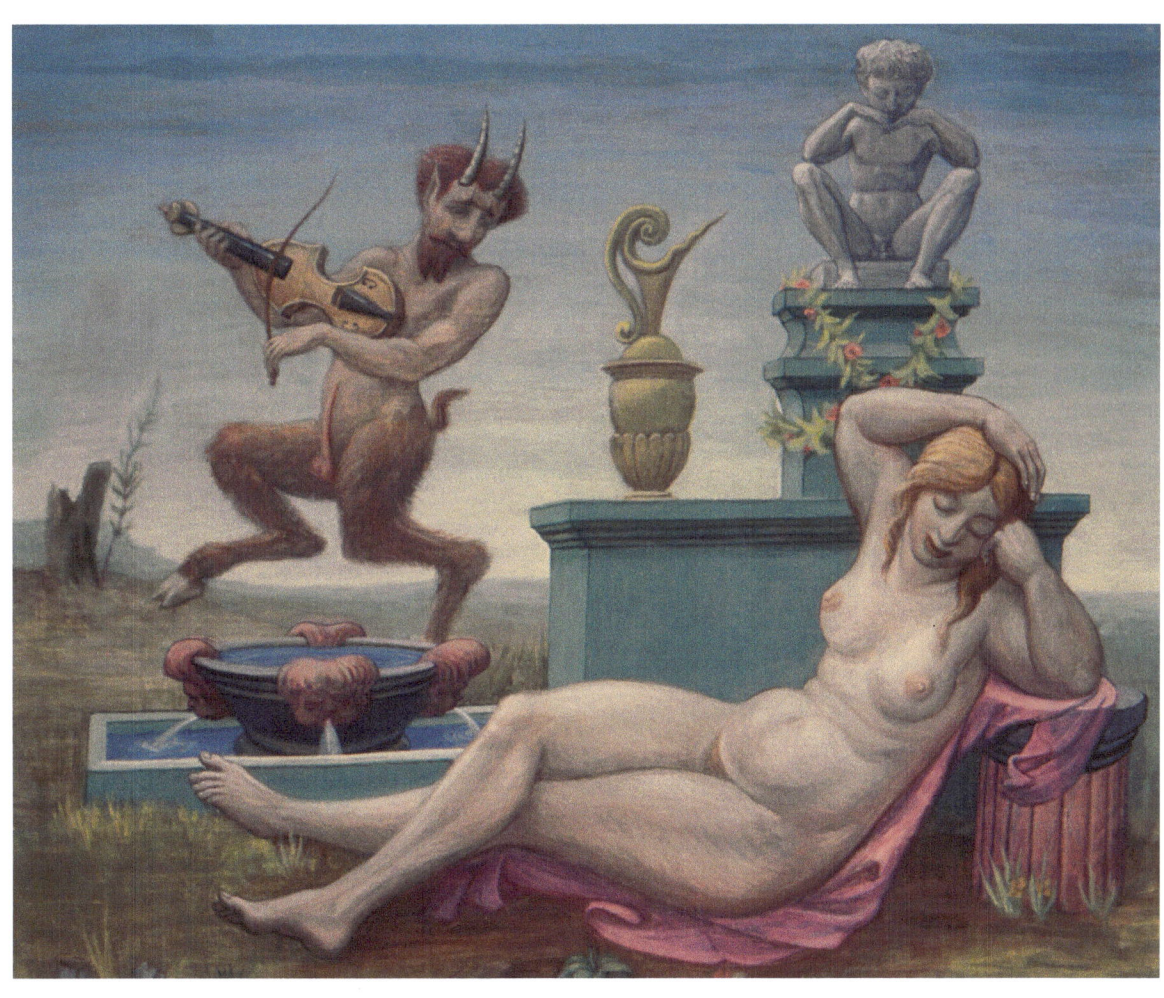

Dancing Satyr and Nymph, 1998, egg tempera, 20 x 24 in.

Again, my painting is from two very whimsical engravings of the Renaissance period.

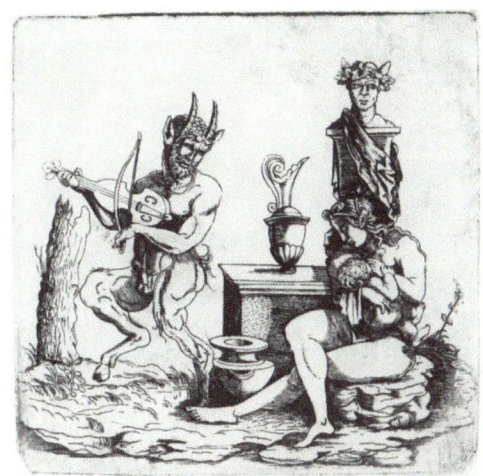

Satyr Playing a Viol Beside a Sleeping Nymph and Child, Il Bambaia, c. 1515–20, engraving

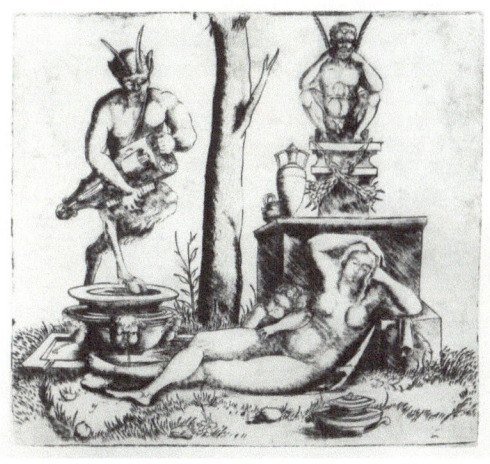

Satyr Playing a Hurdy-gurdy beside a Sleeping Nymph and Child, Il Bambaia, c. 1515–20, dry-point engraving

127

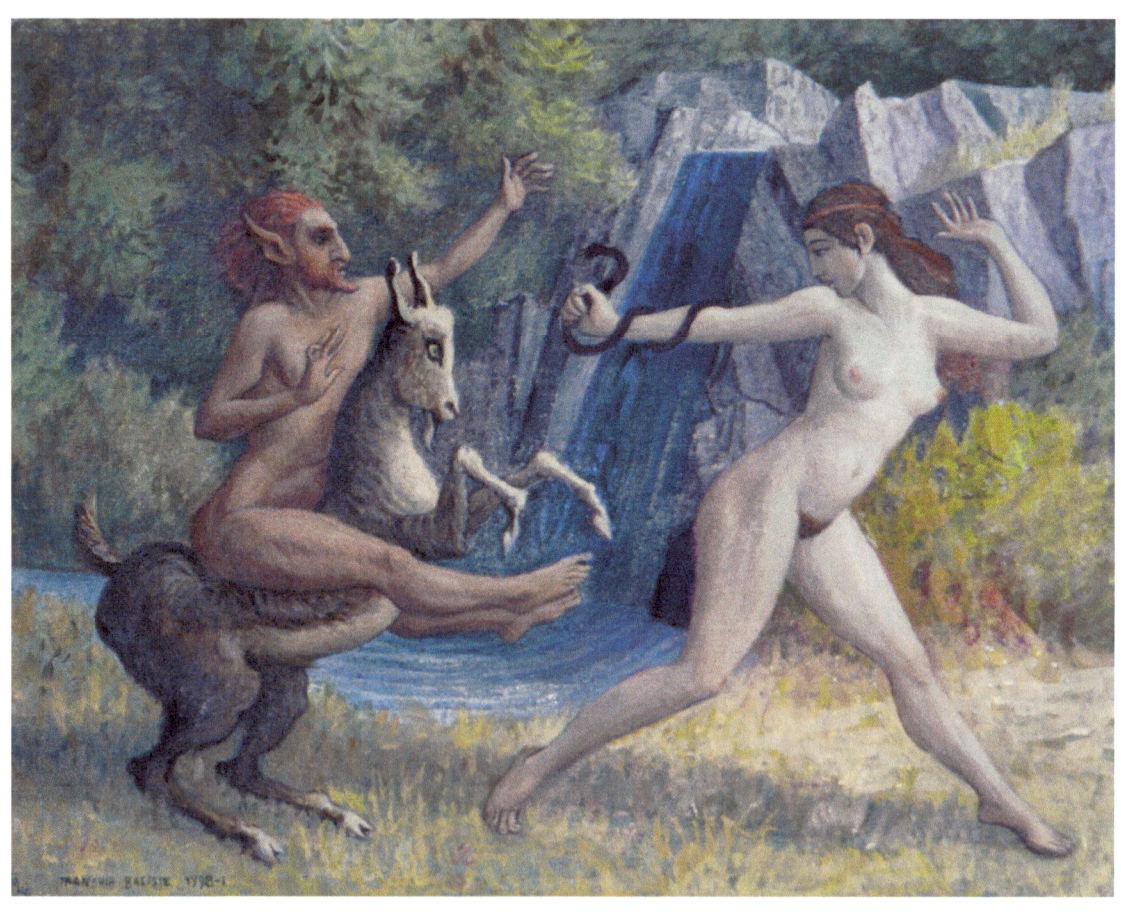

Satyr and Goat with Nymph, 1998–2002, egg tempera, 16 x 20 in.

Unlike the previous paintings, derived from Renaissance images, this scene is a composition from two bronze figurines by the twentieth century sculptor Paul Manship.

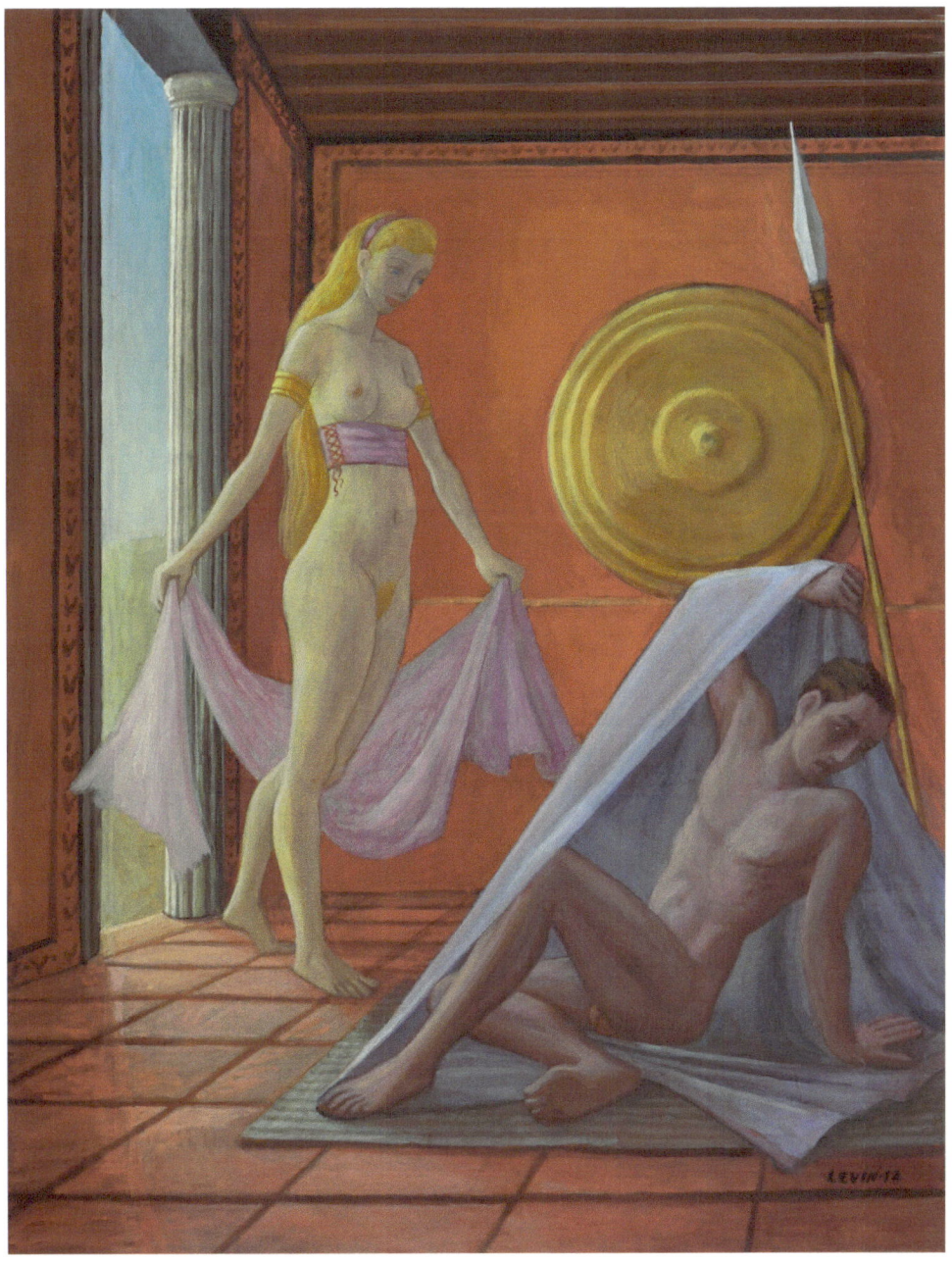

Venus and Anchises, 2012, egg tempera, 24 x 18 in.

Venus came to the mortal Anchises, then gave birth to Aeneas, the founder (with her help) of Rome. I depict Anchises as being afraid of the goddess' love. It was known that mortals loved by gods were ill fated.

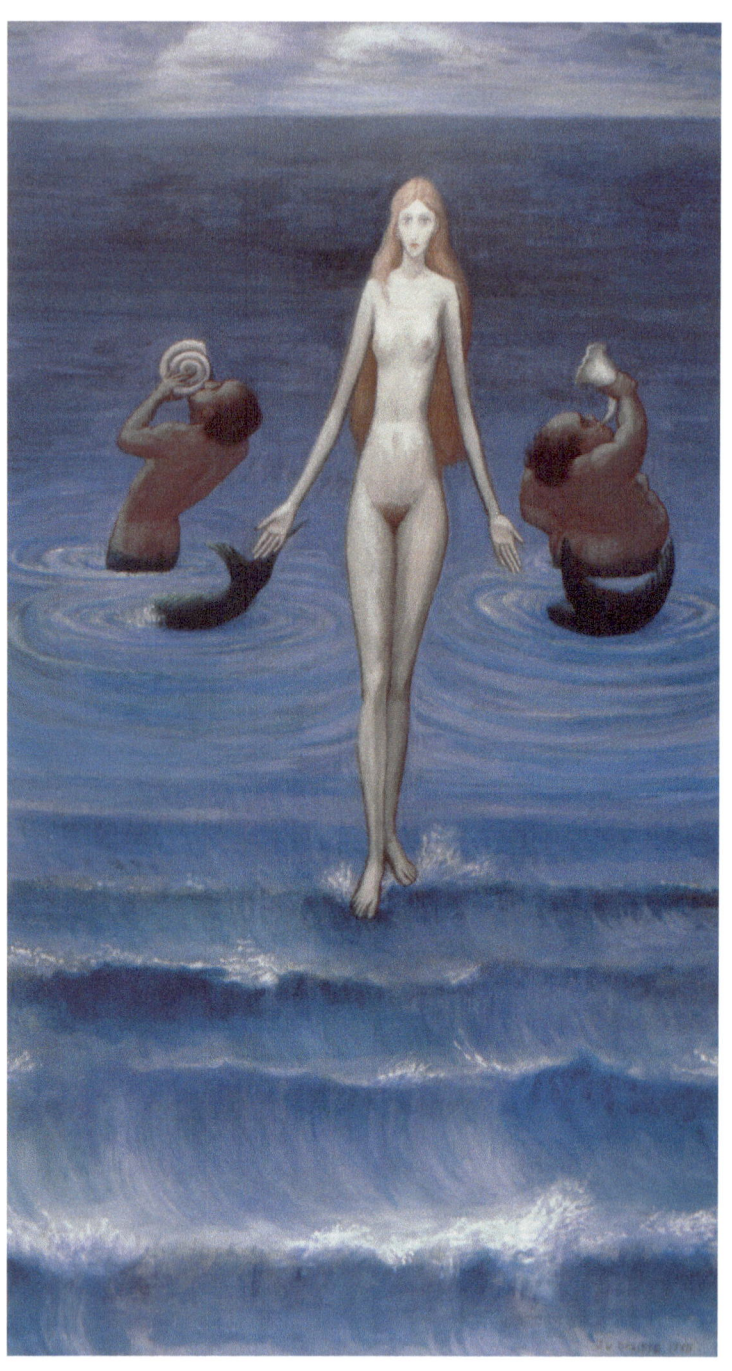

Birth of Venus, 1995–97, oil, 30 x 16 in.

Regardless of Botticelli's *Birth of Venus*, I tried to visualize my own image, taken from Hesiod's account, which has no giant scallop shell. Later, I found a Victorian artist with a similar interpretation.

The Birth of Venus, William Stott-of-Oldham, c. 1887, oil

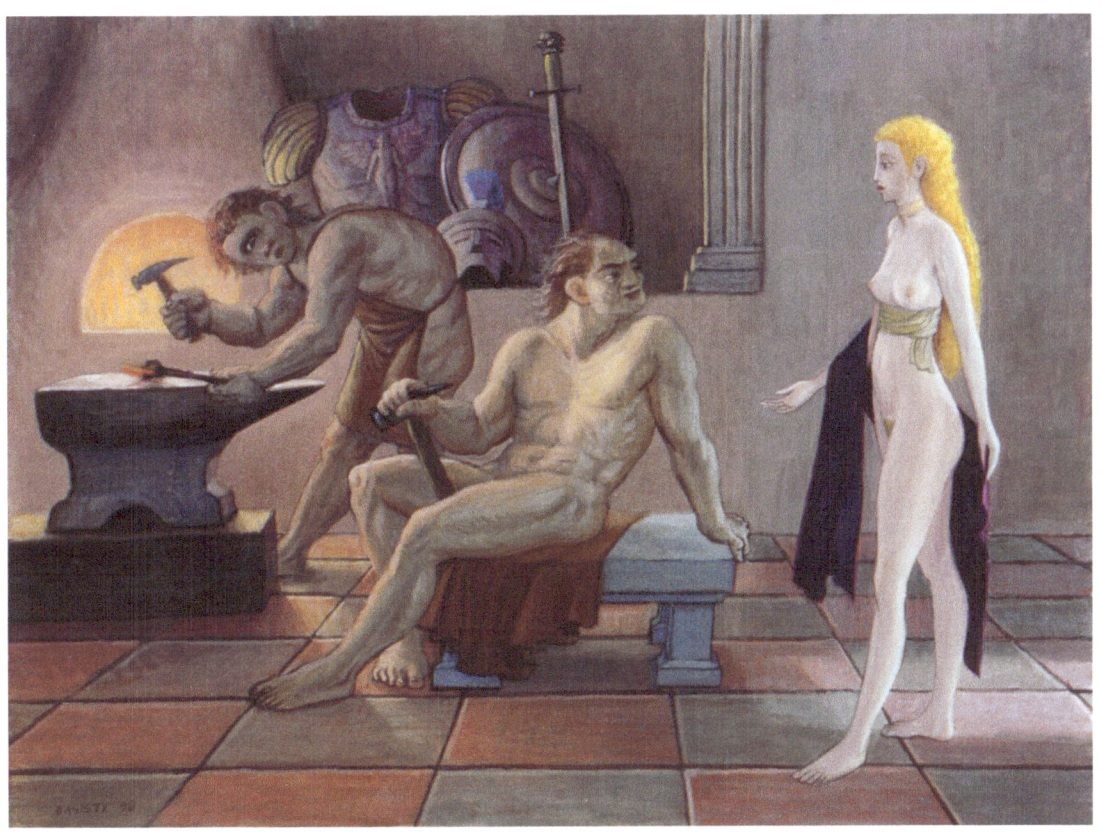

Venus and Vulcan II, 1998, egg tempera, 18 x 24 in.

This, my own version, is classical in its shallow stage-like lineup. I've been literal—including Aeneas' armor, a Cyclops, Vulcan's crippled foot, and Venus' magic girdle.

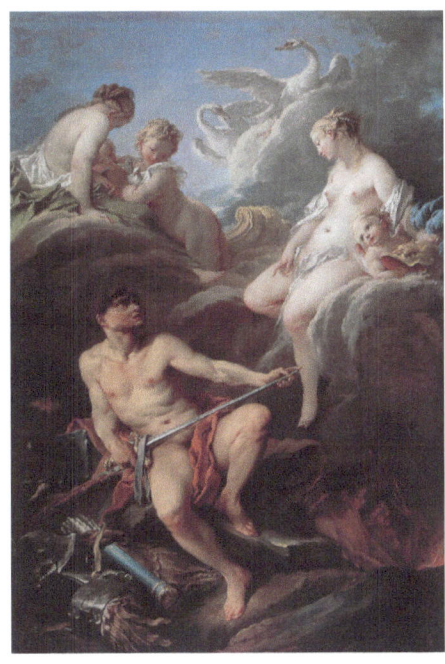

Venus Requesting Vulcan to Make Arms for Aeneas, François Boucher, c. 1732, oil

Initially, I painted a large elaborate copy of this Baroque image, including the barely visible Cyclopes in the cave under Venus.

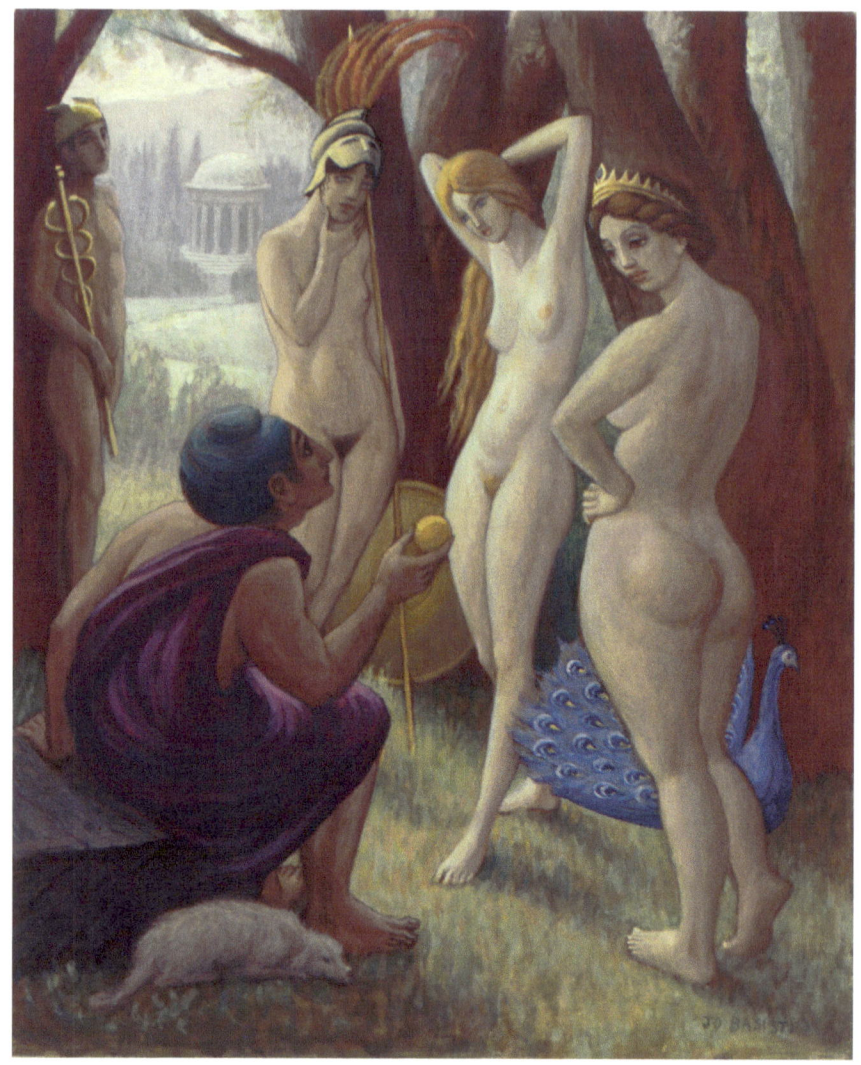

Judgment of Paris III, 1996–99, egg tempera, 20 x 16 in.

This is the traditional treatment of the theme, including Paris acting as a shepherd complete with his dog. Mercury, who arranged the meeting, has his winged helmet and caduceus. The three goddesses are Athena, Aphrodite (or Venus), and Hera with their attributes. Aphrodite's attribute is often her son Eros, or sometimes white doves, but here it is only her beauty. There is even a Roman temple in the background.

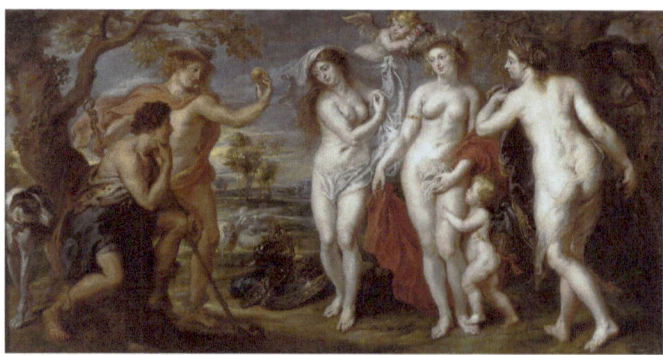

The Judgment of Paris, Peter Paul Rubens, c. 1638, oil

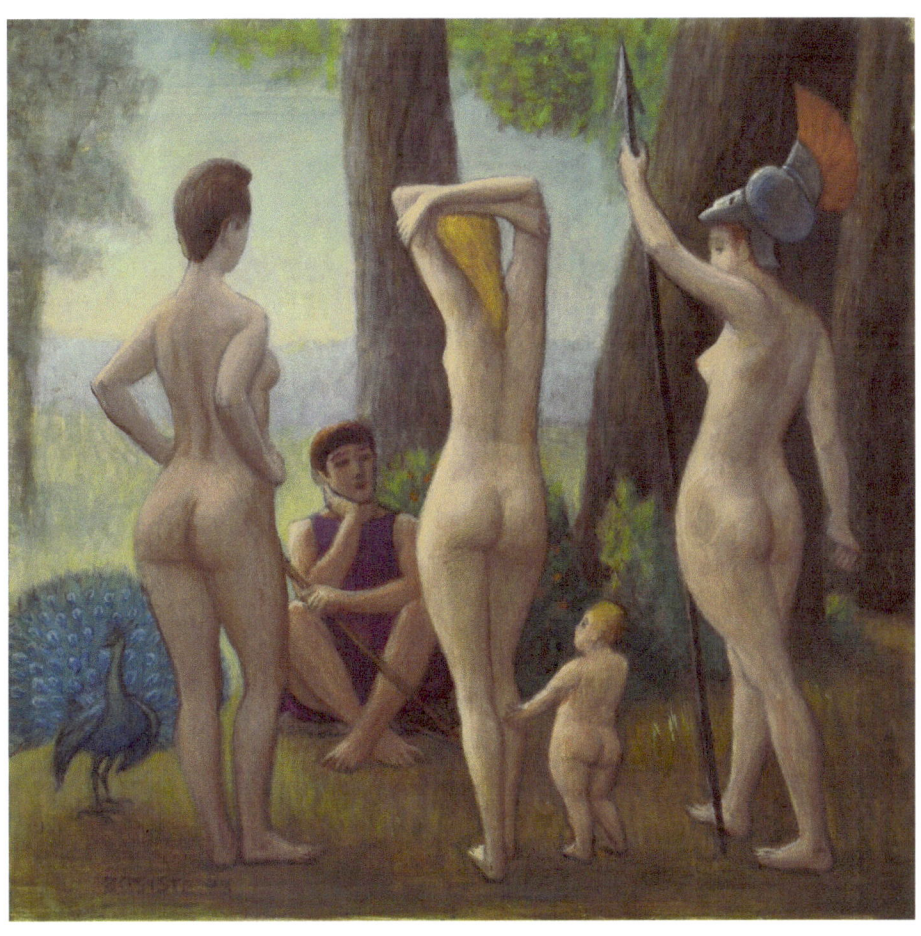

Judgment of Paris (Rear View), 2004, egg tempera, 10 x 10 in.

Many artists painted this theme, but I don't know of any from this point of view.

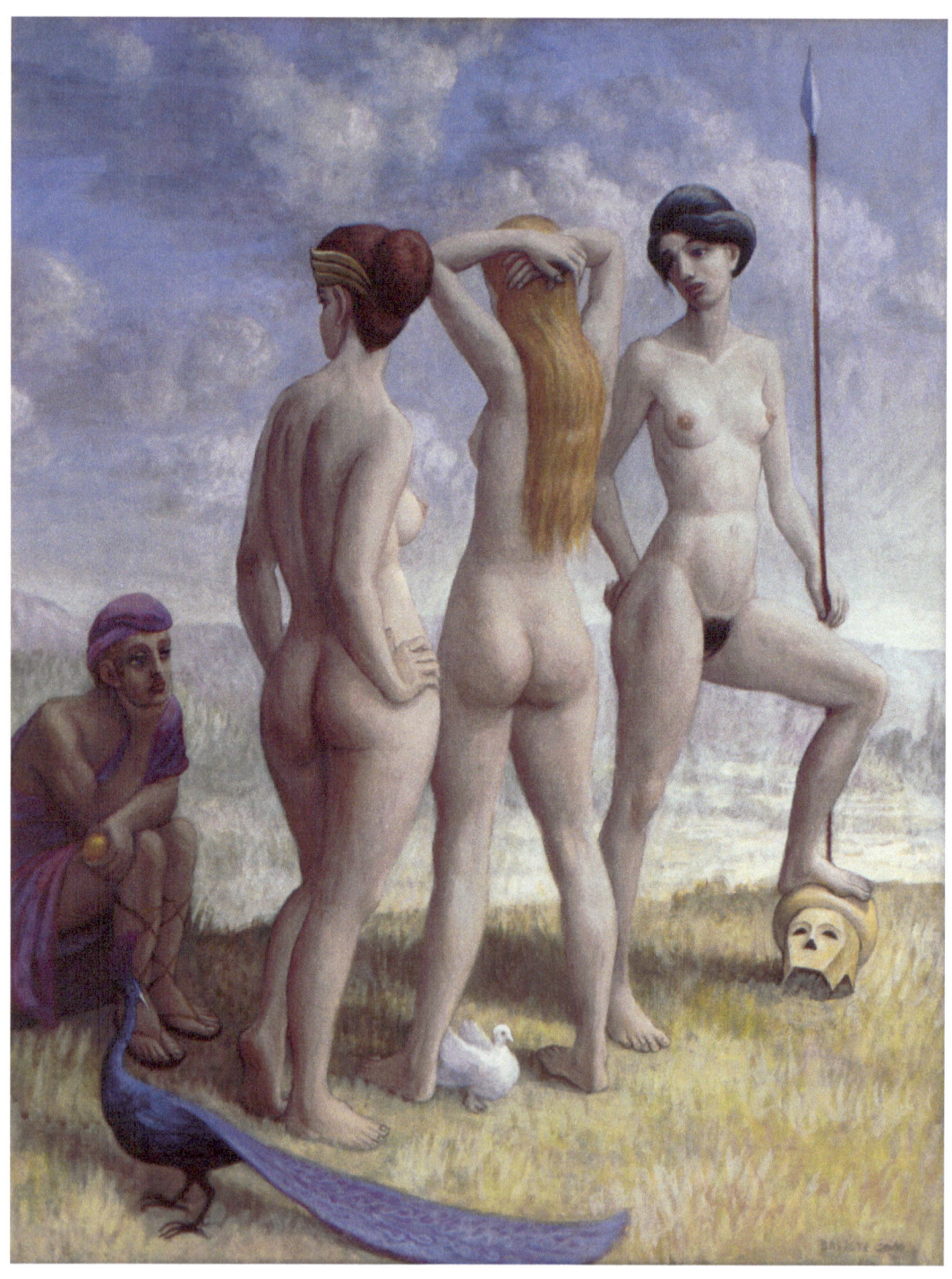

Judgment of Paris, Diptych Left, 2004, egg tempera, 24 x 18 in.
I've stripped down the narrative, featuring the goddesses, each in character.

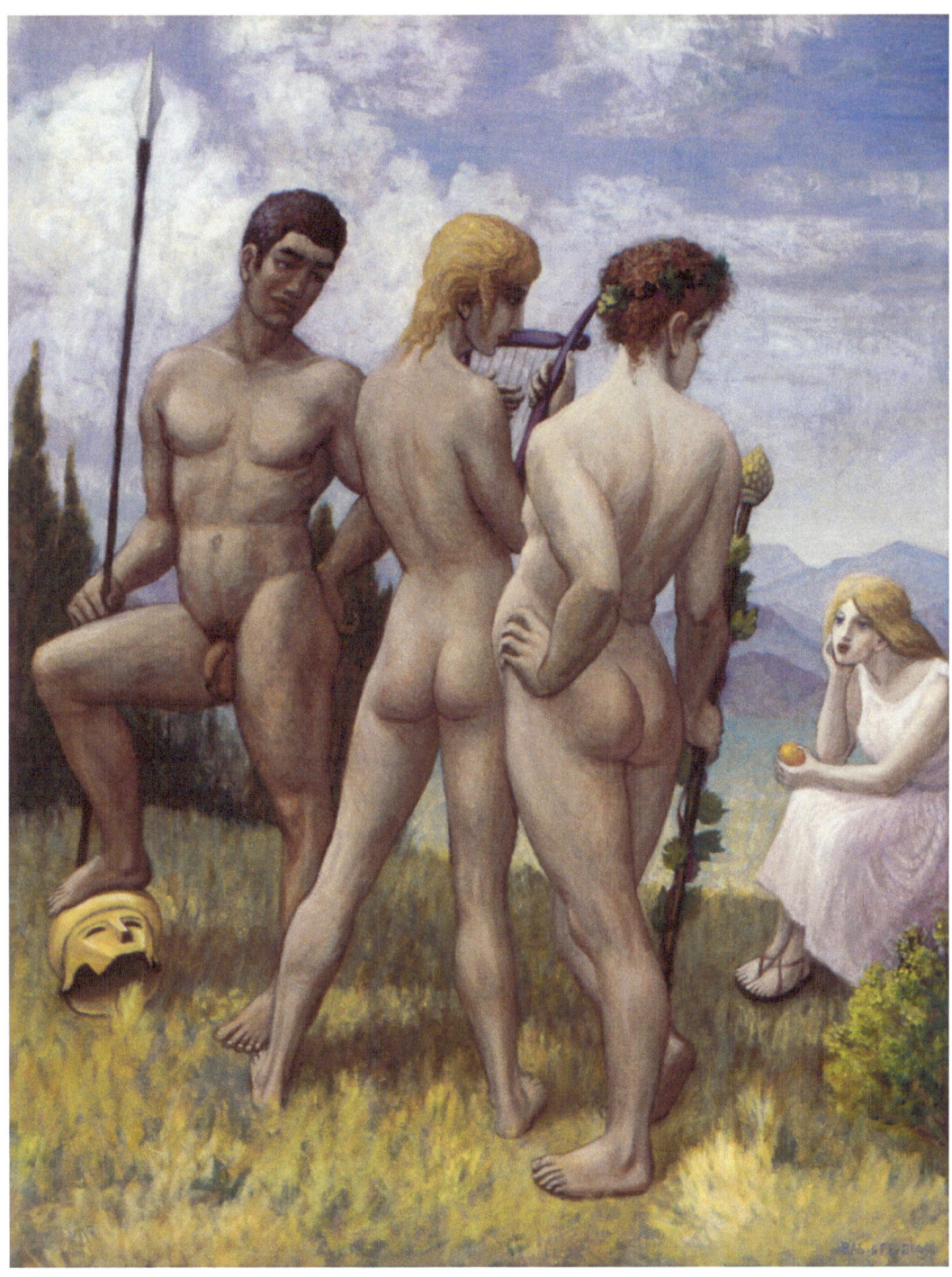

Judgment of Paris Reversed, Diptych Right, 2004, egg tempera, 24 x 18 in.

In this reversal, I've substituted a shepherdess for Paris. The gods are Ares, Apollo, and Bacchus.

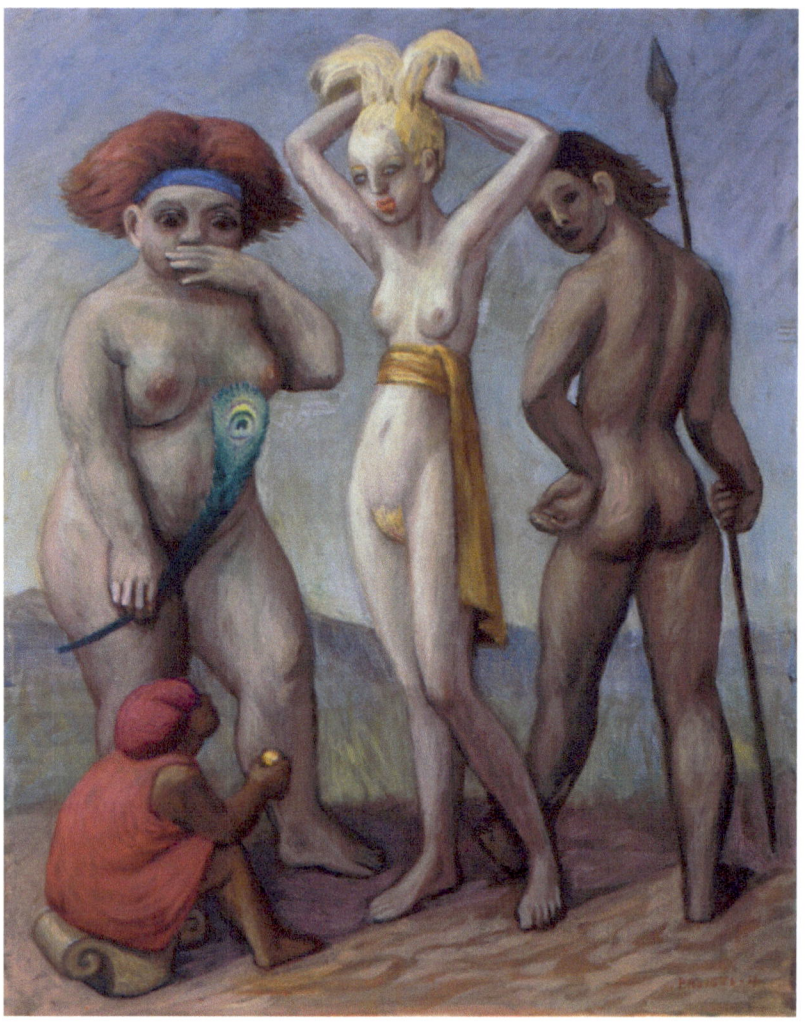

Judgment of Little Paris, 2004, egg tempera, 14 x 11 in.

Paris, a Trojan prince, is judging which goddess is most beautiful. This is the defining moment of a whole galaxy of Greek myths. The scene has often been painted—three nude goddesses, after all. The goddesses being greater than humans, I made them larger. Spoofs are rare, but some of Cranach's versions are quite campy.

The Judgment of Paris, Lucas Cranach the Elder
c. 1528, oil

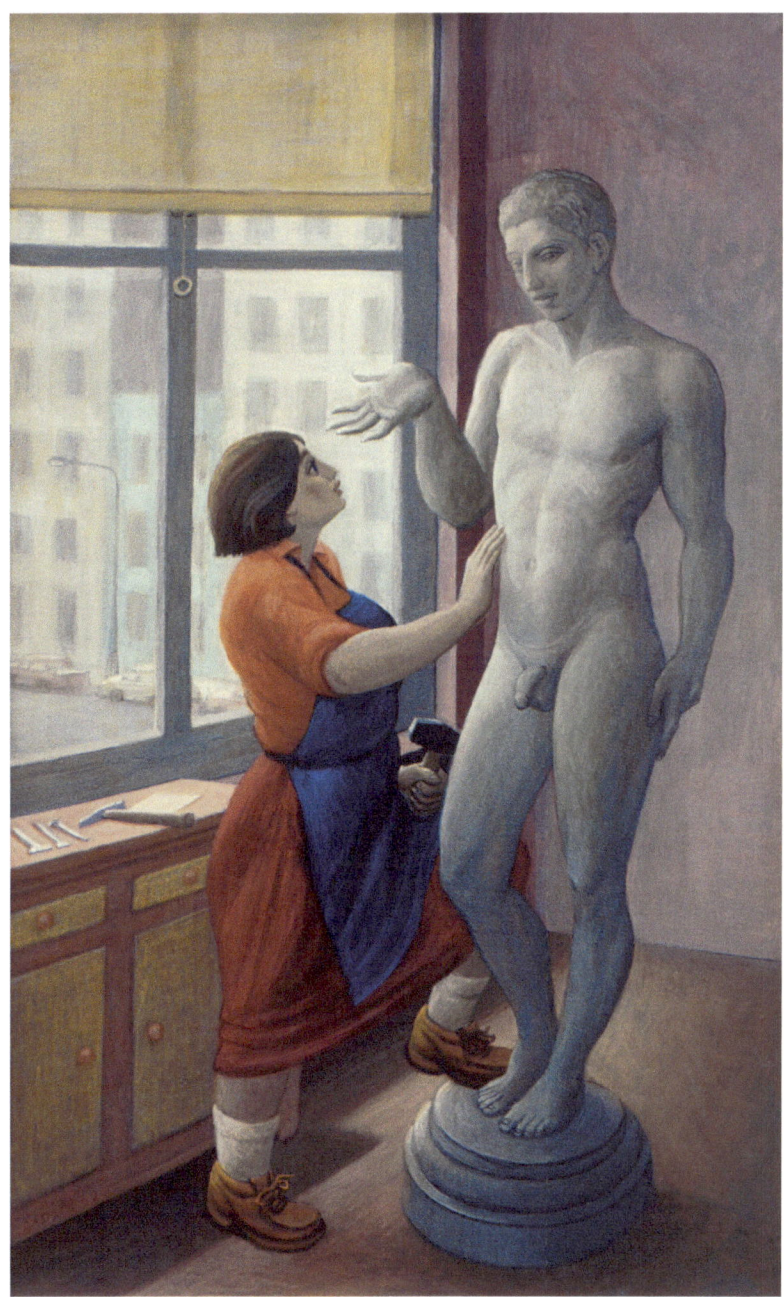

Pygmalion, 1999–2003, egg tempera, 30 x 18 in.

Here, too, I've avoided the male-chauvinistic fantasy by shifting the sexes. This reversal of the Pygmalion myth set in modern time is, I think, original. I've never come across an image of a woman sculpting a male nude.

Pygmalion and Galatea, Ernest Normand, c. 1886, oil

There are nineteenth-century paintings of this subject by Edward Burne-Jones and Jean-Léon Gérôme, but this little-known version is too ridiculous to pass by.

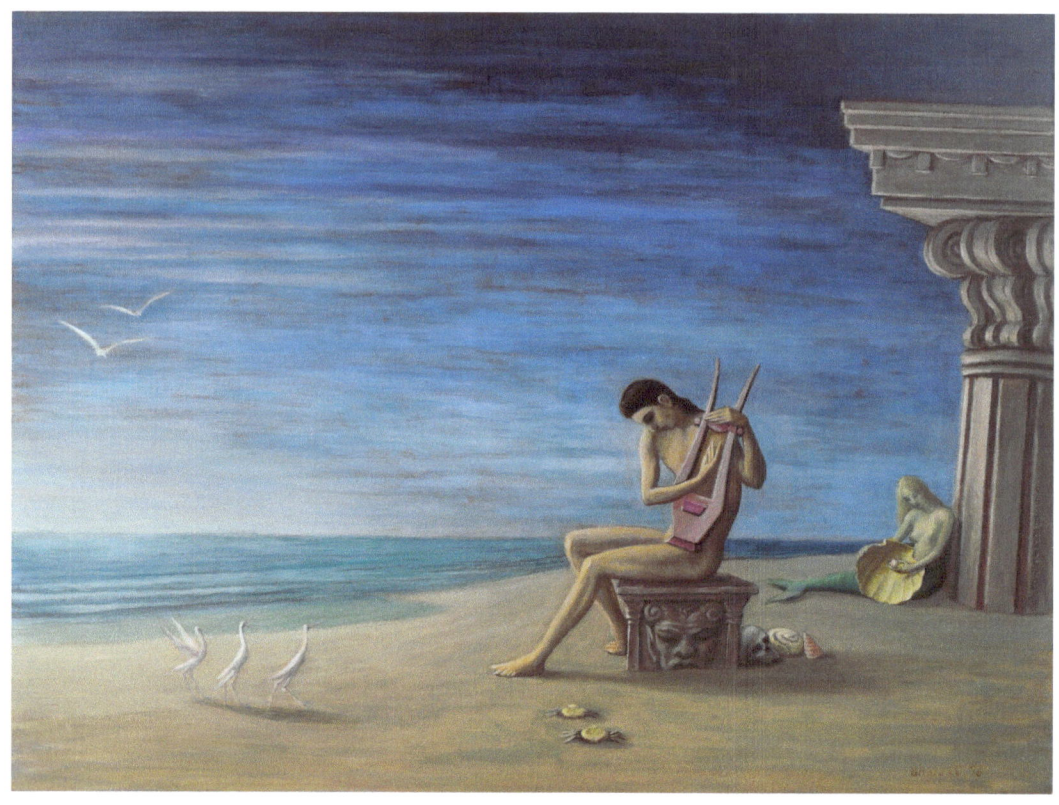

Orpheus by the Sea, 1995, egg tempera, 18 x 24 in.

This painting offers a romantic notion of the lonely Orpheus enchanting the sea creatures.

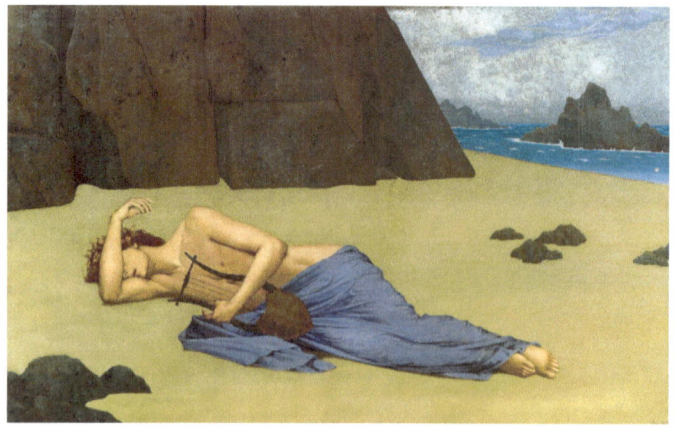

Orpheus Laments, Alexandre Séon, c. 1896, oil

I thought my version quite original, but I came across this image in a book on Symbolist art.

Orpheus' Head at Lesbos, 1996, egg tempera, 22 x 26 in.

I did about eight paintings of the episodes of Orpheus' life, this being the last. The image is entirely my own, except that Moreau did Orpheus' head on the lyre in a different context. It was always hard to find an appropriate style for the mythological paintings, but I think that the style and subject work together here.

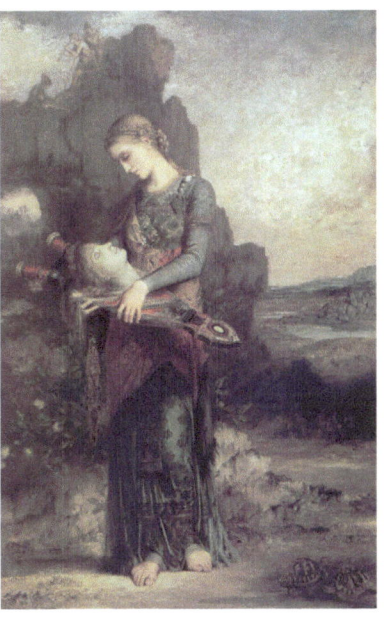

Thracian Girl Carrying the Head of Orpheus on His Lyre, Gustave Moreau, c. 1865, oil

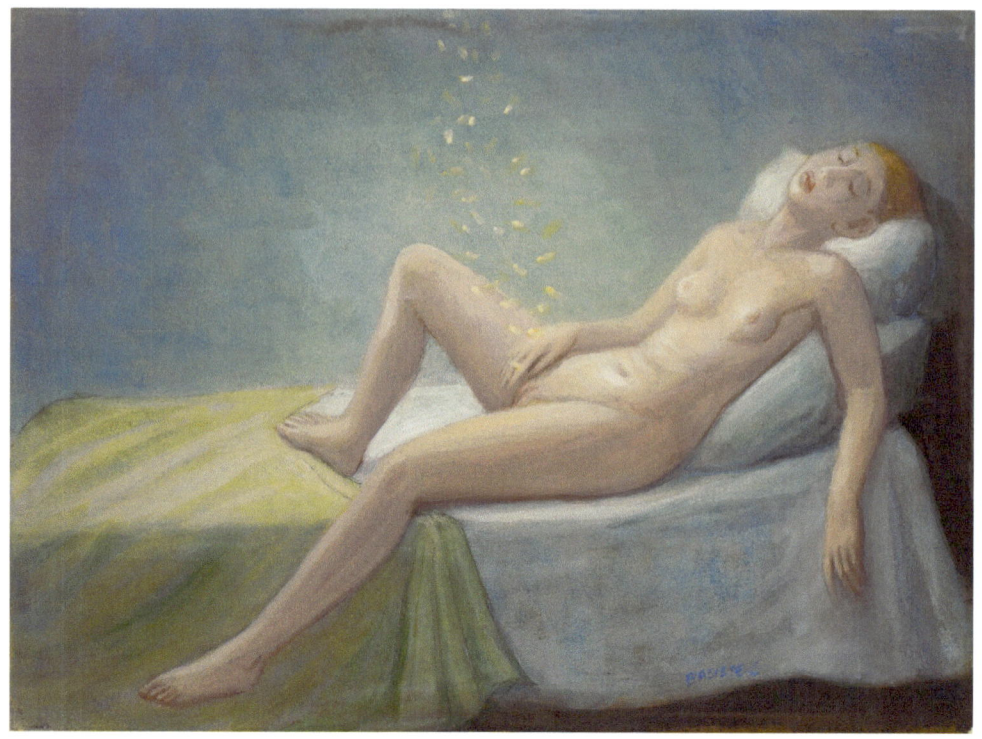

Danae, 2006, egg tempera, 9 x 12 in.

I've painted six versions of this erotic scene. Danae's father locked her in a tower, but Zeus came to her from above in a shower of gold. Her son was Perseus, who fulfilled the oracle's prophesy by killing his grandfather. The shower, usually of gold coins, was painted by Rembrandt, Titian, Correggio, and many others.

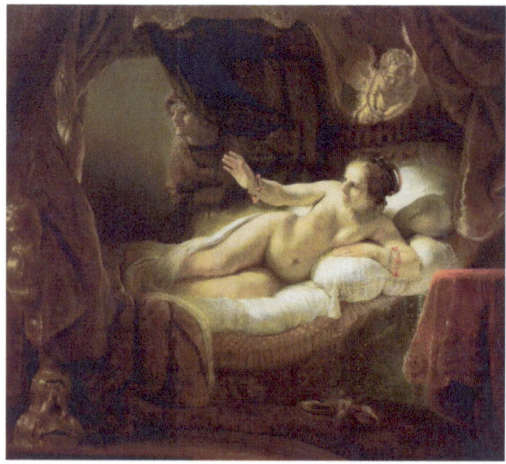

Danae, Rembrandt van Rijn, c. 1636–54, oil

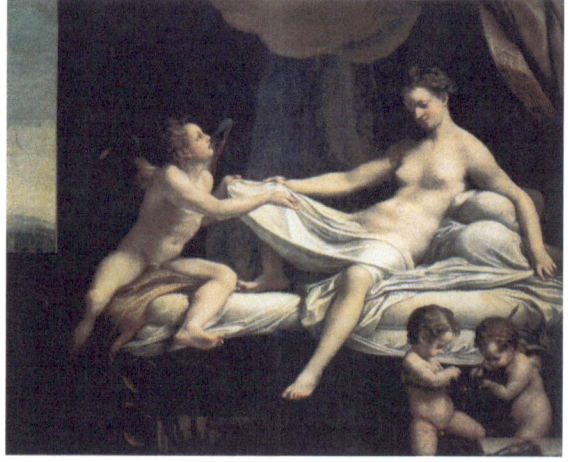

Danae, Antonio Allegri da Correggio, c. 1530–32, oil

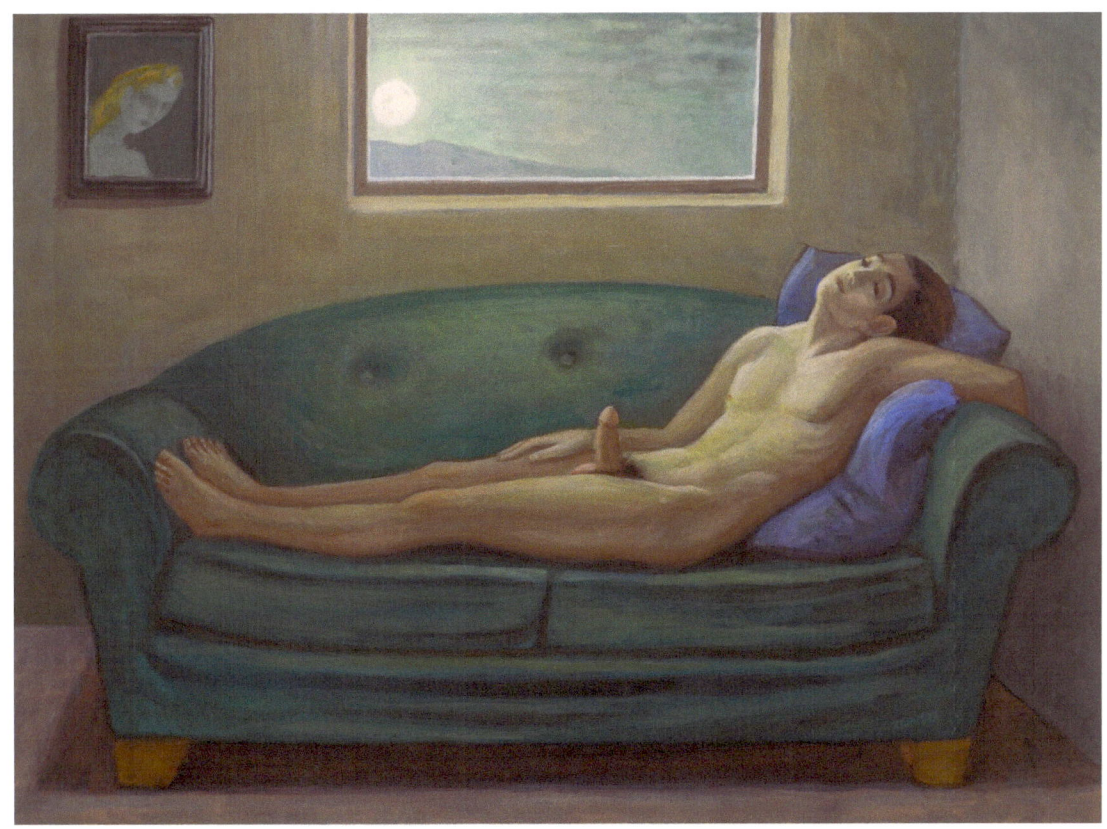

Endymion, 2007, oil over egg tempera, 18 x 24 in.

The moon goddess, Selene (or Diana), seduced Endymion. As he waited for her to come to him, he fell into an eternal trance. Here, the myths reverse sexual stereotypes without my help.

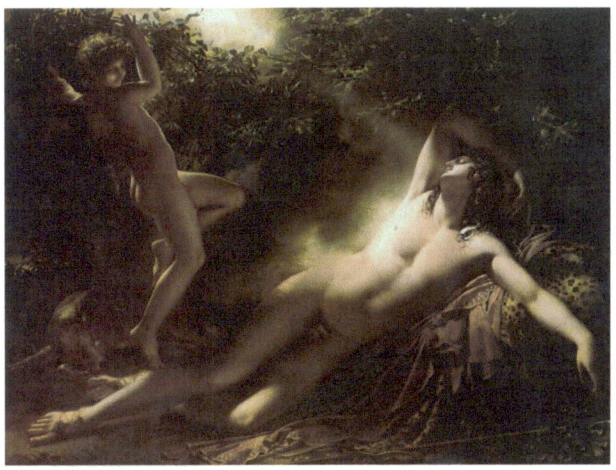

The Sleep of Endymion, Anne-Louis Girodet, c. 1791, oil

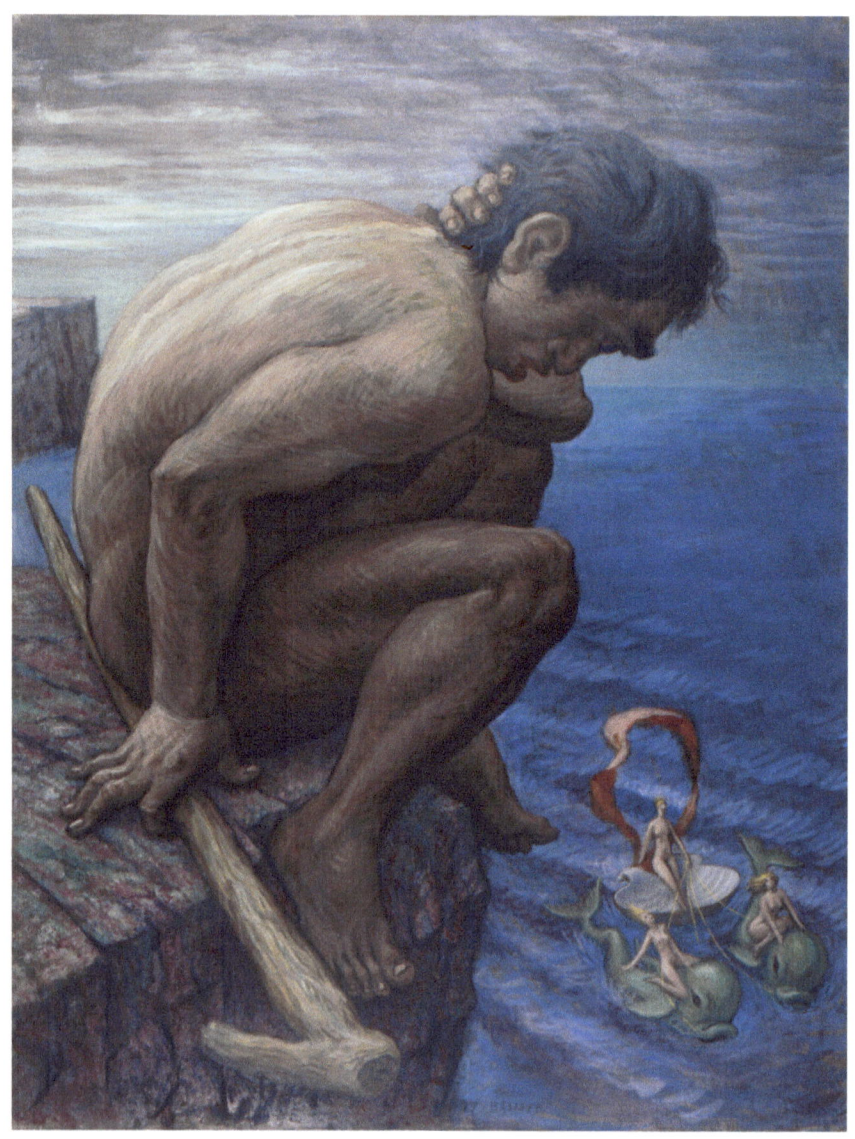

Polyphemus and Galatea, 1997, egg tempera, 24 x 18 in.

This giant Cyclops fell in love with the sea nymph Galatea to no avail. There is a marvelous Greek poem written as if in Polyphemus' voice by Theocritus. Here is an excerpt:

> You slip away from me, girl, unreachably graceful.
> No need to say the reason: this shaggy eyebrow,
> Which stretches from ear to ear across my forehead;
> This single eye and flattened nose; these lips.

—Theocritus, Idyll 11 (tr. R. Wells 1988)

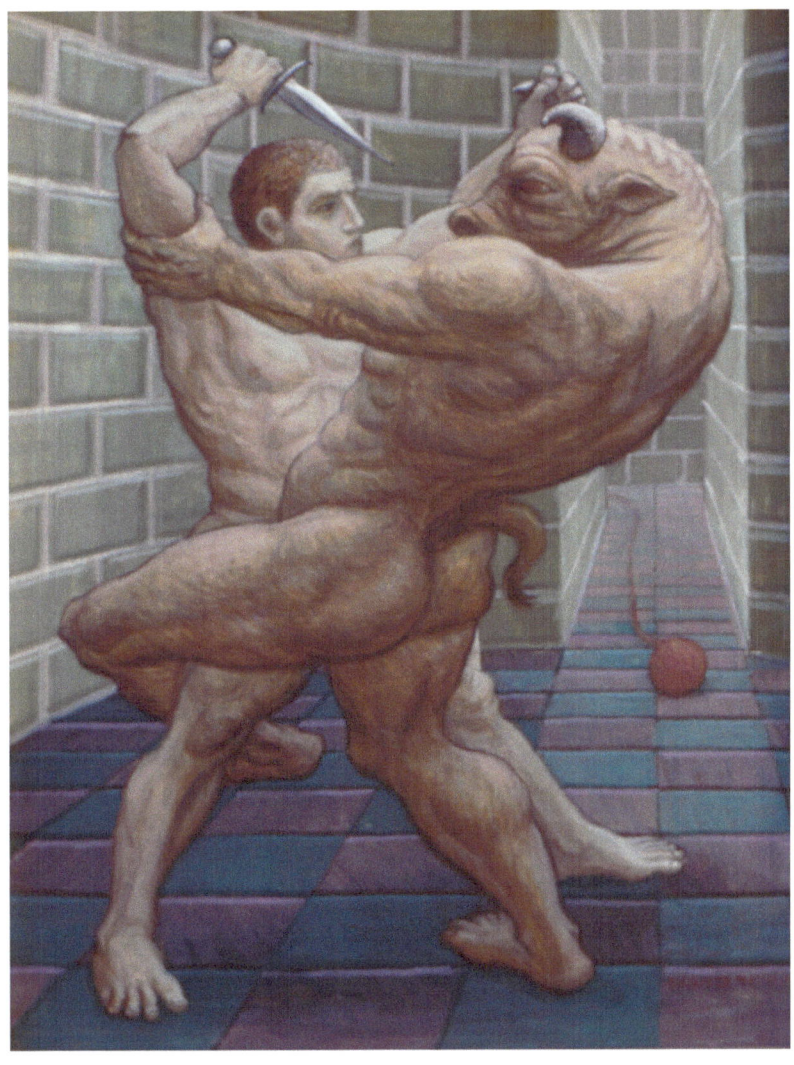

Theseus and the Minotaur, 1998, egg tempera, 16 x 12 in.

This grouping is inspired by another Paul Manship sculpture. The protagonists seem to grow out of each other—a psychologically disturbing image. The tempera is applied in the traditional style of small hatching strokes, a tighter technique than my usual hit-and-miss search for the final image.

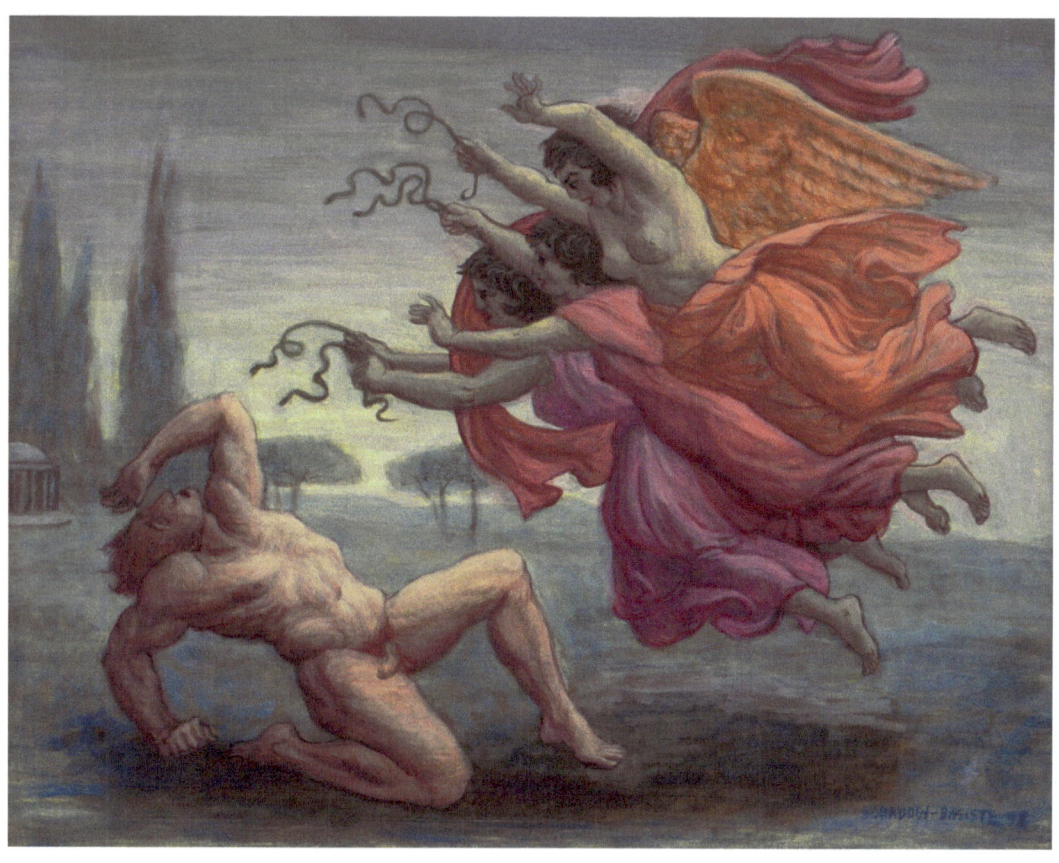

Orestes, 1998, egg tempera, 16 x 20 in.

Orestes was tormented by the Furies because he killed his mother, Clytemnestra. The image was taken from a nineteenth-century German print by a Nazarene, who belonged to a commune of German artists who converted to Catholicism and lived in an abandoned monastery in Rome.

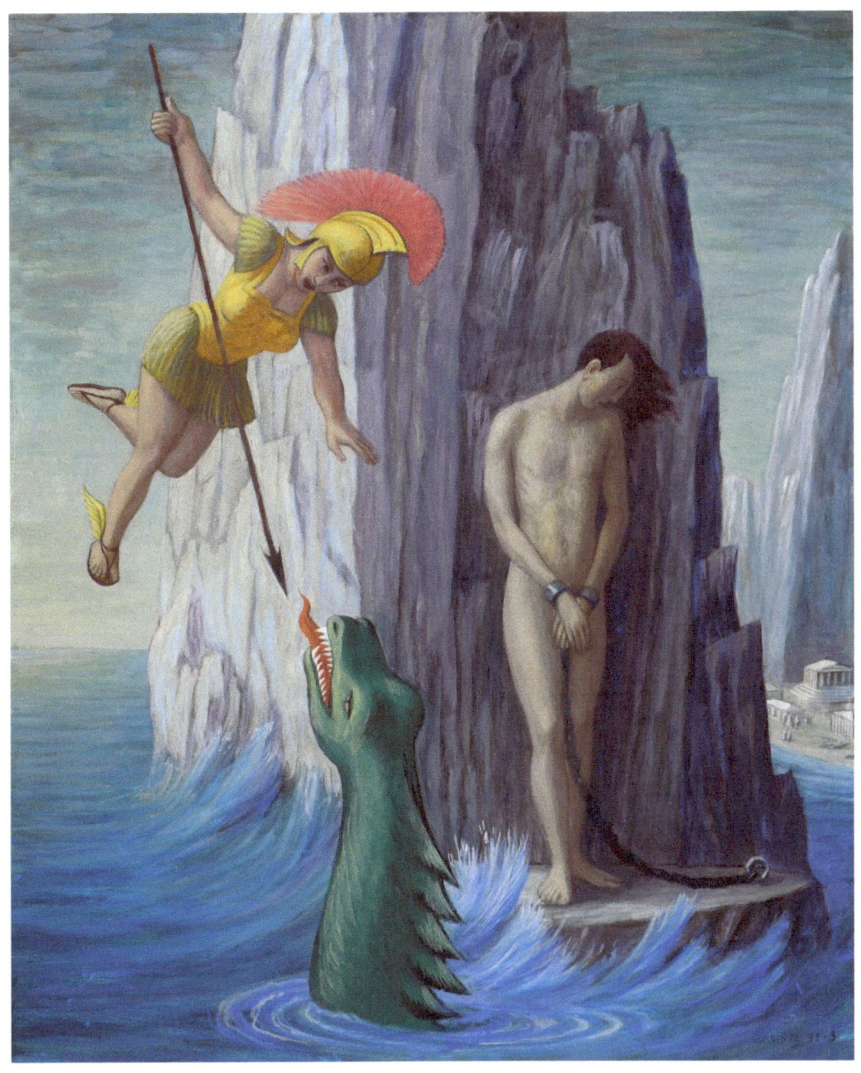

Perseus and Andromeda Reversed, 2003, egg tempera, 20 x 16 in.

The traditional image seemed so sexist and sadomasochistic that I switched the sexes.

V. Contemplative Nudes

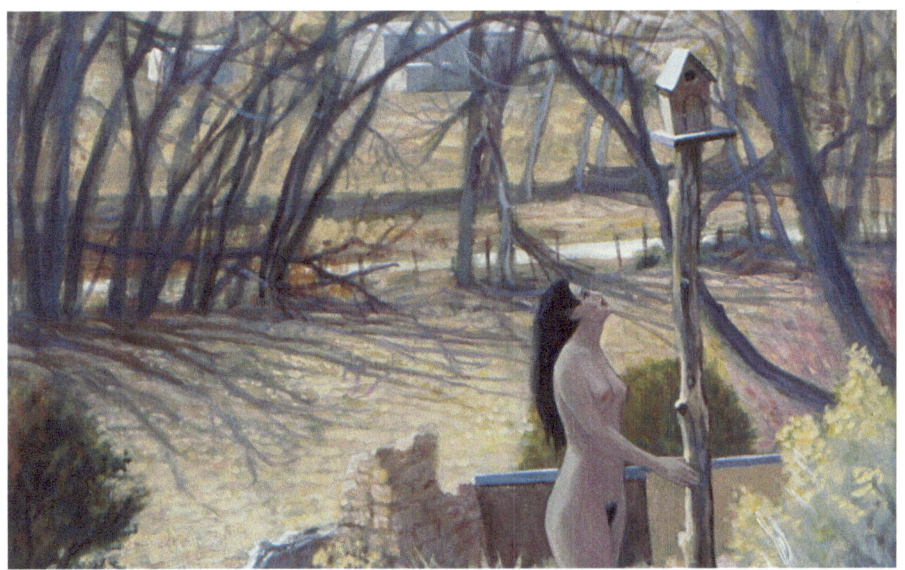

In my paintings from the last twenty years, the nudes seem increasingly introspective. They appear private and self-absorbed, experiencing personal moments in familiar surroundings. There are few extraneous references. These paintings are not meant to express my anxiety. There are no social messages or ironic intentions, nor are they supposed to be illustrating my sexual tensions. And there are no mythological texts or subtexts.

Aesthetic issues of structure and composition are important. In a letter, Thomas Eakins said that a painting is a depiction of a figure defined by light and shadow and surrounded by space. I try to reduce images to their essentials. My style has become an uneasy mixture of social realism, classicism, and art deco.

Several artists come to mind. I am in awe of the pastels by Degas of women washing themselves. In his day, the critics were disturbed by the perceived ugliness of his women, whose unseemly movements they thought should have remained hidden in the privacy of their bathrooms.

Modern feminists have concurred, with the added caveat that the artist and his male public should not have been peering through the metaphorical keyhole. At the risk of being politically incorrect, the Degas nudes do not make me feel that I am a naughty voyeur or that the women are ungainly. To me, they seem healthily self-assured, as I want the women in my paintings to be.

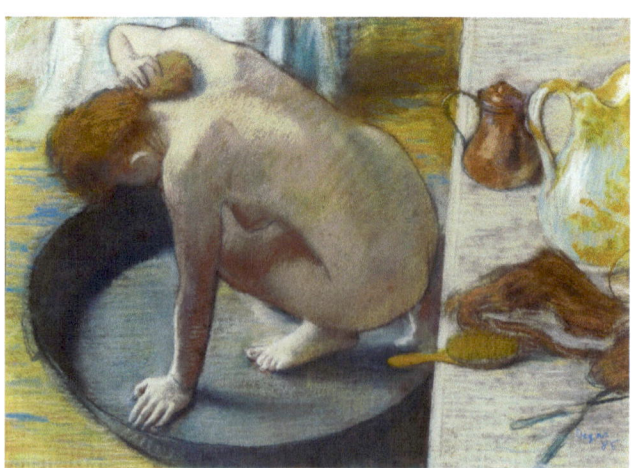

The Tub, Edgar Degas, 1886, pastel on paper

Raphael Soyer, who also loved Degas, has been a strong influence on my work since I studied with him, more than fifty years ago. Like Soyer, I have been depicting slightly melancholy, contemplative young women. My nudes are imaginary, as opposed to his use of models, and are consequently more generalized than his nudes.

On the other hand, the surroundings I paint are more defined, while Soyer's models are depicted in vague studio setups, which often include a cot and a folding screen. My matte tempera surface contrasts markedly with his brushy application of oil paint.

Two other artists who inspire my recent paintings were not painters primarily of nudes: Jan Vermeer and Edward Hopper. They depicted women in interiors, seemingly suspended in the moment. Vermeer's rooms are permeated by a quiet light, while Hopper's space is almost palpable. These are qualities that I emulate.

As with all my nudes, the women in the Nudes at Home series may be "the other," but they are also aspects of me. This series expresses the comfort I feel in my surroundings, and these paintings are, at their best, a contemplative containment in which all the elements are in harmony.

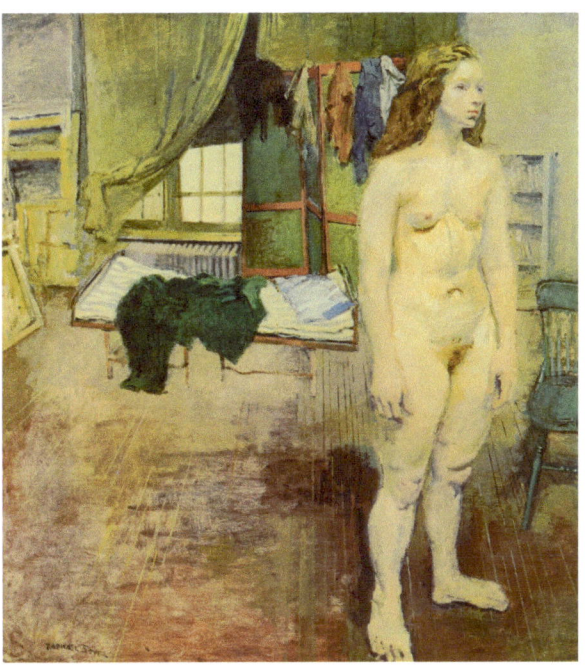

Interior with Nude, Raphael Soyer, 1958, oil on canvas

This large painting was done the year I started painting with Soyer at the New School for Social Research. I saw it at the Whitney Annual, where I felt it more than held its own surrounded by Abstract Expressionism, and other modernist paintings.

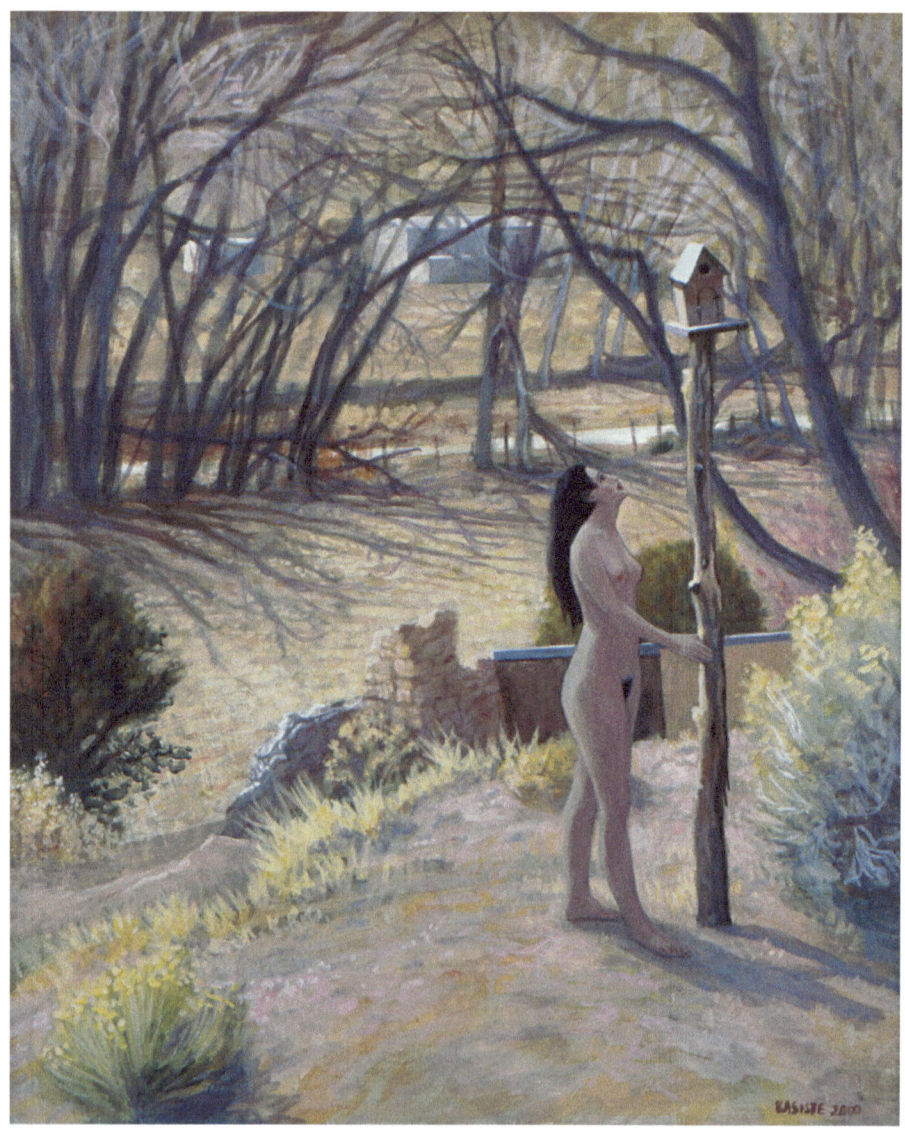

Woman with Birdhouse, 2000, egg tempera, 20 x 16 in.

The Embudo River and the ruins of the first studio I built are behind the nude. The birdhouse is deserted; the nude is fictitious.

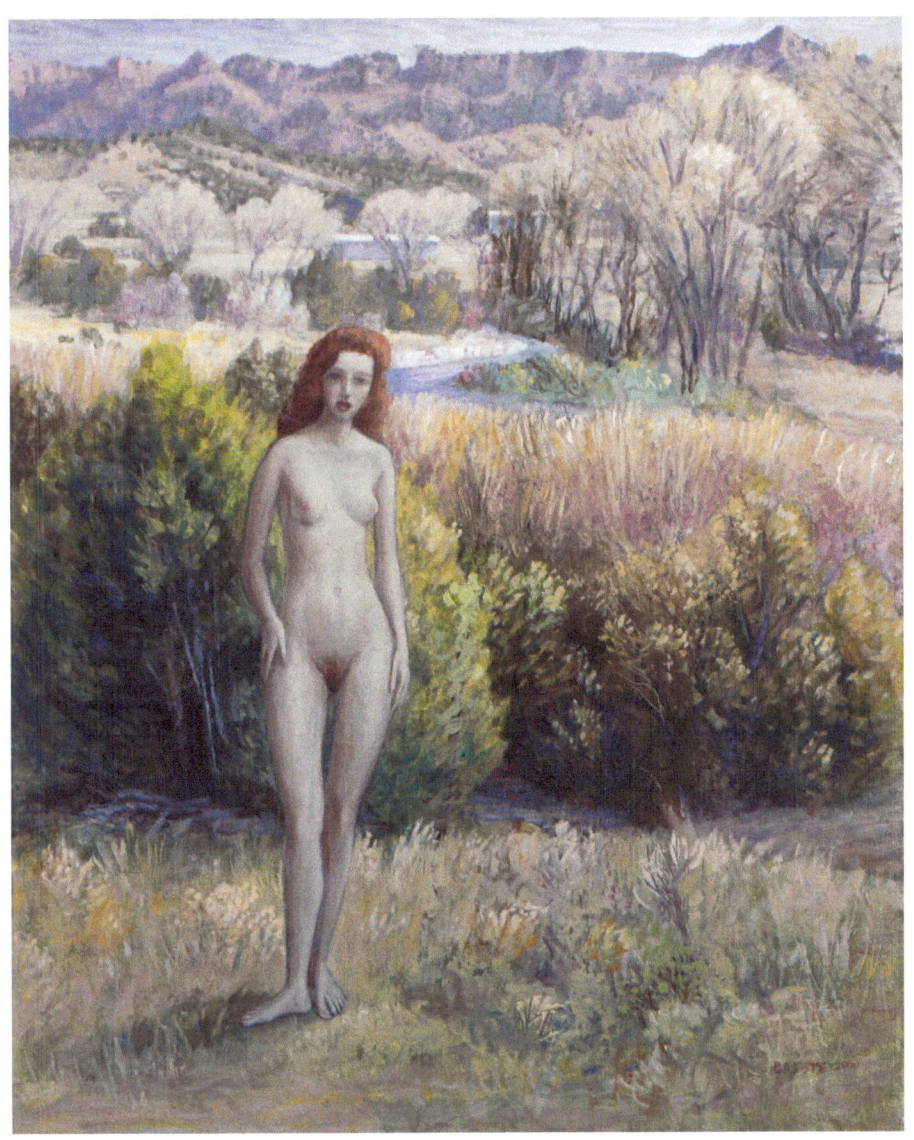

Woman in the Grass, 2000, egg tempera, 20 x 16 in.

Originally, she had a partner, but I couldn't fit him comfortably into the scene. The nymphs that inhabit the landscape around my studio are rarely seen.

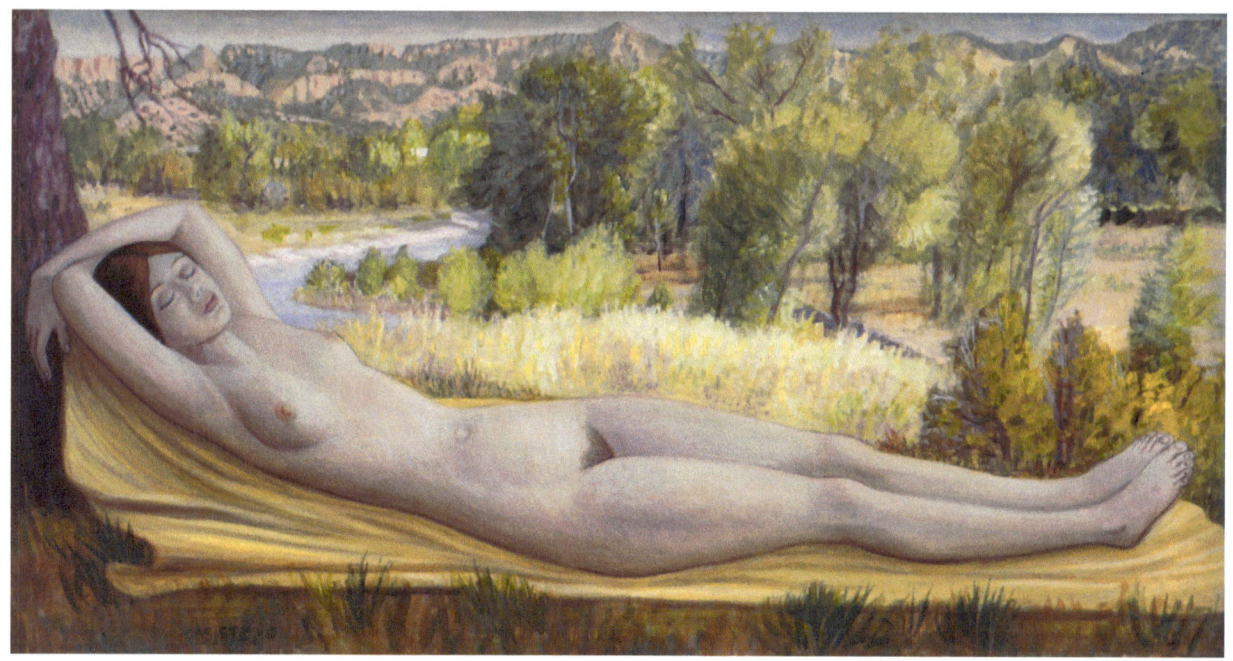

Apodaca Giorgione, 2000, egg tempera, 16 x 30 in.

I've tried to adapt the sleeping Venus to many contemporary scenes. Here, I've added a tree trunk for her to lean against. In Giorgione's painting, there was originally a cupid at her feet, but he painted over it and thus made Venus' identity doubtful. Perhaps he, too, felt that her son Cupid, was an equivocal attribute for the love goddess, or maybe the artist wasn't painting Venus after all.

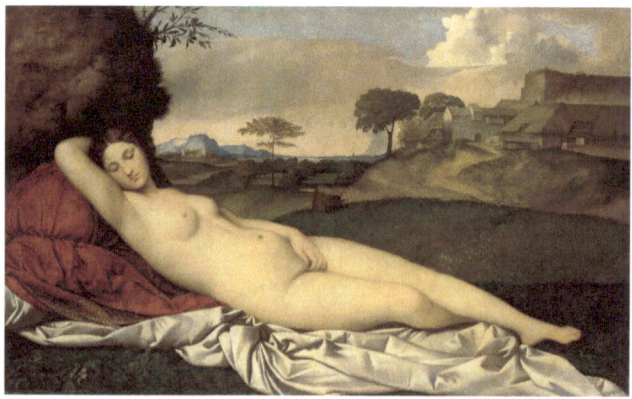

Sleeping Venus, Giorgione, c. 1508–10, oil on canvas

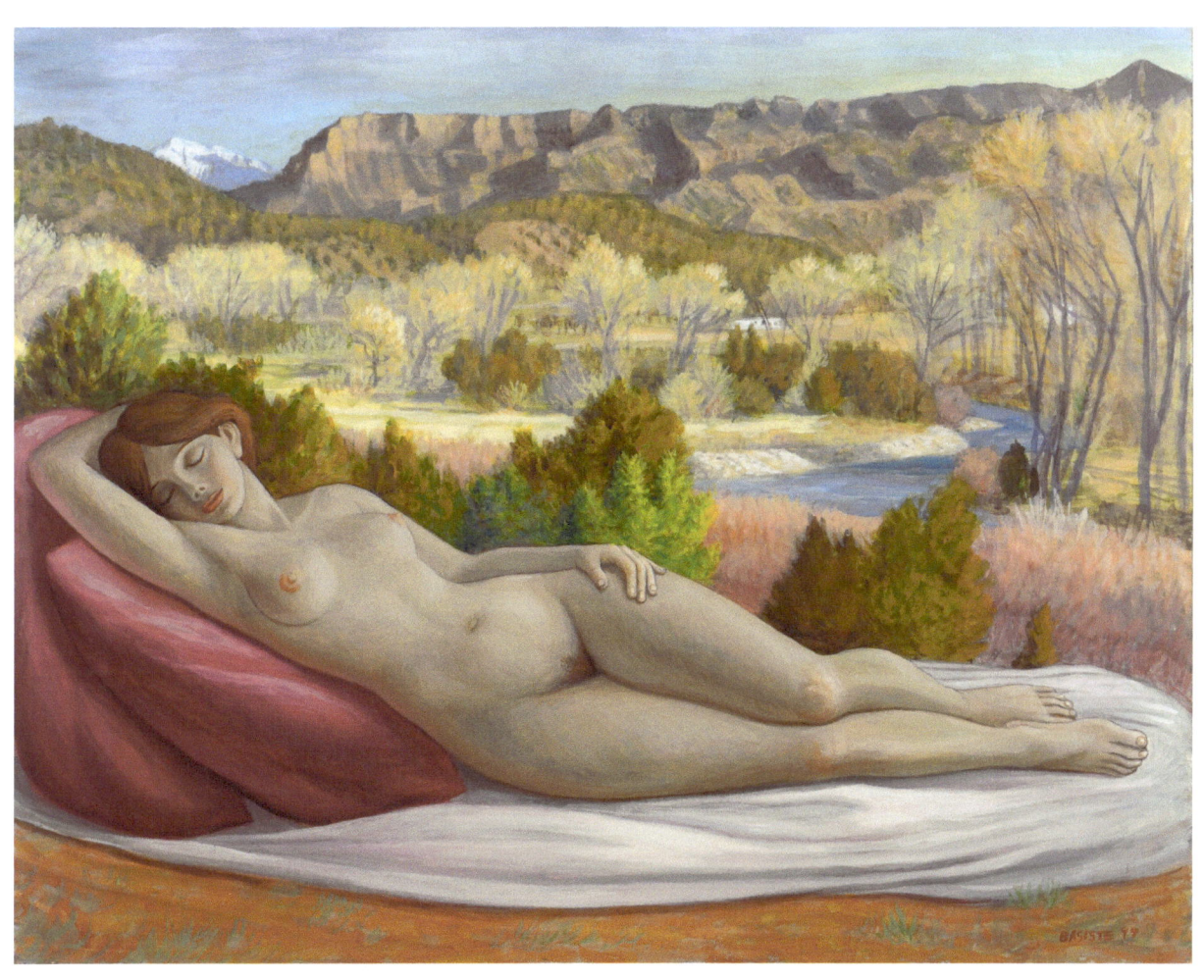

Apodaca Sleeping Venus, 1999, egg tempera, 24 x 30 in.

This painting was adapted from a black-and-white reproduction of a nude by one of Hitler's favorite artists, Adolf Ziegler.

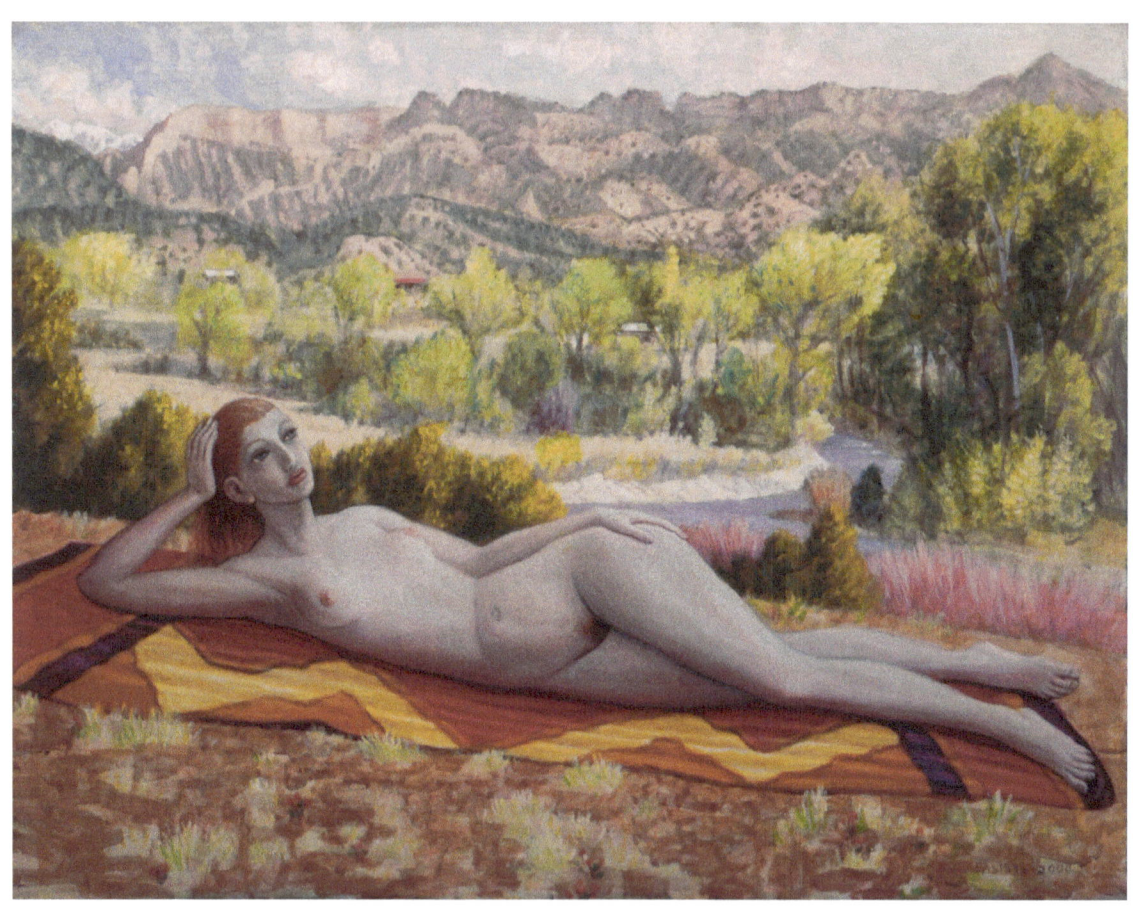

Nude on Red and Yellow Blanket, 2000, oil over egg tempera, 18 x 24 in.

Like many artists before me, I tried to paint nudes in landscapes. At least, I didn't pose models in the studio and then make up landscapes around them. Just the opposite—I painted the scenery through the studio window and then tried to fit imaginary nudes into the scenes. In this instance, I even made up a Native American blanket to protect her from the little cactuses and devil's eyelashes.

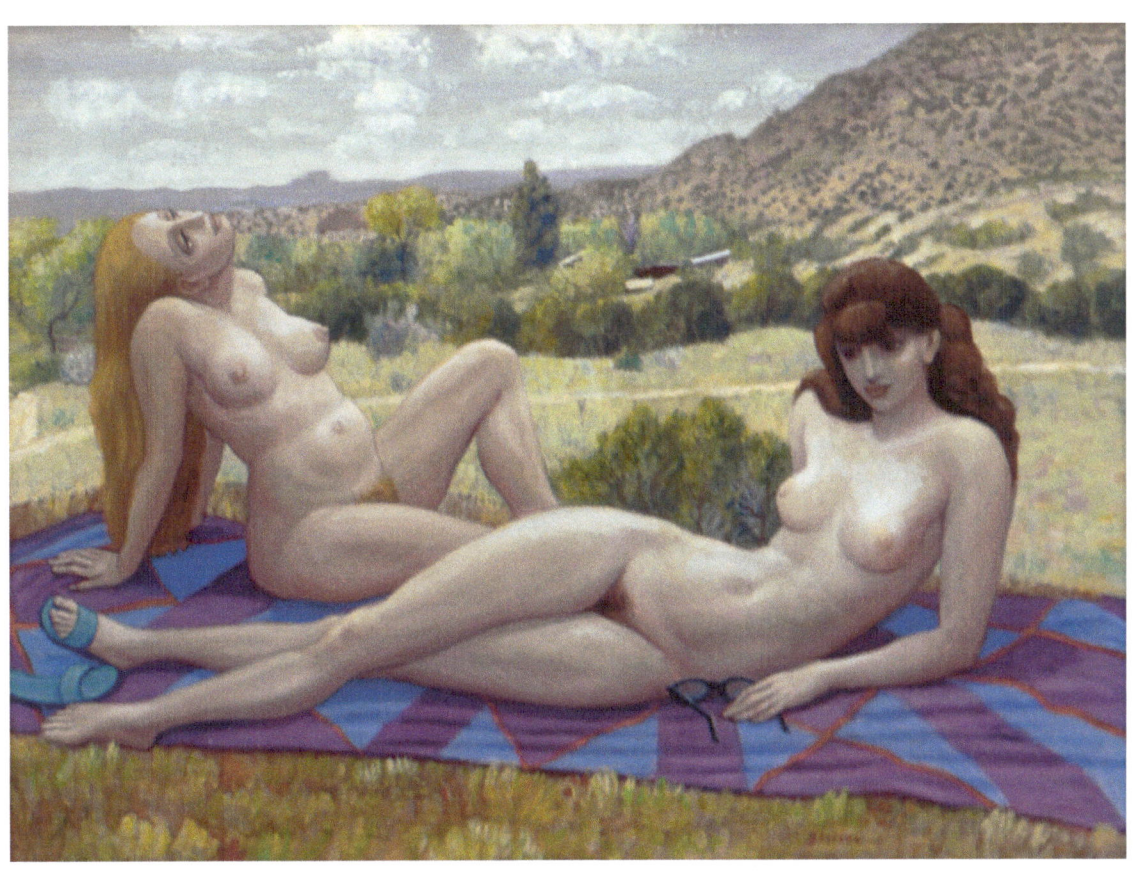

Two Nudes, Apodaca, 2000, oil over egg tempera, 18 x 24 in.

At first, I gave them bathing suits, but that looked ridiculous. This side window looks out over an arroyo, so I created a foreground.

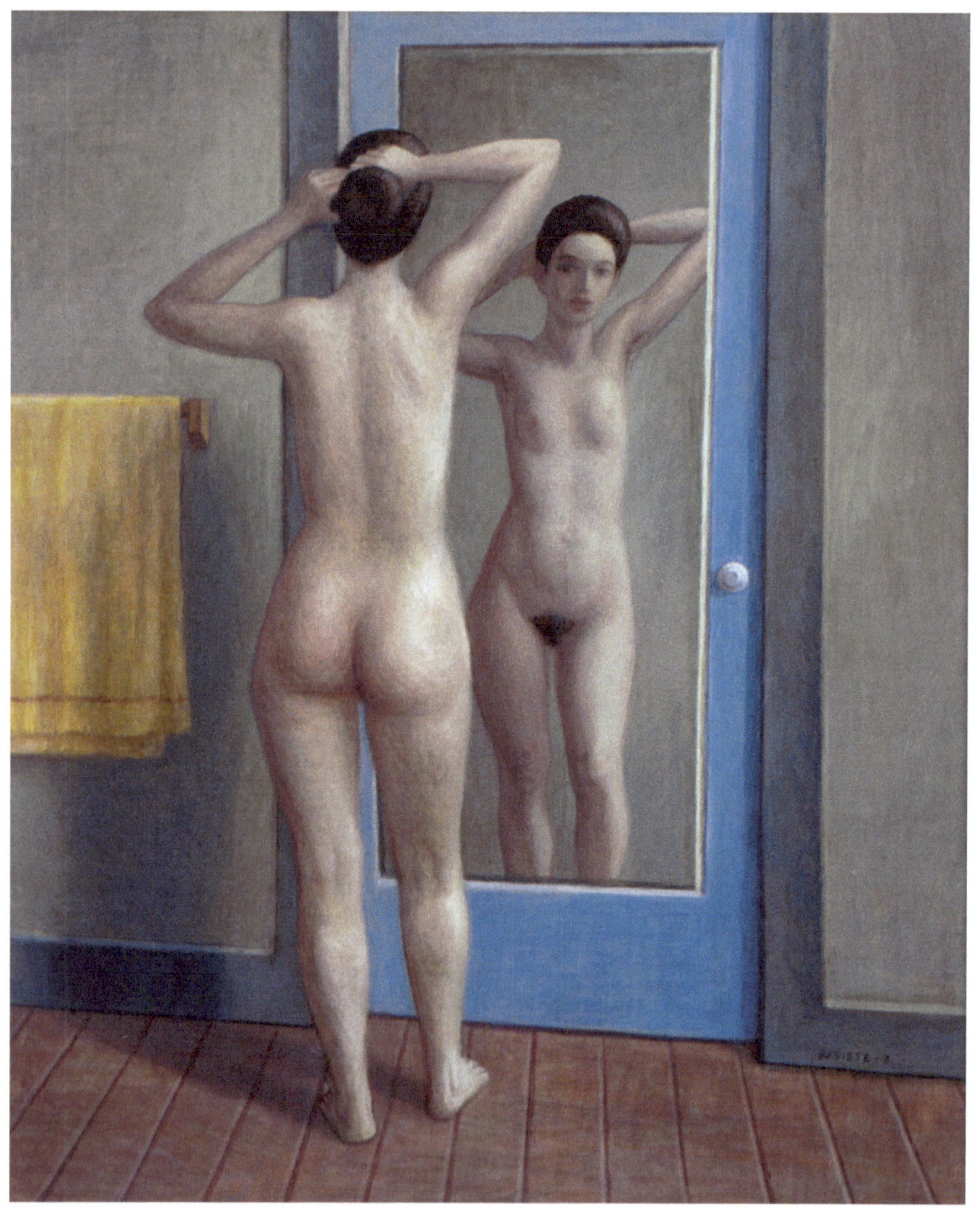

Nude, Door, and Mirror, 2003, egg tempera, 30 x 24 in.

A full-length nude reflected in a long mirror is a complicated subject to paint. We see the woman's reflection, but she must be able to see it, too. And it's hard to make the reflection accurate and in scale. I studied a book of paintings of women in mirrors by artists of the past, and almost all of the paintings were off, especially in the sizes and angles of the reflections.

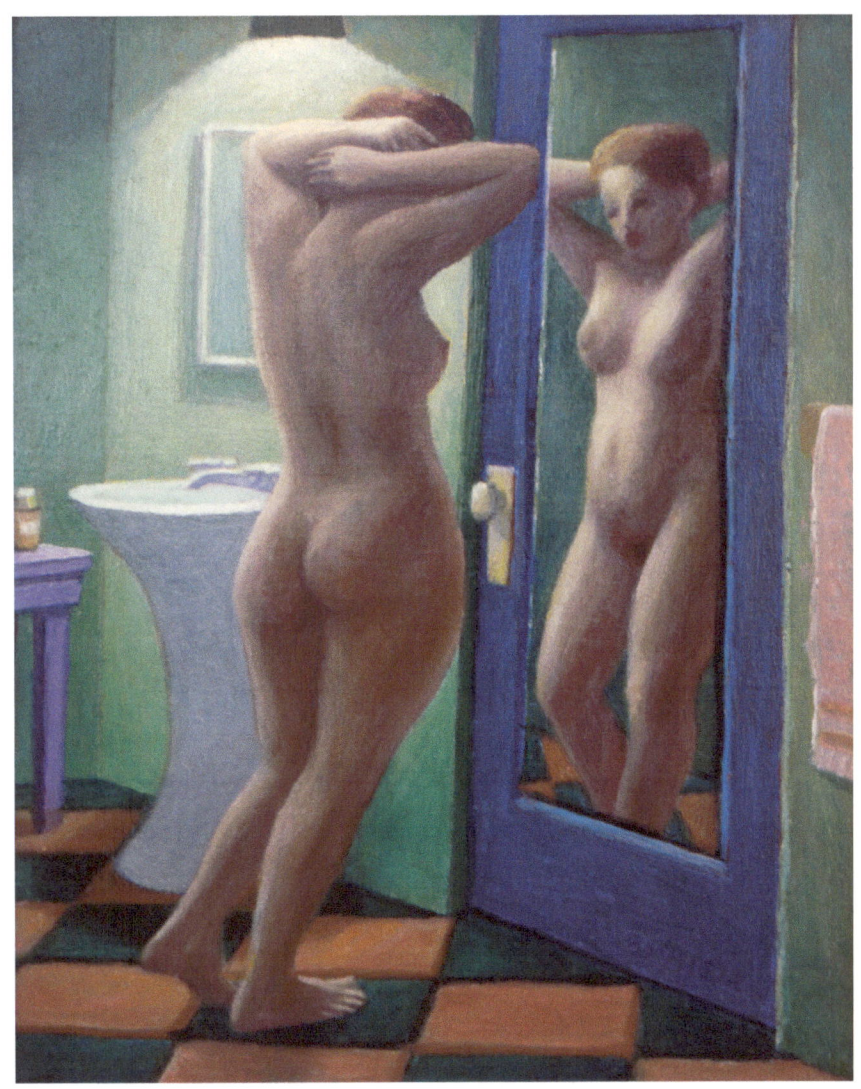

In Bathroom Mirror, 2002–06, oil over egg tempera, 12 x 9 in.

At this angle, in reality, either she wouldn't see her reflection, or we wouldn't. Surprisingly, the crazy colors and bathroom details work well with this figure.

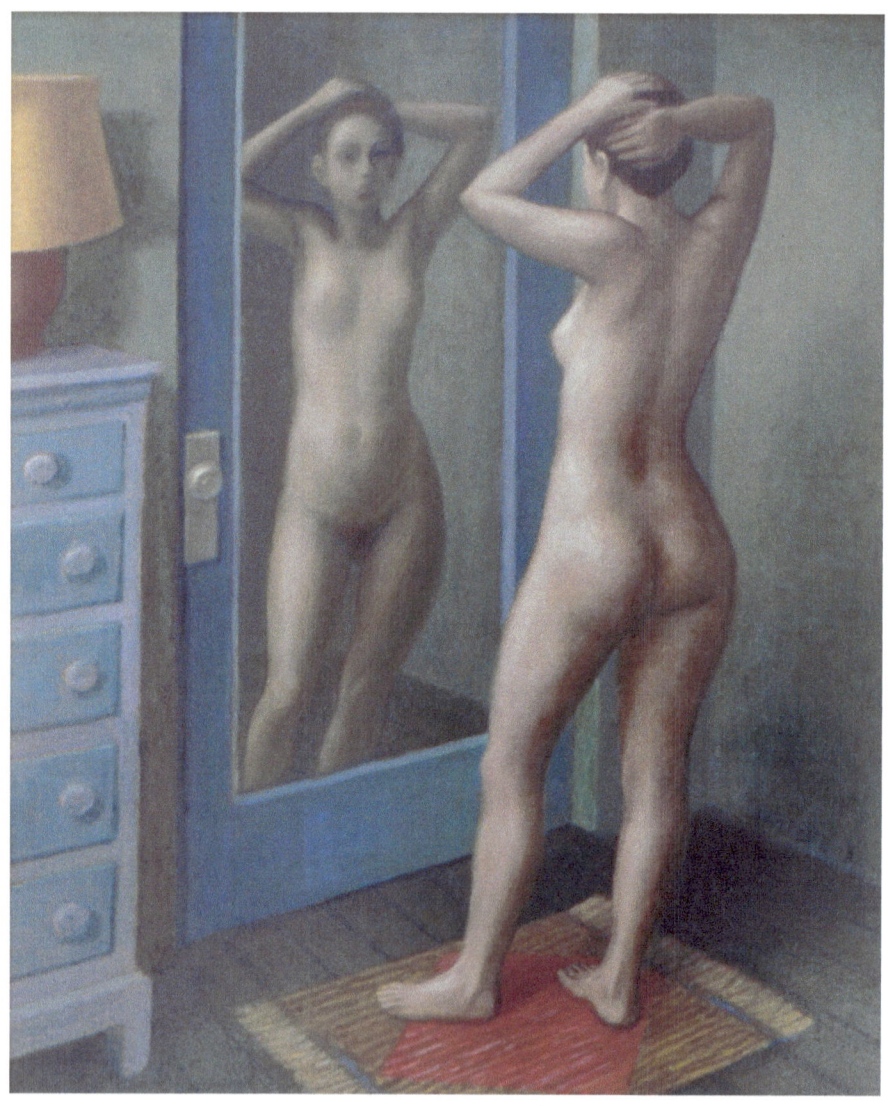

Nude, Mirror, and Blue Dresser, 2003, oil over egg tempera, 20 x 16 in.

I've depicted a detached moment of contemplative self-reflection. Where do the props in these paintings come from? My house has adobe walls, hardened dirt floors, unpainted wood dressers.

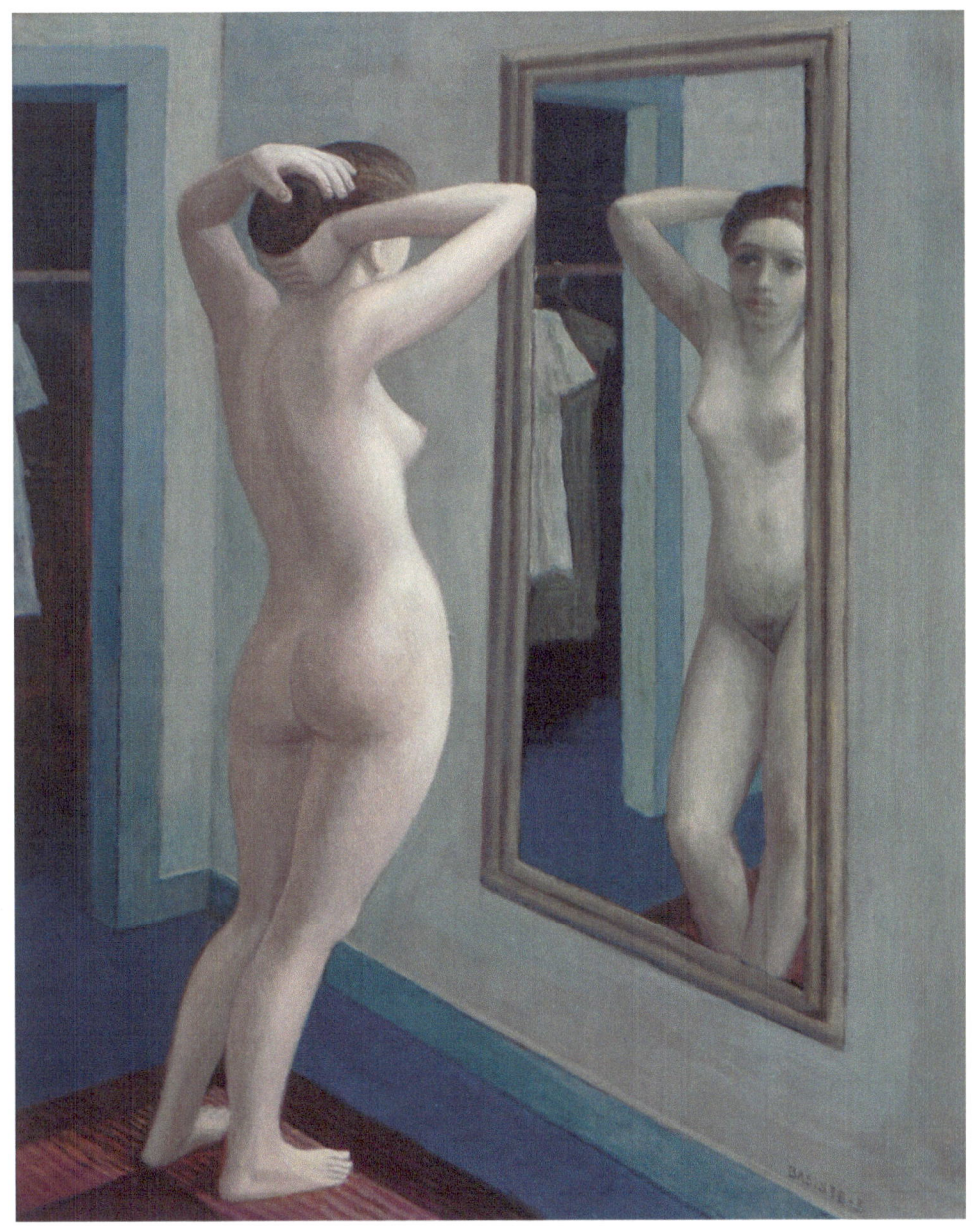

Green Room, 2005, egg tempera, 28 x 22 in.

She likes herself and looks forward to dressing and going out.
This painting has a nice harmony of cool colors.

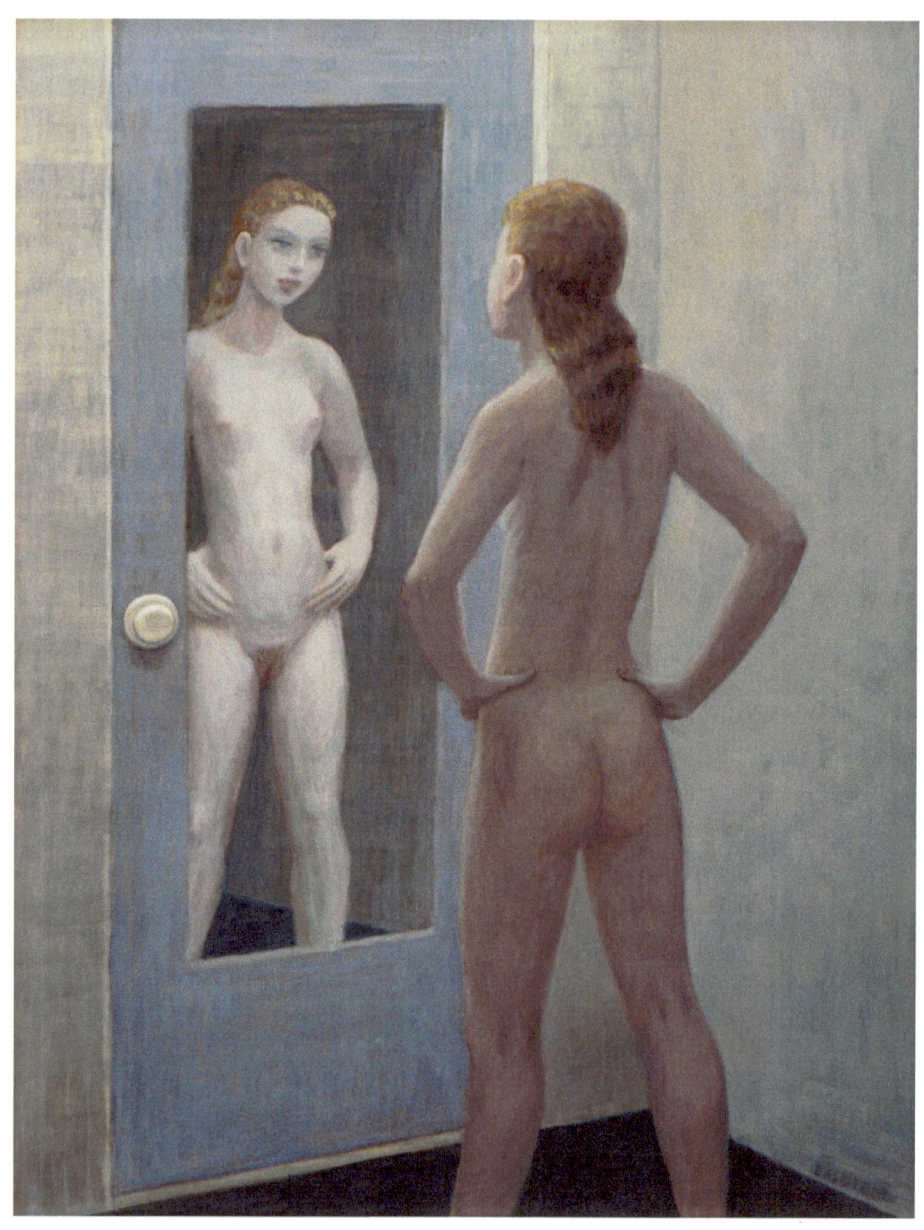

Posing in Mirror, 2004, egg tempera, 24 x 18 in.

This young lady, just developing, is pleased and amused. Is this too positive an image?

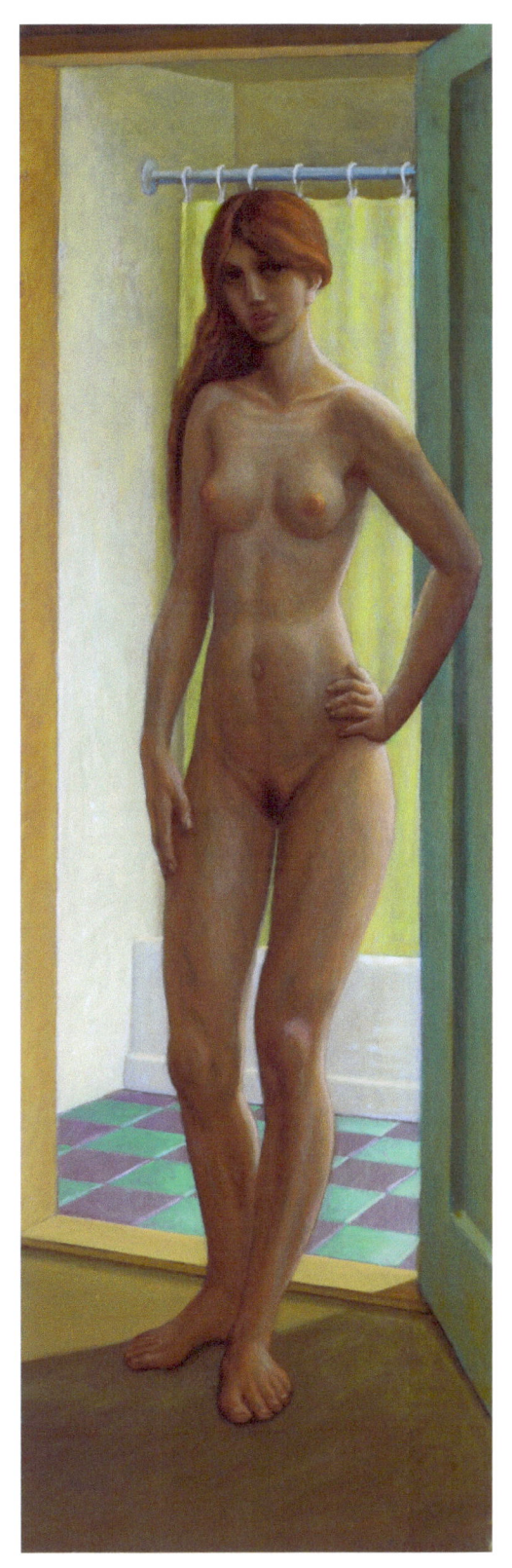

Woman in Bathroom Doorway, 2002, oil over egg tempera, 40 x 12 in.

This long vertical nude was carefully worked up from a study. In an effort at an academic showpiece, I underpainted the panel with egg tempera and then glazed it with oil.

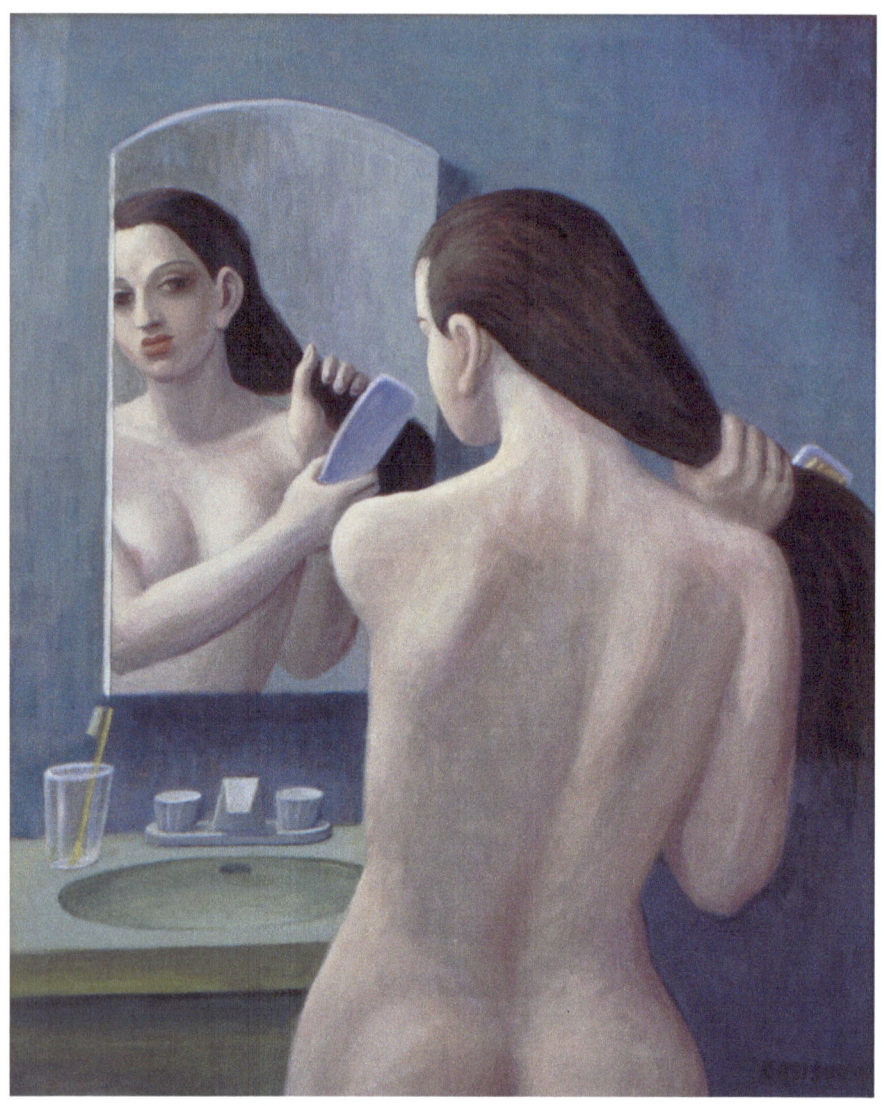

Green-and-Blue Bathroom, 2005, egg tempera, 20 x 16 in.

I've updated Eckersberg (below) by locating the moment in a bathroom and even adding a toothbrush.

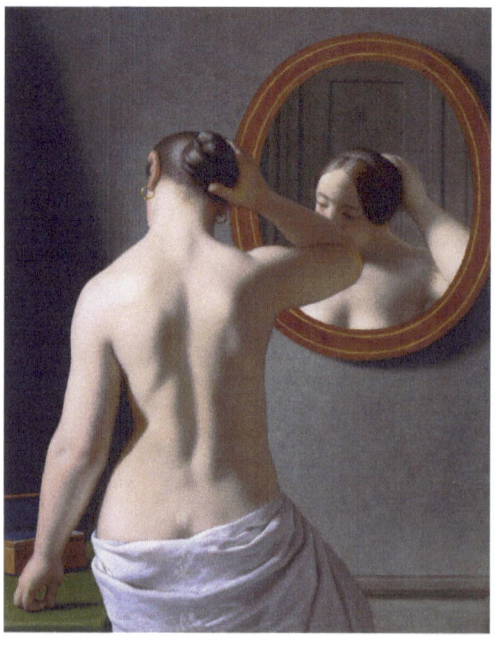

Woman Standing in Front of a Mirror, Christoffer Wilhelm Eckersberg, c. 1841, oil

The artist was a leader of a little-known flowering of Neo-classical realism in early nineteenth-century Denmark.

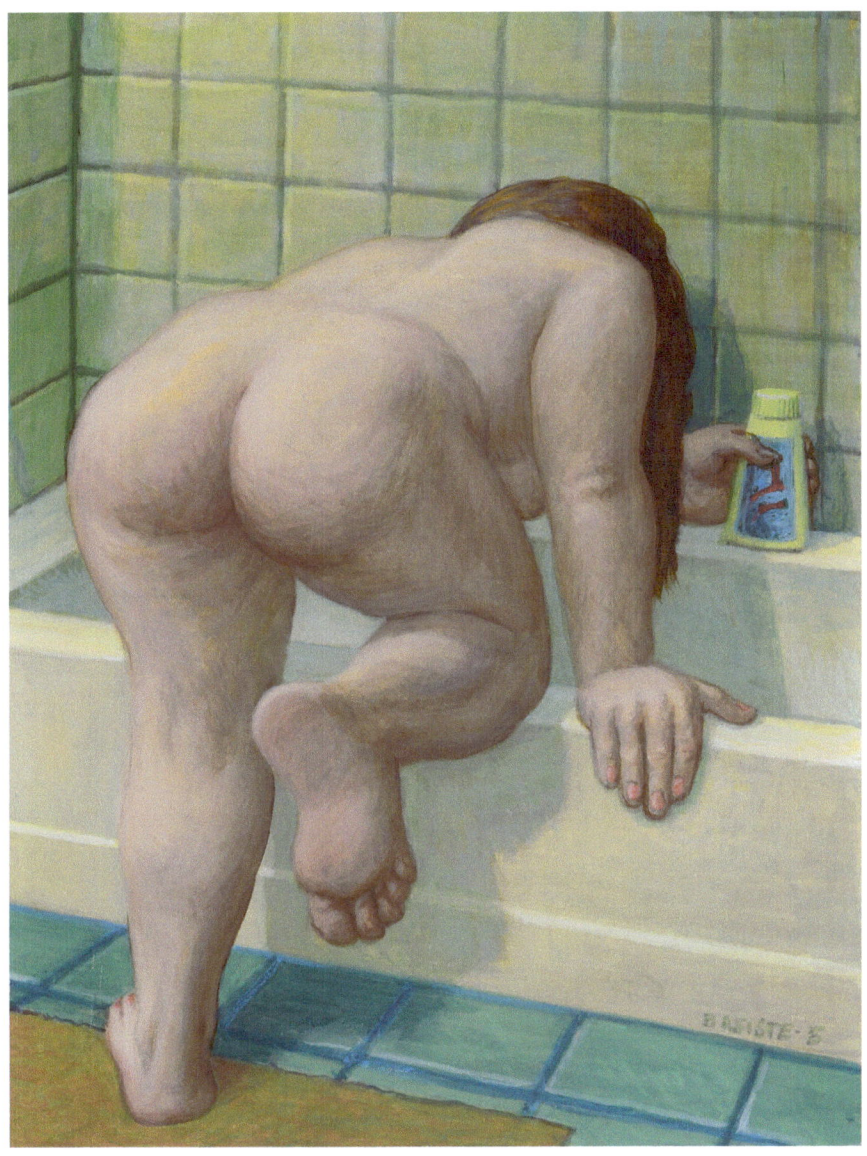

Leaning over Tub, 2005, egg tempera, 16 x 12 in.

Here, we have an awkward pose, not meant to be observed—as if the viewer came into the bathroom unexpectedly. This is the first painting in my bathtub series.

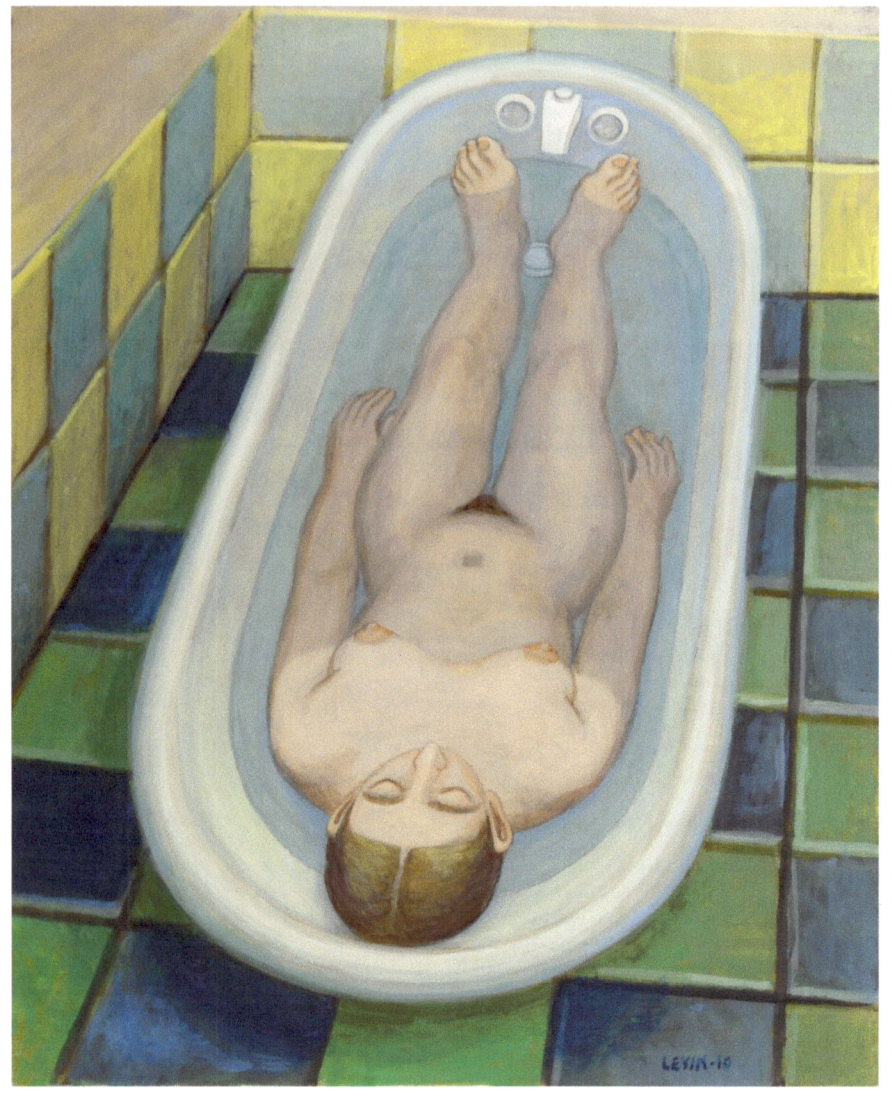

Nude in Tub, 2010, egg tempera, 20 x 16 in.

The upside-down foreshortening gives this image an unexpected floating quality. Bonnard did similar subjects, but my careful perspective structures are far from his carefree spatial distortions.

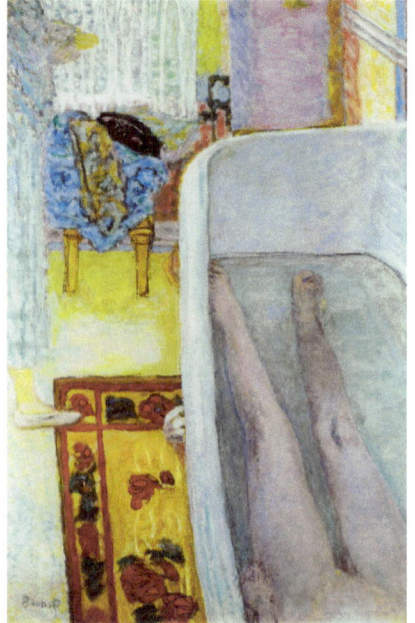

Nude in the Bath, Pierre Bonnard, c. 1925, oil

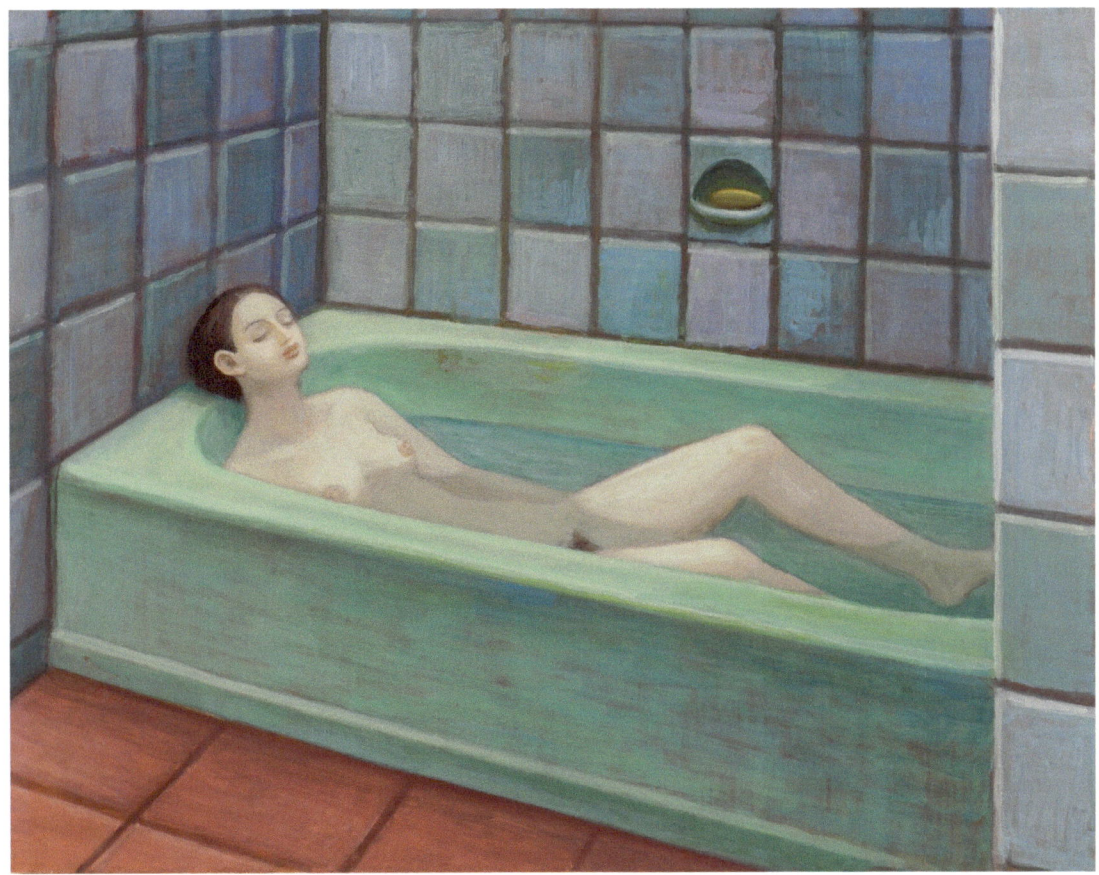

Woman in Green Bathtub, 2008, egg tempera, 16 x 20 in.

I've recently painted and etched several variations of women in bathtubs—up, down, left, and right. I like how the subtle tiles hold the space here. This is close to how our bathroom looks, though we have a window set into the tiles over the tub.

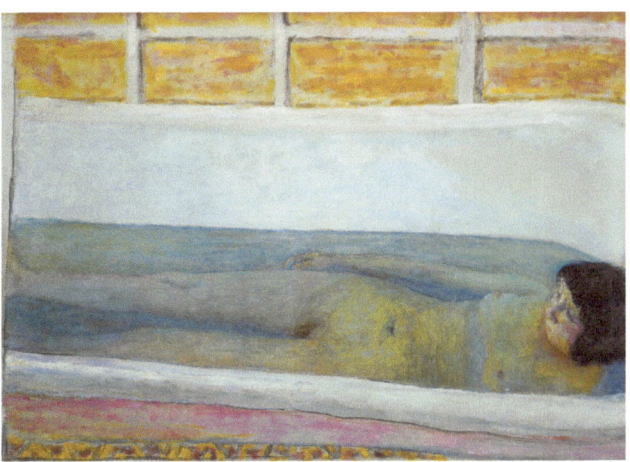

The Bath, Pierre Bonnard, c. 1925, oil

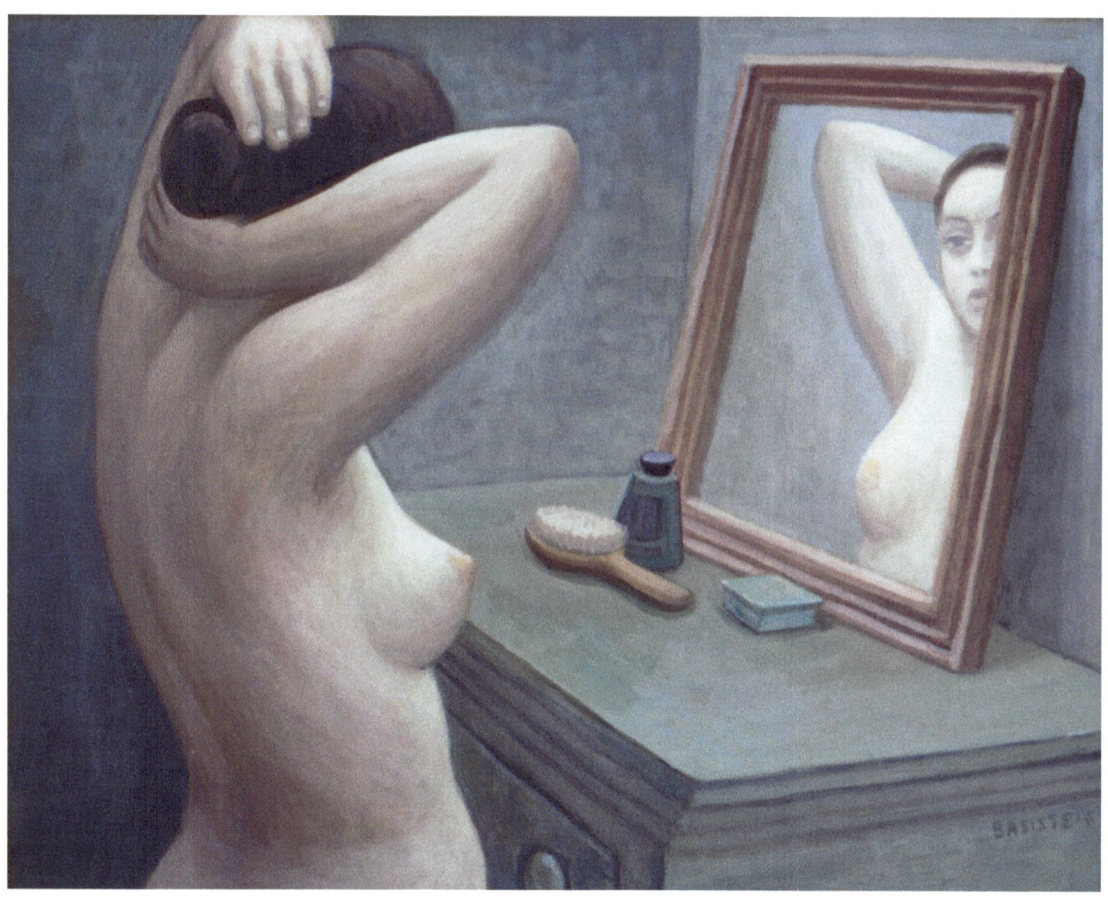

Fixing Her Bun, 2006, egg tempera, 16 x 20 in.

There must be a dozen versions of my composition of a half-length nude with bureau and mirror. This version has an understated, classic simplicity with a strong geometric structure.

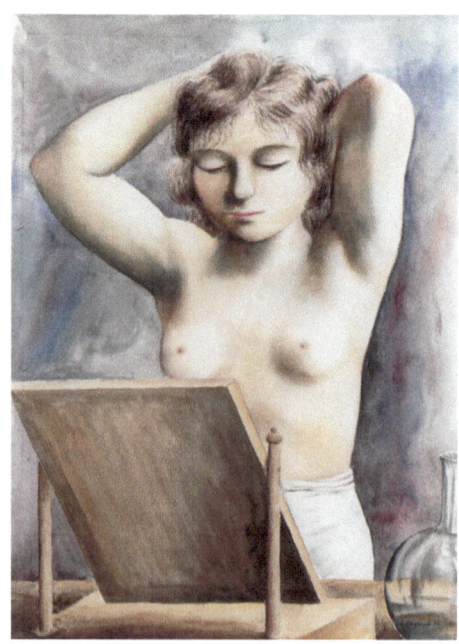

Girl in Front of a Mirror, Georg Schrimpf, c. 1926, watercolor over pencil

In egg tempera I painted a copy of this touching New Objectivity image before I did several versions of my own.

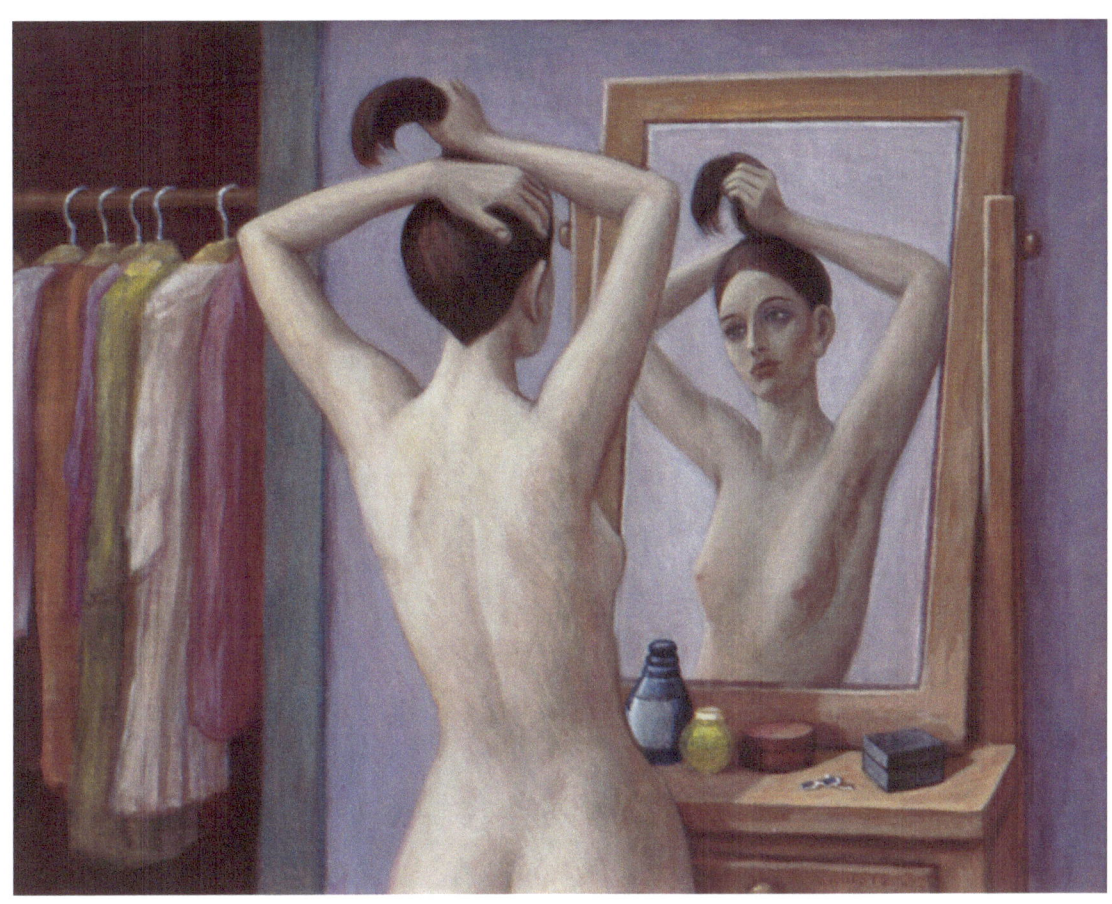

Topknot, 2003, egg tempera, 16 x 20 in.

This is a good design—the closet and the accessories well integrated. But the reflection is leaning the wrong way.

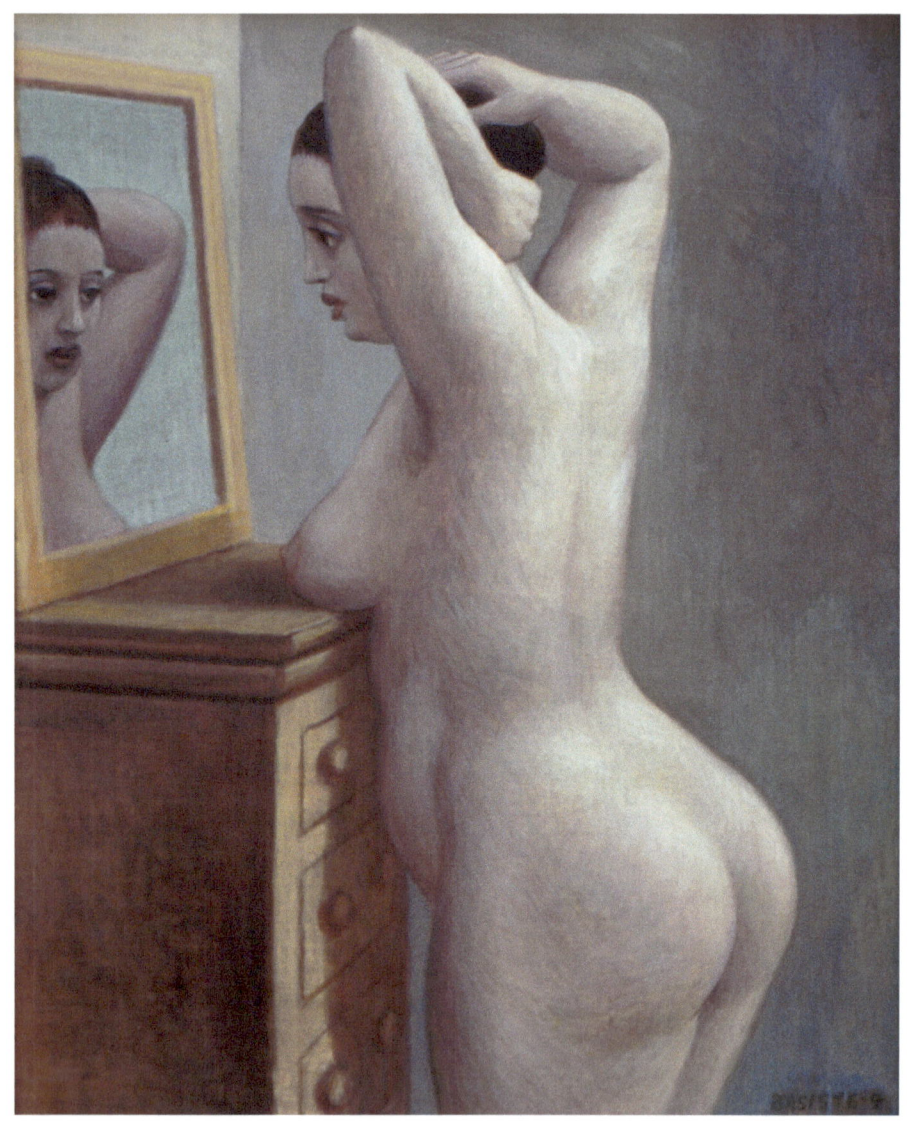

At the Bureau Mirror, 2004, egg tempera, 20 x 16 in.

I like her soft curvy body, the humor of the breasts on the top of the chest, and the rows of knobs.

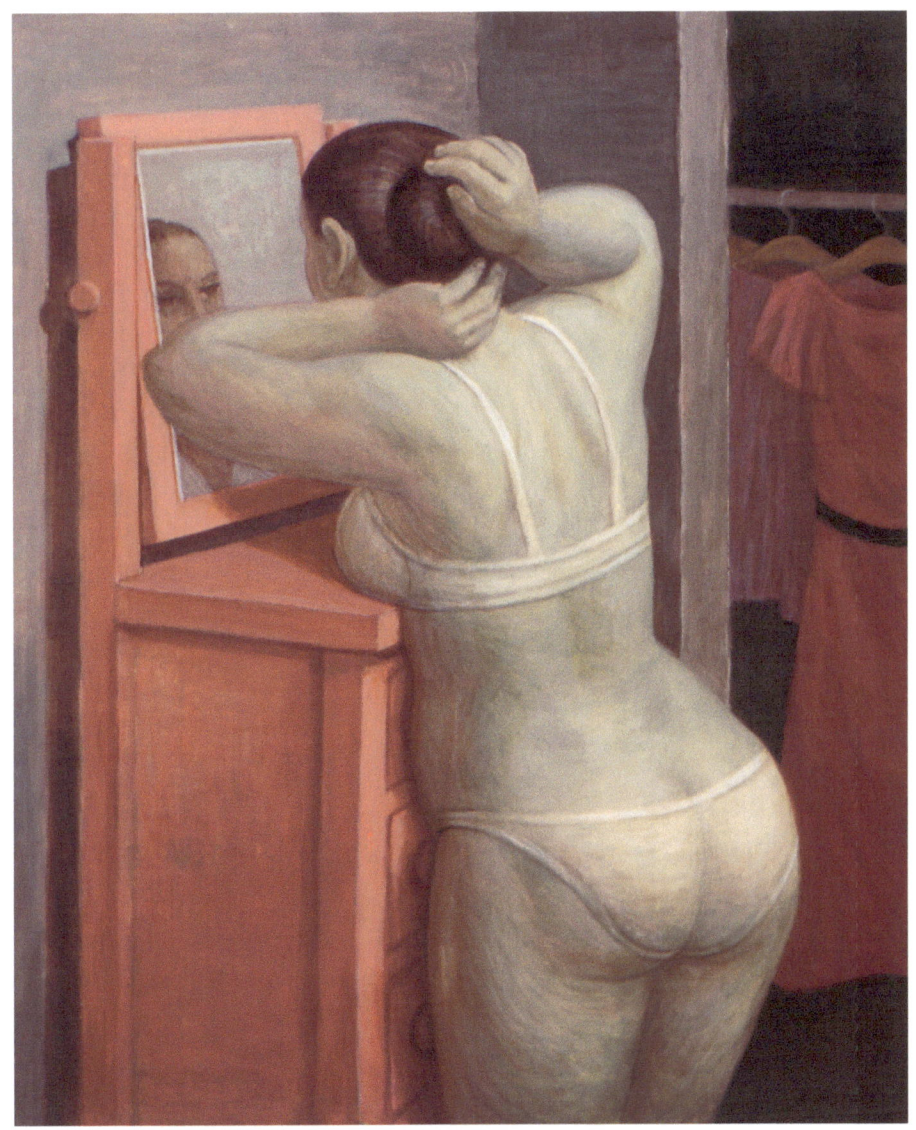

Woman and Bureau, 2005, egg tempera, 20 x 16 in.

Unlike *At the Bureau Mirror*, where the woman and chest of drawers seem to be at odds, they fit well together here, enhanced by the nice harmony of reddish colors.

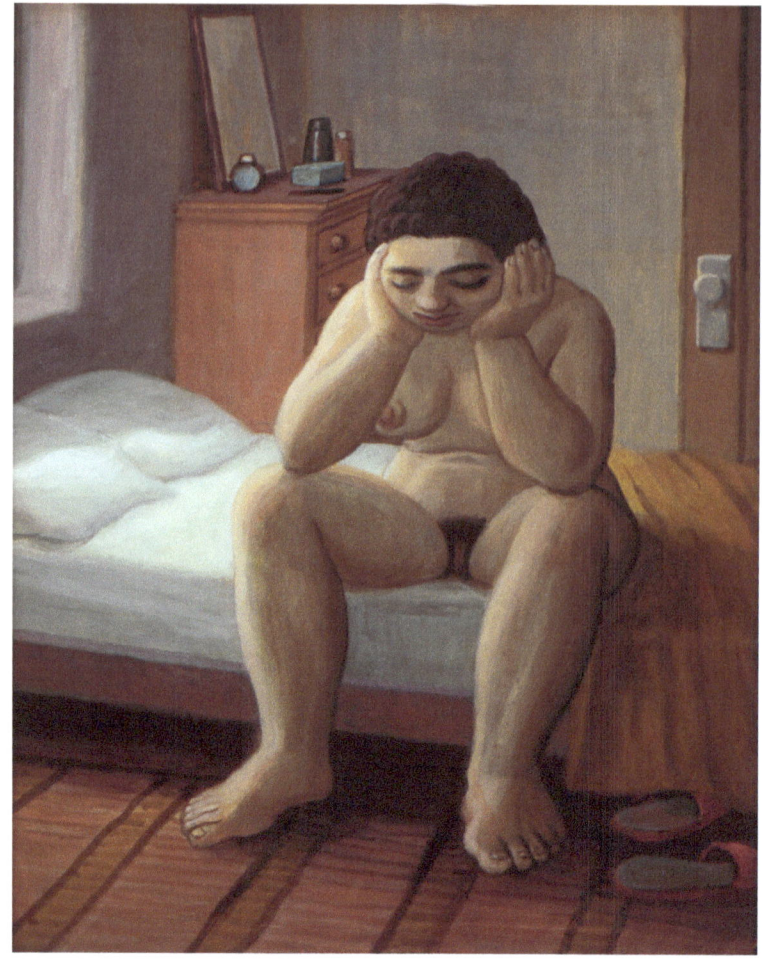

Melancholy, 2004, egg tempera, 14 x 11 in.

This brooding pose is often used in art, from Dürer to Munch. I've tried many variations. This doubtful moment is one I often experience before getting up.

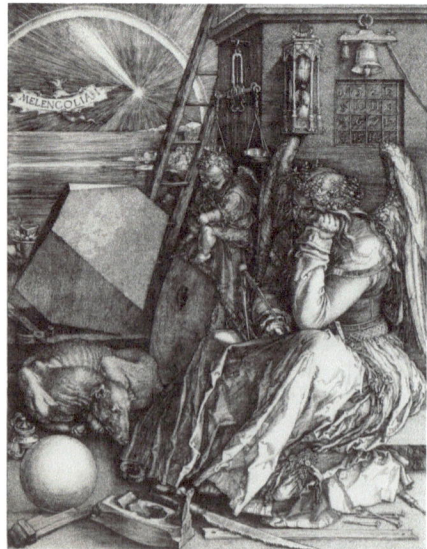

Melencolia I, Albrecht Dürer, c. 1514, engraving

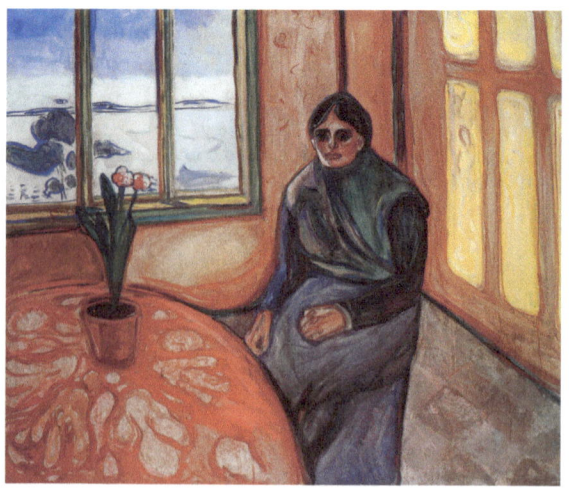

Melancholy (Laura), Edvard Munch, c. 1899, oil
This painting is a study of the artist's sister.

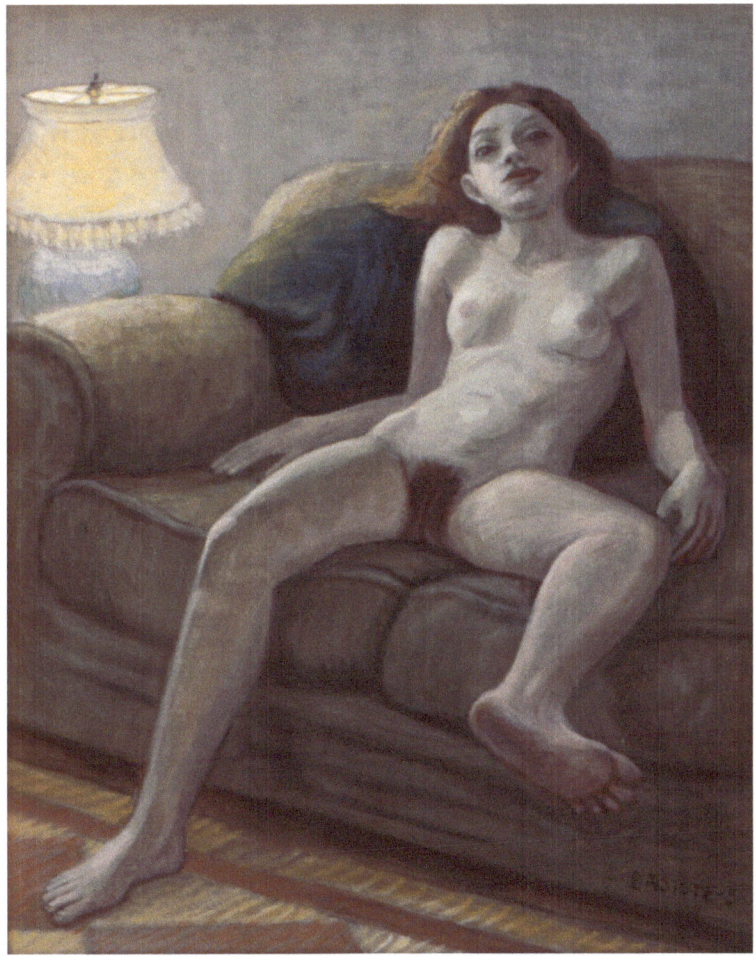

Sprawling Nude, 2005, egg tempera, 14 x 11 in.

This figure was inspired by a painting by Finnish artist Akseli Gallen-Kallela (1865–1931). Done in Paris when he was only twenty-three, *Démasquée* (below) has an insouciance and immediacy—unlike his nationalistic work, which was painted later and was often heavy-handed. In a letter, he referred to *Démasquée* as his "dirty picture." Manet's Olympia also comes to mind because she was perceived as confrontational, even haughty.

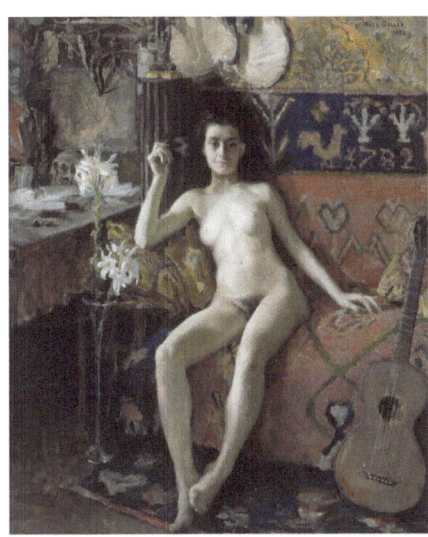

Démasquée, Akseli Gallen-Kallela, c. 1888, oil

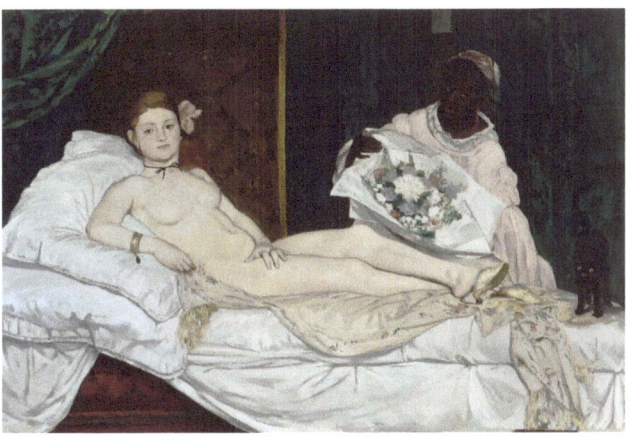

Olympia, Édouard Manet, c. 1863, oil

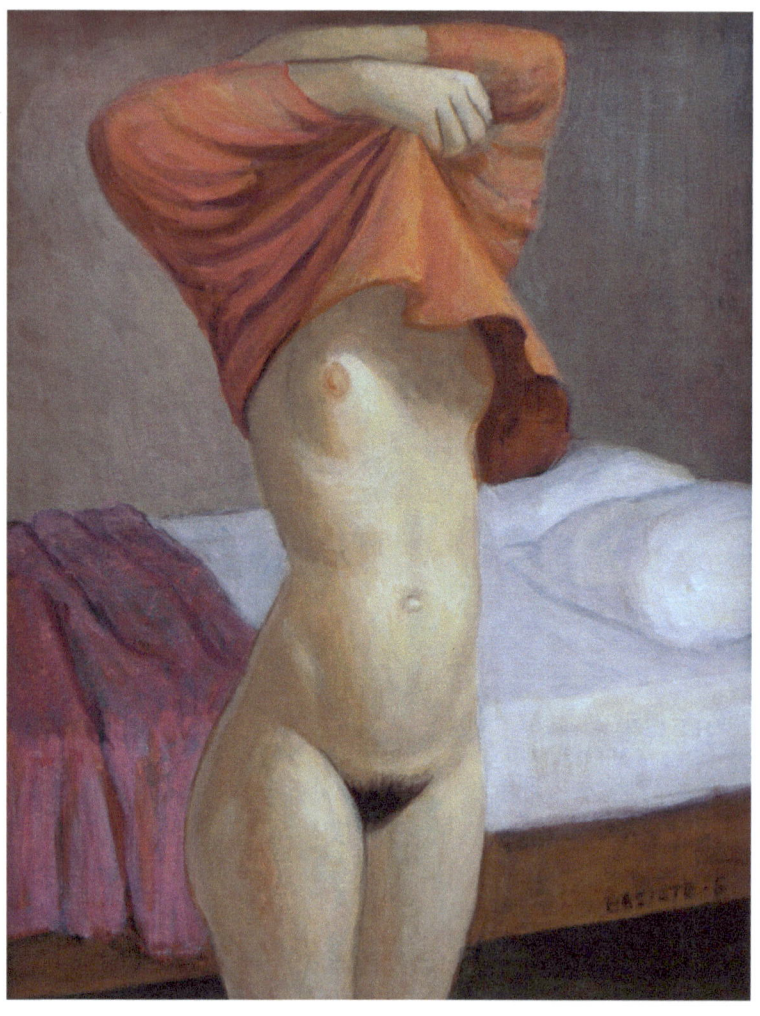

Undressing, 2005, egg tempera, 12 x 9 in.

Here we have a politically incorrect voyeuristic moment, meant to conjure the jolt of excitement and expectation that the partner experiences.

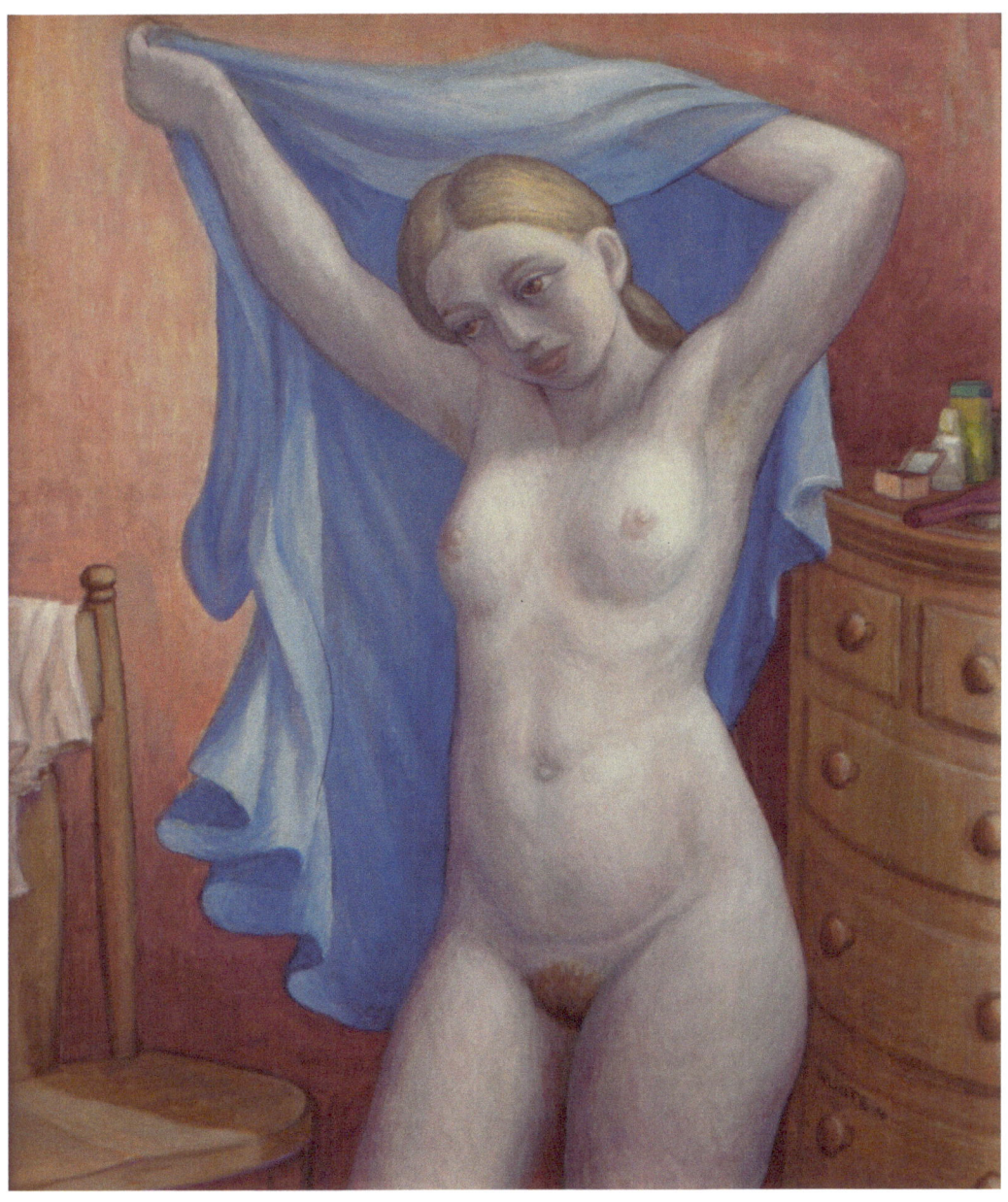

Disrobing, 2004, egg tempera, 25 x 21 in.

This is a more neutral variation of the moment before jumping into bed. But how do we know she isn't putting her robe on? When I was a student, a collector showed me a sketchbook of Raphael Soyer's that was full of ink sketches of women undressing. The intimacy of these sketches made a powerful impression on me.

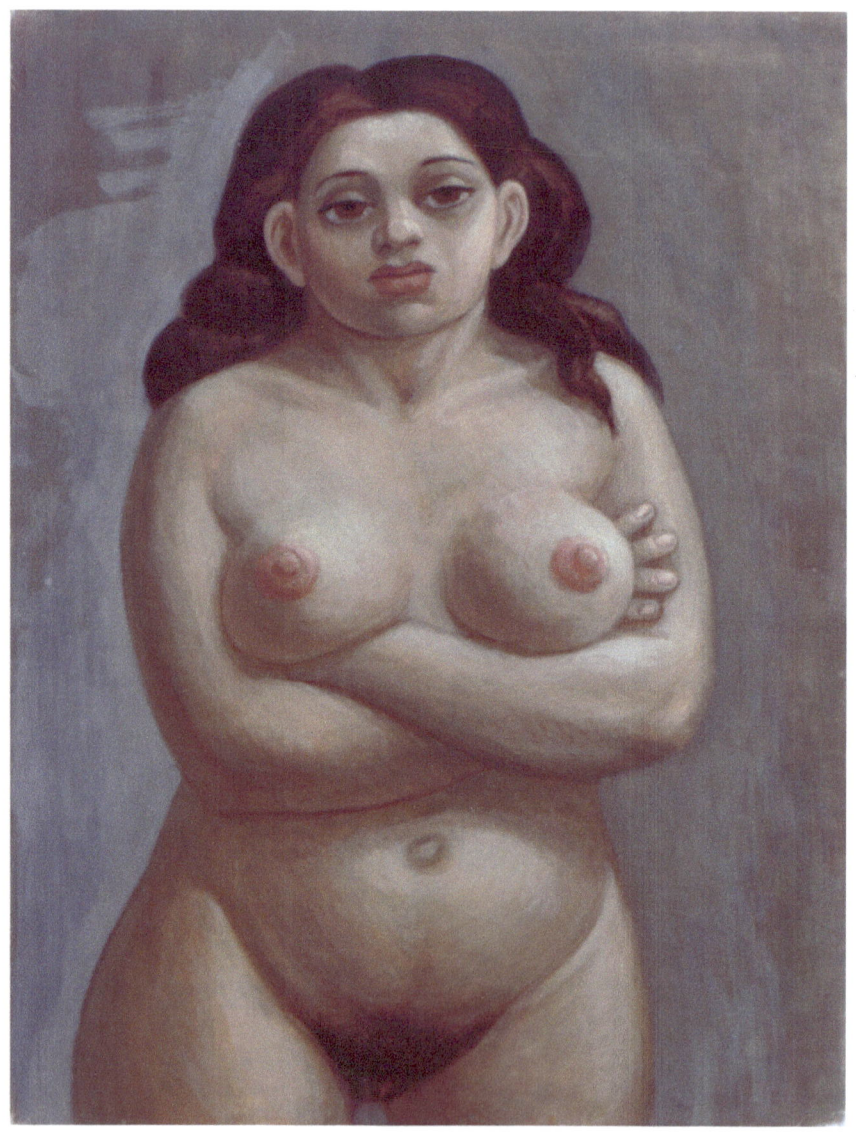

Recalcitrant, 2005, egg tempera, 20 x 16 in.

The nude confronts the viewer and is not impressed. This would be a difficult picture to live with. It even made me nervous while I painted it.

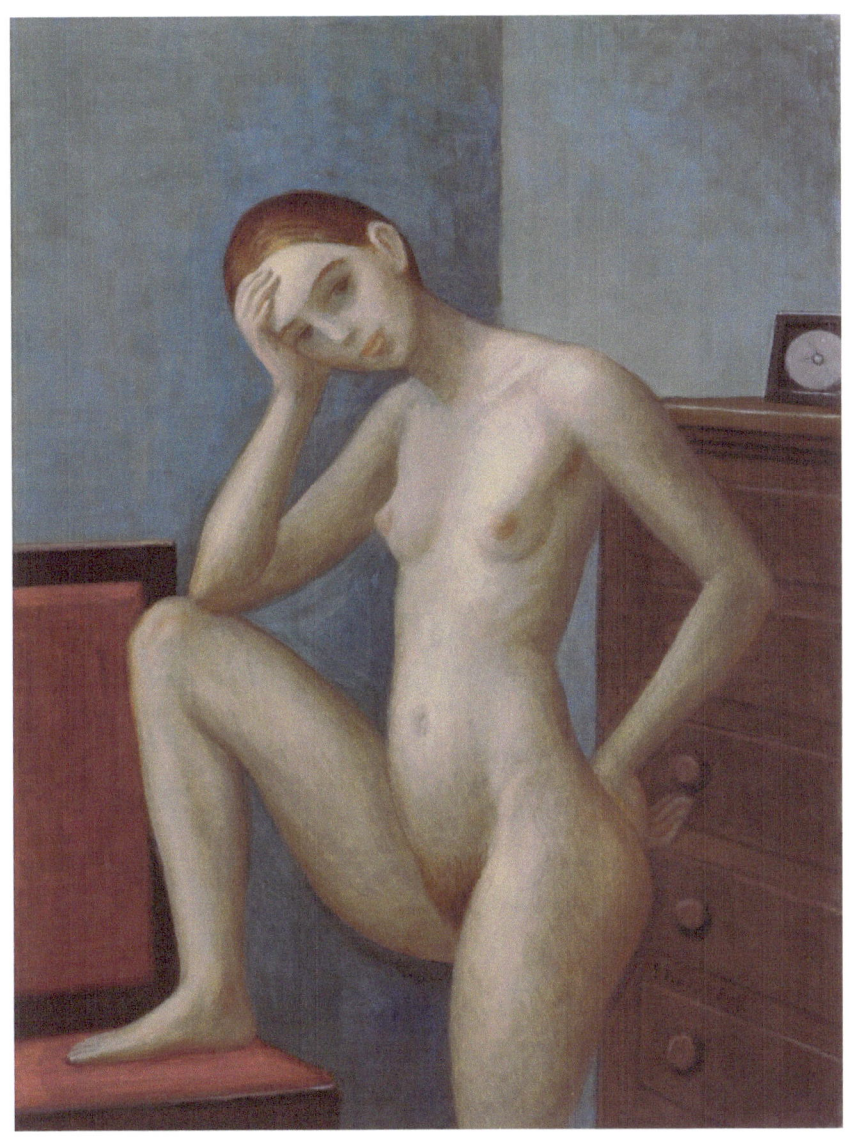

Waiting, 2008, oil over egg tempera, 20 x 16 in.

This painting was hard to name. Perhaps she's waiting for the spectator to react. The oil glazes give the skin soft, subtle transitions.

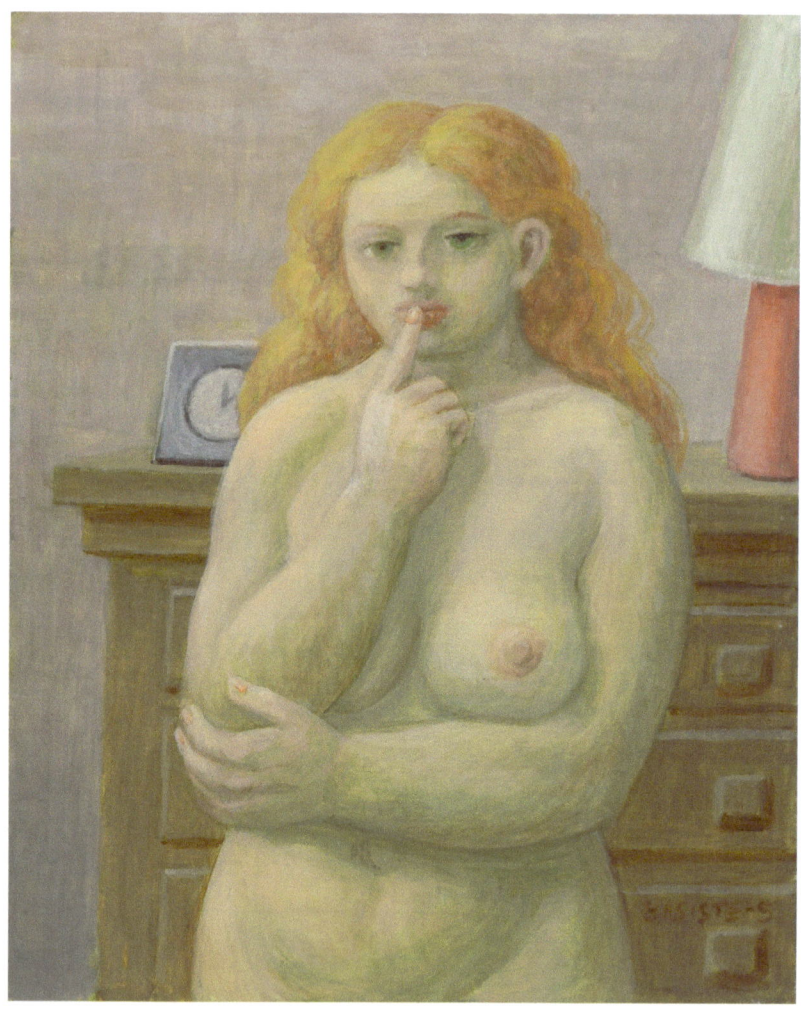

Enigmatic, 2005, egg tempera, 10 x 8 in.

Though a variation of the confrontational nude, this one, while in control, is ambiguous. These last three self-possessed nudes have challenging gazes in common with that of Manet's *Olympia*.

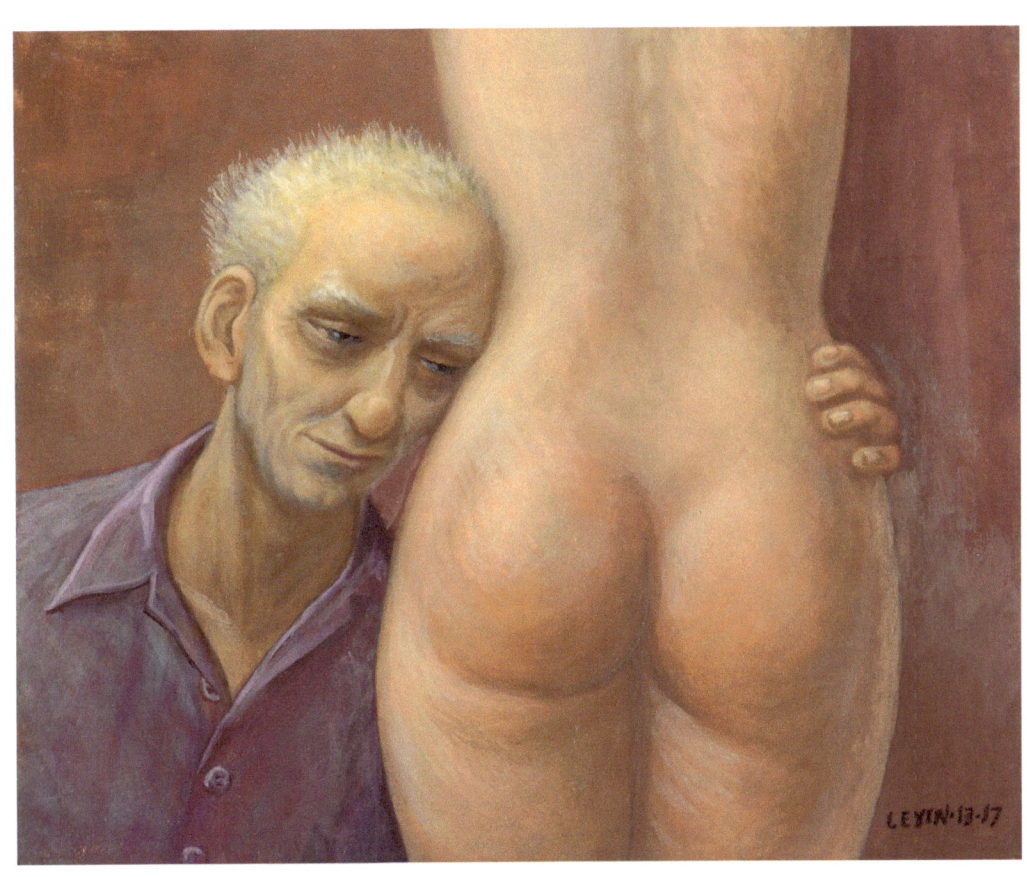

Tired Artist and Muse, 2013–17, egg tempera, 12 x 16 in.
This is a recent painting, done while I was finishing my editing of this book.

Other Sources

Clark, Kenneth. *The Nude, A Study in Ideal Form.* New Jersey: Princeton University Press, 1972.

Dempsey, Charles. *Annibale Carracci, the Farnese Gallery, Rome.* New York: George Braziller, 1995.

Dixon, Annette. *Women Who Ruled; Queens, Goddesses, Amazons; 1500–1650.* London, New York: Merrell, 2002.

Goffen, Rona. *Titian's Women.* New Haven and London: Yale University Press, 1997.

Goodrich, Lloyd. *Raphael Soyer.* New York: Harry N. Abrams, 1970.

Gualdoni, Flaminio. *The History of the Nude.* Milan: Skira, 2012.

Impelluso, Lucia. *Gods and Heroes in Art.* Los Angeles: J. Paul Getty Museum, 2003.

Lucie-Smith, Edward; Chicago, Judy. *Women and Art: Contested Territory.* New York: Watson-Guptill, 1999.

Rey, Xavier; Roquebert, Anne; Shackelford, George. *Degas and the Nude.* Boston: MFA Publications, 2011.

Vigué, Jordi. *Masterpieces of Painting, 1000 Nudes.* Munich: Prestel Verlag, 2001.

www.ingramcontent.com/pod-product-compliance
Lightning Source LLC
Chambersburg PA
CBHW041312180526
45172CB00004B/1074